Tribal Art Traffic

A Chronicle of Taste, Trade and Desire
in Colonial and Post-Colonial Times

Traffic: (...) communication or dealings between individuals or groups; the activity of exchanging commodities by bartering or buying and selling; reciprocal giving and receiving; commercial activity involving import and export trade; illegal or disreputable usually commercial activity (...)

Adapted from *Webster's*

Cover picture: Two Kota-Obamba men arrive at a Swedish mission post in French Equatorial Africa—present-day Congo-Brazzaville—to hand over reliquary figures. Normally, such figures are attached to bark baskets containing the remains of deceased family members. Photographed by the Swedish missionary G.A. Jacobsson, probably in 1917.

Tribal Art Traffic

A Chronicle of Taste, Trade and Desire
in Colonial and Post-Colonial Times

Raymond Corbey

Royal Tropical Institute - The Netherlands

Royal Tropical Institute
PO Box 95001
1090 HA Amsterdam
The Netherlands
Tel: (31) 20 - 5688 272
Fax: (31) 20 - 5688 286
Email: kitpress@kit.nl
Website: www.kit.nl

Imaging of cover picture: Henk de Lorm, Leiden

Cover and graphic design: Nel Punt, Amsterdam
Lay-out: Grafisch ontwerpbureau Agaatsz bNO,
Meppel
Printing: Drukkerij Giethoorn Ten Brink, Meppel

ISBN: 90 6832 197 8
NUGI: 911/611

This book is part of a series concerning museums
and cultural policies in art and culture.
Previously published: *Art, anthropology and
the modes of representation: museums and
contemporary non-western art* Harry Leyten,
Bibi Damen (eds.)
*Cultural diversity in the arts: art, art policy and
the facelift of Europe* Ria Lavrijsen (ed.), sold out
*Illicit traffic in cultural property: museums against
pillage* Harry Leyten (ed.)
*Intercultural arts education and municipal policy:
new connections in European cities* Ria Lavrijsen
(ed.)
*Global encounters in the world of art: collisions
of tradition and modernity* Ria Lavrijsen (ed.)

Contents

Preface

"[The] age of the korwars is gone forever."

Th. van Baaren, *Korwars and Korwar Style*

Among the various sources of inspiration for this book, three stand out. The first is the collections of the Nijmeegs Volkenkundig Museum at Nijmegen University, the Netherlands. I was generously given access to the museum's reserves and was regularly allowed to select items from among its treasures to illustrate my lectures in the anthropology department. The second is the National Museum of African Art and the National Museum of Natural History, both part of the Smithsonian Institution, Washington, D.C., where, as a visiting scholar in the winter of 1992/93, I had ample opportunity to observe behind the scenes and in the storerooms, and to talk to curators as well as to officials handling repatriation requests pertaining to Native American material. While there, my interest in the fascinating adventures of tribal objects grew considerably. A third source of inspiration was my earlier research on western representations and interpretations of non-western peoples in the context of colonial photography, world fairs, museums, and missionary propaganda, studied against the background of western views of humans, nature, and history. The common denominator of that earlier research and the present book is the history and ethnography of ethnographic practices, in the broadest possible sense.

As remarked by James Clifford (1988: 29), "[It] is important to resist the tendency of collections to be self-sufficient, to suppress their own historical, economic, and political processes of production." This book intends not primarily to contribute to the theoretical analysis of those processes, subject of a growing body of literature which is referred to in the notes, but to offer a survey and chronicle—to some extent a *chronique scandaleuse*—of the intriguing movements of ethnographics to and in Europe. It focuses on the Low Countries and their huge colonies, and elaborates upon representative cases, stressing individuals outside the official channels and institutions. It is based on archival and historical research, the sparse available scholarship on this particular subject, a number of formal interviews and frequent informal contacts with Belgian, Dutch, and foreign dealers, and a close monitoring of the goings-on in and around in particular the Brussels tribal art galleries since 1995.

I would like to thank the individuals who were interviewed for this book, as well as everyone who generously gave their opinions or helped me in other ways: collectors and dealers, anthropologists and curators, and librarians and archivists in the Netherlands, Belgium, France, Germany, the United Kingdom, and the United States. A number of tribal art dealers from Brussels and Amsterdam—not least Loed van Bussel, Peter de Boer, François Coppens, Joep Franzen, Alain Guisson, and Jan Visser—allowed me to look inside the shuttered scenes of the trade, which disclose their secrets only slowly and reluctantly, if at all. I would like to give special mention to the stimulus provided by Wil Roebroeks and Léon Buskens. David Stuart Fox, librarian at the Rijksmuseum voor Volkenkunde in Leiden, was consistently supportive in both word and deed—it is a pleasure to work in such a well-managed, excellent scientific library. Guy van Rijn, a tribal art consultant based in Brussels, imparted to me much of his profound knowledge of African art and the African art trade, and introduced me to the tribal art scene in Brussels, as well as providing access to his large archive. Several others are mentioned in the notes. Sherry Marx-MacDonald translated the interview with Tijs Goldschmidt; Fiona Coyne, Mark Vitullo and Marianne Sanders acted as language editors during various phases of the writing.

I regularly visited the Missionaries of the Sacred Heart (MSC) in Tilburg, the Netherlands, who have been proselytizing since the turn of the century in the Netherlands East Indies and New Guinea, and keep magnificent archives pertaining to these activities. I would like to make particular mention of the missionary and ethnologist, Father Gerard Zegwaard, MSC, a pioneer among the Mimika and the Asmat, who passed away suddenly in the summer of 1996.

Earlier versions of the sections on Asmat art, the Brussels tribal art scene, and the Louvre appeared in *Anthropology Today* in 1996, 1999 and 2000, respectively.

Part One:

The Low Countries and Beyond

1.1 Introduction

Since the late nineteenth century, hundreds of thousands of masks, statues, amulets, neckrests, shields, heddle pullies, pots, pieces of cloth, musical instruments, staffs, throwing clubs, bull roarers, spears, and other artifacts have been brought from small-scale overseas societies to the West where they have subsequently been circulating. In this book, the routes of these objects and the channels and milieus through which they moved, and are still moving, during their transatlantic and transcultural diaspora are traced, from the places from which they originated to, and through, the industrialized societies of the North Atlantic Rim referred to as the West, and sometimes even back to where they came from—in colonial and in post-colonial times. A limited number of countries, all of which once controlled large overseas territories, Belgium, the Netherlands, France, Germany and Great Britain, have played the most active role in the western reception of tribal objects. The Netherlands and Belgium and their colonies in Southeast Asia and Central Africa, respectively, will be given relatively full coverage, but related and and parallel developments in the surrounding European countries and in the nonwestern areas of origin will also be dealt with.

As the anthropologist Arjun Appadurai noted in the introduction to a collection of essays appropriately entitled *The Social Life of Things*, items have no meanings apart from those attributed to them by humans in their various contexts. In order to arrive at those meanings we have to analyze their concrete, historical circulation: "(We) have to follow the things themselves, for their meanings are inscribed in their forms, their uses, their paths. It is only through the analysis of these paths that we can interpret the human transactions and calculations that enliven things ... it is the things-in-motion that illuminate their human and social context."[1] The essays in that volume show how much the cultural identity of objects changes as they move through various milieus, thus relativizing the notion of an original or essential meaning and establishing objects-in-transit as an important field of study in its own right.

Not only are studies concerning the history of institutional ethnographic collections in western countries few and far between, but very little if

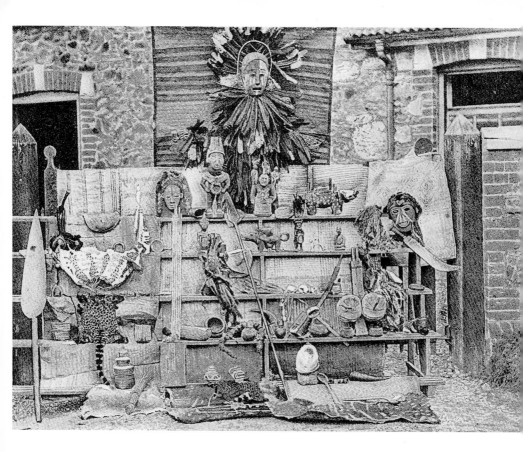

1. "Fetishes and curiosities," collected by R.E. Dennett in the 1880s along the Lower Congo coast and sold by him in England, where this picture was probably taken. From his *Seven Years Among the Fjort*, a Kongo-speaking people now known as the Vili (Dennett 1887). Dennett, an early critic of of the ruthless colonial and missionary practices in Africa, was an agent of a commercial company with many factories along the African coast.

anything has been done concerning what went on—and is going on—outside museums, especially in the world of dealers and collectors, inside museums in regard to travelling objects and the individuals handling them, or between museums and dealers. The French expression *le circuit des objets* is an appropriate description for the subject of this study. Although the focus is on how artifacts have moved and still move about, a number of other aspects of the western reception of tribal objects about which more has been published will be touched upon, such as representations of tribal objects as a form of "appropriation" of cultural others,[2] or issues of cultural property and museum ethics. The fact that the spotlight is seldom on

objects and individuals outside official institutions probably has to do with the circumstance that people in the academic and the museum world frequently look down upon those other milieus—even more so nowadays because of the international stress on cultural property and the ethics of acquisition. At the same time, as will become clear, they interact more intensely with the tribal art market than many of them care to admit.

I am aware that the term "tribal art(s)," like the labels "art(s) premier(s)" (increasingly popular in France), "primitive art," "ethnographics," and "ritual objects," is far from uncontested. Likewise, the terms "tribe" and "tribal" are currently used with some reservation by most anthropologists, and earlier tendencies to underestimate the historicity of "tribal" societies, the disparities within them, and their degree of interaction with other groups are now being criticized. Nevertheless, I use the term "tribal art"—and, alternatively, "ethnographics" or "tribal objects"—in a descriptive sense, for want of better, and because the term is used by those with whom this book is concerned. In any case, the term "art" is in itself already comfortably broad and unspecific, and as far as European traditions are concerned already covers an extremely heterogeneous area, from Byzantine icons to the seventeenth-century winter landscapes of the Avercamps to the performances of Joseph Beuys.

Every single object from Africa, Indonesia, or the Pacific that is now in the West was at some point in history collected by someone, from someone, for someone, for specific reasons, in exchange for money or articles, through friendship or trickery, intrigue, force, or theft. At every step in the often complicated routes travelled by non-western artifacts, these factors again came into play, but usually in quite different ways. In the second part of this book, seven individuals—collectors, dealers, and curators—are questioned about their lives and recent dealings with specific artifacts from specific non-western cultures. In this first part of the book, a roughly chronological survey is given of the traffic in tribal objects to and within North Atlantic societies in the past century. I shall start with some remarks on the meanings and functions of the objects in their initial tribal contexts, and shall then, in a roughly chronological order, successively deal with museums and expeditions, collectors and dealers, the missionaries, artists as collectors, post-colonial developments, tribal art auctions, and, finally, issues of cultural property. I will concentrate on the main lines of this immensely rich and fairly complex subject, illustrating these—*exemplum docet*— as much as possible with characteristic cases, and with a number of mostly unpublished photographs showing objects *en route*.

As one might expect in countries with such a rich history of world trade and colonialism, the Netherlands and Belgium have long been paradises for those interested in ethnographics. Huge collections can be found in

Dutch and Belgian museums, although the extent to which their collections are exhibited as well as how they are exhibited often leaves much to be desired. Apart from in such museums, the many hundreds of collectors of ethnographics in both countries can satisfy their hunger by visiting a number of galleries specializing in "tribal art," or "primitive art" as it is sometimes still called. These galleries are mainly situated in the capitals of both countries: in the Spiegelkwartier near the Rijksmuseum in Amsterdam and around the Grote Zavel square (Place du Grand Sablon) in the centre of Brussels. Anyone wishing for more can be in Paris within a few hours, where—in addition to a number of museums—there are the galleries in the sixth arondissement and the specialized auctions. Paris is a global centre of the trade in tribal art, with New York and Brussels in close second place. France, Belgium, and the United States are countries with a developed collector's culture in this particular field and, in this respect, leave countries like Great Britain and Spain and even the Netherlands far behind.

For the afficionado of ethnographics, Belgium means primarily central Africa, or to be more precise, the Belgian Congo. The collections from the former colony in the Koninklijk Museum voor Midden Afrika in Tervuren near Brussels are unequalled anywhere in the world. It is no coincidence that the tribal art dealer Marc Felix, who enjoys an international reputation as an expert on this region, was born and bred in Brussels and grew up on the Grote Zavel. His views are recorded in this book, along with those of Frank Herreman, who for many years was a curator at the Etnografisch Museum Antwerpen, and is presently attached to the Museum for African Art in New York. As far as the Netherlands is concerned, its museum collections of objects from the Southeast Asian archipelago—the various Batak groups of Sumatra, the Dayak societies of Borneo, the Moluccas, the many Papuan societies of western New Guinea, and so on—are peerless, unsurpassed even by the collections in Indonesia itself.

In the autumn of 1995, the Royal Academy of Arts in London opened one of the largest and most complete exhibitions of African art ever held, *Africa: The Art of a Continent*, which was subsequently displayed in Berlin and New York. Although attention was given to the original meaning, function, and context of the hundreds of top pieces in the accompanying catalogue,[3] the how and the why of the routes taken by these objects was largely neglected. This is often the case, despite the fact that the paths and "life histories" of non-western objects constitute an exciting field of study, especially nowadays when small-scale tribal societies are increasingly being incorporated into worldwide systems of communication and exchange. Through such processes of globalization, the traditional production of tribal objects is changing rapidly both in

style and content. The coconut as raw material, for instance, is increasingly being replaced by plastic or metal. Traditional "animistic" beliefs and practices are being pushed back by Christianity and Islam, or taking on new forms through the adoption of elements from other religions. Since the end of the last century, museum anthropologists have continuously stressed the need for haste regarding the collection and documentation of the cultural expressions of small-scale societies before it is too late. In recent decades, this has been accompanied by the ever more frequently heard complaint from collectors of ethnographics that it is almost impossible to get their hands on "good" pieces anymore. The sharp increases in the market value of better pieces in the last two decades has been another consequence of this scarcity.

In addition to the accelerated loss or change in traditional methods of expression, there are two other circumstances responsible for the spotlighting of ethnographics in the West today. On the one hand, there are the international agreements and continuing debate about how cultural heritage should be dealt with. Who has the moral and legal right to it? On the other hand, a contrast has appeared in the course of the twentieth century between the aesthetic approaches of art historians and art lovers and the ethnographical approaches of anthropologists. A fierce confrontation between these two perspectives took place as a result of the large *Primitivism in Twentieth Century Art* exhibition at the Museum of Modern Art in New York in 1984. It presented primitivism in the work of, among others, Gauguin, the Fauves, Picasso, Brancusi, the German expressionists, Lipchitz, Modigliani, Klee, Giacometti, Moore, the surrealists, and the abstract expressionists. Both the show and the substantial two-volume catalogue, themselves part of the selfsame reception of tribal art in the West they set out to document, provoked a wave of criticism from anthropologists.[4] In one camp, such terms as "tribal art" or, even worse in the ears of the opponents, "primitive art" or *arts premiers* are used. Institutions taking this view prefer an aesthetic, decontextualized presentation of the finest pieces, ideally old and patinated, and they tend to provide little text or context in their exhibitions, although this may be compensated by information given in a catalogue. Like all great art, the piece is supposed to speak for itself, and too much text is considered to be more of a hindrance than a help. Ethnographic museums, on the other hand, are much less biased in favor of the beautiful. They see the objects primarily as cultural artifacts carrying meanings bound to specific cultural contexts that should be made clear in the museum presentation. In this view, an object is primarily of ethnographic interest, rather than being beautiful, early, and patinated.

This controversy is further complicated by the identity crisis with which western ethnographic museums, more so than tribal art museums,

are confronted in culturally pluralistic societies in the present-day post-colonial period and, to a certain extent, postmodern climate of opinion. As far as this problem is concerned, a look at the history of their collections, as offered by this book, is indispensable when coping with issues of museum identity and policy. While the ethnographic museum is a creation of modern colonialist nation-states, the crisis of the ethnographic museum we have witnessed in recent decades is one of the effects of the breakdown of the master narrative of the modern west—the *grand récit* that asserted the unique, universal significance of "enlightened" western rationality and western values and, until quite recently, determined the ethnocentric ways in which other cultures were presented in North Atlantic museums. The idea of a *mission civilisatrice* of North Atlantic vis-a-vis colonially dominated peoples which was implied by that narrative has by now lost most, or at least much, of its force. The demise of colonial domination and of the ideology by which it was justified has forced museums of ethnology to redefine their presentations, their goals, and their identity, and many of them are still trying to cope with this challenge. The Tropenmuseum in Amsterdam offers a case in point.[5] While formerly a colonial museum, in the early post-colonial period of the 1960s and 1970s it focused on educating the public about "Third World" peoples and developmental aid. It currently stresses the common everyday material culture of non-western peoples more than other Dutch museums, as well as focussing on dance, theatre, and music, and on decolonizing the popular imagination by combatting racial prejudices.

Colonial collecting expeditions are no longer possible. Whether the products made by contemporary individuals from non-western cultures, contemporary plastic objects, and tourist curios should get as much attention as fine traditional objects is controversial. Furthermore, the moral and legal title to a certain proportion of extant museum collections is being contested, as is the question of who may be trusted with interpreting and presenting them—for instance, in the case of artifacts originating from North American Indians, Australian Aborigines, or New Zealand Maori.

This book is primarily about the travels, functions, and meanings of ethnographic items among collectors, artists, missionaries, curators, anthropologists, and others in the West. Time and again, however, the first question that is asked is what the initial meaning and function of an object was in the context in which it was originally made and used. Anthropologists generally do their best to pay attention to that original context when exhibiting an item. While a presentation in terms of "tribal art" does not deny this dimension, it does tend to stress the meaning of such an item in a western context of aesthetic appreciation. The parry shield in the Northern Moluccas, the *churinga* among certain Aborigine

groups, and the kris in Indonesia, are three items which can be used to illustrate the manner in which tribal objects figure in their initial cultural contexts.

Ceremonial parry shields such as those illustrated here (Fig. 2) could be found in the Northern Moluccas (Maluku), and in a number of variations in a much larger area, from the south coast of Sulawesi in the west to the northwest coasts of New Guinea in the east. They are narrow, "waisted," generally about one meter long, roughly triangular in cross-section, and often made of *Hibiscus tiliaceus*, colored black with soot and the juices of various plants. Mother-of-pearl and fragments of pottery and porcelain were used for the complicated, symmetrical inlay; the pottery used often originated in the Netherlands.

Even in the Netherlands, it is not easy for collectors to get their hands on such shields, but considering Dutch colonial history, it's still a great deal easier to find one there than in other locations, possibly including the Moluccas themselves, where any remaining shields, as well as those which are still occasionally made in the ritual fashion, are cherished as family heirlooms. Several dozens Moluccan shields are preserved in the storerooms of the Rijksmuseum voor Volkenkunde in Leiden, and other Dutch museums also have quite a few.[6] The oldest I know of are currently preserved in the Royal Danish Museum in Copenhagen. They were among the possessions of Bernardus Paludanus, a physician and collector in Enkhuizen, the Netherlands, who probably obtained them from a merchant ship returning from the East Indies in the early seventeenth century. In 1651, about twenty years after his death, Paludanus' entire cabinet of curiosities was bought by Duke Friedrich III of Schleswig-Holstein-Gottorf for his *Kunstkammer* in Gottorf Castle, which itself was transferred to Copenhagen after the annexation of the dukedom by Denmark in 1712.

The Tobelo of North Halmahera refer to the parry shield as *ma dadatoko*, meaning "protection" or "shielding" by male ancestors.[7] The shield represents a person: the pairs of inlaid white ovals are the eyes, the top is the head, and at the other end, right at the bottom, are the feet. The lines running parallel to the length represent the bloodvessels of the body, and the line carved into the back in which the handle is placed is the backbone, which is associated with the identity and power of the warrior. Like the spears and swords which go with it, the shield belongs to the ancestors with whose power it is invested, to the family, and to the house in which it is kept. It lends weight and reputation to that house and may never leave it, except as a ceremonial gift when a male member of the family takes a bride. Prior to the *pax neerlandica*—the "pacification" by the Dutch—the shields still had a function in battle; nowadays, they are mainly carried during the *hoyla*, a war dance performed as part of a marriage ceremony. Inlay work of foreign origin is associated with all

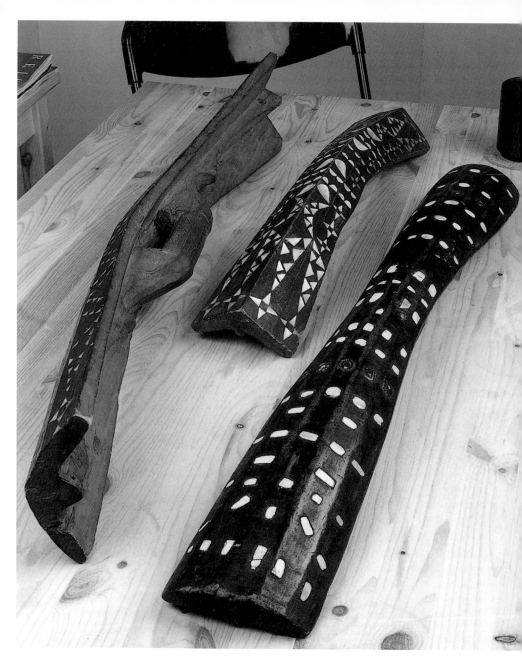

2. Three ceremonial parry shields from the Northern Moluccans, in a private collection in the Netherlands in 1996. The one on the left is 85 cms., the one in the middle 57 cms., and the one to the right 77 cms. long. The right-hand shield is inlaid with fragments of earthenware which probably originated from the Netherlands, while the other two have mother-of-pearl inlays.

things male, while native materials such as the cloth given by the family of the bride are considered to be female. The *ma dadatoko* is an inalienable possession of a warrior, his family, and his ancestors, an inseparable part of his personal, social, and mythical identity.

These are just a few of the most essential meanings of Moluccan parry shields for just one of the many groups in this region among which this type of artifact was found. It would take hundreds of pages to provide information that could in any way be considered complete on the highly complex as well as both regionally and diachronically varying cultural, mythical, and ritual background of these shields.[8] The same is true of a second example of the initial meaning of "tribal art": the *churinga* of certain Aborigine cultures.

Churinga are long, oval, rather flat objects made of wood or stone upon which abstract motifs of circles, lines, and spirals are scratched, up to several feet long. They are considered extremely sacred and secret, a custom which I will honour by not providing any illustrations. Much has been written about their meaning to the various groups of Aborigines who used and sometimes still use them.[9] One might say that they are the embodiment or metamorphosis of totemistic primeval beings or ancestors, the so-called Dreamings. They are associated not only with specific myths, songs, and anecdotes, but are also closely related to specific places and routes to which the patterns refer and to the activities of the Dreamings there. *Churinga* figured in a number of rituals, including initiations. Like the Moluccan parry shields, they are inseparable from the identity of Aboriginal individuals and clans, from places in which they reside, and from the areas through which they move. Aboriginal rights to land have been recognized under Australian law to an increasingly greater degree in recent years. Various Australian anthropologists have recently argued that, in view of this inseparability, the recognition of landrights also implies the recognition of Aboriginal rights to the "cultural property" now preserved in many museums worldwide, including *churinga*.

My third example of the initial meanings of ethnographics concerns a popular "collectible" in the Netherlands: the kris (cf. Fig. 43), a ritual dagger to which magical powers are ascribed. Its blade is invariably double-edged and its haft always represents someone or something, no matter how abstractly. Many Indonesians as well as Dutch of Indonesian descent in the Netherlands are convinced that there are real powers, i.e., spirits or souls, housed in krisses and cherish them as powerful amulets, handed down from generation to generation. The cosmological meanings and ritual functions of krisses are part of an old Javanese tradition of Hindu inspiration; again, as in the case of the Moluccan shield or the *churinga*, so numerous, varied, and complex that several volumes would

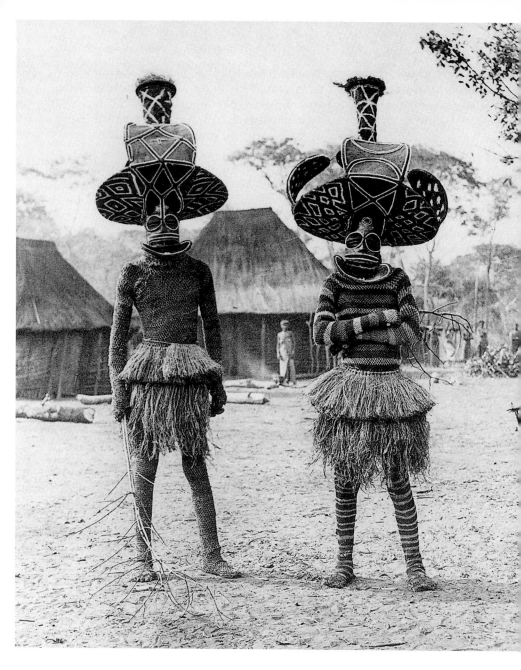

3. "Two *Kalëlwa* masks chase away the women in Samafufu." Photographed by Herman Baumann (Baumann 1935) during the Angola expedition of the Berlin Museum für Völkerkunde in 1930, in the Chokwe village Samafufu. The masks have bright, contrasting colours—red, white, and black.

be necessary for a history and analysis of this phenomenon to have any depth. The main character figuring in that history would be the *empu* or kris smith, the magical master of secret metallurgical techniques which are surrounded with rituals, taboos, and sacrifices, and in which iron ore from meteors played a part. The activities of the *empu* were closely connected with the sacred *radja* and his court.[10] Some Javanese krisses were included in Paludanus' cabinet of curiosities and, like the Moluccan shields, ended up in Copenhagen.

A number of more general statements can be made concerning the meaning and function of such ethnographics as masks, figures, shields, and amulets in their initial cultural context. They usually, or even by definition, come from small-scale tribal societies. In such societies, the community not only includes living people, but also ancestors and spirits, who are likewise part of it. Contact is maintained with both these categories of beings in accordance with strict rules and values. Goods, services, civilities, and messages are exchanged with them. In this context, dance masks embody or, rather, become a certain spirit (Fig. 3). Figures are made of the deceased, housing their souls or spirits to a fairly literal degree, in order to talk to them or make sacrifices to them. A representation of an ancestor, a totem, or a spirit, and therefore the ancestor, totem, or spirit itself, is often worn to ward off evil forces—as an amulet, on a shield, as a boat prow, on an arrow, or on the haft of a tool. In its initial context, what in North Atlantic societies is generally spoken of as "ethnographics" or "tribal art" is an integral part of, among other activities, initiations and sacrifices, harvest and hunting magic, ancestor worship, healing, the display of status, births, weddings, and funerals.

1.2 Museums and Expeditions

In the seventeenth century, a stream of articles from overseas began to arrive to Europe in connection with the trade and expansion of a number of Western powers. Such items tended to end up in the curiosity cabinets and *Kunstkammern* of rich citizens such as Paludanus of Enkhuizen, and members of the nobility such as Duke Friedrich III. Expeditions such as those of the Briton James Cook in the 1770s or, somewhat later, the Frenchman Bruni d'Entrecasteaux, came home with exotic articles and sometimes even with entire collections.[11] In the second half of the nineteenth century, various European states obtained huge overseas territories, where large-scale missionary activities were initiated. The stream of objects from the periphery to the metropoli of the expanding powers grew at a steady rate. Explorers, merchants, ship's captains, scientists, soldiers, missionaries, adventurers, diplomats, planters, doctors, officials, and technicians took western commodities with them to the colonial frontier societies and brought exotic things back to Europe.

In the course of the nineteenth century, often typified as the Museum Age, the earlier curiosity cabinets gave rise to a number of different kinds of museums. For instance, the seventeenth-century cabinet of art and curiosities of the Grosser Kurfürst von Brandenburg, a Prussian prince, later became the Königliche Preussische Kunstkammer (Royal Prussian Art Cabinet), which after 1829 had a relatively independent Ethnographic Collection that developed into the present-day Museum für Völkerkunde in Berlin, founded as such in 1873. This museum now officially houses 342,000 items, among the earliest of which are a number of objects from Polynesia, collected between 1772 and 1775 by James Cook and the Forsters of Germany, a father and son who accompanied him.[12] Newly established museums of natural history, "colonial museums," and specialized ethnological museums gave attention to "lower races" or "natural peoples" and their products.[13] In France, for example, a number of smaller natural history museums—which were initially, and sometimes still are, a sort of colonial curiosity cabinet—are still in existence, in Boulogne-sur-Mer, Rouen, Nantes, La Rochelle among others.[14]

Various interpretations of foreign cultural artifacts replaced one another or existed simultaneously. In the eighteenth century, one talked in a more worldly context of curiosities or rarities and, in a Christian context, of heathen or even devilish fetishes or idols bearing testimony to superstition—idioms that persisted well into the twentieth century. In the nineteenth century, one spoke of artifacts and of curiosities or curios in the sense of exotic souvenirs, which could refer either to things made by native peoples for their own use or to things made especially to be sold or bartered to westerners. Some foreign items were found to be beautiful; others were interesting precisely because they were considered ugly or bizarre. Objects which were unavailable or were not for sale were often commissioned by westerners. Later, in the early twentieth century, then extant interpretive categories such as "rarity," "idol," "artifact," or "arts and crafts" were enriched with concepts such as *art nègre*, "primitive art," "tribal art," and *arts premiers*, which only a few decades before had been unthinkable. Most of these interpretive categories still survive in some form or another. In the course of the following decades, a clearer distinction was made between culture and "race," and the ethnological notion of "artifact" was stripped of its nineteenth-century evolutionist connotation of primitiveness, in the sense of being typical of an early, "primitive" stage in the development of "civilization." At the same time, museums increasingly began to present artifacts in their specific cultural contexts, rather than in supposed evolutionary series. The second half of the twentieth century saw the birth of a new type of museum, devoted specifically to "primitive art."[15]

Dutch colonial rule in most of the Southeast Asian archipelago ended with the Second World War, but the Dutch presence in the western part of New Guinea continued until 1962. Shortly before that, in 1960, Belgium had had to pull out permanently from what has since been an independent state, known at different periods as either Congo or Zaire.[16] Against the background of the colonial practices of both these European states, the Netherlands and Belgium, there was a constant supply of ethnographics, both on an individual level and on the level of large-scale official institutions and activities, such as museums, world exhibitions, colonial exhibitions, and missionary practices. In the same way, countless objects found their way to other European countries from their respective overseas territories during the colonial period. In the United States, Canada, and Australia, where there were small-scale tribal societies of indigenous people within the national borders, things were slightly but not fundamentally different.[17]

While a number of museums originated from cabinets of curiosities, others came into existence as a result of world and colonial exhibitions. They were founded to permanently house objects and products which

had been collected for such events. It was in this fashion that, in the wake of the international exhibition in Brussels in 1897, the Koninklijk Museum voor Midden-Afrika in Tervuren came into being. The Field Museum of Natural History in Chicago, to give another example, was established in a similar way, after the World's Columbian Exposition of 1893. A phenomenon matching the same pattern as colonial and world exhibitions was what the Germans called *Völkerschau*: the exhibition of "exotic" peoples from the colonies who, with their objects, had to show scenes from their daily lives. This took place both as a part of colonial and world exhibitions as well as on its own on a smaller scale. Zoos were popular venues for such manifestations, which were set up by western impresarios.[18]

Belgian and Dutch institutions have comprehensive collections of ethnographics built up in the colonial period. There are about three hundred ethnic groups in the former Belgian Congo, each with their own art styles. Some of the better known ones are the Kuba, the Vili, the Mangbetu, and the Lega—to name but a few. The Koninklijk Museum voor Midden-Afrika was given responsibility for an urgent task in the framework of Belgian colonial activities: the scientific study of the natural and human resources of the Congo. This museum sent numerous expeditions to Africa, and it studied and preserved what officials and others who acted as its correspondents in the colony collected for it. As important, or perhaps even more important, were the numerous gifts it received, for example from Mrs. Jeanne Walschot, who dealt in African art in Brussels since the 1920s, and what it bought in Belgium from private collectors (often ex-colonials), dealers (for example Henri Pareyn from Antwerp, or, more recently, Emile Deletaille from Brussels), and missionary congregations.

As a result of many decades of sustained systematic collecting activities, this museum has the largest and finest collections of ethnographics from Central Africa in the world, some 250,000 items in all, about one fifth of which are objects which would be colloquially be called "tribal art." It stands out not only because most of its holdings were collected relatively early, but also because of the painstaking manner in which many of them were documented. Well-known specialists in the ethnography and material culture of the area such as Joseph Maes, Frans Olbrechts, and Albert Maesen were attached to the museum. The other specialized ethnographic museum in Belgium is the much smaller Etnografisch Museum Antwerpen, which was formally established in 1952 on the basis of ethnographics held by the city of Antwerp in an earlier museum, the Vleeschhuis, and has some 20,000 artifacts from all over the world in its charge.

In the Netherlands, relatively small ethnological collections were associated with schools for training colonial officials (Delft, Leiden) and

military personnel (Breda), with the training of missionaries and missionary propaganda (Steyl, Berg en Dal, Cadier en Keer, etc.), with scientific research on colonial products (Amsterdam, Deventer) and with the academic study of non-western religions (Groningen). There are large ethnographical museums in Leiden (Rijksmuseum voor Volkenkunde), Amsterdam (Tropenmuseum), and Rotterdam (Museum voor Volkenkunde Rotterdam). The development of these institutions was, as in the case of the museum in Tervuren, intimately connected with colonialism.[19] The Tropenmuseum in Amsterdam, for instance, can trace its origin to the Koloniaal Museum in the nearby city of Haarlem and the Ethnografisch Museum of the Amsterdam zoo, Artis—itself a display of colonial pride. It evolved into an independent institution in 1926 on the basis of these two nineteenth-century components. Until 1945, it was called Koloniaal Instituut, and then until 1950 Indisch Instituut. The history of its collections provides valuable insights into how tribal objects circulated in the colonial period and the roles played by various individuals.[20] A number of objects from the Batak of Sumatra in this museum—carved horns containing magical substances, priests' staffs, divining calendars, amulets, figures, bark books containing magical chants—were collected in the second half of the nineteenth century by the linguist Herman Neubronner van der Tuuk, who was commissioned to study Batak languages by the Dutch Bible Society. Two ancestor figures of the Chokwe of Angola ended up in the Artis collection through F. Hanken, an employee of the N.V. Afrikaanse Handelsvereniging (African Trade Society inc.), who collected these around 1875 in a village that had been destroyed by the Dutch as a punitive measure following a trading conflict.

Other items arrived in the collections of the Tropenmuseum as a result of donations, including those from the former governor of Surinam, J.H. Schmidt, and the orientalist, C. Snouck Hurgronje. Numerous colonial officials devoted their energies to collecting for the museum, in particular in the Netherlands East Indies. The contacts made and later cultivated by the first director, the ethnologist J.C. van Eerde, during a research expedition through the colony bore great fruits, including 400 artifacts from the north coast of Dutch New Guinea which were collected for the museum by N. Halie, the head of the administrative post Hollandia, the present-day Jayapura.[21] Halie had to compete with Protestant missionaries who preferred to burn such "idols." The museum came by thousands of items from the Tanimbar archipelago in the south of the Moluccas with the help of the Roman Catholic missionary and linguist Father P. Drabbe, MSC. Important collections from New Guinea—from the Marind-Anim on the south coast of Dutch New Guinea, from Lake Sentani on the north coast, from the Gulf of Papua and from the Sepik river basin—which are now in the Tropenmuseum, were assembled by the Swiss

ethnologist, writer, and adventurer, Paul Wirz.[22]

Ethnological museums in other countries built up their collections in comparable ways. Several German museums, for instance, acquired hundreds of objects from Congo-speaking peoples along the Loango Coast, near the mouth of the Congo, through the German Robert Visser, who from 1882 to 1894 was the agent of a Dutch trading and plantation enterprise there. Maintaining good written contacts with well-placed individuals in the colonies was standard practice among museum directors of the period: "Grab everything you can get your hands on," urged Karl Weule, the director of the Museum für Völkerkunde in Leipzig, to Visser in a letter dated September 9, 1909. In an earlier letter to Weule, Visser had already complained how difficult that was: "Working under the motto <Whatever thou wouldst, delay not> I have been able to achieve the virtually impossible, and you will, of course, understand that sometimes if you want to come by certain articles the end has to justify the means. The free-standing idols of the fast dying cultures here are jealously guarded by the owners ... ; it is difficult to get any of them."[23] Objects collected by Visser comprise parts of the 15,000 African ethnographics from the German colonies in Africa that found their way to Leipzig between 1884 and 1914. In this period, the Museum für Völkerkunde in Berlin did much better than the other German ethnological museums, especially after it had been decided in 1891 that all officials in German overseas territories who were able to obtain ethnographics should hand them over to this museum. From 1896 onwards, this obligation also held for all military personnel and *Schutztruppen*, the colonial police. This measure was so successful that the museum could scarcely deal with the subsequent flood of artifacts.[24]

One of the correspondents of the Berlin museum in German Cameroon was Captain Hans Glauning, who collected both for the museum and for himself. Glauning had close and cordial contacts with *Mfon* (King) Njoya of Bamum, a kingdom in the centre of the colony, especially after he had brought back the head of the king's father, which had been taken in battle by a neighbouring group. When the captain fell in action in 1907, the king sent the German authorities a spectacular, life-size beaded sculpture in commemoration of his lamented ally which was to be put on his grave or given to his family; the latter was actually done. The path of this statue has been reconstructed by Christaud Geary.[25] One year later, it was acquired from Glauning's family by the Berlin museum, which in 1929 exchanged it with the Berlin dealer Arthur Speyer, Jr. for jewels which the last king of the Aztecs had given to Hernan Cortès. Speyer sold the statue to two American collectors, who in turn donated it to the National Museum of African Art in Washington, D.C., where it is today. The figure's precise meaning and function are not very clear, but in general such splendid court

art "attested to royal might and communicated the wealth, importance, and glory of the kingdom to the subjects and to other kings and inhabitants of the Grassfields region.[26] Other objects collected by Captain Glauning, including an equally spectacular beaded stool decorated with figures, also from King Njoya, were sold directly to Speyer by the family. The stool then went to Charles Ratton, the renowned Parisian dealer, whose successor sold it to the Musée Barbier-Mueller in Geneva in 1985.[27]

Another way in which museums came by their objects was through collecting expeditions, which in those days served a number of different purposes simultaneously. Scientific, military, political, and economic exploration and exploitation were closely related.[28] The infantry captain, later colonel, A.J. Gooszen, led a series of scientific and military exploratory expeditions to the south coast of Dutch New Guinea between 1907 and 1915 which were commissioned by the Maatschappij ter Bevordering van het Natuurkundig Onderzoek in de Nederlandsche Koloniën (Society for the Promotion of Natural Science Research in the Dutch Colonies). There he collected about a thousand Asmat articles, of which the majority went to the Rijksmuseum voor Volkenkunde in Leiden. Gooszen brought together another five thousand artifacts in the rest of New Guinea and the Moluccas. The records of these ventures fill eighteen volumes.[29] Anthropologists from the Leiden museum later collected another thousand or so items from the Asmat and neighbouring groups, in 1953 and in 1960/1961.[30]

In Belgium, where there was already a steady supply of Central African artifacts, two collecting expeditions under the supervision of F.M. Olbrechts focused on West Africa. Frans Olbrechts was a professor in Ghent and later became director of the Koninklijk Museum voor Belgisch Congo— as well as the *éminence grise* of Belgian anthropology. He completed his doctorate at Columbia University in New York under Franz Boas—critic of the evolutionists, proponent of a contextualizing approach to culture, and an astute museum collection builder himself.[31] Olbrechts travelled through West Africa from Dakar (Senegal) to Abidjan (Ivory Coast) in 1933, collecting for the Koninklijke Musea voor Kunst en Geschiedenis in Brussels, and brought back approximately 1800 pieces.[32] About such collections he said that, "were they to give a true picture of life and activities of the people in the area through which expeditions had been made, they should be as rich and complete as possible and not neglect a single branch of human activity: all trades, crafts and professions must be represented, all classes of the society and all expressions of culture."[33] But he added that, in all cases, this was only a secondary aim, for the main task of the anthropologist was to study the mind, the stirrings of the soul, and the traditional views of the people in question. While such expeditions collected as systematically and completely as possible,

missionary workers, private collectors, art dealers, and tourists were much more selective and tended towards the exotic, bizarre, beautiful, large, or rare.

Olbrechts had returned from his 1933 adventure with plans for further research into the arts of Ivory Coast, in particular those of the Dan and the Senufo. Two of his graduate students at Ghent University, P.J. Vandenhoute and Albert Maesen, spent a longer period among the Senufo and the Dan in 1938/39, where they carried out research on the cultural functions of tribal objects and also collected for Belgian museums. Olbrechts himself spent some of that period with them. On the basis of their research, Vandenhoute wrote a doctoral dissertation on the Dan, and Maesen one on the Senufo.[34] Just as somewhat later, in the 1950s, a tradition of collecting and research concerning the Asmat began in the Netherlands, Olbrechts' 1933 expedition sparked an interest in the Ivory Coast in Belgium which persists untill today. Earlier, in the period 1926 to 1928, Olbrechts had collected masks while doing fieldwork among the Cherokee and Onondaga Indians under the guidance of Boas; sixty such masks are preserved in three Belgian museums.[35] Between 1953 and 1955, Albert Maesen embarked on a research and collecting journey through the south of the Belgian colony in Africa, from west to east (Fig. 4), in the course of which he collected and documented more than eight thousand objects from eighty-three ethnic groups for the Koninklijk Museum voor Midden-Afrika.[36]

An earlier, German initiative was the large-scale Hamburger Südsee-Expedition, carried out under the auspices of the Hamburg Museum für Völkerkunde, that spent two years, from the spring of 1908 until the spring of 1910, in the German overseas territories in Melanesia and Micronesia (cf. Fig. 5). In this case too, scientific and colonialist motives went hand in hand. One of the tasks was the formation of an ethnological collection that was as representative and documented as possible, before it was too late, for traditional ways were vanishing quickly. The expedition came back with a large amount of data concerning the ethnology, the physical anthropology and the medical problems of the regions it had visited, as well as many thousands of ethnological objects. A portion was destroyed in the Second World War, but the remainder is still in the Hamburg Museum für Völkerkunde. The thirty or so volumes recording the results of the expedition, *Ergebnisse der Südsee-Expedition 1908-1910*,[37] are still authoritative, and oft-used standard works on the areas in question, and have become collectibles themselves.

In Melanesia, the Germans had to deal with competition from the Field Museum of Natural History in Chicago, something expedition members complained about in letters and reports.[38] An anthropologist from the latter institution bought 3500 objects from German dealers in Melanesia in 1908,

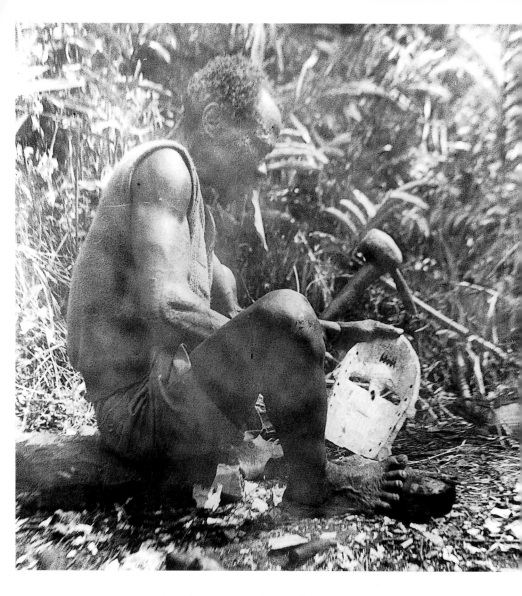

4. A Salampasu man carving a mask in the village of Masaka, Kasai, the Belgian Congo, not far from the border with Angola, in 1954. This is one of a series of photos by the ethnologist-curator Albert Maesen, documenting the manufacturing process of this particular mask during a collecting expedition for the Belgian Koninklijk Museum voor Midden-Afrika.

and the subsequent Joseph N. Field South Pacific Expedition, 1909-1910, led by A.L. Lewis, another of Franz Boas' numerous pupils, produced an additional 14,000 artifacts, as well as 2,000 glass negatives and a wealth of conscientiously recorded ethnographical data. In the years that followed, another 2600 items were bought through German middlemen in Melanesia. The motivation given for this project in the accompanying publications was complex. As was often the case around the turn of the century, there was a strong impulse to collect and codify what was rapidly disappearing, while another aim was to establish collections that were as large as possible for exhibitions and for study. Here again, prestige and competition with the other major natural history museums in the United States played a role.[39] In 1990, eighty years and many collecting trips later, the Field Museum, in cooperation with institutions in Papua New Guinea, initiated a research project involving the collections brought together by Lewis.[40] Visits were made to the same villages visited on the original expedition in order to discuss the meanings and functions of the objects that had been collected in 1909-1910 with the aid of photographs of those objects. Artifacts from Oceania also came to this museum through donations by soldiers of the Allied Forces and through the purchase in 1958 of the 6500 items in the private collection of the Englishman James Fuller.[41]

Paul Wirz, the Swiss ethnologist, noted in 1950 that in areas where there were many westerners, there was little left of any importance, but there were still many things to be found in more remote areas. Of an out-of-the-way village he visited in the Sepik area, he wrote: "As a result of a quick inspection of the village I was convinced that there were still a great many old things in the houses, particularly in the ceremonial house, and that people were certainly willing to part with these objects in return for appropriate remuneration. Beautiful pieces appeared, such as a whole series of chalk gourds, richly decorated with all manner of representations of animal figures, woven and wooden masks, fine wooden dishes for dyes, and stools of all shapes and sizes. I sat for a while in the ceremonial house and they brought me a number of flutes and bullroarers with an air of great secrecy."[42] Most of the ritual objects collected by Wirz in the Sepik area in the 1950s, during the last years of his life, were acquired by the Tropenmuseum in Amsterdam. All in all, about ten thousand pieces he collected during more than forty years of travels, mostly in New Guinea but also in the Southeast Asian archipelago, Ceylon, and Africa, are now in western museums; half of that amount is in the institution he had the closest ties with, the Museum der Kulturen in Basel, Switzerland.[43]

To convey an idea of the extent to which such expeditions contributed to the movements of tribal objects to the West from all corners of the world, a few more examples. Between 1906 and 1909, the Hungarian-born ethnologist and adventurer, Emil Torday, travelled among the Kuba and

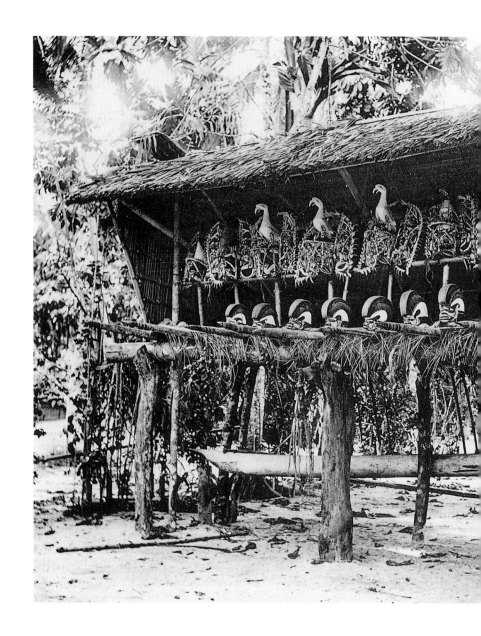

5. Display of *kepong* and *tatanua* masks (upper row and lower row, respectively) in the 1890s at the occasion of a feast commemorating the deceased in Labangesarum, a village on the northeast coast of New Ireland, New Guinea. The island was then a German overseas territory called Neu Mecklenburg. Its spectacular art was fervently collected, dealt in and studied since the late nineteenth century.

other groups in the south of the Belgian Congo for the British Museum, where he encountered the German ethnologist Leo Frobenius, a diffusionist of the Vienna School, who was collecting just as frantically for the Museum für Völkerkunde in Berlin.[44] The intrepid Danish ethnographer Knud Rasmussen travelled by dog sleigh from Greenland to Siberia, in the period 1921 to 1924, to visit numerous Inuit/Eskimo groups during the fifth and longest Thule Expedition. The Aleut-Kamchatka Expedition of the Imperial Russian Geographical Society, from 1909 to 1911, was led by W. Jochelson, who subsequently became the curator of the Museum of Anthropology and Ethnography in St. Petersburg—the home base for many other expeditions both prior and since.[45]

The now unthinkable colonial spirit in which such expeditions were carried out becomes apparent in the following passage from L'Afrique fantome, the much praised combination of a journal intime and a travelogue written by the surrealist writer-ethnologist, Michel Leiris. He was one of the participants of the Mission Dakar-Djibouti, from 1931 to 1933, which travelled straight through Africa from west to east, was led by the French anthropologist and Dogon expert Marcel Griaule and was officially collecting for French museums. The incident, by far not the only one he reports, took place on the 12th of November 1931, in a Dogon village in Mali that was visited by Griaule's expedition. "Yesterday the alarmed people refused us a number of 'rainmaker' figures," Leiris writes, "as well as a figure with raised arms that we had found in another sanctuary. A boy told us that were we to take them with us, we would also be taking the life of the country. Though he had been a soldier in the French army he remained true to the old habits. He almost wept at the thought of the disaster that this would bring upon them, and which had caused a great commotion among the elders. A bandit mentality: as we took our leave that morning from the elders who were so glad that we had been so good as to consider their feelings, we nervously eyed the enormous green parasol under which we normally sought shelter, and which was now carefully folded up. Swollen up as though by a strange tumor in the form of the beak of a pelican, it now contained the figure with raised arms that I myself had stolen from the foot of the altar belonging to this and other figures. I had first put her under my shirt ... and then in the parasol ... while pretending I had to urinate in order to divert attention. That evening my chest was smeared with dirt for my shirt had again served to conceal masks from the village that we had removed from the cave."[46]

This would be considered unethical by present-day professional standards, and indeed contrasts sharply with post-colonial collecting activities such as, for example, those Dirk Smidt talks about in this book, or those undertaken in 1990 among the Aluku Maroons, descendants of rebel

slaves in the rainforests of French Guiana, by anthropologists Richard and Sally Price. Their travelogue on this voyage, *Equatoria*, is dotted with reflections on the possibilities and otherwise of collecting, exhibiting, and doing fieldwork in a postcolonial, postmodern world.[47]

In many overseas territories, production aimed at foreigners sprang up relatively early, mostly more or less as soon as the first contacts were made with westerners. Late eighteenth-century explorers already observed that the supply during their second visit to certain islands in the Pacific exceeded that of their first visit. Western demand was played upon on the native side. A member of the Hamburg expedition of 1908 wrote that " the great demand of European dealers for the beautiful and spectacular woodcarving of the Admirality Islands has directly led to what more or less resembles mass production for export, and it appears that new wild forms are invented for the Europeans that were certainly never intended for the natives' own use."[48] At the same time, he notes that "good, old pieces" had become very rare, and that the ceremonial houses in which they were usually preserved were either ruined or had been burned down, or were new and carelessly built. Changes in both the style and quantity of native production in contact situations are also known concerning, to give but a few examples, *malanggan*-ancestor figures and panels from New Ireland, articles from the Massim area (Papua New Guinea), the art of the Maori of New Zealand, and ancestor figures from Nias, an island near Sumatra. In contact situations, indigenous objects sometimes became larger and more imposing, sometimes smaller and more easily transportable, occasionally more naturalistic, hybrid or untraditional with respect to style, often more finely cut through the use of iron instead of stone or shell chisels, sometimes decorated in a more baroque style, and typically made from other materials than was normally the case—documenting processes of intercultural exchange and acculturalisation.

6. Part of the Central African collection of the Antwerp dealer and collector Henry Pareyn, sold at auction in Antwerp between 10 and 15 December, 1928. Against the left wall, there are, among others things, Songe, Chokwe, and Kuba masks; hanging from the right wall are four Kota reliquary figures, comparable to the two on the cover of this book.

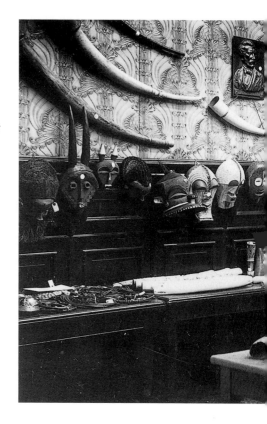

1.3 Collectors and Dealers

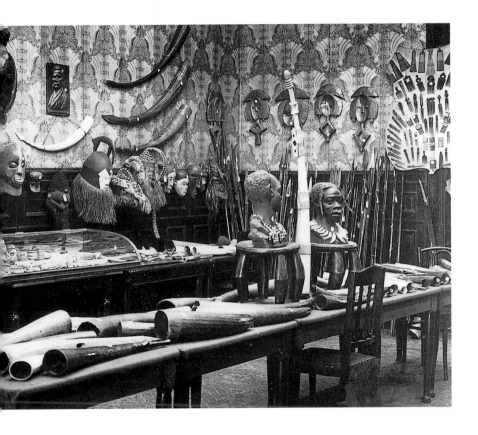

It is certainly not the case that all or even most objects which came to Europe from the colonies ended up in museums. Often they became part of private interiors, or entered the circuits of collectors and dealers. An example of a Dutch collector from around the turn of the century was H.J.A. Raedt van Oldenbarnevelt, a colonial official in the Dutch East Indies, who put together a large collection of antiquities and ethnographics

from that region, including such top pieces as a number of wooden house altars and ancestor figures on large posts from the Moluccas. It was lent to the Tropenmuseum in 1915 but taken back by his heirs at the beginning of the 1980s and auctioned at Christie's Amsterdam in 1983. The title of the auction catalogue was *Oriental Export Porcelain, Works of Art and an Important Collection of Tribal Art from the Indonesian Archipelago from the Late H.J.A. Raedt van Oldenbarnevelt, Formed circa 1900 and Loaned to the Tropeninstituut, Amsterdam, in 1915*.[49] It was not a coincidence that the fact that the collection had been on loan to the Tropenmuseum was mentioned in this—unusually long—catalogue title, for a stay in a prestigious museum is the ultimate, official ratification of the quality of a collection, adding to its pedigree and raising its market value.

In the 1930s, three decades after Raedt van Oldenbarnevelt had formed his collection, Georg Tillmann, a Hamburg banker of Jewish ancestry who had fled from the National Socialists, devoted himself to the collection of ethnographics in Amsterdam, specializing in textiles from the Dutch East Indies. It all began one day when his wife came home with two Indonesian krisses which she had bought in an antique shop around the corner. Tillmann was attracted to them at once and began to frequent Amsterdam antique shops and flea markets, as well as auctions throughout the country. In the seven years before his departure to the United States in 1939, again fleeing the National Socialists, he had collected about two thousand artifacts and pieces of cloth. When he left, he lent everything to the Tropenmuseum; his son transformed this loan into a donation in 1994.[50]

While Tillmann was primarily active within the Netherlands, the collecting activities of the Swiss artist, Serge Brignoni demonstrate that national borders were not a hindrance. Brignoni was influenced by the surrealists in Paris and quickly began to share their passion for tribal art, specifically for Oceanic art, which most of them preferred above all things African. He bought a great deal in Paris, but also regularly purchased Melanesian material from dealers in Germany, the Netherlands, and Switzerland. The catalogue of his magnificent collection, which he donated to the Museo della Culture Extraeuropee in Lugano in 1985, shows a well-balanced whole consisting of fine objects selected with an artist's eye according to their power and expressiveness.[51] The Brignoni case clearly shows that ethnographic collections are significant western cultural phenomena in their own right, not fully reducible to, or fully analysable in terms of, their constituent parts.

While the primary concern of many of the relatively few Dutch collectors was the Dutch East Indies, most Belgian collectors almost automatically focused on the Belgian Congo. In the large seaport of Antwerp, where ships from the Congo arrived daily, the collector-cum-dealer Henri Pareyn

began to buy *negerkunst* at the beginning of the century, for his own collection as well as for trading. Initially, he walked or took a bicycle; then he used a carrier tricycle, and finally a car.[52] He delivered to private collectors, other dealers and museums, and published a few short articles on Congo art. During the First World War, he sold a number of objects to the Congo Museum in Tervuren (now called the Koninklijk Museum voor Midden Afrika), some 1600 ethnographic items to the city of Antwerp in 1920, and another collection to the Wellcome Historical Institute in London in 1936.[53] French surrealists like André Breton and Tristan Tzara regularly came to Antwerp to buy from Pareyn, as did several Paris dealers. The prices realized for good African objects, hailed as fine art in the era of primitivist *négrophilie*, were high and it is clear that national boundaries were no obstruction for the traffic in such possessions.

The largest auction of ethnographics that ever took place in the Low Countries—and one of the largest ever in the world—was the sale of almost two thousand lots of "Art nègre du Congo," brought in by Pareyn, in Antwerp in 1928 (Fig. 6).[54] It went on for five whole days and raised the then phenomenal amount of two million Belgian francs. Before putting his collection up for auction, Pareyn had offered it to the Tervuren museum and to the city of Antwerp, for 300,000 francs, but in both cases the offer was refused. This was bitterly deplored in the Belgian press coverage of the event when it became clear that about ninety percent of the collection had been bought by an English dealer, possibly W.D. Webster, and disappeared abroad.[55] As far as these larger sales are concerned, it is difficult to say whether we are talking about a dealer or a collector who sold his collection several times; it was probably a combination of the two.

From the list of lenders to an exhibition on African art in the Paleis voor Schone Kunsten in Brussels in 1930, which mentions some 25 Belgian collectors, it can be seen that in the Belgium of Pareyn's day people were collecting on a certain scale (cf. Fig. 7).[56] The catalogue of a similar exhibition in the Stadsfeestzaal of Antwerp from the 24th of December 1937 till the 16th of January 1938, organized by the ethnologist and curator Frans Olbrechts, records about fifty collectors, among them a fair number of former colonial officials.[57] The pieces illustrated—Luba, Songe, Lulua, Kuba, Bushongo, and Yombe, among others—are of high quality. The list of lenders of ethnographics for the world exhibition in Brussels in 1958 is even more impressive. In line with these collecting activities, the Belgian ethnographics trade became increasingly more lively in the course of the twentieth century.

While Pareyn certainly was the most prominent Belgian dealer/collector of his day, the most outstanding collector/dealer in Belgium of the subsequent generation may have been Jef Vander Straete, a furniture maker by profession, who grew up in England where his parents had fled during

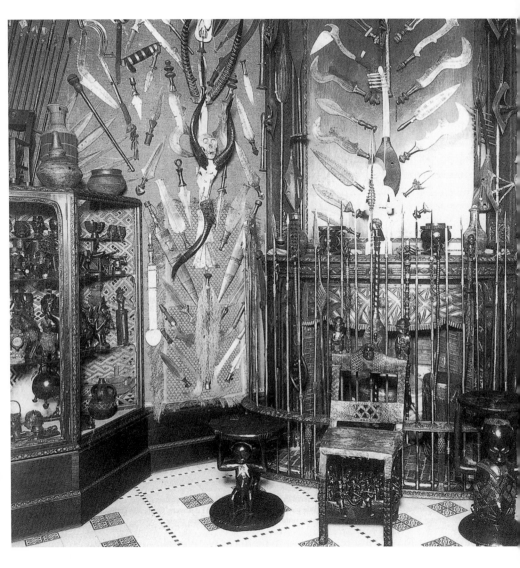

7. Part of the private collection of about 800 pieces of Congolese art of Mr. Alex Van Opstal, c. 1925. He was a director of the Belgian Maritime Trade Company in Antwerp, which did a lot of business with the Belgian Congo. Mr. Van Opstal contributed several objects to the 1936-1937 exhibition of Congolese art in Antwerp. He never visited the colony himself.

the First World War.[58] In 1952, he bought his first African item, a Luba staff, which proved to be the cornerstone for an enormous collection of ethnographics from Africa and Oceania. Vander Straete built up this collection in part through advertisements in newspapers that brought him into contact with ex-colonials, but also through contacts with the home bases of a whole series of Roman Catholic missionary societies: Jesuits, White Fathers, Redemptorists, Crosier Fathers, Capucins, and so on. Top pieces from the Chokwe, the Songe, and many other groups came into his hands and were incorporated into his collection; material of lesser quality was sold off.[59] In 1955, he opened a private museum in Lasne, near Brussels. His son René, who is still active, was also involved, and numerous others were inspired by the two. They made real discoveries, not in the *brousse* of Central Africa, but in the Belgian countryside, for instance, in a village pub full of old masks of the Yaka and Suku or in the attic of a retired colonial civil servant filled with Zande articles which had been collected during a posting to the north of the Belgian Congo.

The fine art dealer Carel van Lier (1897-1944; Fig. 8) was the first to present *negerplastiek* in the Netherlands on a significant scale, from about 1920 onward, in his galleries in Amsterdam, Laren, and subsequently, with considerable success, in Amsterdam again, at Rokin 126, under the name Kunstzaal Van Lier.[60] The tribal art was in a second, connnected, building in the back. "Whenever you entered in those rooms crammed with exotic articles, it was as if you had entered some dreamworld, an oasis of rest in the hectic center of Amsterdam; you could smell the African bush," his daughter Franca Brunet de Rochebrune-van Lier told me. One other thing she remembers is tumbling across a whole pile of dusty Kota figures from Gabon, like the ones depicted on the cover of this book and in Figure 6.

Van Lier was an introvert and sensitive, soft-spoken person, a real art lover who could enthrall his audience when presenting a piece. He combined tribal art with Dutch modernist paintings, antiques, and Asiatica—the combination of ethnographics and Asiatica was and is still not unusual in Amsterdam—and soon he broadened his field to include Indonesia and Oceania, travelling frequently to buy from dealers in other European centres, such as Charles Ratton in Paris. From January 8 to January 31, 1927, he exhibited the private collection of African art he had built up in the Stedelijk Museum in Amsterdam, a major Dutch museum of modern art. It was visited by many and received ample and favourable press coverage. Dutch painters like Wim Schuhmacher, Jan Sluijters, Paul Citroen, Charley Toorop, and Dick Ket as well as Van Lier's clientele became acquainted with tribal art through his gallery, and some of them started collecting it. As in Paris and New York but unlike Belgium, tribal art and modernist painting went hand in hand in the Netherlands. During

the economic depression of the 1930s, Van Lier's business also suffered. He died in March 1945, of exhaustion, after detention in several German concentration camps.

One of Van Lier's wealthiest and most enthusiastic customers of both modern and tribal art was Baron Eduard von der Heydt, a banker who had fled from Germany during the First World War, and himself had opened a gallery of sorts of western and primitive art, in Zandvoort, not far from Amsterdam, in 1925. He called it Museum Muluru and advertized it as "The Negro Paradise." Later, the baron moved to Ascona; most of his collection, including many objects bought from Van Lier, is now in the Rietberg Museum in Zürich. Another client was Han Coray, who had several influential modern art galleries in Basel and Zurich, collected African art, and was the first to exhibit African art in

8. Carel van Lier in the 1920s.

Switzerland, in 1917 in Zürich, in combination with dada art. Most of the *Coray'sche Negersammlung*, as it was called, however, he bought from the Paris avant-garde gallery owner and collector Paul Guillaume. The 1928 economic crisis left Coray and his young, rich Dutch wife bankrupt and provoked her suicide. The better part of his collection, assembled between 1916 and 1928, has been in the Völkerkunde Museum of the University of Zürich since 1940; the "museum of all peoples and all times" he had dreamt of was never realized.[61]

Another Dutch counterpart of Pareyn and Vander Straete was Matthias L.J. Lemaire (Fig. 9), who dealt in ethnographics for half a century, from the 1920s till the 1970s.[62] He began as a teacher, then became a branch manager in a business that imported and sold oriental carpets, and subsequently began to deal in ethnographics that he could easily buy in

9. The well-known Amsterdam tribal art dealer M.L.J. Lemaire in 1952 amidst a
newly purchased collection from the Sepik basin and its surroundings, New
Guinea, which he sold to the Museum voor Volkenkunde Rotterdam (see text).
In the front row are a number of overmodelled skulls from the Iatmul, and next
to his right elbow is a *tatanua* mask from New Ireland.

the seaport of Rotterdam. At the beginning of the 1930s, he sold ethnographics at the Indische Tentoonstelling (East Indies Exhibition) in the Hague. Lemaire did a lot of business abroad, on an increasingly larger scale, in Germany with dealers like Speyer and Umlauff, and in England, with the dealer W.D. Webster. He was close to a number of German and Dutch museum directors, who attempted, as was usual in those days, to fill the gaps in their collections by means of exchange, sale and purchase.[63] At the end of the 1970s, his gallery (Fig. 10) was taken over by his son F.L. Lemaire and his daughter T.F. Lemaire. Jaap Aalderink, Leendert van Lier,[64] Henk Kouw, and Lode van Rijn are other dealers who were active in Lemaire's heyday. Later, in the 1970s, a few American tribal art dealers were also based in Amsterdam.

Lemaire's greatest success may have been the 1951 purchase of the Sepik collection of a certain Dr. Lautenbach from Bad Kissingen in Germany (Fig. 9), not long after the latter's death. Lautenbach was a physician who in 1909 had journeyed through German New Guinea, where he assembled an impressive collection of masks, figures, orators' chairs, human skulls plastered with clay, shields, and other objects. Lemaire sold this collection to the Museum voor Volkenkunde Rotterdam, where old labels with "Dr. Lau," "Dr. med. Lau," or "Südseesammlung Dr. Lau" still adorn most of the objects.[65] One of Lemaire's many sources in the early 1960s was F.K. Panzenbrock, a German crocodile hunter on the Korewori river in the Sepik area, who as a sideline collected ethnographics during his trips. The largest and most exceptional piece Lemaire acquired from Panzenbrock was a figure of a crocodile, almost seven meters long, carved from a single tree trunk (Fig. 10, right hand side), which he sold on to the Museum für Völkerkunde in Hamburg. The then director, Herbert Tischner, a personal friend who regularly stayed with the Lemaires in Amsterdam, devoted a publication to it.[66] Such cult crocodiles, of which only a few are known, were first noticed by a German missionary in 1943, in villages along the Korewori river where they were kept in pairs in ceremonial houses, figuring in initiation rituals and in myths.

Tribal objects in Europe changed hands willy-nilly, crossing national borders and moving up and down the social ladder. From the homes of ex-colonials, they went through fleamarkets, local auctions, and antique shops, and typically wound up in the networks of specialized dealers, at least if they did not get dumped with the rubbish when their owners passed away. Collectors, among whom there were quite a few artists, bought, sold, and exchanged with other collectors and traded with dealers, who again bought from and exchanged with each other both nationally and internationally. Dealers bought whole series of objects from museums which were deaccessioning, as some of the East German

ethnographic museums did in the 1950s, or from the holdings of small missionary museums which had closed down. Missionary societies imported and sold ethnographics. In the Netherlands, colonial and ethnological museums placed countless "school collections" in schools throughout the country, most of which eventually disappeared. Even today, articles that once belonged to such collections pop up occasionally at fleamarkets, still carrying their complicated inventory numbers which varied from one institution to the next. Countless objects also disappeared in peculiar ways from ethnological museums. During a thorough inventory in the Leiden Rijksmuseum voor Volkenkunde in 1996, it appeared that about eighteen thousand items were untraceable, frequently as a result of theft. Many thought it scandalous, particularly because this was the public institution in charge of the national ethnological collections at

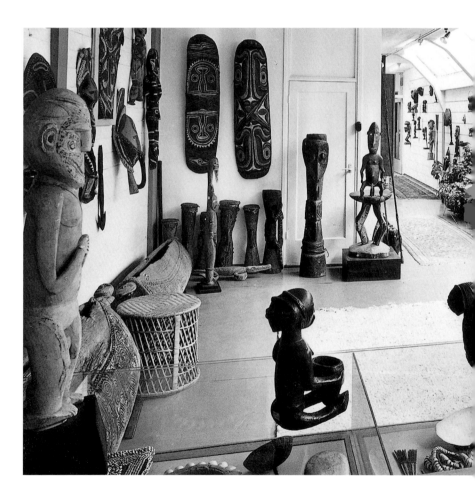

the—considerable—expense of the Dutch people. The damp cellars of this notorious museum, formerly used to house part of the collections, also took their toll.

Central Africa was not Belgium's only interest, nor was the Dutch East Indies the only region from which Dutch museums collected objects. The Etnografisch Museum Antwerp, for instance, procured a collection in 1958 that had hitherto been there on loan. It consisted of more than a thousand weapons and other artifacts from Sumatra and other regions of insular Southeast Asia. The greater part of the collection had been brought together before 1910 by Hans Christoffel (1865-1962), an officer of Swiss origin in the Dutch colonial army and a fanatical collector.[67] An inventory of objects from the Netherlands East Indies in Belgian public collections, compiled by a Dutch museum director in 1938/39, did not list

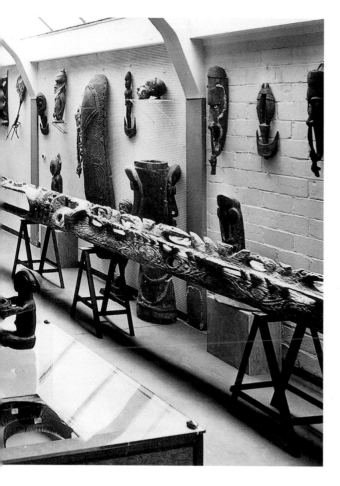

10. Lemaire's tribal art gallery on the Prinsengracht in Amsterdam in the early sixties. To the right is one of the rarest and largest pieces Lemaire ever handled, a cult crocodile from the Korewori River, New Guinea (see text).

much of interest beyond from the Christoffel collection.[68] The Musées Royaux d'Art et d'Histoire in Brussels possess a substantial Melanesian collection, part of which is now preserved in the Tervuren museum as a result of an unsettled conflict between the two institutions.

There were relatively more ethnographics from Central Africa in the Netherlands. In 1903, Hendrik Muller, Sr., director of the Nieuwe Afrikaansche Handelsvennootschap (New African Trading Company) in Rotterdam donated some 400 items from Angola to the Museum voor Volkenkunde Rotterdam. These had been collected by the Dutchman Daniël D. Veth and the German L.J. Goddefroy, of the well-known trading house in Hamburg of the same name, during a collecting expedition to that Portugese colony sponsored by Muller. The young Veth died shortly before the end of the rather unsuccessful venture.[69] Later, the same museum bought Congolese ethnographics from Pareyn. Through the activities of the N.V. Afrikaanse Handelsvereniging, collections from the Lower Congo coast reached several Dutch museums.[70]

While the Low Countries provided the main channels through which objects from the Belgian Congo and the East Indies reached the West, most of the objects from the German overseas territories and trading zones arrived through the seaports of Hamburg and Bremen. German colonial trading houses often also dealt in ethnographics, which were delivered to museums or sold as exotic curiosities. The Goddefroy firm, which had had a trading post on Samoa since 1857 and another in the Bismarck Archipel since 1874, opened its own private museum in 1881: the Museum Goddefroy.[71] Most of its holdings were bought by the Museum für Völkerkunde in Leipzig in 1885, while another portion found its way to new destinations through the Hamburg dealer in ethnographics, I.F.G. Umlauff; the Museum für Völkerkunde in Hamburg also procured some Goddefroy material. Ethnographics collected by the Deutsche Neu Guinea Companie in Melanesia ended up in the Museum für Völkerkunde in Berlin, among other locations. Articles from Melanesia began to arrive in Germany in considerable numbers in a period when the British and French expansion in Polynesia was largely over; this stream of objects came to an abrupt end during the First World War, when Germany lost its colonies.

The history of the German trade in tribal art shows how closely linked the two worlds were in which the reception of tribal objects in the West took place: on the one hand, that of traders and collectors, on the other hand, that of museums and scholars—and this is still the case, even though the latter prefer not to admit this in public. From 1911 until his death in 1952, Julius Konietzko dealt in ethnographics in Hamburg.[72] Commissioned by the large ethnographic museums in Berlin, Hamburg, Lübeck, Frankfurt am Main, Dresden, and Basel, he collected in the first

half of his career in Sudan, Lapland, India, and on the Arau Islands, among other locations. He worked together with his wife, Lore Konietzko, buying for these museums, and also from them. His private collections and his trading stock were largely lost in the Second World War. After divorcing Konietzko, Lore opened her own gallery under the name of her second husband, the physician and collector Georg Kegel. From 1957 onwards, she operated the gallery in association with her son, the biologist Boris Kegel-Konietzko, who adopted the name of his stepfather in addition to that of his father. Lore Kegel regularly traveled to Africa to buy, selling part of what she procured to Dutch dealers, as did her first husband and her son.

I.F.G. Umlauff was another well-known Hamburg dealer who did a lot of business with German and foreign museums, promoting his stock by sending offers and photographs around the world. He started as a taxidermist for the Hagenbeck firm, which ran a zoo and a circus, was a wholesaler in tropical animals, and organized ethnographic shows with living humans from the colonies. In 1912, for instance, the Museum Umlauff, as Umlauff called his enterprise, sold two thousand African objects collected by the German ethnologist Leo Frobenius to the University Museum of the University of Pennsylvania, which added to its African holdings, acquired from missionaries and adventurers since its establishment in 1887 by a number of prominent Philadelphians. After Umlauff's demise in the Second World War, Lore Kegel procured his estate, which had survived the hardships unlike many other German collections: the Hamburg Museum für Völkerkunde lost a total of 70,000 pieces during the war, while the Leipzig Museum für Völkerkunde lost 30,000 pieces, about a fifth of its holdings, in one day, during a bombardment on the 4th of December, 1943.

A third well-known name in the German tribal art trade and equally closely linked to that of a number of museums, was Speyer. Arthur Speyer, Sr. collected and dealt in Strasbourg until 1918, continuing in Berlin until his death in 1923. His son Arthur Speyer, Jr. continued the business there. The worse the economy in Germany became during the following years, the more he aimed his sales abroad. As in Belgium, ex-colonials were rich sources for the Speyers and their colleagues, Germany being full of objects from Cameroon, Tanzania, and Melanesia. The numerous institutions and organizations that occupied themselves with missionary work were also a fertile hunting ground. As a dealer and a collector, Arthur Speyer, Jr. had a strong interest in the cultures of the North American Indians, and later sold a large collection of American Indian material he had compiled to the Canadian government. In addition to German and foreign museums and dealers, the customers of Umlauff, the Konietzkos, the Speyers and other dealers consisted of a relatively

small group of German collectors, in particular artists and well-to-do citizens.[73] Due to the economic *Krach* of 1928 and the fact that the National-Socialists ear-marked tribal art, an example for the modernists, as *entartet*, "perverted," trading and collecting failed to prosper in Germany for quite some time.

As far as developments in France were concerned, three successful dealers who, in addition to many others, succesively left their mark on the Paris tribal art scene were Brummer, Guillaume and Ratton. All three of them bought from colonials and ex-colonials and did a lot of business with avant-garde artists. Joseph Brummer was a sculptor of Hungarian origin who had had a gallery for tribal and modern art in Paris since 1909, and in the interbellum became a trend-setting dealer in New York. Paul Guillaume, a protégé of Guillaume Apollinaire and another advocate of an aesthetic conception of tribal objects, initially sold car tires, a colonial rubber product. He made use of his business connections with the colonies, running advertisements solliciting ethnographics. He was soon established as an influential, highly respected dealer in and collector of African and contemporary art, and one who regularly traveled to Antwerp to buy from Pareyn.[74] When he died in 1934, Charles Ratton, who would be a central figure in the Parisian ethnographics trade until his death in 1986, was up and coming in the field, dealing in tribal art, in antiquities from the Middle Ages and the Renaissance, and in Asian art.[75]

Ratton catered to surrealists such as André Breton and Paul Éluard and to collectors such as the businessman, Baron Eduard von der Heydt, the American-British sculptor, Jacob Epstein and the American cosmetics tycoon, Helena Rubinstein. While his predecessors had focused primarily on Africa, he also put the North-American Indians and the peoples from Oceania firmly on the map. Ratton obtained quite a few top pieces from German museums through exchanges, such as the previously discussed sculpture given by King Njoya of Bamum to Captain Glauning's family, and the famous "Bangwa Queen," discussed below. During the period between the wars, he frequently went to New York where he sold mostly African art, and bought mostly American Indian and Eskimo/Inuit pieces, and was involved in the first exhibitions of ethnographics explicitly presented as fine art in museums and galleries. In 1937, he had a sales exhibition of some fifty fine pieces in the Amsterdam gallery of Carel van Lier, with whom he regularly did business. A number of collecting expeditions by the young anthropologist Hans Himmelheber, who was later to become an authority on African art, were financed by Ratton, who sold the spoils through his gallery. One of these expeditions was to the Eskimo of Nunivak Island and several others were to Africa. While in 1979 the Louvre refused the donation of Ratton's exquisite private

collection of African art to his great displeasure, in 1982 another prominent fine art museum, the Metropolitan in New York, did open its doors to the Rockefeller collection of tribal art.[76]

British collections from the first half of the twentieth century largely reflected the British trade and colonial presence in the Pacific and in Africa. The four most outstanding collectors from that period were William Oldman, James Hooper, Captain Alfred W.F. Fuller, and Harry Beasley, the latter a brewery owner and the only one of the four with substantial means.[77] All four of them accumulated thousands of fine ethnographics as a result of decades of systematic rummaging through fleamarkets, local auctions, antique shops, second-hand shops, and through advertising, exchange and, particularly in the case of Oldman, through dealing. From 1903 until 1914, Oldman circulated illustrated monthly sales catalogues (cf. Fig. 11).[78] Like Umlauff, he did a great deal of business with the University Museum of the University of Pennsylvania, which obtained most of its early African material through him, among other things, in 1924, a collection of eighty-four objects from the Belgian Congo collected a few years earlier during a tour of duty by the Belgian Captain C. Blank of Brussels. Oldman retired in 1927. His fine private collection of Maori and other Polynesian art and artifacts, built up gradually over several decades, was "repurchased" and repatriated by New Zealand in 1948, a year before Oldman's death, where it now remains in several museums. Fuller's widow donated his collection to the Field Museum of Natural History in Chicago in 1963, while the Hooper collection was sold in a series of auctions at the end of the 1970s at Christie's in London.[79] Among the highlights of those events were a few exceptionally rare so-called staff or mace gods from the Polynesian islands of Mitiaro and Rarotonga, but there were also many more common articles of daily use, for Hooper was not exclusively interested in the finest pieces.

In Great Britain, with one or two exceptions, there was no direct link between tribal art and western art; in New York, as in Paris and, on a smaller scale, Amsterdam, the two to some degree went hand in hand in museums, galleries, and private collections throughout the twentieth century.[80] Two well-known names from postwar New York, and two of its many links with Europe, are Julius Carlebach and John J. Klejman, both Jewish, from Germany and Poland, respectively, who did not get along very well. Carlebach did a good deal of business with the surrealists and with the Heye Foundation Museum of the American Indian.[81] Klejman had formerly been an antiques dealer in Warsaw and developed good relations with the private collectors Nelson Rockefeller and Raymond Wielgus, through whom many of the objects dealt by both Carlebach and Klejman ended up in the Metropolitan Museum and in the Indiana

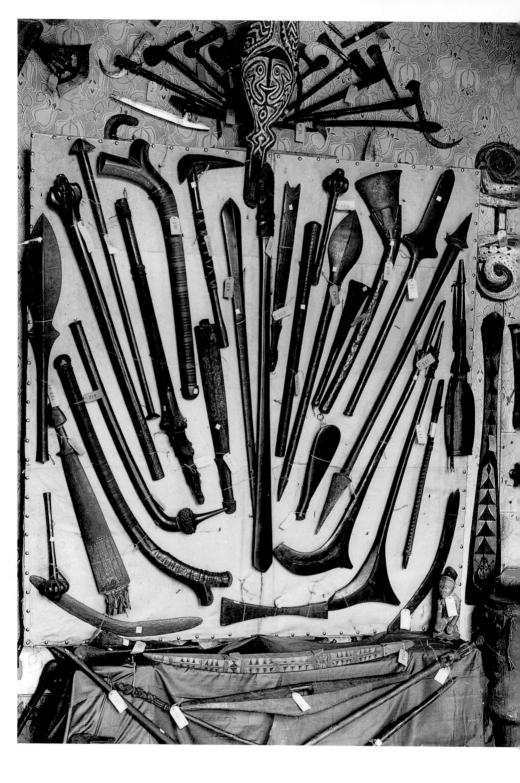

University Museum in Bloomington, respectively. Both dealers bought in Europe and sold in the United States.

Most of Pareyn's African collection which was auctioned in 1928 went to England, where it was again sold to other parties. Later, numerous Pacific objects travelled from England to the Netherlands, and on, through Lemaire and others who started regularly buying in England in the 1950s from dealers and at auctions. It is clear that while there were privileged points of entry into industrialized societies through colonial connections, national boundaries were not much of an obstruction to the traffic in tribal art. A figure like Ratton, based in Paris and buying and selling in Berlin, New York, Antwerp, and Amsterdam, was by no means an exception. One network of lines along which objects moved across borders and between metropoles were connections between dealers; another one, partly overlapping the former, were international connections between modernist artist-collectors, which I will deal with below. But first we should take a look at the various, quite substantial roles of missionaries in *le circuit des objets*.

11. Oceanic objects formerly owned by Jacob Vis, a private collector
from Amsterdam. After his death, his collection was sold to the English dealer,
W.O. Oldman, who arranged the objects in this way and took the photograph,
probably for one of his monthly sale catalogues, about 1907.

1.4 The Missionaries

The European colonial expansion in the second half of the nineteenth century brought with it a wave of missionary activities. As in other countries, many congregations in Roman Catholic Belgium formed ethnographic collections for the purpose of gaining a better understanding of native ways, for missionary propaganda, and for use in the training of missionary personnel. Collections or small "missionary museums" were put together by, among others, the Jesuits in Heverlee, the Crosier Fathers in Diest, the White Fathers in Mechelen and Antwerp, the Redemptorists in Antwerp, the Scheut Fathers in Brussels (cf. Figure 14), and the Capucins in Izechem.[82] In the Netherlands, ethnographic collections could be found in the monasteries of the Missionaries of the Sacred Heart in Tilburg, the Society of African Missions in Cadier en Keer, the Steyler Missionare (S.V.D.) in Steyl-Tegelen, the Congregation of the Holy Spirit in Berg en Dal, and others. The Roman Catholic Redemptorists from Rotterdam, like the Protestant Hernhutters from Zeist, had collections from the West Indies, in particular Surinam. The Steyler Missionare, a German congregation based in the Netherlands, were active in the German territories in Melanesia, and even today display old Melanesian statues and masks in the Missiemuseum Steyl. That museum is additionally interesting in that it has conserved its interiors and *horro vacui* showcases as they were in the 1930s. Apart from building up relatively permanent collections, these and other congregations for many decades sold large numbers of old and newly made articles from overseas through temporary missionary exhibitions in order to raise money.

In the more recent periods of decolonization, secularisation, and the decline of monasteries, the collections of Catholic and Protestant missionary societies proved to be rich hunting grounds for dealers and collectors. In some cases, the sale of recent carvings by these societies on behalf of the makers has continued to the present, for instance, among the Missionaries of the Sacred Heart in Tilburg, who still occasionally sell Asmat statues and shields. This congregation brought material from New Guinea and the Moluccas to the Netherlands for almost a century. Through the Tilburg monastery, many exquisite pieces

12. One of the Roman Catholic Missionaries of the Sacred Heart from Tilburg at a missionary exhibition in Maastricht, the Netherlands, in the early 1920s. The "Headhunter from South New Guinea" is flanked by two Asmat ancestor figures styled after praying mantises. Lying underneath are prepared human heads, probably headhunting trophies of the Marind Anim, living to the southwest of the Asmat. The first Dutch administrative and missionary posts on the south coast of Dutch New Guinea were located in Marind Anim territory.

found their way to important museums worldwide. They were also sold to private collectors such as the artist Serge Brignoni, who regularly visited the Tilburg fathers.[83] That the missionaries didn't necessarily operate along direct lines between European nations and their colonies is evidenced by the existence of a collection concerning Eskimo/Inuit and American Indians in the small Amerika Museum in Cuijk, the Netherlands, brought together by the Fathers Oblates of Mary.

In the present context, we must not forget the Vatican itself, which has extensive, if scarcely studied, and to some degree very early ethnographic collections, resulting from Catholic missionary activities. In 1925, it

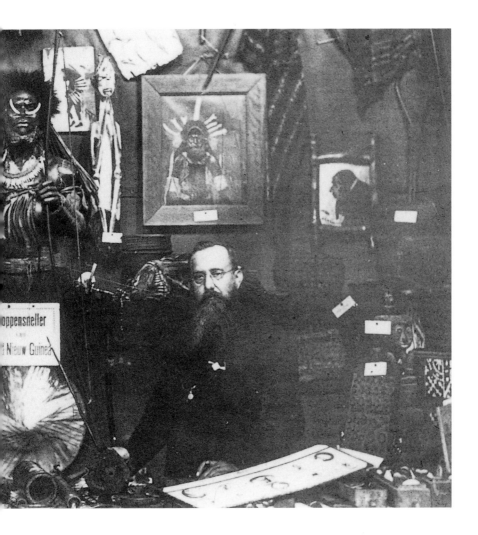

organized a large propaganda exhibition, covering some 6,000 square meters, on the progress of the Roman Catholic Church in spreading the word of God among "heathen" peoples. Pope Pius XI ordered dozens of congregations and missionary societies to send in ethnographics. Despite the initial promise by the Vatican, a considerable percentage was not returned but, together with the collections already present, housed in a new museum, the Museu Missionario-etnologico, in the Palace of Laterans. The museum was moved to the Vatican City in 1973; currently it has a site on the Internet, showing some of its finest pieces.

The Dutch Protestants engaged in similar activities. Protestant

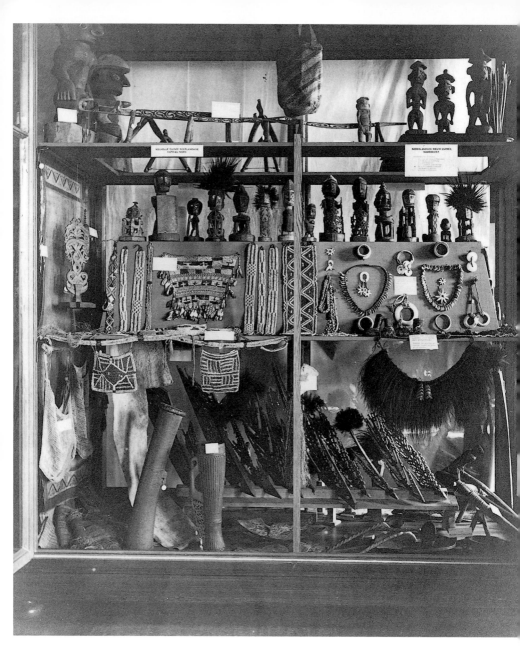

13. A display case in the Museum voor Volkenkunde Rotterdam in December 1903, crammed with objects from the northwest coast of New Guinea, some of which were collected by Protestant missionaries. Top left and right are five or six figures from the Humboldt Bay; underneath is a row of fifteen *korwar* ancestor figures from the Geelvink Bay area. At the bottom, leaning over, are a number of openwork prows from that same area.

missionary societies such as the Nederlands Zendeling Genootschap, the Utrechtse Zendings Vereniging, or the Nederlandsche Gereformeerde Zendings Vereeniging collected ethnographics and used them to furnish small museums, just like their Roman Catholic counterparts. The innumerable *missietentoonstellingen*, temporary missionary exhibitions organized by Catholics in Belgium and in the southern Netherlands (Fig. 12), both overwhelmingly Roman Catholic, aimed at sales and propaganda, were equalled by the Protestant *zendingstentoonstellingen*. It was thus that during the heyday of this type of activity, the first half of the twentieth century, countless objects found their way into Dutch and Belgian households. Figures of ancestors and spirits were presented as heathen "idols" and as expressions of "lower races" not yet so highly developed as western—civilized, rational, and Christian—man, and the connection of the idols with "barbaric" practices such as headhunting was overstressed. For a long period, Catholic and Protestant exhibitions, temporary or permanent, portrayed missionaries in a romantic light as heroic pioneers among the savages, with the evil indigenous sorcerer, the devil's agent, as their opponent.[84] Later, around 1960, the emphasis shifted to the missionary as a sober, hard-working pragmatist. While objects from the colonies were seen as heathen idols in religious contexts, in other western settings they were perceived and presented as high art—for example in Carel van Lier's Amsterdam gallery—or as ritual artifacts characteristic of a specific group and its worldview.

The Rotterdamse Zendelingshuis, a Protestant missionary society, exhibited a collection from the Dutch East Indies at the Internationale Koloniale en Uitvoer Handel Tentoonstelling (International Colonial and Export Trade Exhibition) held in Amsterdam in 1883.[85] This collection had originally been set up to serve as teaching material for new missionaries. The Protestants and the Roman Catholics each collected many thousands of objects among the various Batak societies in Central Sumatra, which are now in several Dutch museums. In the northern parts of Dutch New Guinea, which were assigned to the Protestants while the southern parts were reserved for the Catholics, Protestant missionaries such as G.L. Bink, F.J.T. van Hasselt, and F.C. Kamma collected hundreds of *korwar* ancestor figures and other items in the area around the Geelvink Bay (Fig. 13).[86] The Dutch dealers Loed and Mia van Bussel managed to buy Kamma's small but fine private collection in the early 1980s.

In the Belgian Congo, colonized by a predominantly Catholic country, there was some Protestant missionary activity. Carl Lamann, a missionary of the Swedish Covenant Church, spent the first two decades of this century among the KiKongo-speaking peoples of the Lower Congo in the west. In addition to his proselytizing activities he wrote a grammar of

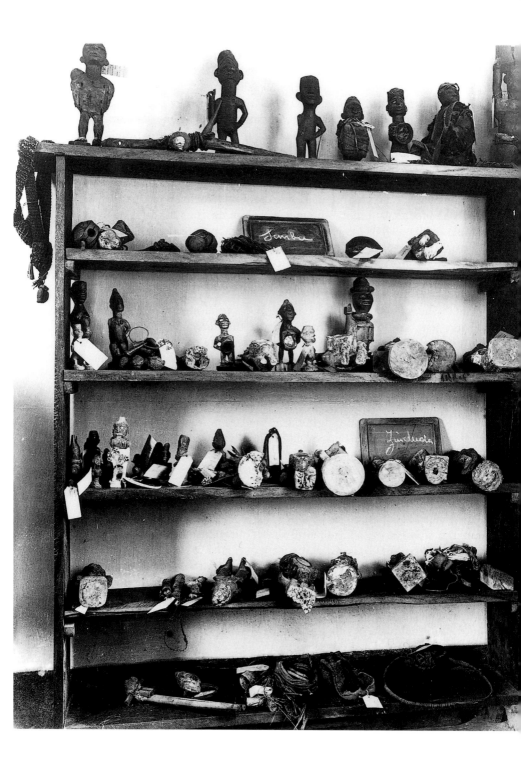

their language, composed a KiKongo-French dictionary, and together with others translated the Bible into that language. He had a great interest in local rituals and traditions, and collected a hundred or so *minkisi* (cf. Figure 14, as well as Figures 1 and 48): statuettes and other articles which embodied powerful spirits from the realm of the dead. These spirits were to a certain degree held to be capable of being influenced by people through the intervention of a *nganga* or sorcerer, who chanted and drove nails into them. The Lamann collection, especially valuable because it is so well documented, is currently preserved in the Swedish Ethnographic Museum in Stockholm. For years, Lamann had native pupils and former pupils of the mission fill in detailed ethnographic questionnaires. That sustained effort resulted in a wealth of information on *minkisi* and everything connected with them, in total some ten thousand handwritten pages. The missionary-ethnographer himself wrote a four-volume ethnography on the basis of this information which appeared posthumously.[87]

The term "nail fetish," which is still sometimes used colloquially to refer to some types of *minkisi*, dates back to the eighteenth and nineteenth-centuries when these uncanny figures were viewed as superstitious idols. They are now greatly sought after by museums and collectors equally but for a long time, until much more recently than most other African figures, they were found to be ugly and repulsive. "Nail fetishes" still surface every now and then, mostly in Belgium. A Brussels dealer told me of one case in the early 1980s when a car stopped in front of his gallery and some people from the province dragged in a huge one, which he bought for a song and not much later sold for a large sum.[88]

The missionaries channelled huge quantities of material into the western world, but at the same time they played another, quite opposite role—that of iconoclasts. Raoul Lehuard, an expert and writer on African art, describes how his father, Robert Lehuard, a railway engineer, collected in French Moyen-Congo, present-day Congo-Brazzaville, in Teke, Lari, Sundi, Bembe, and Kota villages from 1924 till 1933, shedding light on that other role of the missionaries in that particular area, and how one particular collector dealt with it: "[My father] gathered most of the statues he brought back from the rubbish piled up behind kitchens.

14. A collection of arranged and labelled Yombe *minkisi*—figures or objects housing a spirit—at a mission post in Kangu, Lower Belgian Congo, in 1948. The collection was assembled by Father Schermers, a Belgian Scheut Missionary.

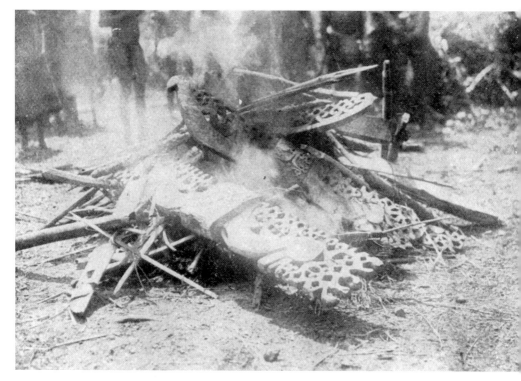

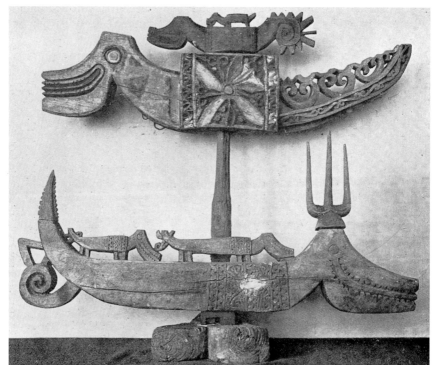

These 'fetishes' had been separated from their sanctuaries because they had lost their force. ... Later, knowing my father was looking for statues, the Congolese brought him those they wanted to give up in return for payment ... [The] colonial administration and the missionaries, often in a joint effort, made themselves guilty of stealing objects which were then usually destroyed by burning them. At the beginning of the century, Father C. Jaffé ... collected all the sculptures he found among the inhabitants of Stanley-Pool and once a week burned a stack of objects that rose to over a metre high. When my father got wind of the priests' activities, he went regularly to select the best pieces from the pile the day before the burning of the heretics."[89]

Iconoclasm is an age-old Christian practice. In colonial frontier societies, the Protestants were much more fanatic in this respect than Roman Catholics. In New Guinea and the Dutch East Indies, where they collected many beautiful items, there were many more "idols" they destroyed or had destroyed (Fig. 15), buried, hid, thrown in rivers, and so on. Sawing off or concealing behind loin cloths the private parts of figures was also quite common. In a missionary periodical, the Protestant missionary F.J.T. van Hasselt, who appreciated the indigenous culture, provides a vivid description of a *korwar* burning that took place in October 1932 on the island of Yappen in the Geelvink Bay, Dutch New Guinea. It took place on the occasion of the solemn baptism of several hundred people. "Even early in the morning", he writes, "there was unusual activity in the village. Groups of young men went from house to house to collect the heathen attributes and figures. They were piled up in the large yard behind the school church. It became a mountain of all manner of charms and things to ward off evil spirits." This was on orders from the village chiefs, who wanted to use the baptism to do away with the old customs. It is noticeable that Van Hasselt's feelings were mixed: "To be honest, I felt a

15 a. "The burning of *naga*," at the instigation of Dutch Protestant missionaries on the island of Alor, Dutch East Indies, at the beginning of this century. The *naga* is a mythical snake or dragonlike figure that occurs in many cosmologies in the Indonesian Archipelago. This photograph forms the frontispiece in the missionary brochure *Van strijd en overwinning op Alor* ("Of Struggle and Victory on Alor"; Van Dalen 1928).
15 b. *Naga* from Alor, about one metre long, which— contrary to the *naga* in the upper picture—were collected around the turn of the century by a Protestant missionary and subsequently donated to the Museum voor Volkenkunde Rotterdam.

THE MISSIONARIES

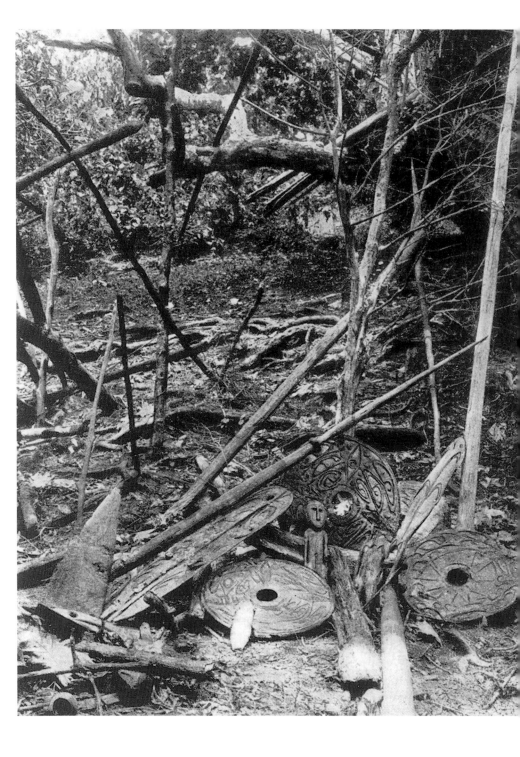

bit bad about it, because there were some priceless ethnographic pieces among those to be destroyed. But here I could not allow my own aesthetic feelings to infringe upon the wishes of the people." After sundown, the piled-up objects—korwars, amulets, statues, drums, masks—were set alight while the school children sang. "A wonderful deed representing a complete break with the old," comments the missionary, and he quiets his own doubts: "Here was a sacrifice the value of which only God himself knows. Who was I to lament the loss of a few ethnographic pieces?" [90]

Such practices were not without precedent. The destruction of indigenous ritual objects by or at the instigation of missionaries, a sort of rite of passage, was a quite common centuries-old practice. This sort of thing happened, for instance, in the course of Catholic missionary activities by the Portuguese in the Lower Congo area in the sixteenth century and during the proselytizing by the London Missionary Society in Polynesia at the beginning of the nineteenth century. In his book *Missionary Enterprises*, John Williams, a member of that society, relates how natives of the Austral Islands gave up their gods in the face of evangelical efforts in the 1820s. Williams calls those gods ridiculous, monstrous, despicable, hideous, and superstitious, and describes how the missionaries triumphantly displayed them in their chapels, sent them to England, hung them up like hanged men and castrated or burned them. In one case, they baked bananas in the hot ashes of the burned figures and then ate them to defy the heathen demons.[91]

"Four great idols were then brought and laid at the teacher's feet," Williams writes about another incident on the island Rarotonga, "who, having read a portion of the tenth chapter of the Gospel of St. Luke, which was particularly appropriate, especially from the seventeenth to the twentieth verses, disrobed them of the cloth in which they were enveloped ... and threw the wood to the flames. Thus were the inhabitants of this district delivered from the reign of superstition and ignorance under which they had so long groaned ... The grief of the women was excessively frantic, and their lamentations loud and doulful. Many of them inflicted deep gashes on their heads with sharp shells and shark's teeth,

16. Sacred objects from two ceremonial houses in the villages of Ayafo and Saboiboi on the Sentani Lake that were burned down by Dutch colonial authorities. These objects, most of which house spirits, were saved by the villagers and hidden away at this secret spot in the forest, where Paul Wirz photographed them in 1926.

and ran about, smeared with the blood which streamed from the wounds, crying in tones of the deepest melancholy ... From this time the destruction of the ensigns of idolatry proceeded rapidly throughout the island."[92] What is often unclear in the sources is to what degree such things happened at the order or initiative of western missionaries, or were initiated by native converts themselves.

In 1902, an anonymous correspondent of the German scientific periodical *Globus*, probably an anthropologist connected to a museum, lamented the "Missionary Vandalism on Nias," as ran the title of the article. Rudersdorf, a missionary of the Rheinische Misionsgesellschaft had destroyed a large number of ancestor figures on that island in the Dutch East Indies in September 1901. The anonymous correspondent found "the still ever-raging zelotism among many bringers of the Word to the heathens" grievious, all the more so because a similar incident in German Cameroon had occurred shortly before.[93] He cites Rudersdorf, who triumphantly had described his actions to those at home in the *Berichten der Rheinische Missionsgesellschaft* of that year. Singing, reciting the Ten Commandments, and saying prayers he went to the house of a local chief, where, Rudersdorf reported, "the large and the small idols were hacked free with axes and knifes; I subsequently threw the first idol over the cliff in front of the houses with the words <God is the Lord, and not these idols >. The other figures followed; I didn't count them, but there were probably well over a thousand." The anonymous critic subsequently remarks on the conspicuous value that such figures, given proper documentation, would have had for museums in Germany, and points out the necessity of a certain degree of ethnological training for missionaries in order to prevent such mishaps from occurring.

A reaction to the aforementioned anonymous charge was sent in by the missionary Mundle, director of the Museum der Rheinischen Mission in Barmen, Germany, who came to Rudersdorf's defence by claiming that this case concerned only the common, roughly carved Nias figures, and not the relatively rare and valuable very finely carved ones.[94] At the same time, he made the intriguing remark that the people on Nias prefered to bury or burn such refined figures rather than see them fall into strangers' hands. Finally, he pointed out that the missionaries had nonetheless succeeded in securing a large number of such figures, and that they wanted to save more in the future. At this point, the editors of *Globus* entered into the discussion: the ethnological and linguistic contributions of many missionaries were beyond doubt, they commented, and generalisations should not be made on the basis of individual cases; on the other hand, it was known that many transitions existed between the rough and the refined Nias figures, and as Rudersdorf was talking about more than a thousand large and small figures without being more

specific, they found that protest was indeed justified; furthermore, in view of other cases such as the recent one in Cameroon it was, in their opinion, more than mere isolated incidents.

Almost three decades later, in 1927, we can see the same ambiguous attitude to native rituals and objects in the neighbouring Batu Islands. On the one hand, there were missionaries like W.F. Schröder and W.L. Steinhart who showed more interest in indigenous cosmology and articles than many of their colleagues, and also collected them. On the other hand, they adhered to the official line with reference to the spreading of the word of God: "As it had been agreed the evening before," writes Mrs. M. Steinhart-Teudt, Steinhart's wife, in a letter, "every Christian family to be baptised would hand in its ancestor figures to us. Likewise all heathen charms such as amulets and talismen were to be removed ... Everything was put next to the church in a pile, to be ceremonially buried during the church service. After the baptism texts had been read the whole community went outside where a large hole had been dug. Next, all the wooden ancestor figures were thrown into the hole and covered with earth. After a sermon and prayers we sang a suitable song in which it was made clear that just as these figures were being buried, so now must all that is heathen in our hearts die and also be buried. The spirit of Christ must now lead us" (compare Fig. 17).[95]

Local converts who cast themselves as prophets or leaders of new religions, Christian or Islamic, or of syncretistic movements in various African countries were often even more fanatical than western missionaries. So it was that the Baga, who live on the insular coastline of Guinea, amid rice swamps and sea inlets, had to deal with aggressive Muslim missionaries around 1955. As the ethnographer Frederick Lamp writes, one of them, Fanta Modou, a Malinke, "claimed to have been sent by the prophet Mohammed to the Baga Koba ... Audaciously attacking the traditional practices and their high practioners, he penetrated the sacred forests, confiscated the masks, and exposed them publicly to the villagers, with ridicule and curses."[96] Adolphe Camara, a Baga who had witnessed this Islamic conversion campaign in youth, told Lamp about Fanta Modou and a second proselityzer: "The day after their arrival, they would seize the art work and the masks, which they sold for profit; others which they found noxious were burned. As a consequence their name was feared. The next morning, along aside the fence, one could see the objects that had been abandoned and exposed to the public and burned, all of this reinforcing the power and the reputation of the two marabouts."[97]

The Baga had earlier been confronted with the curtailing of ritual activities and ritual art by French administrators and missionaries, although the latter collected the very same art themselves, privately or

THE MISSIONARIES

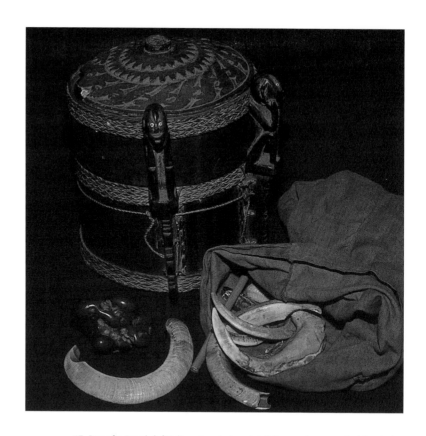

17. Box of a Dayak (of Kalimantan, Indonesia) *dukun* or shaman called Rasak. It was collected by the Capucin missionary Father Christianus at Sedjiram, an early mission post, and kept in the missionary collection of the Capucins in Tilburg, the Netherlands, since 1931. The entry in the collection catalogue, in Dutch, reads: "Accessories of a *dukun* ... Sedjiram. Property of Rasak the sorcerer, who, though converted to Catholicism, continued to practice sorcery. Father Christianus requested that he give up all such accessories, lest the Holy Sacraments be refused to him." The box is 18 cms. high and contains a small cloth bag filled with gall-stones, animal fangs, and other magical objects. It is now in the Nijmeegs Volkenkundig Museum, at Nijmegen University, the Netherlands, along with the rest of the Capucin collection.

officially. For instance, collecting was carried out on a large scale among all groups in Guinea, including the Baga, in preparation for the colonial exhibition in Paris in 1931, for which colonial troops were sent into the villages to search for objects. Since then there has been constant interest in the spectacular Baga objects, especially among French collectors and dealers. When the final pullout became imminent in 1958, French colonials, collectors, and dealers tried to get their hands on as much as possible, literally truckloads full. In the same year, a totalitarian Marxist regime came to power that once again clamped down heavily on the Baga, iconoclastically. Lamp describes the persistent struggles of the Baga to retain their cultural heritage, focussing on the processes of creative cultural reinvention through which the younger generations adopted the traditions of the elders, often in a fashion that bordered on sacrilege and the defiance of strict prohibitions.

The Massa or "Horn Cult" movement among the Senufo of Ivory Coast in the 1950s constituted another case of indigenous iconoclasm. It was described by the missionary and ethnographer Michel Convers, who was initiated into their Poro society under the name Kulaséli.[98] The Massa movement promised peace and prosperity, provided one refrained from magic and other traditional religious practices which were held to be evil. In the Senufo villages, this led to the casting out of ritual objects on a large scale. Desanctified, these were abandoned in great numbers on dumping grounds assigned by the Massa or elsewhere by panicking and fearful villagers, outside the sacred groves where they had been kept until then. Convers decided to save what could be saved, and western dealers and their native henchmen were also quick to arrive on the scene. As a result of these developments in Guinee and Ivory Coast, Baga and Senufo ritual art became better known in North Atlantic societies and well represented in collections there.

A great deal of traditional religious art in Africa and elsewhere perished as a result of suppression and replacement of the traditional religious convictions and practices that constituted the essential frame of reference of tribal art. The direct or indirect destruction of articles by Christian missionaries, through Islamicization, by indigenous syncretistic religious movements, or in the context of so-called cargo cults, however, was a prominent but certainly not the only cause in the demise of traditional art. Colonial domination brought with it new administrative, military, educational, economic, and indeed religious infrastructures. Like a fine-meshed net, they were systematically spread out across the land by the colonisers, radically influencing or suppressing traditional native structures.[99] Villages were regrouped, migrations were dictated, polygamy was forbidden, men were taken to work in other areas, village chiefs were arbitrarily named, and tribal territories were split by newly drawn

borders. Administrative posts, mines, harbours, roads, railways, canals, factories, plantations, and logging areas all had a great impact on the native societies, and the population of more remote regions shrank because people flocked in large numbers to such places. The traditional expertise concerning figures, feasts, and tribal lore gradually disappeared. The systematic collecting activities of western dealers, commencing in a number of African areas as early as the 1950s, contributed to the loss of traditional ritual art, a process that was often precipitous, as in Gabon,[100] but sometimes, especially in remote areas and in thickly populated areas with powerful traditions, happened less rapidly.

1.5 Artists and Ethnographics

While numerous objects from other cultures came to Europe through various channels during the heyday of colonialism, large museums in the colonial metropoles as well as smaller ones, often in the ports, began to flourish. In Paris, modernist artists like Picasso, De Vlaminck, Braque, and Derain were seeking ways to break free from established aesthetic canons and stylistic conventions—both naturalist and (neo)classicist—associated with the art salons of the wealthy *bourgeoisie*, and the masks and figures from the French colonies in Oceania and Africa did not escape their attention. Cubists, Fauves, and other expressionists saw them in the Musée d'Ethnographie du Trocadéro and at colonial and world exhibitions; they bought them at flea markets, in antique shops or from the first generation of specialized dealers and they were thus inspired in their search for new expressive idioms. Before long, such objects were no longer seen as grotesque and ugly curiosities, but as a form of high art— "primitive art," *art nègre*. In the context of this quite sudden reversal, "primitive" no longer stood for something that was barbaric and backward, but rather for primordial purity, unaffectedness, and natural spontaneity. Various gallery owners in Paris, including Daniel-Henry Kahnweiler[101] and Paul Guillaume, combined avant-garde art with "primitive" art. In various western countries, it became fashionable to collect ritual objects from tribal societies, perceived in a new way that diverged sharply from both the ethnographic approach predominant in the museum world, as well as from viewpoints held in religious circles.

Since that time and until today, artists—in interaction with museums and dealers— have been an important factor in the twentieth-century reception of tribal objects. Developments comparable to those in Paris at the beginning of the century also occurred in other locations. Avant-garde artists in New York collected American Indian and Eskimo/Inuit art. In Dresden, under the influence of Gauguin and the Fauves, Ernst Ludwig Kirchner, Emil Nolde, and other members of Die Brücke, an artists' community, sought inspiration from the collections of the Zoologisches und Anthropologisch-Ethnographisches Museum in that city.[102] They were in search of new, deep, original forms of expression, but also, in a broader

sense, in search of a "pure" way of life, beyond the restrictions of western bourgeois society. When the group established itself in Berlin in 1911, the combination of a number of exhibitions of the work of French avant-garde artists with the rich collections of the Berlin Museum für Völkerkunde provided new stimuli in the consciously sought after confrontation with the "original" way of living of *Naturvölker* ("natural peoples").

At about the same time the Blaue Reiter group formed in Munich, centered around Wassily Kandinsky. It was not only interested in ethnographics, again easily accessible in the Munich Museum für Völkerkunde, but also in European folk art.[103] The dada movement, which developed in Zürich among exiles during the First World War and continued in Paris, followed the same pattern, as did the offshoot surrealism from around 1920.[104] In the minds and the art of the surrealists in the colonial capitals, the unconscious of Sigmund Freud and the spontaneous *élan vital* of Henri Bergson melded together with the exotic and the erotic of non-western cultures in expressions of a deeper, more original world which subsequently was critically pitted against European civilisation, seen as repressive and corrupted, and its imperialist practices. Many surrealists collected tribal art, including the Dutch painter J.H. Moesman from Utrecht, and the Groningen (the Netherlands) professor of comparative religion and initially dadaist poet Theo van Baaren. Both were good clients of the art dealer Carel van Lier. Van Baaren (1912-1989) was the founder of Groningen University's Volkenkundig Museum Gerardus van der Leeuw, set up in the 1970s on the basis of his own collection and others, including that of the former Koloniaal Landbouwmuseum (Colonial Agricultural Museum) in nearby Deventer. He was an expert in the iconography of non-western religions, and wrote a standard work on the *korwar* ancestor figures of northwest New Guinea.[105]

One of the most remarkable—and internationally prominent—figures in the surrealist movement was Max Ernst, who while studying in Bonn around 1910 became interested in ethnology and ethnographics. Throughout his highly productive life, this great artist sought the mythical and spiritual harmony with nature that had been lost in the West, with the help of his cherished Hopi *kachina* dolls, bird men from Easter Island, and *gope* ancestor boards from the Gulf of Papua.[106] Many members of these and successive movements in the arts of the twentieth century, including a number of representatives from the Low Countries, not only sought inspiration from ethnographics but also collected fervently. With regard to Belgium in the interbellum period, Flemish expressionists like Frits Van den Berghe and the "post-cubist" Pierre de Vaucleroy deserve special mention. In the Netherlands, Carel van Lier, and, after the Second World War, Leendert van Lier, combined trade in ethnographics with trade in contemporary art.

In 1948, the expressionist CoBrA group—Copenhagen, Brussels, Amsterdam—was founded, together with an international periodical of the same name. The artists and writers associated with this movement were fascinated by the "pure," "virgin" art of tribal cultures, as well as by folk art and children's drawings. Two well-known Dutch members of this movement are Corneille and Karel Appel, both of whom are collectors. Corneille, who has been painting his birds and women in Paris since the 1950s, started in expressionism, went through abstraction, and then began to work in an increasingly figurative and naturalistic style. He was and is a passionate collector of African art, which he continuously and consciously allows to inspire him in his own work. "In my place," he once remarked, "you don't see any spotlights on the figures and masks. They don't stand there in isolation being beautiful. Although many are packed in boxes or bags or are out of sight, I still feel their presence. I don't want them to impose on me, but I have to feel that they are close. That's why I don't mind getting more and more of them. To me, they are a well of inspiration which I can draw upon time and time again."[107] Various journeys to Africa made a deep impression on him and his work.

One of the best-known Belgian artist-collectors is the painter Willy Mestach, who sought and found his own way starting in "figurative abstraction" and the Bauhaus school. Mestach, who collects *au point de vue d'artiste*, as he himself likes to put it, became particularly interested in the Songe of Congo, fascinated both as a collector and as an artist by their powerful and rigorously formal style. His contacts with S. Wauters, a retired colonial official who worked among the Songe in the 1930s, led to his monograph *Etudes Songye: Formes et symbolique*, which is partially based on Wauters' experiences, fieldwork, and photographic documentation.[108] In the two volumes of the catalogue accompanying the large exhibition on primitivism in twentieth century art in New York in 1984, ten of Mestach's top pieces were illustrated, while the exhibition *The Intelligence of Forms: An Artist Collects African Art* in the Minneapolis Institute of Art was completely dedicated to his collection.[109] Mestach's hunt for traces of a universally human "collective unconscious" in tribal and western art, inspired by the psychology of C.G. Jung, is, however, somewhat dated in terms of present-day academic psychology.

Many other names could be mentioned, including those of nationally or locally known Dutch and Belgian artists who occupied themselves with ethnographics in one way or another. In 1997, a Dutch newspaper portrayed six collecting artists, most of them from Amsterdam, who made the following characteristic comments: "You buy it because it bears a secret ... The source of all art is the exorcizing of the fear of death, the fear of the incomprehensible" (Jaap Hillenius); "The origin [of the pieces] doesn't interest me; I only buy primitive art in relation to my own work. I recognize

in it something upon which I myself am working. For me it's about the intimacy of these things" (Eli Content); "This is a wooden Songe mask, about a hundred years old. Just look at the geometry ... <This is me and that is you> it says, just as in the poem by Hendrik de Vries. And you see, it is also completely Picasso" (Jan Wolkers); "What attracts me time and time again is that there is always something in these figures that despite all knowledge cannot be explained. And of that hidden something, that other reality, of which I try to represent something in my painting, I still understand virtually nothing" (Reinier Lucassen).[110] Such primitivist statements may keep many an anthropologist oscillating between cultural critique a la Sally Price[111] and the respect for the western native's point of view as a significant phenomenon in its own right that is part and parcel of the ethnographer's trade.

Among the well-known artist-collectors in other countries were formerly the sculptor Jacob Epstein in England and Klaus Clausmeyer in Germany, and are currently Georg Baselitz in Germany and the Frenchman Arman who lives in New York.[112] Arman, son of a dealer in oriental antiquities and in the 1960s one of the so-called Nouveaux Réalistes, is an interesting case because he goes a step further than other artists who collect ethnographics and draw inspiration from them. He processes ethnographics—such as Dan masks from Ivory Coast, Yoruba twin figures from Nigeria or Nok terracottas from Nigeria—in his own works of art, which he calls *incrustations* and *accumulations*. An example is his *Nok Nok Who's There?* (1996), now in the Musée d'Art Africain de Dakar (Fondation Mourtala Diop), consisting of twenty-five small Nok terracotta heads in piled-up plexiglass boxes. Some find it sacrilegeous to treat African tribal art in this way, even more so because in this case, it concerns archaeological finds of a type which had been illegally dug up and dealt on a large scale. Others, however, see them as intriguing contemporary transformations or appropriations of older art in the framework of a highly original, typically postmodern/post-colonial artistic *mise-en-jeu* of the relations between cultures.

1.6 Post-Colonial Developments

The previous chapter about artists and ethnographics has led us to the post-colonial period. The Belgian colonial presence in Africa ended at the beginning of the 1960s. In that same period, the Netherlands had to withdraw from New Guinea, while fifteen years earlier the Dutch presence in what has since been the independent state of Indonesia had come to an end. In the interviews printed in this volume, the many ways in which the biographies of people and those of objects are interwoven with the large-scale historical background of colonialism and decolonization are clearly illustrated. The best example is probably the life of Jac Hoogerbrugge, an agent for a large transport company in Indonesia and New Guinea, where he collected fervently. Decolonization brought with it a stream of people and objects to the Low Countries. Planters and traders, missionaries and officials, doctors and teachers came back with their families and their possessions.[113] As can be seen in their yearly records, Dutch and Belgian ethnological museums acquired a great deal from such ex-colonials, by donation or purchase; many dealers did good business with them, and a lot of what they brought back wound up in the hands of collectors through auctions.

Most of the old supply channels vanished along with colonial rule, and new routes came into being, though the supply of authentic old articles decreased steadily due to the loss and the modernisation of local traditions. The monasteries slowly emptied, and the phenomenon of missionary exhibitions silently came to an end. While previously it had been the colonial, military, or missionary personnel who brought things back with them it was now much more likely to be the returning development worker, the western dealer who went into the field to buy and collect, and also increasingly the travelling African dealer. Civil war, famine, or other such circumstances, for instance in Biafra or Eastern Timor, led to a stream of objects from those areas to western societies, as did more banal events such as new roads through formerly relatively inaccessible areas, though on a smaller scale.[114] Young states in Africa and elsewhere began to keep an eye on what they considered national property. Some socialist-populist regimes, for instance, such as in Guinea, discouraged, forbade, or

"folklorized" traditional ritual art, while islamization also had a negative effect. Series of woodcarvings, more or less mass produced, began to flood western markets, and the former "colonial museums" were confronted with the task of reconsidering their long term goals and articulating new identities.

A younger generation of dealers entered the scene in the 1960s.[115] By then big names like Webster and Oldman in England, Umlauff and Konietzko, Sr. in Germany, and Guillaume and "Père" Moris in France already belonged to the past. Many dealers such as the Dutchman Loed van Bussel and the Belgian Marc Felix went into the field themselves, Van Bussel in Melanesia, and Felix, who for a long time was a real *coureur de brousse*, in Africa and in Southeast Asia. Felix was one of the western dealers who concentrated on the tribal areas of Indonesia in the 1970s and 1980s. Three others from among the important, reputable and high-priced dealers in Brussels are Pierre Dartevelle, son of a curator at the Tervuren museum, renowned for his fine private collection of African art, and associated with David Henrion; Philippe Guimiot, originally French, who is also an auction expert in Paris; and Emile Deletaille, from whom the Tervuren museum bought a lot. Deletaille sold his fine private collection of Congo art to the new National Museum of African Art in Washington, D.C.. He started out as a private collector of Mediterranean and pre-Columbian antiquities, then started to deal in pre-Columbian art, and later, stimulated by contacts with Jef Vander Straete, began to deal in tribal art as well.

Most dealers in and around Brussels handle a broad range of objects they come across, while specializing in a certain segment of the field. Alain Guisson, for example, specializes in South African art, especially Zulu and Ndebele, and travels a lot for it; Jos Christiaens, in the 1960s a sports instructor in Zaire, in Hemba art; Lucien Van de Velde, formerly an UNESCO-official in Côte-d'Ivoire, in West African art; Pierre Loos, of Ambre gallery, in West African terracottas; François Coppens, in Borneo Dayak; Kevin Conru, an American, formerly classical musician, collector, and auction expert, presently based in London and Brussels, in Melanesian art. Jac Van Overstraeten is an artist and a dealer. Sulaiman Diané, originally from Guinea, is based in New York and Brussels and works along that axis. Tribal art consultant Guy van Rijn's *fort* is a 100.000 item pictorial archive of African art objects that have been auctioned, collected, published, handled by dealers, exhibited, or documented otherwise. Samir Borro, collector/dealer in Brussels, from a well-to-do Côte-d'Ivoire family of Lebanese origin, has a fabulous private collection of art from that country. There are of course many others. Some have become or are becoming quite rich in the process, some not; some are real intellectuals, others not; but all are very passionate about tribal art.

Many of the Brussels dealers have lived and worked in Africa and started to collect and deal there. Guimiot, for instance, started to collect when he worked in Gabon as an official, and soon set himself up as a full-time dealer based in Cameroon, channelling many thousands of objects from Cameroon, Gabon, and Nigeria out of Africa. An auction catalogue entry pertaining to a fine Hemba *singiti* ancestor figure from Congo traces a pattern that was typical for the postcolonial era. The 74 cm. high statue was offered for sale at Christie's of London on June 29th, 1994, as lot number 25, with an estimated value of about £ 60,000. The art of the Hemba, the entry states, "was known only by a few sculptures, those mostly in museums, before the 1960s, when some enterprising entrepeneurs, encouraged by a growing market in African art, explored the area from the north. They persuaded the villagers to part with their heritage, racing their spoils across the Sahara to the market places of the United States and Europe."[116] Export was illegal, but a stamp reading *Département de la Culture* could easily though illegally be bought from officials.

The Brussels dealer Christian Duponcheel was one of the first to put sculpture from the Bongo of southern Sudan on the western market. When, in 1973, he read about cease-fire negotiations between the Sudanese government and the rebels in the south, he took a plane to Sudan where he managed to acquire the support of the rebel leader for his operations in the south. The sixteen pieces he obtained "ended up in museums (in Paris, London, New York), in the hands of antique dealers (Henri Kamer), or in private collections (Frum, de Grunne, de Menil)."[117] Since 1998, considerable numbers of Bongo and Belanda figures from the war-torn Southern Sudan have reached the western market through African and western dealers.

An analogous development in Indonesia is described by the anthropologist Eric Crystal, who did fieldwork among the Tana Toraja of Sulawesi. Within a decade after tourists discovered the area around 1970, he writes, "no burial site in the eighty-three villages of Tana Toraja would be free of the threats of looting and destruction ... International art dealers quickly seized the opportunities presented by the opening of the area to survey and sell on commission Toraja funerary statues. Some European dealers assigned agents with telephoto lenses to survey the many burial sites in the region. Customers in Europe could subsequently select their preferred statue from photographic albums."[118]

The compilation of ethnographic collections in Congo itself, one of the richest areas in the field of tribal art, has a checkered history. The Musée de la Vie Indigène (Fig. 18) was nationalized in 1960, and within a few years everything from its rich collections except one Pende mask of poor quality had disappeared or been sold. In the first half of the 1970s, the newly

18. A point of entry of non-western objects into a new, western taxonomy and a new, predominantly western physical, institutional, and social context: one of the workrooms of the Musée de la Vie Indigène (Museum of Native Life) in Léopoldville, present-day Kinshasa, the Belgian Congo in 1946. In this room, newly acquired objects were identified, described, categorized, numbered, and labelled. In 1960, the museum was nationalized and it is now part of the Institut des Musées Nationaux du Congo. There were a number of small ethnological museums and collections in the Belgian colony, some private, others run by the government or by missionaries (cf. Fig. 14).

founded Institut des Musées Nationaux du Congo brought together some 30,000 objects by means of detailed survey and collecting activities throughout the country, becoming the basis for a number of new, but badly managed museums scattered throughout the country. That national collection was supplemented with over one hundred fine objects from the storerooms of the Koninklijk Museum voor Midden-Afrika, donated by Belgium.[119] Many objects from the new national museums have since disappeared, and it is almost certain they have found their way into western collections. The political instability in Congo-Kinshasha in recent years facilitated the plundering of museums there, and persistent rumors have it that top pieces from that source were offered to Brussels, Paris and New York dealers. In an interview with a Belgian periodical, Thys Van Den Audenaerde, director of the Tervuren museum, pointed to a sale of the Congo cultural heritage on a certain scale, along criminal

channels, with the help of Congolese customs officials, high ranking military, and politicians.[120]

Much earlier, but on a smaller scale than in post-colonial times, western as well as African dealers had already been taking objects out of Africa. Griaule's expedition to the Dogon area in Mali, for instance, also discovered remains of a vanished culture, the Tellem, in that same area, in caves in the Bandiagara cliff. After pupils of Griaule had started to study this culture, the French art dealer and adventurer Pierre Langlois "unlocked" the Tellem to the tribal art scene. Between 1950 and 1954, he travelled to the area four times, and subsequently sold the Tellem figures he obtained —with their characteristically thick sacrificial patina—through several European galleries.[121] The figures were very popular, and around 1954, a number of Islamic dealers from Bamako, the Malinese capital, began to buy Tellem figures directly from the Dogon, who live in the same area, to sell

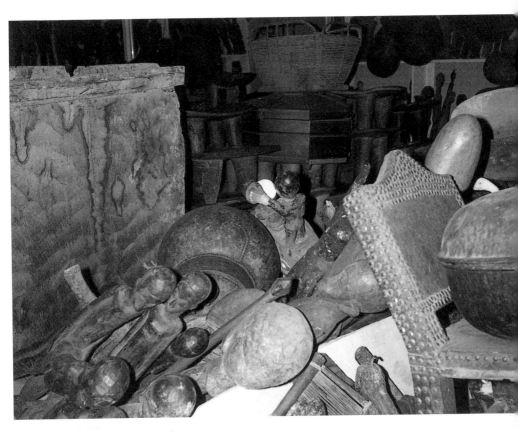

19. "Objects in transit": part of the stock of a Haussa dealer based in Abidjan, Côte d'Ivoire, who buys from small village-based traders and sells to western dealers, collectors, and tourists. Photographed by an Amsterdam dealer on a buying trip, Spring 1998.

them in Europe. By 1965, when the caves were empty, one of those dealers started ordering copies from Dogon smiths, based on published authentic pieces; an ingeniously faked "sacrificial patina" was applied. By then, several dealers from Bamako had taken up residence in Paris.[122]

Real Tellem figures are now much in demand and have a high market value. The Dutch anthropologist Walter van Beek, who carried out fieldwork in the same area, wrote about the production for sale: "The demands of the art and tourist market have triggered a quick response, especially among tanners and blacksmiths. Whereas the production of statues for traditional use has declined, that of statues for sale has become a thriving industry. The Dogon smear these new carvings with

kitchen soot, bury them for a few weeks near a termit mound, soak them in millet gruel, and dry them in hot ashes, all to give them the highly valued patina of long ritual use. Finally, they try to sell them as <Tellem>. This term, which can be used to denote a precise and datable civilization ... in the language of the contemporary art market should be translated as <We hope to convince you this is old>."[123] Van Beek adds that the objects made for sale to tourists scarcely differ as far as style and quality are concerned from those made for ritual purposes, apart from the fact that objects made for personal use are often carved more simply and with less detail.

From 1958 until the early 1970s Henri and Hélène Kamer, two dealers based in Paris and New York who went into the field frequently, developed a strong line in Dogon art.[124] They sold a great deal of Dogon to the private collector Lester Wunderman, who donated most of his Dogon collection to the Metropolitan Museum in 1977 and sold the rest to the Fondation Dapper, an exquisite privately run tribal art museum in Paris.

West-African dealers have come to play a considerable role in the tribal art trade since the 1950s, in particular since the 1967-1970 Biafran civil war. In addition to the Hausa of Niger and Nigeria and the Wolof of Senegal, the Mande—operating within an area encompassing Mali, Burkina Faso, and Guinea—are well represented.[125] Because dealers from these three groups are generally Islamic and as such have no use for religious images or figures, they have fewer religious or ethical reservations concerning the animistic articles in which they deal. They are typically based in towns or capitals (Fig. 19), acting as middlemen between two cultural worlds, that of the African producers of the woodcarvings and that of western consumers. They buy from small travelling rural, village-based traders and sell to western dealers and tourists from their storehouses or market-place stalls. Many small, mostly Muslim traders, so-called "runners" or *rabatteurs*, commute between Africa and Europe or North America to sell their wares, which they often have in commission.[126] They depend on networks of contacts on both sides, some along family lines and some developed while making their rounds of the shops and galleries in cities in Europe and North America. Like their western counterparts, a small number of African dealers, based partially or permanently in large cities in the West, deal in the better pieces, while a few specialize in top pieces.[127]

Along such routes, tribal objects typically pass through several value systems. For the villagers that make and use them, they are connected with the world of ancestors and spirits, and as such have a spiritual value and instrumentality. For the African traders, middlemen between African villages and western urban centres, especially the Islamic ones, they are commodities with a certain exchange value. For the disinterested contemplative art collectors, their value is a transcendent, aesthetic one.

20. An Austrian and an American dealer in a stand at the yearly "open days" of the Grote Zavel tribal art galleries in Brussels, June 1997, discussing the double-faced Bembe (Eastern Congo) helmet mask on the pedestal.

Chris Steiner has analyzed such trans-national chains of supply and demand and the concomitant changes in appreciation in some detail. He focussed his attention on art traders as cultural brokers or mediators of knowledge who add "economic value to what they sell by interpreting and capitalizing on the cultural values and desires from two different worlds" while manipulating "both the meaning and value of objects through contextualized presentation, verbal description, and physical alteration."[128]

Nowadays the few galleries in the Netherlands specializing in tribal art are for the most part located in Amsterdam. In Belgium, there is a clear concentration in Brussels, where several dozen dealers do business, either through galleries or behind closed doors. Brussels, along with Paris, is the first port of call for many small traders from Africa who arrive with bulging suitcases to do business with Belgian and Dutch dealers. What surfaces in Belgium and the Netherlands at flea markets, in antique shops, or at local auctions usually finds its way to the dealers in the capital within a short space of time, through various channels and networks.

Every week scores of new objects reach Brussels, mainly from two sources, the Belgian hinterlands and subsaharan Africa, and real surprises turn up regularly—exceptionally beautiful, old, or rare pieces. This is one of the exciting features of the trade for those involved.

Apart from the usual passers-by, each gallery has a more or less fixed clientele, which shifts to some degree over the years. Serious dealers attach importance to a relationship of trust with good customers, although repeated incidents show that the interpretations of trust can differ. Most business, however, is conducted between dealers, locally and internationally, directly or through auctions, on all levels of quality. Auctions also provide suitable occasions for business contacts before and after the event, also with private collectors and museum staffers. Most of what is auctioned at posh specialized tribal art sales with glossy catalogues in New York and Paris is brought in and acquired by dealers. Tricks and dirty games are not unusual in those arenas, as countless anecdotes and regular bitter or ironic complaints illustrate. In Paris most auction experts for tribal art are dealers too, which creates conflicts of interest. Ethnographics of lesser quality are auctioned in Belgium. Some Brussels dealers participate in up-market antiques and tribal art fairs in Europe and the United States. A number of foreign dealers participate in the yearly Grote Zavel "open house" in June (Fig. 20); this has been a yearly manifestation of the Belgian Association of Dealers in Tribal Art (BADNEA, since 1999 BRUNEAF - Brussels Non-European Art Fair), since 1990. Many American and French dealers, as well as from other countries, visit Brussels and Amsterdam regularly to buy. Most really outstanding pieces never hit the public space of the gallery or the official *vernissages*, but are traded behind the scenes.

The amounts of money that change hands in a typical week in Brussels are considerable. Transactions often involve several people and may be quite complex, for example, when a collector gives a piece he or she (usually he) wants to sell on commision to dealer A, who passes it on to dealer B to offer it to dealer C who is a specialist for the region it concerns but doesn't get along with A or would pay A much less than he would pay B, to whom he is closer. Dealers may team up to share the risk, the buying sum, and the gains when one of them comes across a potentially important carving. How they team up and where and when they gather to talk, drink (usually a lot), and do business reveals the existence of a number of small, changeable, partly overlapping networks. Debts between dealers are typically cancelled out at least partly with pieces or with other debts, past or future. Quite a few conflicts arise in the process, some longlasting. There are dealers who see each other every week but have not spoken or even greeted each other for years. Gossip is very important. "I couldn't do without it," one dealer remarked,

"it guards you from making mistakes and fills you in on what's up; it's how we work." Negative comments on an expensive piece in the hands of a colleague which are broadcast can do much harm. Competition is stiff, foul play not exceptional, and the hierarchy strict.

It is not unusual for collectors to trade in items from their own collections. In this way, many things regularly change hands, moving from one collection to the next. Objects cross borders frequently and without much difficulty—under the current law at any rate. There are all types of dealers in the Netherlands, but hardly anyone of them is part of the international elite, dealing, as some Belgian dealers do, in the best pieces and catering primarily to a handful of wealthy collectors and to museums. A number of gallery owners and dealers strive for and guarantee "authenticity"[129] and quality. Another category is formed by those who don't pay too much attention to authenticity or don't find it very important, and deal in, shall we say, exotic decorative objects.

In this segment of the market, it is not clear what is authentic and old, what is old but was made for sale to westerners, what has been produced to appear to be something which it is not, and what is simply recent serially produced arts and crafts. These dealers are not too concerned about giving honest information about the nature and provenance of what is offered for sale—a code of honour among the previous group, albeit one that is not always adhered to too strictly. In the next, lowest segment of the market, there are little shops with curiosities, bric-à-brac, and mass-produced exotic tourist or airport art. A number of serious gallery owners like to hold opening receptions where they present newly procured objects, and they cultivate their regular clients with whose collections they are familiar, whose preferences they attempt to take into account, and whom they tip off when a suitable piece comes in. At all levels, there are those who earn money as go-betweens, runners, or *schleppers*—the yiddish term sometimes applied to them in New York.

"It's a national sport," one ethnographics dealer said when I asked him whether the manipulation of old labels on pieces was something that— generally, not especially in Belgium— happened frequently; "I could tell you stories that would make your hair stand on end." Blank labels with the dealer Charles Ratton's name printed on them are known to have gotten into circulation. The fine, signed wooden mounts by the Japanese mountmaker and restorer Inagaki, who worked for the best Parisian collectors and dealers in the 1930s, lent additional prestige and value to the pieces mounted on them, but unused mounts are likewise known to have wound up in circulation. Provenances are faked as well. "It is so easy to fabricate a pedigree," another dealer said to me, "you just have to pick the name of a minor figure or family at some outpost from an early travelogue or missionary periodical."

Objects that have been tinkered with is something you see quite often. An object is either "good" or, better still, "important," or it is *kloterij*—a rough term Flemish-speaking Brussels dealers use for objects they don't like. A few examples of "improvements" to pieces that are in themselves authentic are the mysterious and sudden appearance of inlaid eyes instead of carved ones,[130] of an expressive and finely drawn face replacing the original roughly carved one, or of a beautiful "old" patina on a figure that through years of polishing in somebody's sitting room had lost its original one, or initially had none at all. Worse than this are the falsifications where no effort has been spared to make the pieces appear authentic, i.e., old and ritually used, and therefore valuable. In recent years, fake Moluccan ancestor figures made in special workshops in Indonesia were offered for sale in the Netherlands, complete with photos claiming to show them in their original village context. The figures were faked with great patience by copying authentic examples and the application of various processes to make them appear old. Sandblasting, burial in muck-heaps, exposure in the forest for several months, smoking, submergence in streams, and treating them with chemicals are standard procedures. Whatever had been done to these particular pieces, the result was not unconvincing, and at least one well-known and well-to-do Dutch collector was fooled by them. Similar practices take place on a large scale in Africa, in some cases so professionally that many collectors and even seasoned connoisseurs are taken in. Highly ambiguous with respect to the difference between authentic and inauthentic are objects which have been commissioned by western dealers, including the appropriate ceremonies or traditional usage.

The milieus of collectors are just as diverse as those of the dealers: small collectors, artists, afficionados, aesthetes, ethnographically interested intellectuals, people who lived and worked in non-western countries, snobs, lunatics, investors, connoisseurs, speculators, or combinations of the aforementioned. A look in the discreet but flourishing world of the better private collections in Belgium and in the Netherlands was offered by two exhibitions: *Utotombo: Kunst uit Zwart-Afrika in Belgisch privé-bezit* (Utotombo: Art from Sub-Saharan Africa in Belgian Private Collections) in the Paleis voor Schone Kunsten in Brussels in the Spring of 1988, and *Sculptuur uit Afrika en Oceanië* in the Rijksmuseum Kröller-Müller in Otterlo, the Netherlands, in the Winter of 1990/91.[131] *Utotombo* is a word used by the Chokwe in Angola meaning "a good and effective object made with craftmanship and love." The *Utotombo* exhibition in Brussels was composed of over three hundred objects from about fifty Belgian private collections, more than a third of which originated in the former Belgian Congo. A number of dealers were listed among the lenders, testifying to the fact that many dealers are also, or even

primarily, collectors. A volume edited by the Sablon tribal art photographer Dick Beaulieux in 2000 shows top pieces from about fifty Belgian private collections, mostly dealers, with short (auto)biographical notes.[132] The Otterlo exhibition, an initiative of the Dutch Vereniging Vrienden van Etnografica (Society of Friends of Ethnographics)—which has been active in the Netherlands since 1983 and currently has a few hundred members, almost all small collectors—had eighty exhibits from Africa and fifty from Melanesia. All of the exhibits at both shows were of exceptional quality.

Remarkably, the Netherlands has never developed the rich collecting culture with regard to the Dutch East Indies that Belgium has regarding the Belgian Congo. In this respect, Belgium, with its numerous and excellent private collections, easily surpasses the Netherlands. Up-market dealers in the Netherlands regularly complain about the thriftiness that rules here, about the inability to make generous gestures as far as culture is concerned, and a certain incapacity or disinclination to discriminate quality. In Belgium, there are dozens of well-to-do collectors, a relatively large number for such a small country, though they do not like to come to the fore as such; in the Netherlands, there are only a handful and they are just as discreet.[133]

Most of the really good objects that have surfaced in the Netherlands in the last few decades have vanished abroad at once, a phenomenon that has occurred less frequently in Belgium. Two dealers from California I spoke to, both specializing in high quality Indonesian art, including textiles, pointed to their own role in channelling Indonesian pieces from the Netherlands to the United States and elsewhere since the 1970s.[134] An exception is formed by krisses from the former Dutch East Indies: there are about a dozen important kris and kris haft collections in the Netherlands (Fig. 39), and several dozen less important ones. Many Dutch families with an Indonesian background often still preserve one or more of these family heirloom.[135]

A thick volume on African art in private collections and museums in the United States and in Canada published in 1989 gives an idea of the not inconsiderable numbers we are talking about as far as those, much larger, countries are concerned. The compilers of this work looked at 15,000 objects from a total of about 900 collections, and eventually selected some ten percent for publication—1600 objects from 252 private collections and 73 museums.[136] In the United States, and to a lesser extent in France, there is a type of collecting which is rare if not completely absent in the Netherlands: collecting by the very wealthy for status and prestige, as a form of "conspicuous consumption," an indispensable part of a certain life style and cultural identity. Such collectors, often couples, can be found on the boards of museums of tribal art and among the members of the

societies of friends of such museums. Tax-deductible donations of pieces or a whole collection are part of this pattern, and such a deed is usually honoured by a catalogue or wing with the name of the donor on it. Some of these collectors—such as John and Dominique de Menil in Texas and Robert and Lisa Sainsbury in England—again combine or combined top tribal art with contemporary art. The collections of both couples were made accessible to the general public in art museums in Houston and in Norwich, respectively. Both collections provide another example of close ties between the dealers they were bought from and museums.[137] Lord and Lady Sainsbury bought most of their treasures from or through the well-known British dealer, John Hewett.

A successful dealing—and collecting—couple from the postcolonial period, specializing in Melanesian art, are Loed and Mia van Bussel, from Amsterdam. They began small, some forty years ago, with a shop selling curiosities and ethnographics in the Hague. Many ex-colonials lived there, and ethnographics regularly surfaced. Slowly the business developed into something larger, while the van Bussels began to focus on the better pieces, and in 1979 they moved the gallery to Amsterdam. He spent a lot of time travelling and buying, while she mainly promoted the gallery and sales. In the Netherlands, they were well placed to buy in Germany, Melanesian pieces, which they did frequently; in addition, they used to go to Paris a lot.

Now the van Bussels are "just below"—as they put it themselves—the small and select group that forms the apex of the international league in the tribal art trade. Through daily contact with the huge and diverse stream of objects that for decades has passed through their hands, they developed considerable expertise. Both, but especially Loed, are regarded as experts, and their advice is regularly requested by museums and exclusive international art and antique fairs. They are respected, but not always loved, for the extremely strict way in which they control quality, a policy that has more than once led to conflicts with colleagues and collectors who arrived at quicker or different conclusions. "We're a bit smug; we're proud of what we do," Mia told me, "We're always pleased if we've been able to place a fine piece in a good museum or in an important private collection. We've heard said of ourselves, < She is prickly and he is awkward >. People can say that if it pleases them, as long as they don't say that we don't know our job!"

In the summer of 1996, several auctions of African art took place at the auction house Drouot in Paris that were the talk of the town.[138] One of the collections, about forty African objects of unimpeachable quality, bid for and bought by collectors, dealers, and curators from all over the world, was the best African art the van Bussels had come across and kept over several decades. It included a Fang *byeri* reliquary figure from Gabon,

two idols of the Zuzu society of the Gouro in Ivory Coast, about sixty centimeters high, a Chokwe mask adorned with feathers from Angola, and a nineteenth-century neckrest from the Luba in East Congo. The vast majority of this collection had been collected in colonial times and had "pedigree": a demonstrable and—preferably—respectable provenance. Many of the pieces had been published in catalogues of exhibitions in which they had been displayed. The glossy auction catalogue was sold out immediately and is now a sought after reference work.[139] As one of their colleagues said about the couple, "Even ten years ago you could see their name in pedigrees; just by having passed through their hands, a piece becomes more valuable."

As to Dutch collectors, Mia van Bussel feels quite strongly that, like Dutch people in general, they find it difficult to enjoy things. Everything above middling, a little out of the ordinary or extravagant, she says, is treated with suspicion, whereas anywhere else it would be appreciated. "If you go south, there is more generosity, or whatever. I think it's got something to do with the calvinistic nature of many of the Dutch. Isn't collecting simply daring to feel, daring to enjoy, daring to do yourself a favour? Collecting is emotion! Another thing which I noticed is the difference between men and women. We know some independent female collectors, but very few. Collectors of tribal art are almost all men. Quite possibly it has something to do with the economic dependence on an earning husband. So much for Dutch collectors—no offense intended to my good customers."

They feel that much has changed in the period they were active: the business has become tougher, the strict code of conduct there used to be has relaxed. "Everything used to be a lot more friendly. Before, if we had bought something at the auction in Paris, for instance, we all went out together, all the dealers, to have dinner afterwards. What had been purchased stood on the table in front of us and was openly discussed." An example of the strict rules to which they adhere was their long-running cooperation with the important Munich dealer Ludwig Brettschneider, all in good faith; they never went behind his back to his contacts, and he never did that to them either, although it would have been easy, and very lucrative.

Loed was always in and out of Germany, buying and selling ethnographics from the former German territories in Melanesia (compare Fig. 21). He speaks the language—his mother was German—and goes back a long way with a lot of people in the German museum world, many of whom he knows from when they were just assistants in the storerooms; now they are curators or directors. Through the years, he has become quite familiar with the collections of the various museum, including their gaps, a number of which he managed to fill through good cooperation. He always did his

homework well, scanning through publications from the colonial era. Once, for example, he found a reference to a certain Captain Strauch who was supposed to have been collecting in New Britain around the turn of the century. He subsequently started riffling through the phone books of the cities where many ex-navy men live—Hamburg, Bremen, and so on—and struck it lucky. Not long after that he found himself in a posh house sitting opposite a gentleman of that name who was as reserved as he was distinguished. The grandson of Captain Strauch thawed out visibly when it transpired that van Bussel knew there was a peninsula named after his grandfather. The things collected by Strauch were still in the attic, and the Van Bussels were able to buy them. But it has become very difficult now, Loed says, to get at the good pieces. Before he drove 50,000 kilometers a year with not very much money and found a great deal; in recent years, he traveled twice as far with a much larger budget, but found only a fraction of what he would have come across before. The supply has decreased, while the demand has increased enormously. Most good pieces are now in collections, not on the market.

Loed van Bussel has travelled far and wide to find good pieces, not only in Europe but also in Melanesia. Between 1980 and 1993, he was in Papua New Guinea on average twice a year or so, on the islands in the north: New Britain, New Ireland, the Admirality Islands, and the countless small islands around there. He also visited the—formerly Dutch—northwestern coast of New Guinea, from the Humboldt Bay via the Geelvink Bay to the Radja Ampat Islands in the west. Logistically, it wasn't always easy. Many of the islands are pretty isolated; transport is difficult to organize and prohibitively expensive. On such expeditions, surviving on coconuts and raisins, he managed to lay his hands on considerable numbers of fine pieces. "Everything was taken out officially, through the national Museum in Port Moresby, which provided export licenses.[140] Any pieces that they considered to be of national importance they bought themselves, and sometimes I donated things. I experienced a great deal there, some of it fun and exciting, but some of it unpleasant or even dangerous."

On one of his recent trips, in February of 1997, Loed van Bussel visited an area in the mountains of New Ireland, trying to finally pinpoint the location of a cave reputed to be one of the original sites of large human-like ancestral figures carved in limestone, of the *kulap* type (Fig. 22).[141] From his own earlier travels in the area and from sources from the German colonial era—including a German geological map of New Ireland drafted at the beginning of this century—he had a certain amount of information concerning the location. The cave had always been there in the background; it had to be somewhere in those mountains, but nobody knew precisely where. It was an old dream, one which he had

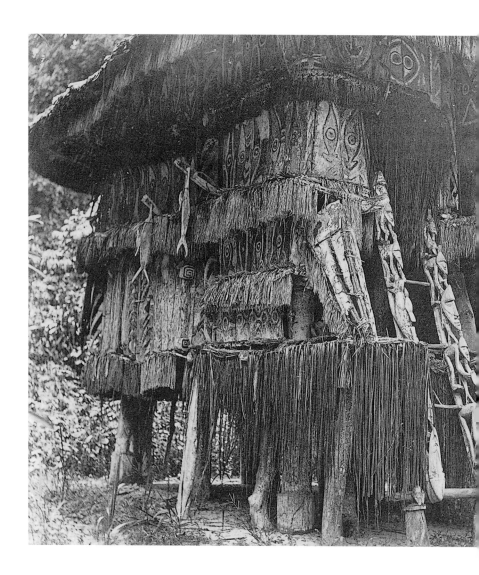

long cherished: to find out where it was, and to let him go down in history as the one who discovered that cave.

"I was of the opinion that everything needed to be carried out through the proper channels, in cooperation with the ethnological museum in Port Moresby, the capital of Papua New Guinea. But that turned out to be a problem: they weren't quite sure what kind of figures I was talking about —imagine that!—and thought it all a bit odd. They were also quite suspicious, and all that while I was basically handing them an important

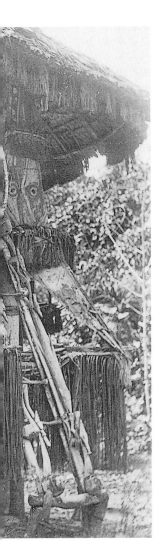

21. Ceremonial house on Seleo, a tiny island off the north coast of present-day Papua New Guinea, in the 1890s. After the picture was taken all the sculptures were removed and transported to the Übersee Museum in Bremen, Germany, where they still are. While there is much on the outside too, the interiors of such ceremonial houses were usually as crammed with ritual articles as the many museum depots and private attics in Germany to which thousands of such objects found their way.

scientific discovery on a plate! In the end, we simply could not agree, so I informed them as to my intentions and went ahead with it." Sometime later, van Bussel discovered that they had sent a message to all police stations and customs posts in the country requesting that he be kept under close observation. "As if I were a bandit! Now, looking back on it, I think all this fuss about me and the cave was quite amusing."

After a trek through the hills, along paths which had almost vanished and were only visible to his guides, van Bussel did indeed discover the

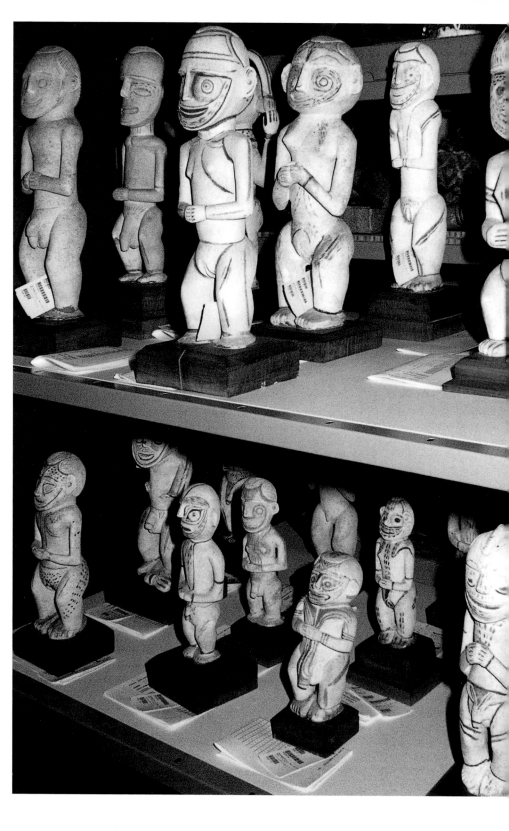

site, near Punam, a village that did not exist anymore because it had been relocated from the interior to the coast by the Germans around the turn of the century. It was not so much a cave as an enormous mud-filled hole in the ground, with some water eroded fragments of smashed limestone figures, and next to it the remains of a building that was once a mission post of American Wesleyans. On his way home, he dropped by the museum and gave the staff the exact location and a complete report. "They still had mixed feelings about the matter, and one of the curators walked off in a huff. So be it—I succeeded in what I had set out to do. Now they have the exact data!"

The unexpected and complicated routes along which tribal objects travelled across the globe in colonial and post-colonial times can be illustrated using a few specific examples: a statue from the island Rarotonga in the Pacific; a number of masks from West Alaska; Venetian glass beads; and, finally, a Dutch missionary coin bank.

The first case also shows the characteristic increase in market value of a fine object while en route. While on a buying trip in England in the 1960s, the Utrecht (the Netherlands) dealer in ethnographics L.F.H. Groenhuizen found an article at a furniture maker's, whose sideline was antiques, that he immediately recognized as a rare and valuable *tiki*—a statue of a god from the Pacific region.[142] It had most probably been obtained by English seamen on Rarotonga island in the early nineteenth century. Much later, it ended up in a school collection in Buxton which fell into neglect and finally came into the hands of the school caretaker. His son sold it to the furnituremaker from whom Groenhuizen bought it for the equivalent of $ 400. Just a few days later, an English dealer offered almost ten times as much for it but was turned down. Back in the Netherlands, he sold the figure for $ 6,000 to another Dutch dealer, who immediately took it to Paris, where three times that much was paid by a dealer who worked primarily as a so-called "runner" for a private museum in New York: the Museum of Primitive Art, which later became the Rockefeller Wing of the Metropolitan Museum. That dealer took the *tiki* to New York to offer it to that museum, but before he got there he bumped into another runner who was working for an important English collector and bought the *tiki* for approximately $ 60,000.

22. Limestone *kulap* ancestral figures from New Ireland in the depots of
the Rijksmuseum voor Volkenkunde, Leiden, in 1997.

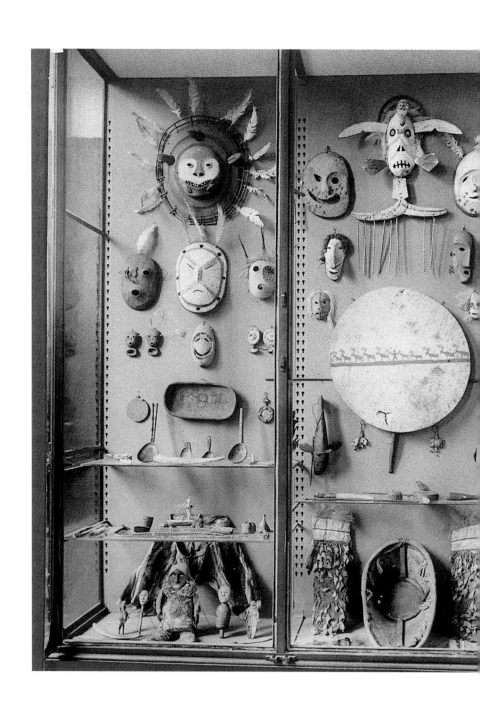

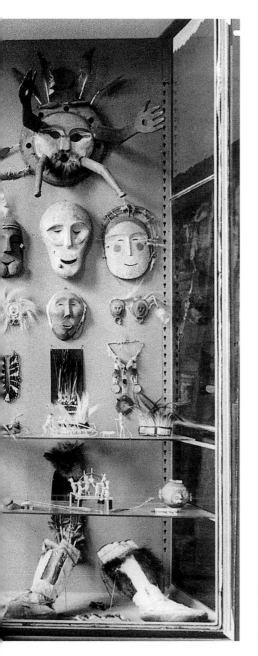

23. Showcase in the Museum für Völkerkunde in Berlin in 1926 containing Yup'ik Eskimo material collected by Captain Jacobsen (see text).

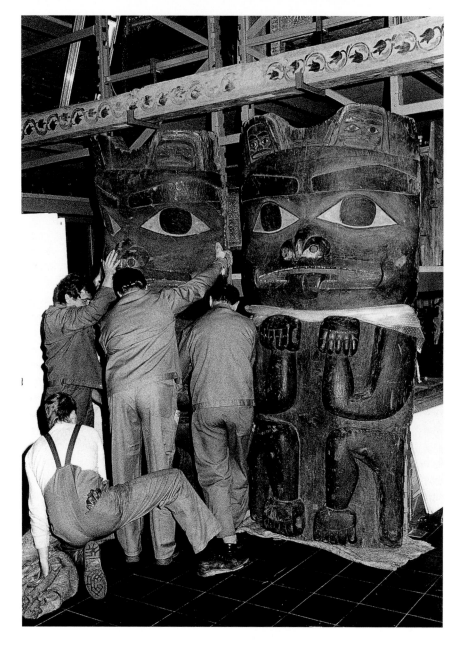

24. Two huge figures from the North-American Northwest Coast in the
Museum für Völkerkunde in Leipzig in 1990. After a stay in Petersburg
and Leipzig as a consequence of the Second World War, these figures,
together with tens of thousands of other ones from several continents,
are being prepared for transportation back to their original domicile in
Europe, the Museum für Völkerkunde in Berlin.

The second case concerns the odyssey of a hundred and thirty Yup'ik Eskimo masks, the fate of which has been a direct consequence of the greater lines of history. The varied, often wildly decorated, and frequently spectacular wooden masks of the Yup'ik of West Alaska represent a whole range of animal and plant spirits, including the spirit assistants of shamans. These masks, which the Yup'ik used to call up those spirits and communicate with them through masked ritual dances, were a horror of superstition and devil worship in the eyes of nineteenth-century missionaries in Alaska, but art at its apex to twentieth-century surrealists.[143] They were part of a collection of a few thousand ethnographics accumulated in West Alaska in 1882/83 by the Norwegian captain, J.A. Jacobsen, for the Museum für Völkerkunde in Berlin.[144] Other Yup'ik masks had been collected a few years earlier by the ornithologist-ethnologist Edward Nelson for the Smithsonian Institution, by the young well-to-do Frenchman Alphonse Pinart in 1870/71, and by the Alaskan Commercial Company collection.[145] All these collectors were active shortly before missionary activities and the goldrush made short shrift of traditional forms of expression.

Several decades of quiescence in the storerooms and display cases (Fig. 23) of the Berlin museum came to an end during the last few months of the Second World War. While the Allied Army pushed towards the city, the masks were transported to a safer place, probably mines in Silesia, together with tens of thousands other artifacts. Thereafter, they remained untraceable for decades; it was not until thirty years later that they resurfaced. They were part of a collection of 45,000 ethnographics taken by the Russians to the Hermitage Museum in St. Petersburg, where they had been packed away in cases and forgotten for those thirty years. In 1977-1978, this enormous collection was transported from St. Petersburg to the Museum für Völkerkunde in Leipzig in a series of heavily guarded convoys; after the reunification of East and West Germany in 1989, it was finally returned to the Museum für Völkerkunde in Berlin in the years 1990 to 1992 (Fig. 24).[146]

But this was not the end of the story. An odyssey implies a return home, and for a number of the Yup'ik masks, this is what happened, at least to a certain extent. In 1996/97, the Anchorage Museum of History and Art organized a large exhibition of Yup'ik masks, including many from Berlin. The museum worked in close cooperation with Yup'ik elders from the Coastal-Yukon Mayors' Association, who at the same time functioned as consultants with regard to the original meaning and function of such masks. The show, called *Agayuliyararput: Our Way of Making Prayer,* opened in Toksook Bay and from there went on to Bethel; both places are in the middle of Yup'ik territory, through which the Yukon and the Kuskokwim flow. From there, it went on to other locations in Alaska, and

POST-COLONIAL DEVELOPMENTS

97

subsequently to New York and to Washington, D.C.. The exhibition became a ritual occasion, a solemn and at times emotional celebration of the return of sacred objects to their land of origin, and had a deep significance with respect to the spirituality and identity of the Yup'ik community. Some pairs of masks which had originally belonged together were reunited after a hundred years of having been separated by the ocean.

The third case is that of countless Venetian glass beads which were exchanged with African peoples by Dutch and other seafaring traders from the seventeenth century onwards. In Africa, these exotic objects came to symbolize wealth, status, and prestige, and were valued for their spiritual and medicinal potency. Some of them found their way back to Europe via the twentieth-century tribal art trade. In recent decades, part of what had returned to Europe was taken to Borneo by tribal art dealers and used to obtain cherished figures from Dayak villagers, who were unwilling to part with these for anything other than the highly valued beads. Some of those beads were then again collected in Borneo by Japanese dealers and ended up in bead collections in Japan.[148]

Another surprising route, finally, was that of a cast iron coin bank or missionary collection box in the form of a *hapneger,* a "(coin-)swallowing black," serially produced and distributed in the Low Countries in the context of missionary propaganda. The bank was shipped to Africa, presumably by missionaries, and ended up in a native village in the border area of Nigeria and Cameroon, where it was venerated in a local cult for a long time. Much later, in the 1970s, it was collected along with other items by a western art dealer and found its way back to Europe, more specifically, to a gallery in Brussels. On October 12, 1976, it was bought from that gallery by the Tropenmuseum in Amsterdam, where it has since been preserved under the collection number 4300-1.[149]

1.7 Tribal Art Auctions

Auctions devoted specifically to tribal art are snapshots with regard to particular moments in the *circuit des objets;* they are rich sources of information about the movements of ethnographics, the formation of collections, and changes in taste, fashion, and market value. An auction is like an hourglass in which the grains of sand come together briefly in the slender neck; it captures points in the life of particular objects which are again dispersed after the event. Well-known auction houses such as Drouot in Paris and Sotheby's and Christie's in New York, London, and Amsterdam have for decades regularly auctioned tribal art. The pedigrees of objects, given whenever possible, show their individual paths, for instance, when material from the estates of ex-colonials is put up for sale. A special category is formed by auction catalogues of particular private collections put up for sale, such as that of the American cosmetics tycoon Helena Rubinstein in 1966, the businessman George Ortiz in 1978, or that of the jet-set interior designer, William McCarthy-Cooper, who died at a relatively young age, in 1992.[150] In such cases, the catalogue codifies the collection's composition before it is dispersed.

This was also the case on the occasion of three auctions of outstanding collections of African art in Paris in June 1996, an unusual concentration of activity in this field. Two of the collections were from the Low Countries: that of the Van Bussels from Amsterdam, and that of the Jernanders from Brussels—two couples, both well-known dealers and collectors.[151] The third collection to come under the hammer was the remainder of the collection of the late Pierre Guerre, an art critic, writer, and lawyer in Marseille who had donated most of what he had assembled in the course of several decades to the Musée d'Arts Africains, Océaniens, Amérindiens in Marseille. Altogether, the three collections comprised some 250 items that together brought a total of over 33 million French francs. The item that fetched the highest price—5.5 million francs—was Guerre's famous Fang reliquary figure from Gabon, which had already been exhibited and published many times.

The auction of a collection or its donation to an institution is frequently the point at which it is documented in a catalogue. The composition of the

whole reflects the collector's taste and aims. Some collectors accumulate items that are as prestigious and as expensive as possible, whereas for others, aesthetic considerations or the desire to create a representative sample of a certain style or region are predominant. Collections are more than the mere sum of their individual components; they are, in themselves, cultural artifacts which seem to have or acquire an integrity which is somehow at odds with the contingencies of their coming into being. With regard to the possible dispersion of one of his collections after his death, Jean-Paul Barbier, the wealthy collector behind the Geneva Musée Barbier-Mueller, once remarked: "To divide up the Indonesian collection would be like cutting a piece from a Gauguin landscape."[152]

For collectors and dealers buying at auction, pedigree and provenance are all-important. A fine pedigree may double or triple the value of the piece. An example of a next to perfect pedigree is that of a Middle Sepik, Papua New Guinea flat openwork suspension hook which was sold at Sotheby's New York as lot 63 of the tribal art auction of May 18, 1992. The 161 cm. hook, with a stone-carved human figure and bird and fish motifs, was made by the Iatmul people. The relevant part of the caption read: "*Provenance:* Collected by Consul Thiel, around 1910; Hamburgisches Museum für Völkerkunde und Urgeschichte, no. 11.88.88; Serge Brignoni, Berne; Mr. and Mrs. Alvin Abrams, New York. Literature: Reche, 1913, Pl. 40; Gathercole, Kaeppler & Newton, 1979, no. 22.37, illus. Exhibited: Washington, D.C., National Gallery of Art, *The Art of the Pacific Islands,* July 1 - October 14, 1979." All this is hard, if not impossible to beat: collected by a known colonial official; depicted and discussed in detail by Otto Reche in his 1913 *Der Kaiserin-Augusta-Fluss,*[154] the most authoritative source and standard work on Sepik art; part of the collections of a famous museum and still bearing that museum's label and collection number; subsequently part of a well-known private collection;[155] and exhibited in the National Gallery of Art. Typically, the dealers who undoubtedly traded the object as it passed from one owner to the next are left out, although well-known names such as Charles Ratton or Merton Simpson may add to a pedigree. The hook fetched $ 159,500, expenses included, which is probably more than twice what it would have realized without such a pedigree. Another example of provenance adding to the value of the item being sold is the frank statement, "Collected on the grave in 1947," pertaining to two anthropomorphic gravepoles of the Konso of Ethiopia, and sold at an auction in Paris in June 1997.[156]

The most famous auction of tribal art ever was probably that of the collection belonging to the American cosmetics tycoon Helena Rubinstein, Princess Gourielli, carried out by Parke-Bernet Galleries in association with Sotheby's, in April 1966 in New York. Item 189 in that auction was one

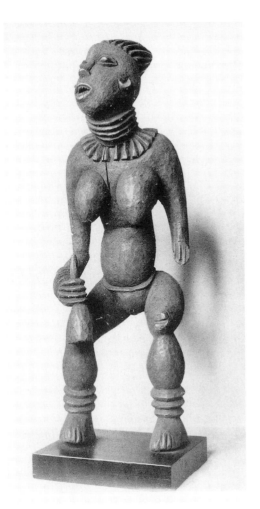

25. One of the most famous and most expensive tribal figures ever: an 85 cm. high figure from the Bamileke of Cameroon, known as "the Bangwa Queen." After it had been collected around the turn of the century by a German merchant, it spent a few decades in a German museum and another few decades in the renowned collection of Helena Rubinstein (see text). In 1990, it was auctioned in New York and fetched 3.2 million dollars, the highest price yet paid for a piece of tribal art in a public sale.

of the most famous items of tribal art ever, thanks in part to its figuring together with a naked model in a well-known picture taken by the avant-gardist photographer Man Ray in the 1930s. The item in question was an 85 centimeters high female figure from the Bangwa, a kingdom in the south of the Bamileke area, in the grasslands of central Cameroon (Fig. 25). It is very expressive, its dramatic pose suggesting movement, which in itself is exceptional for the usually static style of African sculpture. It depicts a woman in the double role of priestress of a cult focussing on the fertility of the earth and a mother of twins, which are also associated with fertility. The woman is dancing and singing in a way associated with death rituals for a deceased king—hence the imposing stance.

The route taken by this statue—known as the "Bangwa Queen"—before and after the Rubinstein auction are known, and they deserve a closer look.[157] The statue was collected in 1897/98 by the German merchant and explorer Gustav Conrau, who was probably the first westerner to reach the Bangwa, while he was searching for manpower for German plantations on the coast of Cameroon in the west. While imprisoned by the Bangwa, he died under not altogether clear circumstances, probably by his own hand. Not long after, the Museum für Völkerkunde in Berlin acquired the pieces collected by Conrau, including the statue, which then crossed paths with Jacobsen's Yup'ik masks. In the late 1930s, it came into the possession of the Berlin dealer and collector Arthur Speyer, who did a lot of business with the museum. Speyer quickly passed it on to his friend and business relation Charles Ratton in Paris, who at the end of the 1930s exchanged it for other material with his client Helena Rubinstein. After her death, it was obtained by Harry A. Franklin and his family, collectors in Los Angeles since the late 1930s who also dealt in tribal art. The Franklins also bought a, possibly the, male counterpart of the female figure from Speyer, which had likewise been collected by Gustav Conrau, so eventually a couple may have been reunited. The Franklin collection came under the hammer in April 1990 at Sotheby's New York,[158] where an anonymous buyer paid 3.2 million dollars for the "Bangwa Queen," considerably more than the 29,000 dollars it fetched in 1967. This is still the highest figure ever paid for a single item of tribal art in a public sale. A Fang head from Gabon was sold privately for more than twice that amount in the early 1990s to a privately run museum in Paris.

Sales of ethnographics from the collections of Eastern European museums in the 1950s and the 1960s form a special case. A number of exceptional objects found their way to their present-day locations in this manner, mostly in the West. In the first half of the twentieth century, deaccessioning was nothing unusual for ethnographic museums. So-called duplicates—but when is something a duplicate, when is it redundant?—were sold in order to raise money to pay for maintenance and for extensions to museum buildings, or were exchanged for other artifacts to fill gaps in the collections. Dutch museums, for example, would typically exchange Asmat woodcarvings from Dutch New Guinea for New Ireland *malanggan* (cf. Fig. 5) with German museums. As a result of deaccessioning practices, one can now regularly find the names of well-known European museums in the pedigrees of objects in auction catalogues, as well as in those of other museums and temporary exhibitions. A couple that frequently bought at Eastern-European museum sales are Jean-Paul Barbier and Monique Barbier-Mueller, the proud owners of one of the finest and largest private collections in the world. "I had the enormous luck," Jean-

Paul Barbier wrote in one of the many publications of the Musée Barbier-Mueller, "to have been able to attend the incredible sales held over a period of nearly thirty years by the ethnography museums of Communist Germany—that is a story that needs to be written—and the museum of Budapest."[159] He then explains how the collections of the Musée Barbier-Mueller, built up around the best pieces from the collection of his father-in-law, Josef Mueller, grew: through purchases at Sotheby's, at Christie's, at Eastern-European museum sales, and from art dealers who were able to gain access to the attics and cellars of officials and military personnel with a colonial background.

A recent salient event in the history of ethnographics in the Low Countries was the auction of the private collection of the art dealer Leendert van Lier (1910-1995), at Christie's Amsterdam in April 1997.[160] Leendert van Lier, an artist himself, concentrated on CoBrA and other expressionist art, on ethnographics, and on oriental as well as western antiques. In the early 1950s, he tried to continue Carel van Lier's Amsterdam gallery, but that did not work out well, so he soon moved his business elsewhere, first to Utrecht, later to Veere and Blaricum. His private collections of items from Oceania, Indonesia, Africa, and America contained many top pieces that were competed for fiercely at the auction: a large drum in the form of a manatee from the Torres Strait, between New Guinea and Australia; a shield inlaid with mother-of-pearl from the Solomon Islands, to the east of New Guinea, of a type of which only fifteen are known, almost all of which are in museums; and a rare and unusually fine ancestor statue from Leti, one of the Moluccan Islands. The auction, *African, Oceanic and Indonesian Art from the Van Lier Collection*,[161] was an international event for which a large number of serious collectors and up-market dealers traveled to Amsterdam, while others made their bids by telephone.

The drum fetched almost $ 100,000, the shield about twice that much, and the ancestor statue around $ 70,000. All in all, about $ 1,750,000 was paid for the 250 lots, much more than expected, and an indication of the scarcity and popularity of fine old pieces, but also of the added value of "provenance" and of a painstakingly orchestrated event at an up-market auction house. Some pieces fetched prices that were up to four times as high as similar pieces without such a provenance in Amsterdam galleries, as several dealers commented cynically, and more than eighty percent went to foreign buyers.[162] Notwithstanding the carefully cultivated aura of an old Dutch collection with colonial connotations, well over half the pieces were originally from abroad: in the 1960s, Van Lier used to travel to Paris once a week and to London every fortnight to do business. Two months later, at the yearly open house of some fifteen galleries in Brussels, various lots from the Van Lier auction resurfaced, mostly in the stands of American dealers.

How things work behind the scenes at auctions is not entirely consistent with the picture the general public has, or with how auction houses like to present themselves. A few years ago in Paris, an auction of ethnographics by a well-known expert was cancelled at the last minute, even though the catalogue had already been circulated, because serious doubts had suddenly arisen as to the authenticity of the majority of the material. The Parisian auction world is notorious for its regular conflicts of interest among auction experts who themselves deal. Generally speaking, well over half of the items are brought in and bought by dealers at tribal art auctions everywhere. Dealers may bid for pieces they themselves brought in, in order to increase the returns. Reputed dealers regularly manage to "kill" pieces brought in by competitors, or at least to lower their price, by subtly uttering doubts about them. Faked pedigrees occur regularly, as several dealers can confirm from their own experience, concerning pieces they themselves have once handled. Lots for which the bids are insufficiently high are sometimes hammered down to "a puppet, the central heating, or the wall in the back," as an insider put it: they are bought by the same person who put them up for sale, by private arrangement with the auction house, so as not to spoil the buying atmosphere.

Auction experts, usually dealers themselves, tend to project an overly positive picture of the expected results to prospective sellers in order to obtain the material, which may then be sold with reserves that are too low. They may also keep the best of what is offered out of the auction and mediate a private sale to an accomplice "to realize a better price," which in fact is too low. When a really important piece comes up at auction, one that is so fine and expensive that it is within the reach of only a few, it is quite common for dealers to form a so-called ring: it is agreed on beforehand that only one of them will bid, and if bidding is successful, the matter is settled after the auction in a cafe next door, where the price may be double what the object went for at the auction itself, the difference going to the other members of the ring who thus get a piece of the cake without getting the item itself.

Relations between the auction and dealing world, on the one hand, and the world of museums and academia, on the other, are close but discreet. Several major dealers I talked to are regularly consulted, officially or otherwise, by museums. They go a long way back with certain museum officials, and they sell and donate to museums. In some respects, their expertise, stemming from their hands-on experience, is unmatched by any curator—although one does not often hear the latter admit this. Along with collectors, dealers belong to the small group of people outside the academic and museum world who know more than the average citizen about what is to be found in museums and what goes on there. A

number of museum people nowadays say, some of them very loudly, that collecting is simply not done and that dealers are criminals, yet, on the other hand, their yearly records are full of donations from the very circles thus frowned upon. Every year various Dutch museums spend a large proportion of their modest acquisitions budgets on ethnographics which they procure from dealers. Generally speaking, it seems that ethnographic museums do not get on as well with dealers and collectors as aesthetically orientated museums of tribal art. The incongruous standpoints voiced by Smidt and Herreman in the following interviews are a case in point, as is a remark by the New Zealand museum-based anthropologist, Terence Barrow, in the preface of his classic on Polynesian art: "As museum assemblages generally owe their origin to private collectors, it does not become museum professionals, as is often the case, to regard private collectors with condescension and disdain." [163] The same goes for their atttitude towards dealers. Another interesting fact in this context is that at least two curators of tribal art in museums, both well-known and productive scholars, one at the Art Institute in Chicago, the other at the British Museum, subsequently worked as tribal arts specialists for large auction houses—Christie's New York and Christie's London, respectively.

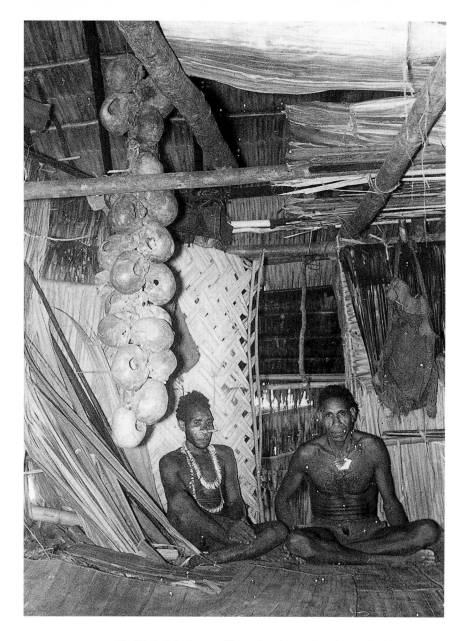

26. Chief of the Asmat village of Atsj sometime during the fifties, with his *kus fe*—a bundle of captured human heads, strung together. The *kus fe* is the pride of every Asmat warrior and guarantees him respect, as well as good care in his old age. Photographed by Father C. van Kessel MSC, a Missionary of the Sacred Heart who collected countless Asmat ethnographics that were sold through the congregation's home base in Tilburg, the Netherlands, to museums and collectors worldwide.

1.8 Asmat and Tiwi Art

Two special cases of western dealings with things tribal are provided by Asmat art from New Guinea and Tiwi art from Australia. The Asmat and their spectacular ritual art are well represented in Dutch public and private collections, and it is no coincidence that this subject comes up several times in the interviews in the second part of this book. As until today there have been no less than fifty documentaries and films made on this Papuan people, it is obvious that there are a number of things here that appeal to the western imagination.

The Asmat number some 60,000 and live in the dense mangrove swamps and adjoining rainforests on the south coast of what is now Indonesian Irian Jaya, but until 1962 they were under the political control of the Netherlands. They traditionally had elaborate cosmologies and intricate initiatory cult systems, central to both of which were a belief in the necessity of the regeneration of fertility and—for most subgroups—headhunting practices (Fig. 26).[164] After earlier more incidental contacts with westerners, including Dutch expeditions between 1907 and 1915, the area was firmly placed under Dutch control only after the Second World War. Those first expeditions collected almost a thousand articles from the Asmat. Since then, many thousands of shields, ancestor statues, and other woodcarvings, as well as hundreds of the monumental *mbisj* ancestor poles, up to eight meters high, found their way to monasteries, museums, galleries, attics, sitting rooms and collections in western societies, mainly through the Dutch, before Indonesian rule began in 1962.[165]

Research into the background of Asmat woodcarving and *wow ipits*, woodcarvers, was carried out in 1960-1961 by the anthropologist Adrian Gerbrands from the Dutch Rijksmuseum voor Volkenkunde, who brought together some 600 woodcarvings and spared no effort in documenting their functions and meanings in as much detail as possible.[166] He devoted particular attention to the manufacturing processes of figures and shields in their cultural context and to the woodcarver's individuality—a line of research continued by his pupils, including the Leiden anthropologist-curator Dirk Smidt. The role played by Gerbrands in the Netherlands and Olbrechts in Belgium was similar to that of Franz Boas

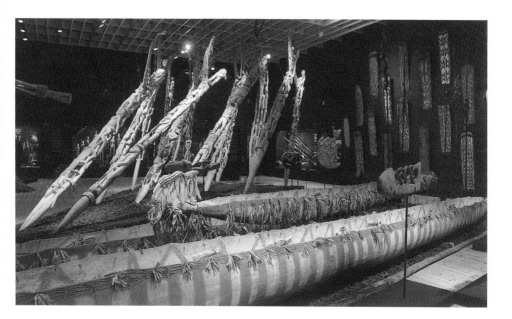

27. Part of the Asmat exhibition in the Berlin Museum für Völkerkunde, Winter 1995/96. The *mbisj* poles, six to seven meters tall, figure deceased individuals and traditionally had a a central role to play in the *mbisj* ritual, connected with headhunting and the initiation of boys. Against the back wall to the right are a number of *jamasj* shields of various substyles (cf. Figure 29).

in American museum anthropology, albeit on a smaller scale. Michael Rockefeller, a wealthy American student of anthropology, was collecting from the Asmat at around the same time, coordinating his efforts with those of Gerbrands, and lost his life in the process. A portion of what he accumulated has been on display in the Metropolitan Museum of Art in New York since 1982.[167] While there was a great demand for woodcarvings and correspondingly copious production both in the years before and during the Dutch pull-out, Indonesian authorities harshly repressed traditional rituals and the articles associated with them in the 1960s.[168]

As a result of the UNESCO Asmat Art Project, led by Jac Hoogerbrugge, a revival of woodcarving took place around 1970. These and more recent woodcarving activities for foreign museums and markets show fascinating experiments with the traditional artistic idiom. The local Bishop, A. Sowada, an American, has been stimulating the production of art since the Asmat Art Project ended, in particular by organizing a yearly woodcarving competition. Much has been collected

since 1972 by Gunter and Ursula Konrad, a German couple[169] who have privately been visiting the Asmat since the early 1970s, documenting, collecting, studying, and encouraging artistic production. The bulk of the material they have assembled has been on loan to and displayed in the J. and E. von Portheim Foundation Museum of Ethnology in Heidelberg, Germany, since 1979.[170] Part of that collection was in the exhibition *Asmat: Mythos und Kunst im Leben mit den Ahnen* (Asmat: Myth and Art in Living with the Ancestors) in the Museum für Völkerkunde, Berlin, Germany, Winter 1995-1996 (Fig. 27).[171] While the permanent Metropolitan Museum exhibits present Asmat objects as art, the Berlin exhibition took an ethnological, contextualizing approach.

The image created by this exhibition somehow had a timeless quality.[172] Dutch colonials, Dutch, and later American, Roman Catholic missionaries, Indonesian functionaries, and Indonesian transmigrants, as well as logging and mining companies and their personnel were all strangely absent, while in fact they have figured prominently in Asmat life since the 1950s. There were no Asmat portrayed as living in modern houses, as many of them now do. There was no mention at all of the Catholic Mass, which many Asmat attend regularly and eagerly. There were no people in Western or Indonesian style clothing, no schools, airstrips, or churches to be seen. All this had been carefully omitted. Hardly any attention was paid to wage labour and other changes in subsistence patterns away from the traditional foraging ecology and to the concomitant sociocultural and socioeconomic shifts in Asmat life. The specific chronological and geographical patterning of acculturation phenomena was not addressed.

The twelve fine *mbisj* poles on display (Fig. 27, to the left) were cut in a rich baroque style which is less traditional than the exhibition makers would have it, and is in fact typical of recent woodcarving for commercial purposes. Moreover, these twelve *mbisj* poles were made of hardwood, whereas traditionally only the relatively soft mangrove wood was used. A large majority of the objects exhibited were made between 1971 and 1994, when market-oriented woodcarving prospered, but mythical and ritual backgrounds were highlighted while market-oriented production was underplayed. The role of the Konrads themselves, taking pictures, making notes, collecting, and probably compensating people financially, remained unclear.

The Berlin exhibition was more a presentation of a, or "the," pre-contact situation, but using mostly recent materials, and without being explicit about its aim. The result was ambiguous. Instead of adopting a processual and dynamic perspective on Asmat culture and society, the exhibition conflated historical changes into a quasi-timeless ethnographic present. To a certain extent, it offered an image of a quasi-isolated, pristine, primeval people without much history, still leading "authentic" lives—with the

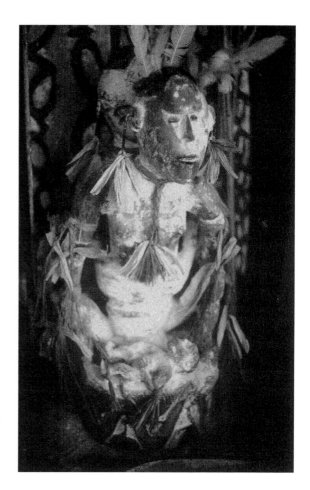

28. Asmat carving of Mary,
the Virgin giving birth to
Jesus, assisted by a midwive.
Photographed by Dirk Smidt
in the Roman Catholic
church of the the village
Sawa in 1993.

exception of a quite sudden shift to the "modern," yet in an important
sense, quite traditional art in the second part of the exhibition. In fact,
the exhibition's subtext on "primitivity" and "authenticity" provided
another chapter in the history of the multifarious reception of tribal
objects in North Atlantic societies, collected and interpreted as they
have been alternately as curiosities, idols, ritual paraphernalia, or great
art. Nonetheless, the exhibition constituted a monument to the Asmat
people who, despite forced assimilation and marginalization, continue
their traditions in new ways. The somewhat ironic dedication in the
concomitant essay volume— "Dedicated to the people of Indonesia on the
occasion of the fiftieth anniversary of independence"—betrays some of
the political complexities involved.[173]

Some of the most intriguing Asmat artifacts, ethnologically, iconographically, and aesthetically, of the last few decades are monumental woodcarvings in and around churches which merge Christian and traditional Asmat contents and styles.[174] An example of such a "Christian-animist" figure is an Asmat representation of Mary, the Virgin giving birth to the baby Jesus, assisted by two midwives, with a wealth of naturalistic detail in the representation of the child as it comes out of the vagina that would be unthinkable in western religious iconography (Fig. 28). The figure was carved for a Christmas celebration of the birth of Jesus, which, at the initiative of the parish priest, was to some extent merged with the traditional *pir* feast. The wood for the figure was taken out of the forest in a ritual manner, to which end a whole group stayed away for several weeks.[175] This was traditionally the case, and on this occasion adopted a new meaning, that of Advent. At the same time, beetle larvae for consumption were bred in sago trees felled for that purpose. Subsequently, in the large *geredjeu*—literally "church/ceremonial house," a neologism of the priest—a small hut was built of the type traditionally used by Asmat women to give birth. A woodcarver was requested to carve the figure in the hut without anybody seeing it. Initially, it was closed on all sides, and only on Christmas eve was it opened up so that everybody could suddenly see the figure representing the birth of Christ.

The world of the Asmat is still one of spirits and ancestors.[176] They do see another world, coming from the outside—the missionaries, the Indonesian migrants, the westerners—but they think predominantly along traditional, mythical lines. The rich, poetic language in which the Asmat speak and think is full of these notions, convictions, and feelings, and Christian beliefs are incorporated into this world: Christ becomes an ancestor who lost his life in a violent manner, and his body and his blood are consumed in a ritual manner. Other figures from the Christian cosmology, such as prophets, saints, angels, and devils, are also seen as spirits or ancestors.

To many dealers and collectors, Asmat means early, patina, savageness, exotic—and high prices. In their eyes, "Christian-animistic" figures are "not authentic." They do not want to know that intensive rituals still take place in which the most beautiful recent woodcarvings are used. They are usually more interested in the formal aesthetic aspect of the objects than in their meaning for the makers, although to the Asmat a woodcarving is never an aim in itself, but a person from their world, someone they relate to, a participant in their rituals. These days, the Asmat cater to the western desire for antiquity and patina by artificially making new woodcarvings seem old, for instance, by roasting them and smoking them. Traditionally, however, they used to keep shields packed up against a wall or high on beams so that the pictogram on the front that represents an ancestor

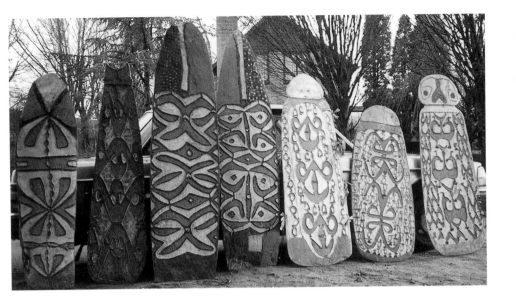

29. Asmat shields (*jamasj*) from various (sub)style areas of the Asmat in Irian Jaya. They bear highly stylized representations of ancestors, which were supposed to invigorate their owners in battle, as well as iconographical allusions to headhunting. The shields are laid out for sale to prospective buyers in a village in Brabant, the Netherlands, by the parish priest, who is a former missionary. Autumn 1996. Compare Figure 34.

would be as fresh as possible. Another response to the western demand is the production of "authentic" Asmat art in specialized ateliers on Bali.

In 1996, eight shields (comparable to those in Fig. 29) which had been sold shortly before by the Tilburg missionaries were being offered by a well-known Amsterdam antiques dealer at a small but exclusive antiques fair. I was able to reconstruct the routes taken by these shields and the way prices developed. The dealer was asking between $ 1750 and $ 2250 a piece. The Asmat makers had received $ 50 per shield from the missionaries, which is an exceptionally large amount—dealers usually give them two or three dollars a piece. The Amsterdam antiques dealer had bought the shields from the Dutch missionaries for $ 350 a piece. When I asked the dealer about the origin of the shields—which, in fact, I already knew since the missionaries had shown them to me a few months earlier—he gave me a truly fantastic answer: "These shields, Sir," he said, as he stood in his three-piece suit, pulling on a fat cigar in the corner of his mouth, and surrounded by a crowd of stylish artlovers, "were found

in the attic of an old monastery out in the provinces, covered in dust." He was insinuating that they had been there since the beginning of the century or so. What he said was partially true, because the fathers do indeed keep the woodcarvings they sell in a storeroom in the attic, but at the same time it was a double exoticization: first of all, because he was making it seem as if they were old Asmat, and second because they were supposed to have come from the provinces, far away from the bubbling, trendy capital, from the dusty attics of a centuries-old monastery. In fact, those shields were certainly no more than two years old, probably even less. That truth was the last thing the dealer wanted known, for in this patina-loving milieu, a recently-made shield cannot be "authentic" nor, consequently, valuable.[177]

Although there has always been much less Australian Aborigine art in the Low Countries than Asmat art, dealers such as the Lemaires have always traded modest numbers of it, mostly purchased at auctions in London, and most ethnological museums have a certain amount of Aborigine material. In 1990, an exclusive, old Australian collection of some sixty Aborigine *churinga* was offered for sale, partly in Amsterdam and partly in Paris, at prices of well over ten thousand dollars each. Someone had somehow managed to transport these out of Australia a short time before, despite laws pertaining to cultural property. An elegant catalogue, poetically entitled *Au commencement était le rêve*[178]— In the beginning was the dream—accompanied the articles, which were ranked among the most sacred and secret in the Aborigine societies they originated from. They sold well.

There is currently one up-market gallery in Amsterdam[179] specializing in fine recent Aborigine art, while there are several shops offering more common Aborigine articles. In Tilburg, the Netherlands, there is a large wholesale business that has imported thousands of recently produced Aborigine fine artwork objects and sold them in Europe. The Nijmeegs Etnografisch Museum devoted two small but fine exhibitions to Aborigine art, in the late 1980s and the early 1990s respectively, the latter of which was on Tiwi art. An exhibition devoted to contemporary Aborigine art, stressing the so-called Dot Art Movement of the Central and Western Deserts, took place in Brugge, Belgium, in 1996, and subsequently travelled to Groningen, the Netherlands. In 1997, half of the objects in a large exhibition of Aborigine art in the Eusebius Church in Arnhem (Fig. 30) were furnished by the Tilburg wholesaler.

The changes in western perceptions of the Australian Aborigines in the course of the twentieth century were considerable. While around the turn of the century, in the spirit of that period, what they made was taken to be the expression of a very primitive race, a portion of what they make now is considered to be fine art and fetches immense amounts of

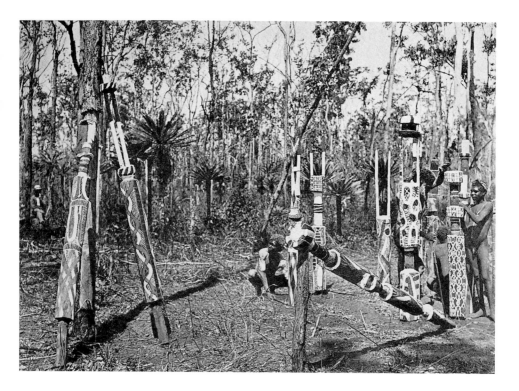

30. Tiwi gravepoles on Bathurst Island, northern Australia, around 1911, and a display of hollow funeral posts from nearby Arnhemland, northern Australia, at a sales exhibition of recent Aboriginal art in the Eusebius Church, Arnhem, the Netherlands, in the summer of 1997.

money. Herein lies an important difference with Asmat art, which has also undergone a vivid revival and renewal, but has hardly come to be perceived as high art, and has consequently not become a commercial success. In both cases the changes in the production of art have been dramatic: in addition to the continuation of traditional types, styles, and materials, there are now many new ones as a result of interaction with outsiders and their views.

Traditionally, as touched upon already in connection with *churinga*, Aborigine ritual objects and the rituals in which they figured express the connections between the people of now, the so-called Dreamings or ancestral beings, and the sacred places—connections which are also described in the stories and myths that are passed down from generation to generation. Specific places correspond to specific Dreamings in the mythical geography of traditional Aborigine cultures. All this is accompanied by strong feelings and values. In and through their rituals, the Aborigines maintain their relationships with the ancestors and with each other. Their ritual articles function as a visual and tangible means of communication in which more abstract cultural ideas are given form and are thus easier to pass on; they enable individuals to structure their experiences in various domains, to communicate them and to integrate them in their collective cultural world, and thus help to constitute and express the identity of persons and of groups.[180]

To the Tiwi of Melville and Bathurst Islands on the north coast, for example, grave poles (Fig. 30), which are placed in groups around the graves, are traditionally very important. Just like figures, bark baskets, spears, and other ritual paraphernalia, they were painted with colourful abstract geometrical patterns, while changes were continually made to their hewn-out basic form. A second type of article that was and still is very important to the Tiwi is the *arawinkuri*, a large spear, some three metres long, with hardwood barbs on either side. They are painted in bright colours with red ochre, white pipe clay, and black charcoal or battery soot. The *arawinkuri* was primarily the status symbol of influential men; in addition, it functioned as payment and in various rituals.[181] Around the turn of the century, spears were seen primarily as weapons by westerners, and were collected as such. The museum displays in which they ended up were still inspired by the evolutionist view of cultures and history: mankind was supposed to have progressed through a number of different stages, eventually reaching "civilisation"; in such museum displays, the spears represented the earliest stage.

Hermann Klaatsch, a German physical anthropologist who collected among the Tiwi in 1906, embodies such a vision perfectly. He thought that they were a sort of missing link, among other things because of what he considered the "archaic" form of their skulls, but also because their

big toes, like those of apes, were virtually prehensile. Thus, he took the view that as a kind of "contemporary ancestors," they could be a source of much information on the earliest stage of mankind's development. Klaatsch was actually more interested in Tiwi skeletal material than in ethnographics, in particular skulls. He did not refrain from plundering graves, selling some of his finds to finance his research. What he collected is now largely preserved in the Rautenstrauch-Joest Museum für Völkerkunde in Cologne. Tiwi objects collected by the anthropologist Sir Baldwin Spencer in 1911 and 1912 are now in the National Museum of Victoria in Melbourne, and material collected by the British doctor, Henry K. Fry, is now in the Pitt Rivers Museum in Oxford. Klaatsch, Spencer and Fry were three important early collectors. In the course of this century many followed, among others the anthropologists Charles Mountford and Jane Goodale in the 1950s, who collected for Australian museums and for the Museum of the University of Pennsylvania respectively. Both of them had left evolutionism far behind them and were more interested in Tiwi culture as such than in its position on a supposed evolutionary ladder. Somewhat later the artist Karl Kupka collected items that are now largely preserved in museums in Paris and in Basel. A small number of Tiwi artifacts from the beginning of the century are preserved in Dutch museums, artifacts which were probably purchased from British dealers.[182]

In the course of the twentieth century, the desires of western buyers have had a great influence on Aborigine art, stylistically in particular. Just as in the case of the Asmat and other groups elsewhere in the world, production for sale to outsiders began to take place. Tourists have been buying Aborigine articles as souvenirs or curiosities since the 1920s. One remarkable change among the Tiwi was the appearance of Purkupali figures—representations of a mythical ancestor who was supposed to have brought death to the world—on grave poles in the forties, and later, likely influenced by Christian art seen in churches, also as separate statues. This latter is one of the examples of the influence, initially extremely repressive, later somewhat less so, that missionaries had on Aborigine art and rituals. Other results of such western influences included the Tiwi's use of iron wood for carving, which is harder and more durable than the types of wood traditionally used, and the considerable increase in the dimensions of the grave poles in the course of the century. As is the case with spears, grave poles are made for sale to galleries, collectors, tourists and museums, as well as for the local community's own cultural and ceremonial practices.[183]

Other types of Aborigine articles currently being greedily snatched up are printed cloths, baskets, graphics, gouaches, ceramics, boomerangs, didgeridoos, and mythical representations on bark, paper, linen, or emu

eggs. Here, originality and creativity are held in high esteem, although artists largely stick to traditional "totemistic" motives and themes even while using new techniques such as ceramics or prints on cloth.[184] Since the 1960s, bark paintings, in particular, have been expressly viewed as art, both in western museums and in the national and international art trade, sometimes fetching more than a hundred thousand dollars a piece. Nowadays, they are also offered for sale on the Internet. The lion's share of the yield goes to the distributing arts and crafts collectives to which the artists are attached, organisations which in turn are supervised by advisors or managers appointed by the government.

What we see here is an example of globalisation: the ever-increasing interconnection between local societies and large-scale global processes. Just as with other groups, art production among the Tiwi has become central to the group's identity—how others see them and how they see themselves—in a new way. The artworks with their varied and shifting meanings function as mediators between groups and cultural worlds. The Aborigines have succeeded in achieving a high profile in the media, politics, and in the art world. The Australian state uses Aboriginal icons extensively on stamps and banknotes, and displays them in public buildings and places. By references to its original inhabitants, it presents itself as belonging to the Pacific region rather than to the West, which fits in with the current tendency of increasingly focussing political and economic policy on Southeast Asia. The slogan "We have forty thousand years of history" is an expression of this new identity.

The manner in which the Aboriginal cosmology figures in New Age discourse worldwide fits in with other patterns of globalisation, as does the fact that hundreds of people in the Netherlands and Belgium now enjoy playing the didgeridoo—a traditional ritual wind instrument made from a pipe of eucalyptus wood as thick as a man's wrist, bored through by termites, with a mouth piece made of kneaded bee's wax. According to various Aborigine creation myths, the deep, intriguing sounds it produces helped the world and everything in it to come into existence. In the last ten years or so, the use of the didgeridoo has spread quickly worldwide, achieving several new functions in the process, for instance, as an instrument used by musicians and pop groups, but also as a psychotherapeutic healing technique. In the popular imagination of North Atlantic societies, the Aborigine has become an icon of spirituality, of close ties with nature, of an unbroken continuity with a happy, distant past, of originality, spontaneity, and authenticity—in short, of all those things that western people perceive themselves as not having.

1.9 Cultural Property Issues

Native artifacts have a part to play in the political struggle of native groups for autonomy and land rights. As sketched on the preceding pages, Aborigine groups underscore their claims with traditional representations such as paintings in which the group is strongly linked with specific mythical beings and the traces their actions have left in the landscape. They negotiate their identity and their rights in terms of the cultural values represented by their art. Their art therefore has political import and, since the 1970s, has been considered legal proof in cases concerning landrights. In 1992, in the controversial Mabo Case, the Australian High Court struck down the legal foundation for the colonisation of Australia—that the continent was *terra nullius:* belonging to nobody, and subsequently, in 1993, the federal government adopted the *Native Title Act,* which dictates that the rights must be returned to the native inhabitants and that they must be compensated.

This law has implications for what happens to Aborigine objects in the hands of strangers: whoever recognizes the rights of the Aborigines to the land must also recognize their rights to their ritual articles because people, land and rights are inextricably bound.[185] Legally, and also in the opinions of an increasing number of anthropologists and museum curators worldwide, human remains and sacred articles are considered inalienable cultural property, and in principle should be returned to those who have rights to them. "In principle" because in practice there are of course all manner of problems, such as insufficient information about the articles, or that they are in foreign institutions or private collections. Nowadays, museums in Australia show great reserve when it comes to displaying native articles that may be secret or may have certain restrictions concerning who may see them.

All over the world Aborigines are now regularly making claims to religious articles and the physical remains of individuals from their tribes, at both museums and auction houses, and with varying success. On October 1, 1991, for example, the physical remains of a few dozen Aborigines were handed over by the Edinburgh University Museum to representatives of the Foundation for Aboriginal and Islander Research

Action in an, as representatives complained to the press, unceremonial and unworthy manner.[186] "Their spirits are crying out," they stated. This claim for restitution of physical remains that had been plundered from graves or even, in a number of cases, acquired by murder, had caused severe conflicts in the museum about which policy to adopt.

In recent decades, the traffic in tribal objects has come into the public eye in the context of international discussions and agreements about who has the moral and legal right to specific objects. There is a growing, though not altogether undisputed, tendency worldwide to restrict the movements of cultural articles by checks at national borders and the monitoring of the activities of museums. The debates concentrate on several subjects: the acquisition policy of museums, state supervision of the transport of artifacts across national borders, and the issue of restitution to original owners. The concomitant key phrases are "ethics of acquisition" and "cultural property." Museums which are members of the International Council of Museums (ICOM) adhere to agreements made concerning acquisition. A number of states adhere to rules laid down in a 1970 UNESCO convention, the aim of which is to restrict free international trafficking in cultural artifacts: the *Convention on the Means of Prohibiting and Preventing the Illicit Import, Export and Transfer of Ownership of Cultural Property*. In the United States, a *Native American Graves Protection and Repatriation Act* has been in force since November 1990. Institutions are obliged to return Indian material to the communities from which it originated if so requested. The very strict 1995 *Unidroit Convention on Stolen and Illegally Exported Cultural Objects* is still controversial and far from being enforced internationally. It is probable that such rules and international agreements will further restrict the circulation of tribal objects in the near future.[187]

The ambivalent relationship between some museum staffers and the art trade in the Netherlands became even more tense in 1995, as a result of negative publicity concerning West African archaeological finds which had been confiscated by Dutch customs, and the publication of an edited volume protesting the trade in "cultural property."[188] For many years, two curators of African departments of museums in this country have been particularly vehement in their advocacy of a tougher approach to the trade through stricter laws and stricter ethical codes for museums. The publication of that edited volume caused a group of Dutch tribal art dealers to complain bitterly in an interview in *Vitrine* magazine that they were being lumped together with certain less reputable others.[189]

One of those dealers voiced the same complaint at about the same time in the *Nieuwsbrief Vereniging Vrienden van Etnografica* (Newsletter of the Society of Friends of Ethnographics): "Dealers in tribal art should not be treated as though they were all the same. Of course, there are less

respectable figures who are only in it for the money, getting up to all kinds of tricks, who make their purchases in dubious circles, and who, in a word, do not pay too much attention to ethics. But fortunately there are also honest dealers who refuse to buy dubious goods and who can defend their pieces and prices with a clear conscience, who basically go about their trade correctly and take it seriously."[190] On the basis of this reaction to an earlier letter to the editor of that magazine, by a collector complaining about such irreputable practices, it is clear that the relationship between dealers and collectors—just like that between dealers and curators—is not always ideal either. One seasoned ethnographics dealer remarked that "all of my customers, like all collectors, are nuts in one way or another."

Symptomatic of the divergent agendas and lines of approach of anthropologists and museum curators on the one hand and dealer-experts on the other is a venomous review by an anonymous anthropologist of a standard work[191] on African art co-authored by the Parisian museum consultant and former tribal art dealer, Jacques Kerchache. This reviewer saw the book, largely illustrated with objects from private collections, as a beefed-up sale catalogue which fits in with the practice of canonisation and commodification of objects through their publication—frequently, ironically, by anthropologists.[192] While anthropologists are criticized in that particular book, the reviewer points out, it is itself largely based on work done by those same anthropologists. Nevertheless, Kerchache attacks "the anthropologists" a number of times, who, as he writes, "castigate the peoples of Africa ... in their research institutes"—peoples "who have so often been used and misused for all kinds of western purposes already."[193] In reaction to such implications, the reviewer points to such events as a safari in the 1960s in Upper Volta, present-day Burkina Fasso, financed by a rich American collector: "While the participants waited in their air-conditioned cross-country vehicles their henchmen stole the masks from the huts in which they had been placed. A high price was paid for this systematic campaign in the land of the Bobo: there were countless suicides of villagers who felt they could not live on after the loss of their masks."[194]

In contrast to this collecting activity among the Bobo was the purchase of an ancestor figure in Irian Jaya in the spring of 1997 about which a dealer reported that it took place after a long negotiation with the village elders. It concerned a distressed, at first sight, authentic *korwar* ancestor figure, about 35 centimeters high, from the south coast of Bintumi Bay, formerly McCluer Gulf, where it stood in a gallery in a chalk cliff carved out by the sea. When the dealer expressed his interest in the figure, the clan leaders discussed for a whole afternoon whether they should sell it, and if so for what price. They decided in favour of the sale, and had two new figures carved the next day: one female, in order to replace the

figure that was to be sold, and one male, as a successor to the already crumbled male of the couple in the gallery. Two village elders subsequently accompanied the dealer to the gallery, with the newly carved figures and also dishes with cigarettes, coconut oil and betel nuts. The dealer's female companion was at a certain moment told to stay behind, for what was to transgress was not fit to be seen by women. In a small ceremony, the soul in the old *korwar* was then transferred to the new one. At a certain point, one of the two villagers, obviously very emotional, said in Bahasa Indonesia to the figure something like: "Don't worry, it's fine, it's fine; here's a new place for you, just don't worry."[195] At the same time, paradoxically, something along the lines of "you'll make a long journey, but don't fear" was also stated. After the ceremony was over, the old figure was given to the dealer for a price that was considerable by local standards.

Despite the Islamicization of the Bintumi Bay area, its inhabitants still perceive the world in terms of spirits and ancestors, as evidenced by other figures the dealer came across. Wild pigs, a plague to the garden crops, were sometimes killed—in itself no problem for Muslims. However, small wooden figures were carved for the souls of the pigs, just as *korwar* were still carved for human souls, and these figures were given special treatment.

A strict viewpoint with respect to cultural property can be found in the foreword by M.T. Somare, the then Chief Minister of Papua New Guinea and President of the Board of Trustees of the Papua New Guinea Museum, in the exhibition catalogue *The Seized Collections of the Papua New Guinea Museum*. "When (these) objects ... were seized before illegal export," Somare writes, "the authorities were not only saving irreplaceable works of art from leaving our country, but actually defending our cultural values from further erosion. Throughout history Europe saw much of her most sacred art disfigured and destroyed by new ideologies. The encroachment of a new way of life, new religions, and the determined onslaught of those who seek to convert art into cash, is Papua New Guinea's parallel. If these creations had been taken, we would have lost a way of life."[196]

An opposite, more liberal position is taken by private collector Jean-Paul Barbier in his introduction to *Tribal Sculpture: Masterpieces from Africa, Southeast Asia and the Pacific in the Barbier-Mueller Museum:* "Although it is generally undisputed that private collectors are responsible for nearly all the collections that became public, on the other hand, there is always someone who asks whether the *objets d'art* accumulated over a lifetime have been collected 'correctly.' The wealth of western collections may appear insolent, but in fact they reflect a profound respect for our fellow-men, so near and yet so far. Suffice it to say, in brief,

that a collector worthy of that name is anything but a vandal, anything but a thief. ... (It) is certainly better for a mask that is no longer worn, a statue that is no longer worshipped, to find its way into one of those temples of beauty called museums, than to be destroyed. Had there been no market for antiques, the truth is that everything would have disappeared."[197]

In 1977, the Netherlands returned a number of cultural treasures from its national collections, kept in the Rijksmuseum voor Volkenkunde in Leiden, to Indonesia, where they are now in the National Museum in Jakarta. Among the items returned were pieces from the precious court treasures of the ruling family of Lombok, looted in 1884 during the bloody subjugation of that island. This black page in colonial history is a Dutch equivalent of the destruction and plunder of the Benin court in West Africa at the hands of the British in 1897, after the Oba of Benin had gotten in the way of British trading activities. They left with more than two thousand bronze and ivory treasures, most of which were official war booty, while the remainder was carried away by looting soldiers. Included were some 900 of the famous Benin bronze panels with representations in high relief of kings and courtiers from earlier generations in full ritual costume, as well as many life size bronze heads made in remembrance of the royal personnages they represented or as trophies commemorating vanquished opponents.[198] Part of this booty was sold to dealers in Lagos, another part was lent to the British Museum by the British government, and yet another portion was sold to the Museum für Völkerkunde in Berlin and to several other museums; the remainder was auctioned in London, and thus, partially through dealers, wound up in the collections of a large number of museums worldwide, including museums in the Low Countries. Through the soldiers, numerous other objects came into the private possession of British families.

Benin bronzes are now among the most valuable and sought after African collectibles. Even before the turn of the century, pieces from Benin were appearing in the catalogues of the British dealer, W.D. Webster who delivered these to, among others, the Naturhistorisches Museum in Vienna, the Museum für Völkerkunde in Berlin and the Rijksmuseum voor Volkenkunde in Leiden. The Vienna museum had raised funds for this specific purchase by soliciting the nobility and industrialists. General Pitt Rivers, whose collection is now in the Pitt Rivers Museum in Oxford, bought 240 Benin pieces from Webster in 1897. The dealer W.O. Oldman sold a group of sixty pieces to the University Museum of the University of Pennsylvania in 1912. There are always some Benin articles in circulation. Sotheby's London, for instance, auctioned twenty-four items from a European private collection in June 1980.[199] In 1989 the Metropolitan Museum in New York accepted the donation by Klaus Perls, a dealer in western art, of his private Benin collection.

1.10 *Arts premiers* in the Louvre

As mentioned already, Robert Lehuard, a railway engineer in colonial French Moyen-Congo during the 1920s, developed a certain predilection for the type of indigenous statuettes that the local Roman Catholic missionary collected during the week and burned every Saturday. One of the objects that he collected was a so-called *bitégué* of the Wumu Téké, 38 centimeters high: a sitting male ancestral spirit with whom an individual could communicate through a *ngaa*, a priest or sorcerer, and who provided protection. Through the collection of Lehuards son and the exclusive Parisian tribal art gallery Ratton Hourdé this object has finally wound up at the Louvre.

It was with a great deal of fanfare that this lofty institution on April 13, 2000 opened a pavilion with 117 top pieces of tribal art, part of a Musée des Arts et des Civilisations which is now under construction at the quai Branly, in the shadow of the Eiffeltower. The Musée de l'Homme (270.000 objects), which is but a stonethrow away, and the Musée national des Arts d'Afrique et d'Océanie (30.000 objects) near the Bois de Vincennes, will both be incorporated in the new institution and cease to exist. Both institutions are suffering from no small degree of malaise, ill-fit housing, and a lack of personel, money and political goodwill.

Georges Pompidou built Centre Pompidou; Valéry Giscard d'Estaing the Musée d'Orsay; Francois Mitterand the Institut du Monde Arabe and the Bibliothèque de France. This new museum, to be opened in 2004, is Jacques Chiracs *grand travail*. It will be housed in a spectacular construction on pillars containing 9000 square meters of exhibition spaces and 8000 square meters of storage space, designed by the French architect Jean Nouvel, who earlier signed for the Institut du Monde Arabe. Chiracs project has in the past ten years or so led led to no small amount of conflicts in museum, political and scientific circles in the former colonial metropole. This is one of the most recent chapters in the history of western dealings with tribal art.

Chirac has always had a predilection for tribal art. In 1991 he became friends with the aforementioned museum consultant, connoisseur and collector Jacques Kerchache (Fig. 31), the actual brain behind the project.

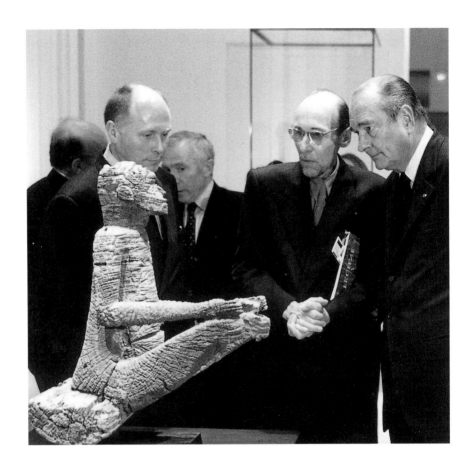

31. President Jacques Chirac (far right) with, next to him, tribal art expert Jacques Kerchache, during the opening of the first Louvre pavilion with tribal art, on April 13, 2000. They are looking at a centuries-old sacred statue of the Mbembe, Nigeria, which was acquired by the Paris art dealer Hélène Kamer (Hélène Leloup) during the Biafra civil war, around 1970, and sold to the Musée des Arts d'Afrique et de l'Océanie in February 1974.

In 1990, the latter, together with 150 prominent writers, art historians, politicians and the like, had published a manifesto entitled *Pour que les chefs-d'oeuvre du monde entier naissent libres et égaux* in the newspaper *Libération*, in which they argued in favour of the inclusion of the traditional art of small-scale nonwestern societies in the Louvre.[200] One year later, when they met on the island of Mauritius, he managed to acquire Chirac's support for this enterprise.

Kerchache, now 57, was previously for some twenty years a succesful dealer in tribal art, which he sold for high profits to collectors, museums, and other dealers. He regularly travelled great distances to acquire pieces directly from their makers or from local go-betweens in both Africa and Southeast Asia, and from 1965 untill around 1980 he ran a gallery in the rue du Seine. One of his first larger sales exhibitions there, in 1967, centered around some 25 Mahongwe m'bweti reliquary figures which he had found in Gabon, in a dried well where they had been dumped by missionaries in the 1930s.[201] The Gabonese embassy in Paris got wind of this and lured Kerchache to Gabon where he was arrested and encarcerated for a short period after being charged with art smuggling. The m'bweti were confiscated, handed over to the embassy, and then mysteriously disappeared; they never reached the Gabonese national collections.

In the course of the 1970s Kerchache developed a new ambition: the documentation of all aesthetically important tribal art worldwide. His well-to-do parents supported this project, which involved visits to public and private collections around the world. In 1994 he curated a spectacular exhibition on the Caraibean Taïno in Paris, to the great pleasure of the then mayor, Chirac, and in 1995 he realized the exhibition *Picasso/Afrique: Etat d'esprit*, in the Centre Georges-Pompidou. Kerchache is also the chief editor of the hefty and authoritative standard work *l'Art africain*,[202] briefly discussed in the foregoing chapter, which resulted from his documentation project.

Kerchache's past as an art dealer was carefully omitted from the official publicity surrounding the opening in the Louvre. He is a man with both many friends and many ennemies. Some see him as a brilliant cultural czar, others as a slick and irritable individual who is not afraid to show his temper.[203] That he is both very successful and very knowledgable is however denied by almost no one. One influential dealer in African art felt there was something of a witch hunt going on in the French press against Kerchache, orchestrated primarily by ethnologists and art historians-curators of the Louvre. "I have no stake in it, he is no special friend of mine, and I do not want to gloss over everything that he has done," he told me, "but I do think that this is going somewhat too far. The man is a visionary, a major authority on tribal art, and that everyone can now enjoy a hundred or so of top pieces in a top museum we owe to him. *Il faut rendre à César ce qui est à César.*"

The change of names of the planned museum with its recently opened *antenne* in the Louvre is significant in itself. It started with a campaign for a Musée des Arts premiers, completely in the spirit of Chirac and Kerchache. A wave of protest by anthropologists soon followed. Such luminaries as Louis Dumont and Henry de Lumley quickly committed themselves to print on this issue. In their view, cultural backgrounds and

ethnographical context were more important than the aesthetic contemplation of isolated objects, and *arts premiers* still sounded too much like the derogatory *art primitif*. Furthermore, their Musée de l'Homme, with its rich tradition of anthropologal study of all aspects of humans, including their biology and prehistory, was to be abolished. Soon after, therefore, the name was changed to Musée des Arts *et Civilisations* premiers, and than the much-debated "premiers" was eliminated alltogether. As it has all proven to be such a controversial issue, the official name is as yet Musée du quai Branly. Some cynics have suggested that it be called *tout simplement* "Musée Chirac."

In this shift from pure aesthetics to art and ethnology the prominent left-wing anthropologist Maurice Godelier (65) played a significant role. It was an inspired move on the part of left-wing Jospin government to recruit this heavyweight for the *Mission de préfiguration*, to serve as a counterweight of the allmighty artistic director Kerchache. The New Guinea specialist Godelier fought, and continues to fight, for what he calls a resolutely post-colonial museum, which, in a multicultural society, provides reflection not so much about others as with and for others. Under his leadership, and with the advisory guidance of a large number of broadly and internationally selected advisory committees, the "tribal art" in the planned museum is provided with a thorough cultural contextualisation, which is to be presented using the latest digitally interactive technology. In addition, the new institution is to become a centre for anthropological research and teaching, on, with and partly by the relevant nonwestern societies.

It is rumored that the *cohabitation* between these two Parisian mandarins, Kerchache and Godelier, is as uneasy as the political one between the left-wing government and the right-wing president—a "cohabitation commerciale," according to the newspaper *Le Canard enchainé*,[204] in a slap at Kerchache and his close ties to the world of tribal art dealers and collectors. The latter is represented by, among others, his friends and former clients artists Georg Baselitz and Arman, and the aforementioned wealthy Swiss collector Jean-Paul Barbier, who runs his own Musée Barbier-Mueller in Geneva. These three individuals were employed in the project as advisors.

In 1997 Barbier sold 276 high quality pieces from Nigeria to the Musée national des Arts d'Afrique et d'Océanie, for some 40 miljon French francs. Four of them are now in the Louvre. This purchase was made to fill a gap in the national ethnographic collections. After all, these collections generally consist—as they do in the Netherlands, Belgium, Germany or Great Britain—of colonial heirlooms and booty, and Nigeria was never a French colony. International conventions designed to protect cultural property now and in the future as a side-effect tend to protect

and even legitimize former acquisitions.

In a similar fashion the multichromatic, hermaphroditic *uli* ancestor figure from New Ireland which can now be admired in the Louvre was acquired to fill out such a gap, and other purchases were being planned. In the context of a presidential *grand travail* a few million francs more or less are not a great issue of debate, and it is at moments like this that Kerchache's contacts come in handy. The *uli* was purchased for 18 million French francs from the well-known Paris tribal art dealer and gallerist Alain Schoffel, who claimed he could have got an even higher price in the United States—but, as he pointed out, the honour of having his name and his piece in the Louvre is priceless. After a successful career, Schoffel has retired to a castle in the provinces. In the Musée de l'Homme some gnashing of teeth accompanied the thought of what they could have done with the amount of money that the French state spent on this sole object.

In the former colonial metropole the tensions between several of the parties involved continue: between the art world and the ethnological milieu; between the ministry of culture (which is responsible for the soon to be closed Musée des Arts d'Afrique et d'Océanie) and the ministry of national education (responsible for the Musée de l'Homme); between those in favour of tribal art in the Louvre, and the curators and director, Pierre Rosenberg, of that institution, who opposed this move strongly. Individuals on both sides of the issues have accused their opponents of racism, both for trying to keep tribal art out of the Louvre as well as for an aestheticizing, exoticizing approach to ritual objects. While the Museum of Modern Art in New York, for example, has shown tribal art since 1935, the more traditionalist and bourgeois than avantgardist Louvre refused the collection of reliquary figures from Gabon and other African art which the Parisian art dealer Charles Ratton wished to donate to the community in 1979. Individuals in the advisory committees are likewise not very satisfied with their role. "It's all cosmetic," one anthropologist complained, "in fact, decisions are taken at the top while we are only consulted on details and inconsequential issues." Two other sources made similar statements indenpendently. Conflicts and oppostion abound, but the president has pushed his project through in good French political tradition.

But what a fantastic sight it is, meanwhile, there in the Pavillon des Sessions on the quai des Tuileries, where the average waiting time in line on the first day was an hour and a half. That *malanggan* (cf. Fig. 5) for example, which was used in a death ritual on New Ireland around 1890, the sort of piece that stole the hearts of Paris surrealists and was formerly in the private collection of André Breton. Or take that Kwakwaka'wakw mask from the Canadian west coast. Closed it is a raven, when open an ancestral humanlike figure into whom the raven changed in the mythical primeval time, a transformation that was dramatically performed in the

winter rituals of a secret society, year in year out. A spectacular three meter high house pole of the Paiwan of Taiwan was loaned by a Taiwanese museum—one of the results of Kerchache's worldwide search.

Most of the in total 117 objects are from the two aforementioned and other French museums. Others were loaned by foreign museums. Also included are fifteen recent purchases, and a group of recent gifts from dealers and collectors. The selection was made by Kerchache, and, as he explicitly indicated, based on aesthetical considerations, not on rarity, age, or ethnographical features. In an annex to the austere, evenly lit and spaciously arranged pavillion of 1400 square meters there are twelve interactive consoles where visitors can tap into a wealth of contextual information, including early ethnographical footage.[205] It is all beautiful, but, characteristically enough, at the same time but a small corner of the largest and perhaps most prestigious museum in the world, situated at quite a great distance from the main entrance. The title of the catalogue, *Sculptures: Afrique, Asie, Océanie, Amériques*,[206] is very much in the Louvre style, as is the set-up of the pavillion, though none of the 48 authors who contributed to the catalogue is affiliated with that institution.

The origins of the objects in the Pavillon des Sessions illustrate the degree to which we are dealing with colonial heirlooms in the museums in Paris, as in those of, for example, St. Petersburg, Chicago, Hamburg or Leiden. The institute which is presently called Musée de l'Homme issued from a world's fair which exhibited and celebrated one nation's worldspanning endeavours in 1878. Numerous expeditions provided a regular flow of pieces to the collections, as well as adding to the by now 300.000 photographs. The Musée des Arts d'Afrique et d'Océanie was originally the Musée des Colonies, founded in the Palais des Colonies of the 1931 colonial exhibition. Next it was called Musée de la France d'Outre-mer, until minister of culture André Malraux remoulded it into its present state as an art museum.

For centuries ancestor figures, masks, and other ritual or ceremonial objects from small-scale nonwestern societies were seen as hideously ugly heathen fetishes, or, in a more secular context, rarities and curiosities. Early 20th-century avantgarde artist such as Picasso and Derain, however, started to speak of *art nègre* and *art primitif*. It was at that time that it was first suggested that this type of art be included in the Louvre collections. Claude Lévi-Strauss repeated this in the 1940s, and André Malraux, who preferred the term *arts primordiaux*, once again made the suggestion in the 1950s. It deserves mention that before he became minister the latter, like Kerchache, was a not uncontroversial art dealer and adventurer.

The term "tribal art" is handy and comfortably short, but both "tribal" and "art" are disputable. The alternative term "non-western" also refers to

such societies as China or India, and has the further drawback that it is more of a negation than a definition. In the Louvre the neutral but somewhat unwieldy phrase "Arts de d'Afrique, d'Asie, d'Océanie et des Amériques" is used, although the term *art primitif* does occur on at least one panel.

For those who want truely to immerse themselves it is possible to cross the Seine by way of the Pont des Arts and peruse the narrow streets around the Hôtel des Monnaies. There, one can find a dozen or so serious galleries specializing in tribal art, such as—exclusive and very expensive—Leloup, Ratton Hourdé, and De Monbrison. Galleries of a more dubious nature can however also be found there. As in the case of the Grand Sablon in Brussels, as much, or perhaps even more trade goes on behind the scenes. Every fall, an exclusive Salon d'Art tribal is held on the Champs-Élysées which attracts several thousands of visitors within a few days time. Just around the corner is the small but posh and professional Musée Dapper, a private initiative, that since its foundation in 1986 has organized some 25 impressive temporary exhibitions of top-notch tribal art, presented in an aesthetically refined fashion and accompanied by a like number of scholarly catalogues. Undoubtedly the new exhibits in the Louvre will stimulate the trade in tribal art in Paris and elsewhere to no small degree. Sotheby's New York used the opening of the Louvre pavillion to its own advantage and showed material from its upcoming New York auctions in Paris in the same week, including part of the spectacular private collection of the Brussels aristocrat Comte Baudouin de Grunne.

On the other bank of the Seine fierce struggles take place between wealthy collectors for the best pieces and between dealers for the richest and most prestigious clients. Here it becomes clear to which degree these objects lead new, second lives in North Atlantic societies, with new uses and meanings, and a just as interesting cultural history. Here they become objects of new cults. The objects pass through the galleries and disappear into private collections, resurfacing occasionally, and in some cases, as the voluminous Louvre exhibition catalogue illustrates, they wind up in museums, side by side with pieces collected on expeditions.

The ancestor figures, masks, amulets, shields, poles and so on found in Paris have escaped rot after being discarded by their makers, the completion of certain rituals, or Islamicization. They have escaped destruction by missionaries, syncretistic indigenous movements, or populistic regimes—due to the efforts of collectors and dealers, or at least this is what is argued by the latter. In Africa they have often passed through the hands of specialized Senegalese, Haussa, Congolese or other *rabatteurs*, who cover large parts of the continent in the course of their activities. These dealers maintain close contacts with travelling western

dealers, and with western galleries to which they travel. Civil wars such as in Biafra or, more recently, Congo-Kinshasha and Sudan resulted in a greater flow of ritual objects which have been bought, taken or stolen from altars and other sacred places, or from museums. Most of what is offered in the West is falsified. Terracotta findings such as Nok from Nigeria, Koma from Ghana and Djenné from Mali are plundered and smuggled on a certain scale. To such fascinating, bizarre or bitter backgrounds the world of galleries, private collections, and auctions as well as the *grand travail* of Kerchache and Chirac are directly or indirectly tied. It is questionable therefore whether that project will ever become so resolutely postcolonial as Godelier wishes it to be.

•

As they moved to and through industrialized North Atlantic societies, through monasteries, galleries, private dens, museums, auction houses and artist's studios, and sometimes back to their places of origin, tribal ritual objects assumed new identities and new values, as curiosities, souvenirs, idols, ethnographic artifacts, commodities, collectibles, *objets d'art*, and cultural property. The traditional supply lines, intricately connected to the colonial system, dried up and were replaced by new ones when the colonies became independent. The period of the large private collections formed in the colonies or indirectly from colonial sources is now definitely over. In the second half of the twentieth century, the emphasis has increasingly fallen on the circulation of ethnographics in the West and, additionally, on new supply lines such as travelling African traders.

While ethnographics travelled to North Atlantic societies from other parts of the world there was also a stream of objects that went in opposite directions. No matter how one-sided the relationship, tribal objects often ended up in western hands through exchanges of goods, services, duties, gifts, and money. It has recently been stressed that, in such transactions, the native counterparts were far from passive or indifferent, but often turned the situation to their advantage—a point that in fact implies a new line of research.[211] From Europe came a stream of iron, tools, fire arms, crucifixes, beads, mirrors, western currencies, clothing, and materials. The Netherlands and various other European countries have exported printed cloth on a large scale to a number of African and other non-western countries for many decades. Proof of the refinedness of African tastes is the fact that it took quite a while before the European firms were able to produce cloths and dyes that satisfied African customers. Western nails, mirrors, beads, and printed cloth often returned to the West adorning tribal sculpture.

The matter-of-fact way in which museums collected during and just after the colonial period has given way to uncertainty and reflection on the role of such institutions in a post-colonial, changed and changing world. In a number of cases, for instance, in the United States, the ethnological museums have become a multicultural society's cultural and political arena, offering a platform for continuous discussion and dialogue between ethnic groups. One issue in those multivocal exchanges is how to cope with a past of colonial exploitation. Another function of museums that has kept pace with the changing times is the articulation of cultural and political identities—specifically of ethnic groups, such as in several small museums of indigenous cultures on the American Northwest Coast,[207] or in relatively recently emerged states such as Indonesia or Papua New Guinea.

In 1988, the Museum for African Art in New York staged an exhibition that was characteristic of the post-colonial era but would have been unthinkable a few decades earlier: *ART/artifact*.[208] It juxtaposed different styles of presentation of African culture: one room was crammed with spears, masks, stuffed animals, and all kinds of exotic objects in the typical style of a colonial museum at the turn of the century; another room offered sophisticated ethnological contextualisation; a third presented just a few beautiful objects in the style of an art museum; in yet a fourth, the only exhibit was a common fishing net from Congo, dramatically illuminated on a platform, which, as it turned out, many visitors spontaneously experienced as "high art." The exhibition also had a showcase with a text warning the visitors that it contained some fakes, without specifying, however, which objects were fake and which genuine.

All this was meant to confuse the visitors, and it did. It made them aware of their expectations and stimulated them to question them. By juxtaposing different styles, the exhibition made its visitors reflect upon the exhibitionary practices themselves, which most of them normally would take for granted while studying the exhibits and the captions. It drew their attention to problems which are inherent in (re)presenting cultures, and to museums and exhibitions as historically and culturally contingent phenomena themselves. *ART/artifact* was a typical postmodern endeavour, characteristic of a climate of opinion that stresses the politics, the poetics and the semiotics of representations, ethnographies, and exhibitions. It was an intriguing attempt to deal with the contemporary identity crisis of the ethnographic museum.[209] In a similar way, the renewed Museum of the American Indian in New York—which has by now been transferred to Washington, D.C.—offered three types of commentary and information with each exhibit in the 1990s: the native's point of view, the art historian's point of view, and the anthropologist's point of view.

Collecting has many aspects, and it is too complex to be reduced to one

of those. Among other things, it is aesthetic wonder and delight on a daily basis; a cognitive activity of ordering and categorizing the world, or part of it; a search for and expression of identity; an articulation of taste; a strategy of desire; an activity of appropriation. There is one aspect, however, that is striking in connection with the social life of ethnographic things *sensu* Appadurai, and that is the element of contest. These objects-in-transit not only have many and shifting but also and in particular contested meanings all along their complicated paths. In their areas of origin, native, Christian, and Islamic views compete, sometimes to the point of physical destruction. To some traders, they are commodities; to others, high art. Collectors disagree about their authenticity, desirability, and value. In the museum, there are the native's, the art historian's, and the anthropologist's points of view on what they mean and where they belong.

An element of contest is also apparent on another level: that of fierce competition between collectors, between dealers, and between institutions. The better Brussels dealers, nearly all also collectors, are engaged in a continuous struggle for preeminence, for status: who has the best private collection, deals in the rarest pieces, organizes the finest *vernissages?* Who has the best taste? Who has "opened up" new areas? "Good taste" is an expression you hear a lot in these circles, where the desire for pieces is at the same time a desire for status, and reputed pieces and reputed dealer-collectors are mutually constitutive. Such gestures of competitive display as a Chokwe ancestor figure priced at 1,5 million dollars in the stand of a well-known Brussels dealer at one of the most prestigious art fairs in the world in 1997, or the stream of well-researched thick volumes on Central African art published by one of his colleagues, are hard to beat. The Brussels, and indeed the international, tribal art scene is a cultural arena in which a sustained, obsessive, agonistic "tournament of value" takes place.

That concept was coined by Arjun Appadurai for status and power contests, usually through valuable and rare objects enhancing a person's standing. "What is at issue in such tournaments," Appadurai writes, "is not just status, rank, fame, or reputation of actors but the disposition of the central tokens of value in the society in question."[210] Here, the biographies—"pedigrees"—of things and men are intercalibrated. In particular those few times when I had the much appreciated privilege of being shown the most private and cherished possessions of some of the top Brussels dealers, I had to think of the *kus fe,* the string of hunted human heads that is the inalienable pride of the Asmat warrior and guarantees him prestige (Fig. 26). A similar argument can be made about the French or American tribal art scenes, where such tournaments of value are particularly strong due to the intricate connections between

collectors, dealers, and museums. "If I don't bid for a piece, it's no good," I heard one of the major Brussels dealers boast.

Part Two:

Seven Portraits

Introduction to the Interviews

While the first part of this book sketches the history of travels of and dealings with tribal objects since the late nineteenth century, the following interviews provide a number of perspectives on the circulation and various roles of tribal objects in recent years.

What quickly becomes obvious is that no clear distinction can be made between such categories as collector, dealer, anthropologist, and artist. Most of those interviewed do indeed fit into one of those categories insofar as their main activity is concerned, but the dealers, for instance, are also collectors and one of them, Marc Felix, clearly has scientific aspirations. Collectors in turn enjoy upgrading their possessions actively, which means that they regularly get rid of pieces; here, it seems that there is often a smooth transition between collecting and dealing. The most clear-cut figures are the curators, who don't—or scarcely—collect as a result of a more or less explicit professional ethic.

I have chosen to begin with the ex-colonial and collector Jac Hoogerbrugge because his life has been so closely connected with colonial history, and because he was collecting in the field relatively early on and has much to say about what he observed there. Next follow two conversations with dealers: Mamadou Keita, a second-generation tribal art dealer originally from Mali based in the Netherlands, who also talks about his father, Niame Keita; and Marc Felix, a dealer in Central African art in Brussels, and author of several authoritative standard works on that subject.

These are followed by interviews with two collectors who have quite different approaches: Tijs Goldschmidt, who is only interested in aesthetics, and the reputed auction expert, restorer, and materials specialist Coos van Daalen. The series is rounded off by interviews with two curators: the Dutch anthropologist and specialist for Oceania, Dirk Smidt, who worked for a long time in Papua New Guinea[212] and is now affiliated with a Dutch museum, and the Belgian Frank Herreman, trained as an art historian, initially employed by a Belgian ethnographical museum and now attached to a museum of African art in the United States.

Recurrent themes in these interviews are the "art or artifact" issue,

authenticity and its simulations, the complex relations between museum staff and the dealing world, and cultural property. Interesting contrasts are formed by Smidt as an antropologist-curator versus Herreman as an art historian-curator, and again Smidt as a curator specialized in Melanesia versus the Van Bussels, presented in the first part of this book, as dealers specialized in Melanesia. The interview with Herreman is especially revealing with regard to connections and differences between the European tribal art scene and that in the United States. One thing which is made clear in the first part of the book is the prominent role of Asmat art in the Netherlands; three of the following interviews—with Hoogerbrugge, Goldschmidt, and Smidt—add to the case study on Asmat art in Part One.

In some of the following conversations a quote by the American sociologist, Erving Goffman—who studied people's everyday behaviour from the perspective of "presentation of self" and "impression management"—repeatedly came to my mind: "[When] an individual appears in the presence of others, there will usually be some reason for him to mobilize his activity so that it will convey an impression which it is in his interests to convey."[213]

2.1 Collector in the Tropics: Jac Hoogerbrugge

His work in the East Indies and New Guinea allowed Jac Hoogerbrugge to probe deeply into the material culture and cosmologies of a number of tribal peoples who are well-known among collectors, curators and anthropologists: the Batak of Sumatra, the Lake Sentani, Humboldt Bay and Asmat peoples of Irian Jaya, and the Dayak of Borneo. Later in his life, back in the Netherlands, he contributed to the knowledge on several of these groups through a series of publications. Now in his seventies, and as amiable, witty, and erudite as ever, he is still delving ever deeper into colonial archives and hunting out ethnographics several days a week.

Hoogerbrugge was seventeen and had just finished school when the Second World War broke out. In 1942, when the German occupiers earmarked men of his age for *Arbeitseinsatz*—labour in Germany—he went underground and was soon involved in resistance activities. After the war he was only interested in one thing: getting away, preferably overseas. A new period of adventure began for him in the Netherlands East Indies, where the cry for independence and autonomy was growing stronger by the day. There, from 1946 to 1949, he served as an officer in the Dutch forces opposing the nationalists, his talent for languages coming in handy. After three years of service in the field, he was transferred to military transport coordination, a post in which he established contacts with the Koninklijke Paketvaart Maatschappij (KPM - Royal Dutch Shipping Company). After being demobilized in 1951, he went to work for this transport company, first in Jakarta and later, in 1954, in Tenggara Balai on the east coast of Sumatra.

What was the earliest expression of your interest in, shall we say, exotic objects?
In Jakarta in the late forties, I developed an interest in antique Chinese porcelain, which, along with Hindu-Javanese antiquities and antique silver, was not only eagerly collected by rich local families but also by many Dutch people. For me this was a completely new world, different, refined, one which I, as an ex-military man, had no idea about. I not only found the vases and dishes and bowls themselves mesmerising, but also

the stories linked to them, and the way in which the people handled them and appreciated them. At a certain point, I heard about the prominent Chinese antiquarian Lee Cheong. It took a whole year before I could pluck up the courage to actually go inside, and for some reason or other he took an interest in me, though on my very modest salary I couldn't afford to buy any of his expensive pieces. The old gentleman himself usually sat in the back of the shop like some Chinese sage and hardly ever came out to see customers, a job he left to his staff, but for me he made an exception. He had fantastic stories about his pre-war trips to China, buying and collecting, and I was an eager listener. However, my interest in Chinese porcelain faded. Although I still have a few choice pieces Lee Cheong pushed my way, the high prices were an obstacle.

Where and when were you confronted with tribal art for the first time?
After a while, I was promoted to the post of independent agent for the Koninklijke Paketvaart Maatschappij in Tenggara Balai, on Sumatra, a two hour drive from Berastagi in the Batak Lands, where my wife and I—we had just married—spent most of our free time. It was there my first real contact with tribal art took place. The Batak villages were isolated, protected, quite inaccessible socially, and the atmosphere was often pretty sullen but also, because of that, intriguing. They weren't especially friendly, and why should they be—we were more or less intruders, with our old Ford and our cameras. There wasn't much, though, in the way of art in the villages, and what there was wasn't all that easy to see, so initially I bought mainly from dealers. They were from Padang, and next to the Chinese formed the second important category of traders in Chinese and indigenous art. They worked with *tukang cari*, "trackers," younger members of their families who were sent out to remote locations to hunt down porcelain and other antiques. I frequently visited a Padang trader who had a shop in Medan. Like all these traders, this one was primarily interested in Chinese porcelain, which he usually sold in Hongkong where it fetched a bundle, but he also sold objects from the nearby Batak lands, and it was from this man that I bought my first Batak art: little pots for *pukpuk*, a magical substance, priests' staffs, house ornamentation, and bone amulets with ritual inscriptions.

How did you view these objects? Aesthetically?
Aesthetically, yes, but not only that. From the beginning, I had an interest in the meaning of the figures and the contexts in which they appeared. The Bataks are fanatical chess players. I am too, so I played with them regularly, in the villages, mostly by the side of the road, and with a large audience. Also, I often sat in the villages drawing—another passion of mine. Both activities led to good contacts, which enabled me to obtain

information on the meaning of all these strange things, and, after a while, to buy directly from the Batak themselves, without dealers coming between us. At one point, I was able to buy a wonderful and very old *tunggal panaluan*, a richly carved staff, from a Batak *datu*—a priest or sorcerer—on Samosir, the island in Toba Lake. I had to promise him I would offer an egg to it every day.

How did you subsequently end up in New Guinea, trading one well-known area of origin of tribal art for two others: Toba Lake for Sentani Lake and Humboldt Bay?
In 1956, we had to return to Holland, which had to do with the increasingly difficult position of the Dutch company where I was employed in the new, independent Indonesia, but in the same year we flew back again, this time to West New Guinea, at that time still under Dutch control. Hollandia, present-day Jayapura, was no great shakes, but the surroundings, especially Sentani Lake and Humboldt Bay, were beautiful, and we were immediately *senang*—at ease. I didn't really know what to expect there in the way of ethnographics, but with my passion for drawing and the native culture, I quickly found my way to the villages around the lake. I copied the complicated spiral motives on the prows of the Sentani canoes, the people there liked that, and it led to contacts. In addition, I had a few lads from the lake working at my office, including the son of an *ondofolo*, a traditional village chief; that again provided a way in. Initially, there seemed to be nothing, but after a while quality objects began to come my way, though not very many. In any case, I was an exception, because the other Dutch people generally only came to the lake on a Sunday for a beer, a picnic or for motorboating. They didn't have a clue about this other world—the world of the Sentani people, the world of the villagers, as secluded as that of the Batak.

The earliest Protestant missionaries on the northwest coast are known to have burned native ritual objects regularly, or at least to have encouraged the natives to do so. Is that perhaps why you came across so little art?
The area had already been Protestant for three generations, and—with a few notable exceptions like the missionary and ethnologist Dr F.C. Kamma—the missionaries indeed did not have much patience with the traditional myths, feasts and ritual objects. However, the burning of the magnificent ceremonial houses on Sentani Lake (Fig. 16) wasn't the work of the missionaries, as is often believed, but was a rash action carried out by a certain administrator. A lot of additional damage was caused by the *guru*, the village teachers, who were hired by the colonial government from the Moluccas. They looked down on the native culture and found it *adat bodoh*—traditional rubbish. The final blow came during the Second

COLLECTOR IN THE TROPICS

143

World War, when the Japanese and subsequently the Allied Forces built their huge war bases next to Sentani Lake. In fact, it was a miracle that I could still lay hands on anything old in the way of objects and stories. Later, in 1962, the area became part of Indonesia, and there was an enormous stream of immigrants from Java and other parts of Indonesia who brought their Islamic lifestyle with them. Due to all these developments there's now even less left of the old culture than in our days there. It was only in hindsight, long after I had returned to Holland, that it became clear to me how exceptional the collection was that I had been able to put together. I was just in time!

What sort of objects did you collect around Sentani Lake?
Wooden dishes, bark cloth, paddles, glass rings and beads, gourds and spatulae for chalk, hooks to hang things on, drums, dance staffs, neckrests—all used and fairly old, and much of it decorated with the typical Sentani spiral and wave motives. There were also, but only in very small numbers, the famous and fairly abstract Sentani sculptures and figures, carved on house posts, which at the end of the twenties caused such a furore among the Paris surrealists. In addition, there were

32. Mr. Hoogerbrugge in his attic in 1997 with one of his treasures: a prow collected in Yamna, a Humboldt Bay village, around 1920.

newly carved sago beaters and other things for daily use, made to sell to the Dutch at fairs, stuff that appealed to me much less, because it was mostly pretty sloppily made. I was hunting for the really old pieces, was nuts about them—and still am, for that matter. It took me years to find certain items.

Besides buying directly from natives, did you acquire things through intermediaries, as you did in Sumatra?
I did. My work as a transport agent permitted me to establish contacts with ships' officers, and through them also with planters, missionaries, and other people in isolated locations along the north and south coast. Although it could be really difficult to find old things, such contacts regularly bore fruit. For instance, there was Father van Kessel, a Catholic missionary on the Casuarine Coast in the south to whom I sent building materials in return for ethnographical material. I can also remember a German, a very nice chap, who managed a plantation on one of the islands west of Hollandia, somewhere in the Sarmi region—I am not quite sure where anymore. I had been able to arrange something for him, and in return he promised to look out for old things for me. For years there was nothing, but one day he appeared, shortly before he left New Guinea for good, with two of the most beautiful canoe prows I had ever seen. And then, of course, there were my watercolours which I exhibited and sold. If people lived in an interesting place and couldn't readily put up the money to buy one I would ask them if they could look out for things for me in return for a picture. A few times, I was able to lay my hands on things in very unexpected ways. For instance, I had been hunting for ages for one of those characteristic, richly carved prows (Fig. 32) from the Humboldt Bay, which borders on the Sentani Lake, but they appeared no longer to exist. Occasionally canoes came into the bay to trade, however, from villages far to the east, across the border with Australian New Guinea. I sometimes bought chalk gourds from them, so they knew that I was interested. One day, to my great surprise, they appeared with a weather-beaten, incredibly large and beautiful Humboldt Bay prow. It came, as soon became clear, from a Humboldt Bay canoe that had sunk in their waters and had washed up on the beach shortly before.

Did you come across C.M.A. Groenevelt, the field collector for the Amsterdam and Rotterdam ethnological museums?
That was inevitable. At a certain point, he stepped into my office in Hollandia, a large man with grey curly hair, jovial, much older than I was, and a man who had stories to tell. Initially we hit it off, for we were both passionate collectors. I collected for myself, while he was a field collector for two Dutch museums. For some time, I was greatly in awe of

him; I showed him the ropes around the lake, made a few contacts for him, arranged transport, and so on. I got him a beautiful old canoe from the lake, one which is now in the Rotterdam museum. But I found his way of collecting was too colonial: he would sit under a tree in the shade and order the people to bring him all sorts of things; he just barked at them. I was a colonial too, and even an ex-military man, but I respected people, and wouldn't ever think of belittling them. Years later, I met him again doing the same thing, this time on the south coast, among the Asmat, where he had the chief of police and the local priest collecting for him. You would expect that he, as a representative of a museum, would bother that everything he collected was well documented, but no! As much as possible had to be snatched together as quickly as possible. The people themselves saw nothing, didn't get anything in return, and still haven't.

You sound frustrated.
I guess so. Let me explain. What I don't like is that it all was, and still is, one-way traffic. Everything disappeared to Holland, while even nowadays, with all the debate on the ethics of collecting, the Dutch museums that house those collections, with their yearly budgets of millions of guilders, make no effort at all in this direction. Not even photographs or information pertaining to the things they took away are made available to their makers. No catalogue of the huge collections assembled by Groenevelt has ever been made, let alone sent back to New Guinea. That I find frustrating—yes! Another example of one-way traffic is the collections brought together by one of the Protestant missionary societies on the north coast which are now in the Museum voor Volkenkunde Rotterdam. Nothing from those collections has ever gone back in any form, either.

In 1967, you published a lengthy article on the mythical backgrounds of Sentani art; in 1992 you contributed extensively to an edited volume on the art of the northwest coast; and in 1995 you wrote on Sentani barkcloth in the Festschrift for the ethnologist Simon Kooijman.[215] These publications are now considered important sources on the area. How did they come about?
It is, of course, not entirely automatic that someone who collects also does research—though that's perhaps a bit too large a word for what I do—and publishes; in my case, all the more so because I never studied anthropology or anything along those lines. From the beginning, however, I've realized that it is of the greatest importance to document what you collect. I think of my objects as documents pertaining to people's cultures rather than as art. When I was doing watercolours in and around the kampongs on the lake, at the foot of the Cyclope

Mountains, where the scenery is beautiful, I tried to gather information. Time and again I asked about the meaning of the creation myths which were recited in a special sacred language, and the significance of songs, dances, feasts, tattoos, of all sorts of ritual articles, and of certain recurring motives in carving. Initially I got answers which I couldn't make any sense of at all, so I became more and more intrigued and continued asking. I can tell you, it wasn't easy. Sometimes people didn't really feel like talking, sometimes they wanted to chew some betel nut first, or the wind suddenly began to blow so hard that they had to rush home in their canoes. Always putting it off: *lain kali*, another time, was the standard response. But eventually I managed to write down a respectable number of creation myths told to me mostly by *ondofolo*—village chiefs. Kamma, the Protestant minister who was in Sorong and at Geelvink Bay even before the war, encouraged me a lot. He had an extraordinary feeling for the indigenous traditions, published quite a bit on the cultures of the north coast, and also collected.[216] We had quite a few discussions on the parallels between the myths of Sentani Lake and those of Geelvink Bay.

What was it that fascinated you the most in Sentani cosmology?
I was trying to find a core, or at least a principle of cohesion in the enormous amount of data with which I found myself confronted. The typical Sentani ornamentation, formed by waves and spirals, is highly significant in this respect. You find it on many articles, for instance on the bottom of the well-known wooden bowls, on the blades of paddles, on gourds, and on bark cloth. That pattern points directly to the cosmic order and the coming into being of everything in the beginning. By decorating objects with this pattern they were slotted into the cosmological order, and thus started to figure in it in a fertile and productive manner, contributing to the maintenance of that order which is necessary for life and fertility.

You were particularly interested in the maro, *the Sentani and Humboldt Bay bark cloths which are often decorated.[217] Can you elaborate on that?*
The word *maro* refers to cloth made out of beaten bark and to the aprons worn by women which were made of this type of material.[218] According to the Swiss ethnologist Paul Wirz such cloths were also hung by graves (Fig. 33). Sources from around the turn of the century report occasional decoration consisting of the well-known spiral and waves patterns, but traditionally most of the cloth appeared to be undecorated. In this respect, things changed in the twenties and thirties, as I have shown in my articles on the subject. In that period, you see fantastic fish, reptiles and plant patterns appearing on the *maro*, painted in a lively, naive realistic style. I think that this should be seen as a reaction to the demand by westerners.

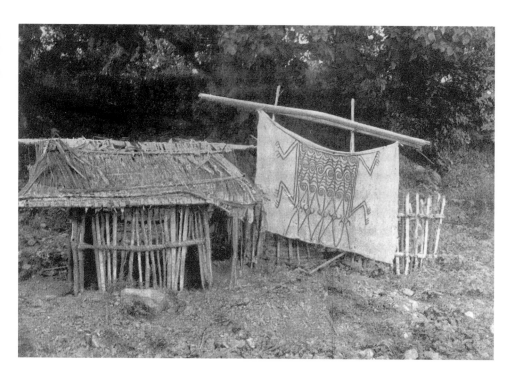

33. The grave of a young women, adorned with a decorated *maro* bark cloth. The physical remains of the woman are buried in a shallow grave, upon which a little hut has been constructed to house her soul. Photographed by the Swiss anthropologist, Paul Wirz, in 1926, near a village on the Sentani Lake. The *maro*, which is 175 cms. wide, was collected by Wirz and bought from him by the Museum der Kulturen Basel, Switzerland, where it still is. Early Sentani bark cloths are much sought after by museums and private collectors.

Westerners such as Jacques Viot and Paul Wirz?
Quite. The Parisian art dealer, surrealist, and writer, Jacques Viot collected fifty-odd bark cloth pieces in the Humboldt Bay area in 1929, which were exhibited in Paris at the beginning of the thirties. There, they were in great demand among the surrealist painters and collectors, especially after an exhibition in the Musée d'Ethnographie du Trocadéro in Paris in 1933.[219] Paul Wirz was also actively collecting in 1921 and 1926, as were other people, like *Herr* Stüber, a German colonial who had a plantation in the Yotefa Bay area, but who also sold all sorts of natural history objects to tourists and to museums. A collection of forty-one bark cloth pieces that he assembled was bought by a well-to-do American

couple during a cruise along the coast and is now in the Cincinnati Museum of Natural History. What quite possibly also played a role in the changing iconography of the cloth was a colonial arts and crafts exhibition in Batavia, present-day Jakarta, in May 1929. By searching in newspapers and magazines, I found out that some twenty-five people from Sentani Lake and Humboldt Bay took part. In these sources, there is mention of bark cloth painted with patterns in the New Guinea stand. These Papuans, far away from their villages for the first time in their lives, were confronted with the art production from no less than twenty-two other regions in the colony at these arts and crafts exhibitions. That event was on so huge a scale, with tens of thousands of visitors, that it indeed would have been strange if it had had no influence on the Papuans after their return home. If I've got this correct, Viot was collecting in the Humboldt Bay area soon after the Batavia group had returned home, so it is quite possible that many of the cloth pieces collected by him were so finely decorated as a result of the Batavia experience.

What was the state of affairs with respect to these bark cloth pieces in the fifties, when you lived there?
At that time, I did indeed search high and low for *maro* painters, but I couldn't find any except for a few amateurs without real experience. Much later, in 1971, I became acquainted with Nyaro Hanuebi, a man of nearly fifty from the village of Nafri on Yotefa Bay, who was said to be able to paint *maro*. After lengthy discussions, in particular with his female relations who would have to make the bark cloth, he finally did produce four magnificent paintings for me, which depicted reptilian beings with human faces. In the meantime, I had also gotten to know Sibo Sriano, another man from the village, who was seventy years old and had formerly painted *maro* but felt too old to do it then. He could also remember quite well that two ceremonial houses in his village had been burned down when he was about fifteen years old. Sriano identified the reptilian beings Nyaro Hanuebi had painted as *uaropo*, spirits from the sea and from the bush which one can see moving in the dark as illuminated dots. I find it amazing that such myths still existed after such lengthy, far-reaching, and often painful contacts with other peoples. First there were the Dutch, bringing a Christian belief system with them, then the Japanese, after that the Americans, then the Dutch again, and in 1962 came the Indonesians, bringing Islam with them. People come and go and change, but the *uaropo* are still the same, that was Sriano's philosophy. When I came back a year later, despite his initial refusal, he had made a few magnificent *maro* paintings for me, of specific spirits which he identified and described to me in great detail. In 1976, I was informed in a letter that both of my friends had passed away.

COLLECTOR IN THE TROPICS

149

When Netherlands New Guinea was transferred to the United Nations in 1962 and a year later became part of Indonesia, was that the end for you?
Initially it was—we had to leave. I was one of the very last to depart, in a Piper Cub, via Australian New Guinea, having literally collected up to the last minute. In those last few days, I managed to get my hands on a very special *korwar* ancestor figure from the Geelvink Bay area, which I bought from a Chinese man. I left with that figure literally under my arm. Once again, I was lucky because travelling through the Sepik area I was just in time for the famous Mount Hagen festival, to which many tribes contributed, where I collected a few more nice things. Back in the Netherlands, I attempted to make a few contacts at the ethnological museums, but for some reason or another it didn't seem to work very well. People were far too busy, and didn't view New Guinea as interesting following the political disaster—except in Delft. There I got off on the right foot with J. van der Werff, the curator of the Indonesisch Ethnografisch Museum Delft, and an erudite and enthusiastic individual, who helped me in publishing my Sentani material in *Kultuurpatronen*, the museum's periodical.[220]

After a few years in Holland, however, you went back to Indonesia again.
Yes, with considerably broadened background knowledge. This time I stayed in Indonesia from 1964 till 1966, without my family, and again for my old employer, the Koninklijke Paketvaart Maatschappij. The company no longer had access to Indonesia, but being based in Singapore there was, of course, great interest in what was happening in the archipelago concerning shipping. So they sent me there, alone, with orders to collect as much information as possible on the entire region. With a thick wad of cheques, I went adventuring. Those were two crazy years. The country was unsettled: rebellious soldiers and provinces challenging state authority. But with money, patience, and a glib tongue I slipped between them and could get everywhere, from Sumatra to the heart of the Moluccas. In small towns along the coast of Borneo, I was able to buy fine *mandau*—richly decorated machetes—and woodcarvings from Dayaks who came down the river to trade whenever a ship was expected from Singapore or Hong Kong.

A few years later, in 1969, you returned to New Guinea, for quite a different reason: the United Nations Asmat Art Project. How did you become involved in that project?
I was telephoned by someone from the United Nations who offered me the post just like that. Sukarno had entered the United Nations again, and Dutch money for the development of New Guinea which had been frozen at the United Nations became available on this occasion. It had to go to

the Papuans themselves, and was not to fall into Indonesian hands. A small proportion of it was earmarked for a woodcarving project in the Asmat community on the south coast.[221] For the United Nations, it was no problem to get as many academics as they wanted, but they were looking for someone with practical experience, someone who could get the carvings out. So I went there in 1969 and set up the Asmat Art Project for the United Nations, which I led until 1972.

The Asmat are, of course, famous for their rich ritual woodcarving: shields (Fig. 29), ancestor figures, the enormous mbisj *ancestor poles (Figure 27), dishes, paddles and so on. What was the situation like when you arrived there in 1969?*
It was completely dead! The ceremonial houses were empty, absolutely empty. A few good carvings could be found, but only in isolated villages. Directly after the take-over of western New Guinea the Indonesians had strictly forbidden anything linked to traditional feasts and rituals—much more strictly than the Dutch before them had discouraged certain practices. They were very repressive, in part due to the prejudice they had against the Asmat, who in their eyes were *orang makan orang,* maneaters. This was all highly exaggerated, of course, although if you've ever heard the drums in an Asmat village at night I can imagine you might think along those lines. Soldiers went round and burned whatever they found. All of the woodcarvings were systematically destroyed. In their eyes, they were closely connected to aggression and headhunting. Most of the priests in the region, in those days at least, were not exactly in favour of a revival of traditional culture either, with one or two exceptions.

So you succeeded in getting the Asmat woodcarving project off the ground?
After the usual problems had been solved, for I was, of course, operating on territory which was under the rule of Indonesian authorities and also within the sphere of influence of the missionaries. In the beginning, it certainly wasn't easy to get the carvings out, but after a while it all worked out. You can indeed say that there was a revival of the traditional woodcarving.[222] The most beautiful things were made, initially small ones, later also large ones, such as *mbisj* poles. In the five years the project ran, several thousand objects were produced, all of which I carefully catalogued. I numbered and described every single article, and in addition drew or photographed a large number of them. In this way, a unique archive was created which I still have; I am sure something interesting can be done with it one day. Most of the shields, figures, dishes, panels with illustrations in bas relief, paddles, and so on I sold to museums throughout the world—on behalf of the Asmat. In addition to the good stuff, there was an awful lot of junk, so I had to be very strict in

34. The carving of shields for a shield ritual in Atsj, central Asmat, Dutch New Guinea, in 1958, photographed by Father C. van Kessel, MSC. According to the late Father Gerard Zegwaard, MSC (personal communication, 1996), Atsj in those days "was a much-feared village, a cauldron of violence; people from other villages literally started to tremble with fear when they came near to it." The shield to the right of the woodcarver in the foreground is now in a private collection in the Netherlands.

keeping up quality. In this way, I got the good carvers on my side. The *mbisj* ancestor or memorial poles, by the way, couldn't be carved just like that. A feast was necessary, and that again was difficult given the attitude of the Indonesian authorities.[223]

With regard to ethnographics, many collectors and dealers make a sharp distinction between indigenous ritual use on the one hand and production for sale on the other ...
... which isn't necessarily the case here: take the *mbisj* poles, for instance; there, it was a case of both at once. That it was necessary to hold a feast when carving them shows that it wasn't just a production line of art for export, as is often maintained.[224] Still, the majority of what the Asmat woodcarvers made was not, or only briefly, used before it was sold. The production and the decoration of Sentani Lake *maro* barkcloths, to take another example, was greatly influenced by western demand as early as the 1920s, yet the very same people who demanded authenticity paid huge amounts of money for this sort of stuff, so they weren't very consistent either. I think objects made for sale are an underrated category, while old and patinated so-called authentic carvings are overestimated. The discrepancy is immediately made clear in the different prices people are prepared to pay for each category of Asmat art. Nonetheless, older pieces are, in fact, often rarer and better sculptures, although recent "inauthentic" carvings can be very beautiful and equally traditional with respect to style and content. I mean, they are made by the same people, based on the same traditions, using the same artistic idiom, aren't they?

What have you been doing since? Are you still involved in New Guinea?
Certainly! As soon as I got home I was travelling again, although now it was in books, old periodicals, old newspapers and the rich archives here in Holland. I read Paul Wirz on Sentani Lake, De Clercq and Schmeltz on the Geelvink Bay area, and the catalogue of the 1959 Sentani exhibition at the Metropolitan Museum in New York, all of which for me were breathtaking literature, for I knew from personal experience every one of the villages that they were talking about.[225] I cherish those books. In Indonesia, I scarcely had access to such sources. Since my homecoming in 1972, I've set myself to the task of collecting documentation concerning Netherlands New Guinea: brochures, photos, postcards, documents, and articles from old newspapers and periodicals. I've also continued to collect here in Holland, at flea markets, auctions, that sort of things. Really early pieces from the Southeast Asian archipelago are not easily found anywhere, but ironically enough they are nowadays more readily available here in Holland than in the region of origin, because of the colonial connection. At a street market in Rotterdam, for instance, I

found a beautiful multicoloured bead apron from Geelvink Bay, and a richly decorated loin cloth of beaten bark from the McCluer Gulf, a little bit to the west—wonderful pieces both of them, and extremely rare.

Have you been back to New Guinea since the early 1970s?
In recent years, I've regularly been spending my holidays in Jayapura. To my great surprise, I found twenty or so recently manufactured bark cloth pieces in the University Museum there and in the new State Museum—the Museum Negeri Irian Jaya. About half of them were from Sentani Lake, and one was really a fantastic piece. On that occasion, I also made contact with Uwus Onggé from the village of Harapan, who still makes gorgeous *maro*. A revival is taking place, although the exact background isn't entirely clear to me. A woodcarver on Biak, an island in Geelvink Bay, is again making ancestor statues, *korwar* (cf. Fig. 13), which are just as beautiful as the old ones. I have also seen a new type of carving: gorgeous wooden panels with *korwar* patterns. At a certain moment, I ran into someone going around in a T-shirt with *wor* written on it, a word I remembered well. I spoke to him and he told me that there are now *wor* dance and singing groups; he even wrote down the lyrics for me. You can't imagine what a headache the wild, strictly forbidden *wor* practices were to the colonial authorities and the missionaries in the old days!

2.2 Mamadou Keita, Art Dealer from Mali

Mamadou Keita is a member of a well-known Islamic family of Malinke background from Bamako, Mali. A well-spoken forty-eight year old, he has been a dealer in tribal art based in Amsterdam since 1978. Nowadays, he operates from his apartment, but from 1979 to 1986 he had a gallery on the Nieuwezijds Voorburgwal. While most of the Africans on the European dealing scene are go-betweens, so-called *rabatteurs* or "runners," commuting between the areas of origin in Africa and western metropoles where good pieces fetch good money, Keita is one of the few Africans who is actually based in one of these cities. He was probably the first African to own and run a gallery in Europe, and he specialized in the better, more expensive pieces. Many fine objects now in reputable collections both public and private passed through his hands. His clientele includes or included such well-known artists as the German Georg Baselitz and the Swede Co Hultén. In the course of our conversation, he pulls a number of books from the shelves of his cherished tribal art library with illustrations of items he has handled, the adventures of which he can relate down to the last detail. Although Keita deals mainly in African art, pieces from Indonesia, Melanesia, Alaska, and other areas also come his way.

In the preface to her book on Dogon sculpture, the French dealer Hélène Leloup provides an interesting sketch of the ethnographic art milieu in postwar Mali and its connections to Paris.[226] *How did your father, Niame Keita (Fig. 35), fit into that picture?*
He was one of the major Malinese dealers. In the Second World War, he had been *tirailleur sénégalais* in the French army, cannon-fodder *pour la France*, just as my grandfather in the First World War, and when the war came to an end he continued his trade in materials, clothing, sugar, salt, and other things, in Mali, and at a certain point also in France. When he noticed that there was interest in African masks and figures in that country, he soon began to specialize in that field. Nowadays it's fakes all the way, but not in those days; everything that went through his hands was authentic. Before long he was delivering crate upon crate to dealers in Paris, Basel, Brussels, Milan, Frankfurt, Hamburg, and here in Amsterdam,

ART DEALER FROM MALI

35. Two generations of Malinese dealers in tribal art, father and son. Below, Niame Keita, from Bamako, Mali, in a hotel room in Geneva in 1984. He is holding a helmet mask of the *Epa* society of the Yoruba, Nigeria, and is sitting on a—hardly visible—Chokwe chair, which, a few days later, he sold to the Swiss collector, Joseph Mueller, and is now in the Musée Barbier-Mueller in Geneva. To the right, Mamadou Keita in his Amsterdam gallery in 1985, with a Punu masker from Gabon. For decades, the mask was in a French family with a colonial background; now it is part of the collections of the Musée Dapper in Paris.

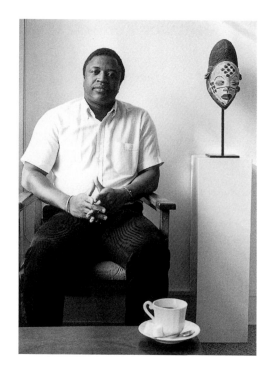

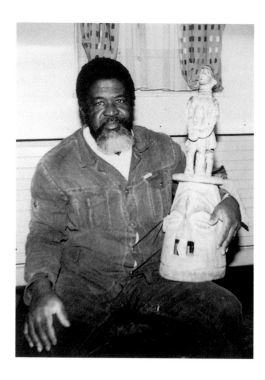

and later on a fairly regular basis also to museums throughout Europe. At a certain point, he began to travel to the United States as well. If you consider it, all in all he must have brought thousands of items to Europe. He stayed active until 1985 and passed away in 1989. His clients trusted him to such a degree that they would buy his crates unopened—it was always good stuff. He also received western dealers and collectors at our family home in Bamako. My father was as generous and hospitable as an African should be; he received them like kings, took care of their every wish, including helping them to make contacts in Mali.

How did your father come by his pieces?
Mainly by buying in Africa, at the grass roots level in villages, but also through the help of a network of middlemen, just like other Malinese dealers of his generation, such as, to name but two, Mamadou Sylla, also a Malinke, but originally from Guinea, who at one point went to live in Paris, and Amadou Diabaté, who also did a lot in Italy; the best Dogon and Bamana in Italy got there through him. In Bamana, Malinke, Dogon, and other villages in Mali it was easy for them to come by masks and statues, which were usually made redundant after having been used once at a feast, an initiation, or a funeral, or were no longer considered important after Islamicization or Christianization. The fetishes had to be "sworn out." As far as all this was concerned they were busy in the perfect period. Until the mid-seventies, my father operated mainly in West Africa; thereafter also, to some extent, in Zaire, Angola, and Zambia, where he went into the bush. Before that he had already been to Congo-Brazzaville a few times.

Did your father and other Malinese who did well in the ethnographic art trade encounter much competition from westerners?
There were a number of French officials, mostly the so-called *commandants* in the villages, who channelled objects through to France and Europe. If you go through recent French tribal art auction catalogues you can see that items from the estates of French colonial officials still pop up with a certain regularity. Furthermore, there were the missionaries, who had a very complex relationship with native fetishes. They discouraged their use, had them burned, confiscated them, but also often traded in them, displayed and sold them at temporary exhibitions in Europe, or even set up small museums housing them. In the third place, there was competition from western dealers such as Hélène Leloup, who in the fifties started to go into the field themselves to buy, in Mali and in many other tribal art areas in Africa. A salient example of that pattern is the way in which Belgian and French dealers removed thousands of artworks from the Belgian, and subsequently independent, Congo, often operating on a large scale and in an very systematic manner.

ART DEALER FROM MALI

157

What is the current situation in Africa?
These days it's mostly small African traders who bring in the pieces. For a long time, they went straight to Paris from the former French colonies, but now that it has become more difficult to get a French visa a lot of runners go to Brussels first and on to Paris from there. Most things from the Democratic Republic of Congo still go to Brussels first because of the old colonial connections. There is some good stuff, but also a lot of rubbish: tourist junk as well as shrewd fakes from specialized workshops. In the seventies, there was the Surabaya Hotel here in Amsterdam, on the Nieuwezijds Voorburgwal, where the stamp market is now. That was where the Africans who came in with art lodged; its rooms were choc-a-bloc with figures and masks. Dutch dealers and gallery owners went there to do their buying. In those days, I sometimes accompanied African middlemen as they travelled around Holland; I introduced them to people and translated for them.

How did you yourself get into the business?
In the beginning, I was not in the least interested in the business activities of my father, but I was quite familiar with them, for as a boy, I used to help pack crates, so I held lots of objects. Apart from being from Mali, the land of the Bamana, the Tellem, the Dogon, the Senufo, the Bobo, and the Malinke, I look upon such objects differently than the average Dutchman, although I have to admit that I grew up in a large city where, as a citizen and as a Muslim, I had only an indirect link to traditional tribal culture. In high school in Bamako, with the White Fathers, I learned how to be European, and part of that entailed looking down upon native fetishes. Even then my father tried to stimulate my interest in tribal art, but initially in vain. In 1972, I went from Mali to Paris to study economics, but didn't like it. In those days, I frequently helped my father with the transport side of his business, for instance, when there were problems at customs. He was an ex-soldier and a French citizen, spoke fluent French and a smattering of English, but could scarcely read or write. In 1976, I had to deliver some stuff to Holland, which is were I met my first wife, who was Dutch. Not long after that I came to live in Holland. Throughout those years, I continued to help my father, and at a certain moment, I too ended up in the trade, in the late seventies, albeit after a lot of hesitation. It is difficult to pinpoint that particular moment, but one consequential event from that period was seeing an exhibition on African art in Brussels, combined with a visit to the nearby museum in Tervuren. An American dealer I had struck up a friendship with took me there, and it was my first conscious confrontation with African art—a real eye-opener. Another event from those days was when, a year later, in 1978, I saw Bamana men dancing with *tjiwara*, antelope headpieces, on the occasion

of a harvest festival in the Kolokani district in Mali. I had known about these masks since I was ten, because I had packed them for my father, but now I saw them in a new light. At home, we hung them up in the kitchen, in the steam, which is where the Bamana themselves keep them.

You said you hesitated a lot. Why was that?
It had to do with the attitude of the Europeans with whom my father did business. Time and again, I noticed that although they were interested in African objects, they were not in the least bit interested in Africans as people, not in Africans in general, not in the people who had made and used the objects, nor in me and my father. When he had sold them something beautiful it was usually "We bought that from an African," but only rarely "We bought that from Keita." There were also cases where it was completely denied that a beautiful old piece had come from an African, this African, but instead it was claimed that it came from "an old European collection." That attitude has obviously lessened, but it still annoys me today.

What is it exactly that disturbs you?
Some in this business have the tendency to see Africans as people who know nothing about their own culture and have no eye for art. What we Africans do know we're supposed to have learned from westerners. I could name some, luckily only a few, dealers and collectors here in Holland who have talked about me in this way. People here like to see the African in the role of the runner who brings things from Africa, which will then be judged by the western connoisseur, dealer, or collector. From that point of view, of course, an African can't have an independent gallery or be an art dealer, nor can he own a good private collection of tribal art, because he can't possibly have any expertise. He can't have an eye, patience or love for pieces. We should never forget, however, from whom those famous western experts on African art like Frobenius, Griaule, or Himmelheber got most of their information, stories and insights: from Africans![227]

Apart from being a dealer, you are also a collector, unlike most Africans in the business.
Most of the African middlemen I know—by this, I mean the people who buy in Africa and sell here, the ones called "runners" —don't have the same affection for the pieces that I do. They are concerned with the money: what they pay, how much it costs to get the stuff here, what they sell it for, profit. They have neither a collection to which they are personally attached, nor an interest in the background of the pieces nor a library with reference works. I do! I have a private collection consisting of a few score objects; every now and then something comes in and something

else goes out. The few Africans I know who are also collectors in addition to being art dealers have generally lived for quite a long time in Europe or America, and began collecting here. One of them is Sulaiman Diané, originally a Malinke from Guinea, who is based in New York but is also quite active in Europe, especially Brussels. He's a real expert in African art, a discreet, outstanding dealer, and as far as I know the only African who has been officially declared an expert in a western country. Another one is Mourtala Diop, dealer and collector of tribal and modern art in Dakar, Senegal. Many of the objects in the 1994 Tanzania exhibition in Berlin came from Diané, although he was not given the honour he deserved on that occasion.[228]

How are your contacts with the tribal art scene in Holland?
Initially, I worked quite a lot with Dutch dealers, but now I work mainly with foreign ones. I got on and still get on well with a number of my Dutch colleagues, but I also met with opposition, notably when I started to develop in the direction of an independent dealer. Someone from Africa is welcome to come along with a bag of figures, but he must not try to deal independently, for by so doing he becomes a competitor with regard to Dutch customers. Certain Dutch dealers tried to discredit me, but they couldn't say I had bad stuff. What I had was good and sold well, to respected collectors and dealers. So then some said that I was too expensive—for an African. That was their line of attack. At one point, in 1984, I had the opportunity to become the first official expert and valuer of African art in the Netherlands, but the whole thing fell through at the last moment because of professional jealousy. I have repeatedly lent pieces for exhibitions or publications where my name remained unmentioned, although other, European, dealers or collectors were given proper credit. Why not, you might ask yourself.

I am under the impression that the tribal art business in general, not just that of the Netherlands, is not exactly a world of harmony.
That's why I can relate to what happened to me. It's not just in Amsterdam or Brussels that the tribal art business is a world of arguments, backstabbing, and cheating, but also in Paris, New York and wherever else in the world. Hate and envy everywhere! Everyone is fishing in the same pond for the same fish big and small, the collectors, so they all stand on each other's toes. There are a number of dealers in ethnographic art who aren't too fussy when it comes to giving reliable information along with the pieces they sell. Instead, they tend to cook up the type of information that brings them the most money from the pockets of gullible collectors. The same thing happens at auctions, where you regularly read forged pedigrees in the auction catalogues.

How about your contacts with the African runners who make their rounds each week in Holland and Belgium to offer what they have to galleries and dealers?
There aren't any contacts! For some reason or other, they never come to me. It probably has something to do with the fact that I am an African. What really gets to me is the impolite and condescending manner in which some—luckily not all—western dealers treat them, more so because they come from societies where politeness and manners are stressed much more than here in Europe. I, too, have had a few unpleasant experiences in that respect, and still have them occasionally. In this respect, too, my position as an art dealer is influenced by the fact that I am an African myself.

You have two brothers who also deal, one here in Amsterdam, the other in Canada. Do you work together?
No. We get on well, but we don't do business with each other. For some reason or other that doesn't work. Throughout the last twenty years or so I have seen quite a number of partnerships of two or three people in Belgium, France, England, and also the United States, but generally they turned out not to be very longlasting. From the moment I began to create a profile for myself as an independent dealer, I began to work less and less with my father. As long as there is a hierarchy, I mean as long as one of the two is in charge, it's okay. What you see quite often, however, is fairly close and long-standing business relations between individual dealers who operate independently.

Have you ever been taken in by false pieces?
Everyone is taken in. That's part of the price you pay, as a dealer or as a collector, and it's how you learn—those lessons are unforgettable. Nowadays, the chance that I will make a mistake has grown very small, which is fortunate, because in the years that I was busy building up my experience, workshops sprang up in Africa where, as a response to demand by western dealers, expert fakes are produced on a fairly large scale, in the right style, with the right material, and with patinas and traces of use that at first sight are very convincing (Fig. 36). Experts, too, are sometimes fooled, for instance, when, at the better western auctions, shameless fakes are put up for sale with fake pedigrees, including the name of some ex-colonial, or on those occasions when fakes figure in the advertisements of dealers in the glossy magazines of the trade.

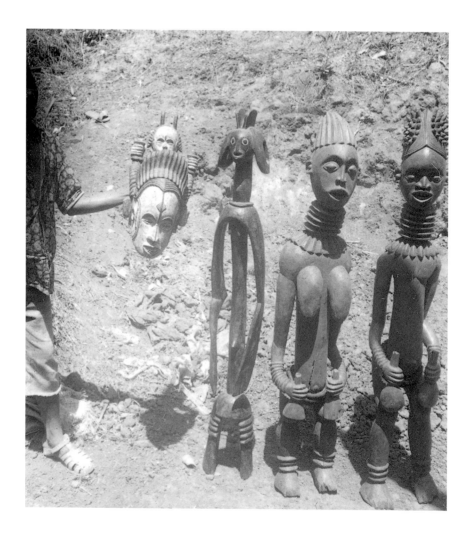

36. Four freshly produced falsifications in three different styles photographed in one of the woodcarving ateliers in Fumban, Cameroon, in 1993. Such items, with artificially and ingeniously produced traces of wear and age, are offered for sale as genuine old pieces at high prices. The mask, which is held by one of the local woodcarvers, is in the style of the Idoma of Nigeria, the figure next to it in the style of the Mumuye of Nigeria, while the two figures to the right are in the style of the Bamileke of Cameroon (cf. Fig. 25).

You are from Mali, a country from which large numbers of archaelogical finds are smuggled out to the West. Many professional archaeologists and museums regard this as the plundering of the cultural heritage of the peoples of Mali. How do you see it, both as a Malinese and as an art dealer?

I think it is rather complex. Now I am not just talking as an art dealer, but also as a Malinese. First and foremost, let me point out that I am against large-scale plundering of the remains of our old civilisations. Important sites must be protected and what is found there should, in my opinion, be preserved and studied. On the other hand, I think that a Malinese farmer who, while working in his fields, finds artifacts produced by his ancestors has, to a certain extent at least, the right to deal with them as he wishes, including selling them. With his large family and usually poverty, and the sudden droughts with which he has to struggle in the Sahel zone, he can certainly use the money. One good Djenné terrracotta piece is enough to feed him and his family for two years. The Malinese middlemen also make money in this way, and can thus support their families. Why should museums and scientists in the West tell the peoples of Mali what they should and shouldn't do? Imagine the opposite scenario. I always watch the Antiques Road Show and similar programs on television. What if African museums forbade those people to sell the family paintings and antiques they bring in on those occasions, should they so desire?

So you think it's wrong to declare everything illegal?

Definitely. The extreme point of view taken by a number of archaeologists and ethnologists, including some hardliners here in the Netherlands, is, I think, unrealistic. There is so incredibly much! At a certain point, enough is known about a certain culture's past, and museums contain enough finds of that type. Beyond that point, the returns of further efforts diminish sharply. Let us also not forget that most of the important pieces which have found their way to the West through villagers, missionaries, dealers, and so on sooner or later end up in museums, or are studied and published on even when in private hands. Furthermore, while in Holland the four largest ethnographic museums have publicly declared that this trade is wrong, it is still the case that three of those museums have been buying pieces from dealers in tribal art since time immemorial and are still doing so every month!

You imply that there are double standards as far as the museums are concerned: on the one hand, they criticize the dealers, but on the other hand they buy from them, consult them, and so on?

Yes, although you can't tar all the museums with the same brush. I could indeed point out to you many pieces in Dutch museum showcases and

depots that have come from dealers, as well as pieces that were sold by Dutch museums to dealers in the eighties. Some of those pieces have been through my hands as well. Often you're talking about a longstanding, exclusive and confidential relationship between a curator and one or more dealers. This is something which you can clearly see in the United States, where certain curators of museums, usually museums of tribal art as opposed to ethnological or natural history museums, cherish relations with certain individual dealers, "house dealers" so to speak, who consequently also supply the circle of wealthy collectors, trustees, board members, philanthropists and the like who are connected with the museum.

Are there still good things coming out of Africa, or is it over, finished, as a result of Christianity, Islam, westernization and urbanisation?
It is certainly not all finished, although a lot less surfaces than in the colonial days, and although the production of fakes threatens to overshadow the old production for the tribe's own cults. Apart from being Muslims or Christians, a lot Africans are animists as well. They still believe in the power of the spirits and the ancestors, and continue to make use of figures, masks and amulets in their dealings with them. For instance, beautiful Dogon is still coming out of Mali. Africa is so big! Even quite recently, regions which as far as art production was concerned were virtually unknown were still being "opened up" by dealers. Some of those dealers, incidentally, very shrewdly published the pieces they had collected before selling them, to increase their market value.

What do you personally find the most appealing region or style?
I have no preference, although most of what I deal in is African. Everything may be beautiful, whether it comes from New Guinea or Ghana. I may be moved by a sorcerer's wand from the Batak of Sumatra, by a shield from the Solomon Islands, or by an Eskimo mask. With respect to Mali, everybody wants Dogon, preferably one example of each type from each period. Of course Dogon, or Fang, or Chokwe is beautiful, but then I say, take a look at Bamana! Bamana art is underestimated. With regard to Bamana as opposed to Dogon most collectors are satisfied with one or two pieces. I also pay serious attention to things which are less popular. Almost everybody wants figures or masks, while there are also beautiful shields, knives, and staffs to be found in Africa.

Can you give an example of something fine and non-African that has passed through your hands?
At the beginning of the eighties, I handled twenty or so Eskimo masks from Alaska which I found very attractive. They were from the private collection of a Hamburg dealer. That those masks, which are fairly rare

in this part of the world, surfaced in Hamburg is probably not pure coincidence, as the Hamburg Museum für Völkerkunde sent a collecting expedition to Alaska at the end of the last century, and it's a known fact that earlier on museums held a more liberal view when it came to "deaccessioning" objects than is now the case. I, in turn, sold the masks, mostly on the American market, but also to Dutchmen and Belgians. By the way, as this would seem to be the end of our conversation—can I add something to it?

Of course.
I would like to use this occasion to express my gratitude to my father, Niame Keita, for opening my eyes to the wonderful world of African art, and to thank all the collectors and dealers who honoured me with their trust.

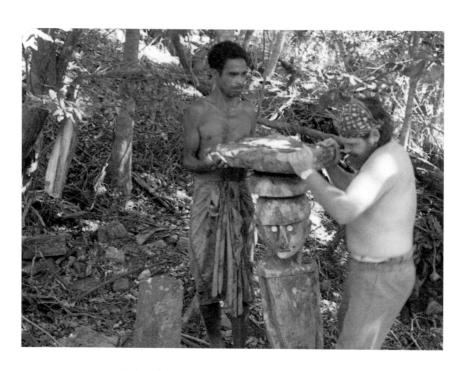

37. The Belgian tribal art dealer Marc Felix during his wild years, removing a stone ancestor figure he had just bought in Eastern Timor in 1974.

2.3 Marc Felix and the Congo

The Belgian Marc Leo Felix is an outstanding specialist and a reputable dealer when it comes to the tribal art of the Democratic Republic of Congo, formerly Zaire, and before that a Belgian colony. He has published extensively on Central African art, and directs the Congo Basin Research Institute in Brussels, where he also has a gallery. As both an expert and a dealer, he numbers museums and universities among his clients, next to some of the wealthiest private collectors. His private Congo collection is one of the finest and most complete in the world.

Felix grew up the son of a chemist on the Grote Zavel, a well-known square in Brussels and a centre of the trade in tribal art. There, as a young boy, he derived great pleasure from browsing through the various antique shops, while his imagination thrived on reading Stanley, Livingstone, Karl May, James Fennimore Cooper, Tintin comics, and missionary periodicals. His parents' house was frequented by expressionist painters of the CoBrA movement[229] such as Bram Van Velde, Jan Coboer, Corneille, Christian Dotremont, Roel D'Haese and Marcel Broodthaers, many of them collectors of *art nègre*. Another well-known artist and collector, Willy Mestach, lived around the corner and was to become one of his mentors.

Marc briefly attended the art academy and studied art history, but he soon grew weary of this and signed up on a merchant ship bound for the Belgian Congo. During his second journey on that vessel he jumped ship and stayed in the Congo for several months, until political developments forced him to return to Belgium. Home again, he fulfilled his military service obligations and once discharged he opened a small antiques shop on the Grote Zavel, which did well until the tax department reminded him of his obligations towards the community—a tax debt so high that he could scarcely scrape the money together. Subsequently, he went to work for an oil company in the Arab Emirates, where he learned to speak fluent Arabic. But Africa beckoned, and after a few years he went on to Nigeria, still in the oil business, where he divided his time between his work and collecting ethnographics among the Ibo, Ijo, Eket, Urhobo, and other tribal groups along the southern coast. From Nigeria, he went to Cameroon in

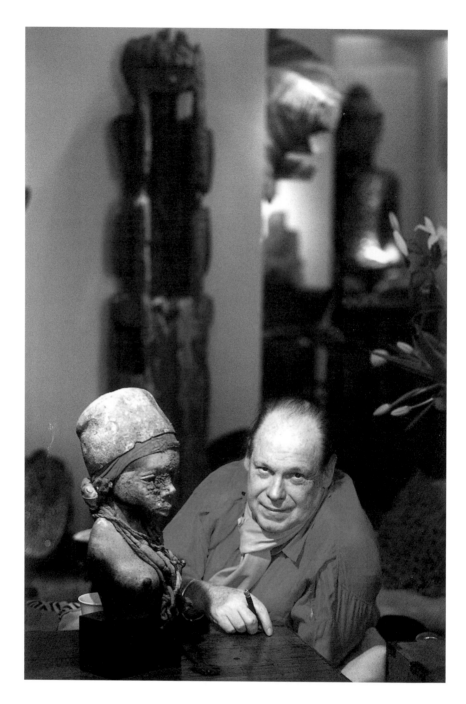

38. Marc Felix at home in Brussels, in 1999.

1967, and from there to Gabon, still in the oil business, and by now collecting ceaselessly.

In a well-to-do suburb of Brussels, seated in an exquisite sitting room packed with beautiful African art, I talked to this thoughtful, man, who sports cowboy boots and a pony tail.

Your work for oil companies in several African countries must have offered good opportunities to add to your collection.
Well, theoretically, yes, but actually, no. In those days, I hadn't yet developed a discriminating eye. I was too enthusiastic, bought whatever I saw, much of which I later regretted. Sometimes, I was in the *brousse* for weeks yearning to see something, and then when I finally found it I had the tendency to overestimate it. It's much easier to go to an art dealer, where you can take your time to study things, compare them with other pieces, and even have the opportunity to go home or to a library to look them up. To be honest, I bought a lot of junk in those days. Not so much fake as ugly—I mean really ugly. Anyway, for about two years, from 1966 till 1968, I worked and collected mainly in the southwest of Gabon, among the Lumbo, the Punu, the Shango, and the Mitshogo, and also the Galoa. At one point, however, a river boat in which I had invested met with an accident, and I lost everything. Then I went to Nigeria, at the time of the war in Biafra, and subsequently to Cameroon. I was about thirty then.

When and how did you start to deal in tribal art?
At that point, in Cameroon, where Douala became the home base from which I operated, buying in both Cameroon and Nigeria through a network of African helpers. I joined forces with a well-known French tribal art dealer who lived there, Philippe Guimiot.[90] He was older than I was and knew a lot. That was the beginning of my activities as a dealer. When I met him, I suddenly realized how little I actually knew about African tribal art, in spite of my enthusiasm and my familiarity with a number of African societies. When Guimiot went through my collection in Brussels, which I kept in my parents' house, he turned his nose up to most of it, and quite rightly so. My frame of reference was still far too limited. I'd seen far too little really good material with which I could compare what I came across. You need to see lots of quality old pieces in collections, in museums, and at exhibitions in order to get a feel for it. You need to struggle through the literature. That's exactly what I started doing then. With the additional advantage of my African experiences, I learned quickly.

What form did your partnership with Guimiot take?
I was largely out in the field collecting, in Africa and in Indonesia, while he attended to selling the material in Paris, Brussels, and the United States. For a number of years, it went really well. In 1971 and 1972, I travelled to Indonesia, not just because I was sick of the misery that I had come across in Africa, but also because the art from the Indonesian Archipelago was virtually unknown outside Holland. On Sumatra, around the Toba Lake, I found good Batak material that sold very well in the Brussels gallery we had opened. Next, I paid short visits to Kalimantan and Nias, and longer ones to Timor (Fig. 37) and Atauro. Kalimantan, Nias and Timor are well-known for their art, but it was a surprise for everybody to learn that there was something worth finding on Atauro—a small island between Timor and Wetar. You could say that that was my first big discovery.[231]

You enjoy a certain reputation for having participated in the "opening up" of a number of hitherto virtually unknown tribal art areas such as Atauro, Vietnam, East Africa, and the Ituri Forest.
In the case of Atauro, nobody even suspected that there was anything there, but my intuition told me that there must be something, because beautiful things were known from all the surrounding islands. And indeed, I went there and found art which was completely unknown to the western world: spectacular male and female ancestor figures, some of them enormous, up to three meters high, but mostly smaller, which functioned as the bow and the stern of boat-shaped monuments made of piled-up stones, which referred to the arrival of the ancestors on the island. With the permission of the local authorities, I did some collecting there. In the western world of collectors and specialists, these figures caused quite a stir.

And how did it go in Vietnam?
In 1974, after my collecting ventures in the Indonesian Archipelago I went, via the Philipines, to the hill tribes in central Vietnam: the Jöraï, the Södang and others, known under the general name of Moï, though that's an incorrect and derogatory term. My attention was alerted to them by a book by the German ethnologist Hugo Bernatzik.[232] I found these groups interesting because of the great similarities concerning patterns and styles they had with the Malaysian peoples of insular Southeast Asia. In the hills of Vietnam, you find the same type of houses, with canoe-shaped ornaments on top of them, while the people there have never even seen a canoe. I also noticed linguistic similarities. Several tribal groups that I visited in India fit more or less the same cultural register. Among those hill tribes, I primarily collected Jöraï grave poles,

which mark out their *pösat*, the burial grounds, and have powerful, coarsely carved figures on them in the typical crouching posture, the elbows on the knees, that can be seen in the art of a number of Austronesian groups.[233] The death ritual, whereby the deceased passes on to the domain of the ancestors, often goes on for several years and when it draws to its conclusion the enclosures and the grave poles are renewed. I was able to lay hands on a considerable number of these poles when they were taken down for renewal.

If I remember correctly, you published an article on cultural affinities between the various Austronesian cultures.
More specifically, the relationship between Indonesia, on the one hand, and Madagascar and East Africa on the other fascinated me—naturally, considering my African background. I tackled this problem in an article in the periodical *Tribal Arts*,[234] in which I compared objects from Madagascar and the African east coast with objects from the Batak of Sumatra: the same masks, the same magician's horns, priest's staffs and anthropomorphous figures. Art doesn't lie! Here again, as in Vietnam, stylistic and iconographic relationships are echoed in linguistic similarities, as well as in various crops which appear to have been brought from Southeast Asia to East Africa.

So from Southeast Asia your interests shifted back to Africa?
My interests and my activities. I went back to Africa, first to Congo, then to East Africa, again because everybody said there was no art there, which I thought was highly unlikely. I went there and found marvellous things. I was more or less the first; others soon followed. My ambition in those years was to discover something new regularly, and to a certain degree I succeeded in that.

Are there now still regions which with regard to art production are still relatively unknown, where discoveries can be expected to be made in the near future?
Well, completely unknown, no, but there are some regions that are so little known that it is almost scandalous, for instance, the Kasai in Congo, where there's still an awful lot to discover because it is a diamond region and for this reason was always closed to outsiders. It's very dangerous there, nowadays, because of smugglers and drunken soldiers. I feel too old now to go and play Indiana Jones, and the younger generation doesn't dare. The Kasai is a cross-roads of Central African styles—it is where the civilizations of Angola, Zambia and Congo meet.

These collecting ventures to various corners of the world that you just described—were they lucrative?
Yes and no! Yes, in the sense that I was able to get my hands on good pieces regularly and in that I discovered all types of things, and no, because travelling is very expensive, and for every journey that produced results there were several more that didn't produce anything. The money we—Guimiot and I—earned was gone before we knew it, on expenses and on advertising costs. Personally, I lived very simply, and would make do with anything, no matter how spartan, but not Guimiot. And that was what eventually led to the break between us, in 1975. He and I lived more or less in different worlds. He played the gentleman-dealer, living luxuriously, staying in the best hotels, flying first class, giving expensive dinners for customers and relations. He certainly knew how to present our objects, but he himself was too fond of luxury, was lazy, and spent far too much, out of joint means. Despite these critical remarks, however, Guimiot's expertise cannot be denied; I would like to stress again that I learned a great deal from him. He's still in business, based here in Brussels.

What happened after you broke up with your partner?
After breaking up with Guimiot I had no choice: I had to go and sell things by myself. Initially, I felt more as though I should be out in the field, but it turned out well and I even started enjoying it. From that point on, I devoted my time to tracing tribal art from the former colony of Congo in Belgium. Many people here had things from the Belgian Congo, rubbish as well as good stuff. I bought a lot from ex-colonials, from monasteries and missionaries, and from other dealers who picked up their stuff from the same sources. Some of the ex-colonials are agreeable and colourful people, but others are simply frightful. Last week, for instance, I had dinner with a couple who spent thirty years in the Congo. It was disgusting! Absolutely no feel for or interest in the people and their culture, whatsoever. The only contact they had with the native population was their "boy." But when it comes down it, it was in these circles that I did—and still do—my buying. In addition, I went to Congo regularly, where I made numerous interesting finds with the aid of my staff there. I sold in Europe and the United States, to private collectors, dealers, museums, and universities. It was big business! Belgium turned out to be a gold mine—I've managed to trace some real treasures, often through the grapevine. Now I am known as a specialist in Congo art, a limited area, but this specialisation is my strength, and universities and museums throughout the whole world know that and consult me.

How does the trade in ethnographics here in Belgium work and where do you fit into it?
In Belgium, there are dozens of private individuals, maybe a hundred or so, who systematically track down colonial families and see if they have any ethnographics left. They go from one family to the next, tracking their relations, ex-colleagues, and friends, working very thoroughly, also covering garage sales, local auctions, fleamarkets, and antiques shops. They sift through everything systematically. This group, most of whom are not officially registered as dealers, form the base of the dealing pyramid, so to speak. They mostly sell to the middle layer, which is formed by fifty or so official dealers in tribal art, both large and small, mostly conducting their business here in Brussels around the Grote Zavel. The apex of the pyramid consists of only a handful of dealers, who trade in the best and most expensive pieces.

Why don't the runners sell the best pieces directly to museums or serious collectors themselves?
Well, it just doesn't work that way, for a number of reasons: they don't have enough expertise, they don't have the right connections, they don't have the reputation, and they don't have enough capital. A serious dealer backs whatever he sells, he guarantees it, and takes it back if necessary, completely refunding the purchase price in cash. The tribal art scene is one with very strict rules. I would never infringe upon the territory of my runners. If I hear that something has popped up in their territory, I don't go myself but I give one of them a tip. He'll pick it up and bring it to me. It's a very precarious set-up. The dividing lines are fine and sharp.

Can you give an example of the route of a particular object?
I'll give you one from my own experience. A while ago, somebody bought a small human figure, cut from elephant ivory, at an auction in a little town here in Belgium for 13,000 Belgian francs, which is about $ 300. It was a so-called *bwame* statue from the Lega in East Congo, probably centuries old. That individual sold it to a small-time antique dealer in the same region for three times as much. The antique dealer suspected that it was something good, and took it to a tribal art dealer in Brussels, who paid him about $ 3,000, three times what the antiques dealer had paid for it. The tribal art dealer in turn came to me, specialized as I am in Central African art, and received $ 12,000, four times what he had paid for it— still for the same little African statue. I, in turn received an offer of $ 25,000, the very next day, which I refused. The figure, which is beautiful, one of the finest I have ever seen, is now in my private collection. It is quite common for a good piece to pop up in this way and travel through these channels before ending up somewhere up-market.

Are the countless fakes in the field of African art a problem for you?
I still make mistakes, fewer as the years go by, but I still make them. A few months ago I bought a six piece lot from one of the small-time dealers that regularly come by, in order to obtain the only piece in that lot that really interested me: a BaKongo *maternité*—a mother with a child. In order to get it, I had to buy the whole lot. That's how it works; in order to keep the relationship going I am almost obliged to buy. We all have our own game to play. He wants to sell as high as possible, I want to buy as low as possible. You don't show too much emotion, but a little bit emerges nonetheless. That happened on a Friday evening. The next morning, when I came downstairs and looked at it in daylight I immediately noticed that the *maternité* was a shrewd forgery. So it still happens. When buying, you try to react to your intuition, to really use your eyes and think; but at the same time you cannot show too much interest, you have to act fast, make snap decisions, negotiate a fair price, make the deal. In fact, it is only then, once you've got the piece, that you have time to examine it at your leisure.

How do you go about examining an object?
The better objects are subjected to a standard inspection which normally takes up to a few hours. Everything is looked at thoroughly: the type of wood, any other materials used, manufacturing techniques, dyes, pollen, patina, wear and tear, the nature and extent of any restoratory work. Those are the basic things. Next, you study the style and the iconography, what it represents, by comparison with other pieces. This is where the literature and my large data base on Central African art come into play. That is the first part of the judgment process, the analytical phase. The second part is more intuitive. I put the object in a cupboard, the one which I call my "observatory," under spotlights, on a very slowly revolving plate. Then I sit back and let it sink in. Now, contrary to the negotiation situation, I have time to observe it properly. Through such a standard examination a buy that at first sight I had thought was authentic can still be proven to be false. Every now and then that happens, not often, but with a certain regularity. This procedure also helps to prevent me from making mistakes with respect to my clients.

How does the world of collectors of ethnographics in Belgium compare to that in the Netherlands?
First of all, it must be said that in the Netherlands there is a much wider-spread interest in ethnographics than in Belgium. Next we have to establish that people in the Netherlands people are much more easily satisfied—or should we say too easily satisfied? In the Netherlands, people buy a great deal of mediocre or even fake African pieces, which

Dutch dealers generally buy here in Brussels, or from African runners. Dutch dealers also buy some rather third-rate stuff from me, for very little. Belgian collectors tend to have better taste. In Belgium, there are perhaps twenty really serious collectors, almost all of whom wish to remain anonymous and are pretty well-to-do: lawyers, medical specialists, industrialists, noblemen, and so on. What's curious, incidentally, is that they sometimes prefer to buy abroad, for example in Paris. Ironically, you can buy plenty of pieces there which in fact are the property of Belgian dealers who are aware of this phenomenon and sell them through colleagues there—which, of course, makes the pieces more expensive.

What, as a dealer, are your experiences with tribal art auctions?
I have very mixed feelings about them. Like most dealers, I buy and sell a lot at auctions, where, unfortunately, a lot of games are played. The only auction house that I really trusted in was Christie's of London. As for the auction world in general, and Paris in particular, I don't trust anybody. It is all quite dodgy, while at the same time they handle a lot of good stuff every year. 1996, for instance, was an especially good year: in June, three fine collections came under the hammer at Drouot: the Pierre Guerre collection from Marseille, that of the Van Bussels from Amsterdam and the Jernander collection from Brussels.[235] Jernander, like myself, bought a great deal from Belgian ex-colonials. The auctions yielded a lot, but the yield was not optimal in my opinion because so much was put on the market at the same time. Had it been more spread out, it could have fetched twice as much. I bought several pieces on those occasions.

Both in the Guerre collection and in that of the Van Bussels, there was a wonderful Fang byeri reliquary figure. To me, the two pieces seemed equally beautiful, old, and well-documented. Nonetheless, to my surprise, the Guerre Fang fetched three times as much as the one from the Van Bussel collection. How is that possible, and why is it that Fang figures are so expensive in the first place, often several times as expensive as equally fine figures from other categories?
As far as I am concerned both pieces were indeed equally fine. The difference is that Guerre's Fang has become an icon, while the other is simply a good Fang and nothing more. The Guerre Fang has been exhibited and published on many times since the thirties, much more so than the Van Bussel Fang; therefore, it has a better pedigree, and consequently more prestige and a greater value. Furthermore, you may have noticed that the Guerre Fang has been rendered in a drawing by the renowned artist Arman, a collector himself; the drawing was on the

MARC FELIX AND THE CONGO

175

cover of the auction catalogue. That also adds to the pedigree. And why are Fang reliquary figures so expensive in the first place? Well, I can tell you: they are easy—of course, they are old and beautiful, at least a certain number of them, but above all they are easy. Many of the very rich collect art in general and spend tens of thousands or even hundreds of thousands of dollars on one purchase without much further thought. Some of them, at some point, become interested in primitive art. For those people, a Fang is one of the more obvious choices: it is recognizable, well-known and prestigious. Most of the really good Fang *byeri* are in the possession of people who don't collect African art as such. There you won't find any Baule from Ivory Coast or Sukuma from Tanzania, for Baule is too delicate, to refined for them, while Sukuma is too coarse, too wild. They want something in-between. It has to have something mysterious, a quality a good Fang figure usually possesses, but on the other hand, it must not be as frightening and extreme as BaKongo *nkisi,* "nail fetishes." All in all, Fang fits the bill perfectly.

You just mentioned your private collection. So you do have one?
Of course I do. There are three people inside of me: the dealer, the collector, and the scholar. Each of them looks at things with a different eye. Up to this point in our talk, I have mostly been speaking as a dealer. I am busy with African art twenty-four hours a day. I don't have any hobbies. In fact, I have two large collections, which are both still growing. Each fulfills a personal passion. One of them is a typological Congo collection, which has to be as complete as possible. We are talking about some three hundred tribal groups here. I collect as systematically as possible, with a particular interest in the gradual transitions between style areas. As a scholar, I buy research pieces for this typological collection for which neither the dealer nor the art collector in me has any interest. The other collection consists of classical pieces from Congo, which aesthetically belong to the international apex. In this collection there is Luba, Songe, Tabwa, Chokwe, Yombe, Lengola—you name it; everything. Every time I find a better piece one of the others has to slide down the scale. While my typological collection has to do with culture and cultures, this one is about Art—with a capital A. In both cases, my aim is not commercial but purely idealistic. Eventually, I want to present the typological collection, which to me is the most important, to a university, where it is to be used for study and reference in the training of a new generation of specialists in the field. The art collection, on the other hand, will go to an art museum.

Now we touch upon a second period of your life, if I may call it that, which began around 1985.
You can certainly call it that, for the last twelve years or so, I have indeed been on a new track. Up until around 1985 I was mainly dealing, and even today I still deal, though less intensively then before. About twelve years ago, however, dealing was pushed into second place, for since then my real mission in life has been to document as completely and scientifically as possible the art production of Congo. My typological collection is part of that project. Up until then I sold everything on. It's strange, isn't it? I began as a collector, then I became a dealer, and now I am collecting again, albeit in a different way. Actually, it all began because I was embarrassed that I had so little documentation to pass on with the pieces I sold. It just wasn't available. Time and again, I couldn't answer the questions of my buyers well enough, so I started to search for literature and documentation everywhere: in the Africa museum in Tervuren, in the library of the former Ministry of the Colonies, and in various Belgian university libraries. But there appeared to be no good reference works. You could find a little bit here and there, but that was all.

About ten years ago, I bought your first book, 100 Peoples of Zaire and Their Sculpture.[236] *So that book was in fact a solution to this problem?*
The book was an initial solution to the problem, as I made clear in the foreword. In it, I laid out the main facts as they were then known pertaining to a hundred tribal groups, together with drawings and short descriptions of the most important types of objects. Each tribal area had a page of text and a page of drawings. The basis for this was the folders with clippings, copies, and notes that I had made for each tribe, and added to pieces I sold. But as I already said: it was just an initial solution. More important was my initiative, in the eighties, to set up a documentation centre for Congo art, the Congo Basin Art History Research Center. Now that I am over fifty, I don't go off into the bush so lightly. The pleasure that I used to get from physical challenge I now get from my mental efforts. Finding that out was one of the greater surprises of my life. When I was forty-five, I thought that the best years of my life were over, but now I know that if I am lucky enough to have one I shall greatly enjoy my old age.

What should I envision when you say documentation centre?
I have gathered together a group of paid and volunteer staff, six or seven people. Everything, and I mean quite literally everything, known on the arts of Congo is made accessible through an enormous data base, which is divided into style areas: all the literature, from the earliest to the most recent, up to and including the most obscure articles in missionary periodicals; all known photographs and drawings of objects and their

ritual or daily ethnographical context; information retrieved from auction catalogues on pedigrees and prices, and so on and so forth. We pay attention to the materials used, technology, iconography, style, typology, ethnography and the life history of objects. In addition, every Central African work that comes in is photographed digitally and extensively documented. We have our own technical draughtsman and use the most advanced digital technology.

What do you intend to do with the data base?
First of all, I want to know as much as possible about the things I myself am trading. Secondly, when consulted by a museum, for instance, I get along all right with the expertise I have built up, but the judgments I render as an expert, however reliable they are, are still pretty much intuitive. What I want is to be able to explain and argue to others more explicitly what I am intuitively pretty sure about. Thirdly, and most importantly, all others who are interested must have free and complete access to this information. Everyone should be able to consult the data base. We are also busy creating a course in Central African tribal art, which will offer the hands-on experience that is missing everywhere, especially for young people: the pieces, not just the pictures.

How highly do you value Belgian academic scholarship with regard to tribal art from Central Africa?
I greatly appreciate the work of a number of Belgian scholars, for instance, Daniel Biebuyck, author of the two-volume standard work *The Arts of Zaïre*,[237] and Jan Vansina, another Belgian anthropologist, who teaches in the United States. They are both very sensible scholars who have carried out extensive fieldwork, have had intensive contact with the people, and are thus capable of compiling, generalizing, explaining, and extrapolating data in a manner that shows their feel for the local relationships. On the other hand, I do not have a very high opinion of certain structuralist ethnologists. They are intelligent people, much more intelligent than I am, but they do not really look at the material with regard to form and style, and understand nothing of stylistic variations and developments. The preconceived theories in their heads select only those facts that fit their theories, facts which, to make matters worse, they obtain mostly from secondary sources, and in translation, not the original languages.

What's the present situation in Belgium, at universities and in museums, as far as scientific research on tribal art is concerned?
Sadly, the politicization of scientific circles has advanced to an extreme. What is more important than the skill and knowledge of the candidate is

the language one speaks, and the individual's religion, political orientation, gender, skin colour, and connections. If the job is intended for a French-speaking socialist it will go to someone with that background, regardless of whether there are better candidates. As far as that is concerned Belgium is corrupt. One example is the Koninklijk Museum voor Midden-Afrika in Tervuren, where the head of the ethnography department is a very capable, internationally-known specialist, but in the field of South-American Indians. In this museum, which boasts the finest collection of Central African art in the world, there is now, ironically enough, a dearth of expertise with regard to this region. Take a few good Central African figures to this museum for Central Africa and you will find out immediately that they are not capable of interpreting them. In Belgium, there are also unfortunately quite a few scientists who are rather narrow-minded, and hide their lack of expertise and their fear of real experts behind an ivory tower mentality—as though there is no expertise outside their academic circles! That, I really can't stand.

What's your own ideal as to how to proceed when studying the tribal art of a region?
My ideal, apart from a solid base in research and fieldwork, is a round table with all the pieces on it, and completely open discussions between those sitting around that table: members of the tribal group in question, preferably initiates, dealers and curators, ethnographers and linguists, historians, missionaries, and materials experts. That would be the ideal situation, but unfortunately the reality is quite different. An awful lot of rubbish is being written by people who haven't been out in the field, or perhaps only for a few months, who don't speak the language, who are familiar with just one of the angles of approach I just mentioned and who don't care to consult with specialists from other disciplines.

How do you see the relationship between dealers and museum curators?
Generally speaking, it is strained and ambivalent. In museum circles, nowadays, you hear a lot of criticism aimed at dealers, but let's not forget how much museums depend on dealers, both as far as expertise goes and in putting together their collections. In the last thirty years or so, a great deal more has been found out about African forms of expression and their contexts, much if not most of that thanks to dealers, who have explored Africa thoroughly and uncovered a lot of new stuff. An example is what was made known about East Nigeria at the end of the 1960s. Or take the amazing art of the Hemba, the Kusu, and the Bango-Bango in Congo: that was completely unknown, while they are by no means small tribes. Take the Moba in Togo, the Lobi in Burkina Faso: completely unknown. However, there are two sides to this. On the one

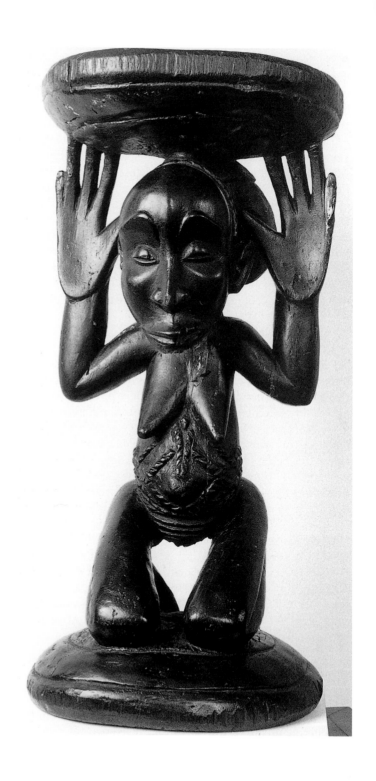

hand, dealers literally save pieces which are then preserved and studied in western countries, which is positive. The tragic part of it is that the dealers take away the good traditional pieces which are the examples the younger generation needs.

At the same time Christian, Islamic and new syncretistic beliefs are pushing aside the old, mythical, "animistic" convictions and rituals. Yes, and because of this the people there know less and less about the traditional art—which, after all, is not *l'art pour l'art*, but ritual art. I have often enough saved rejected objects from rotting away in areas that had recently come under the influence of Islam; these were things for which the people no longer had any interest. I am not a saint, and I don't want to be one, but this just happens to be the case. Let's be honest, on other occasions I have also messed up whole villages and even given cause for bloodletting when an old village head sold me an item to which others in the village still attached great significance.[238] I am aware of the good and the bad aspects of my trade.

Let's get back to your scholarly efforts. 100 Peoples of Zaïre *was the first of a series of thorough monographs, on Maniema masks, the art of Tanzania, and that of the Ituri forest, the KiKongo speaking tribes, the stylistic variations of Congo masks, and so on. Your most recent book deals with the masks of Zambia.*[239] *Relatively unknown territory?* Sure. Only little was known on that subject. The masks from Zambia bear salient cultural and stylistic relationships to masks from neighbouring Congo. I did fieldwork for it, scrutinized as many masks in collections as possible, and scraped together as much information as possible from all kinds of sources. I look at geographical distribution and numerous types of affinities, primarily with neighbouring groups, but also with groups in a range of about a thousand miles. In a number of cases this provided surprising clues regarding the area of origin and the diffusion pattern of a certain tribe or style. My next project, by the way, is a completely revised and updated version with colour drawings of *100 Peoples of Zaïre*, which has fulfilled an obvious need—some five thousand copies have been sold.

39. A so-called caryatide stool of the Luba, Eastern Congo (see text). About twenty stools in this particular style are known, which are all attributed to one hand—that of the Master of Buli—or at least to one workshop. Collection M. Felix.

My last question, Mr. Felix: until now, what has been your greatest surprise or discovery concerning one single piece?
My most exciting episode was discovering a Caryatide stool by the so-called Master of Buli, in 1980. At that time, about twenty such stools were known, all of which were attributed to one craftsman—Frans Olbrechts coined the phrase "the master of Buli"—or at least to one workshop.[240] They are about half-a-meter high and were used in the swearing-in ceremonies of tribal chiefs by the Luba and the Hemba of East Congo. When I came across this one, a similar one had just been auctioned at Sotheby's in London for US $ 540,000, at that time a record price that made the papers worldwide, and was paid by the Metropolitan Museum. Six months later, to everybody's surprise, a stool of the same type, which is very rare, was brought to the same auction house (Fig. 39). This time, however, there were doubts about the patina, which differed from that on the first stool, so it was sent to the museum in Tervuren to be examined. The style and the materials turned out to be exactly right, as did the stool's age, which was established through ring dating of the wood. The somewhat strange patina appeared to have to do with a very thin layer of plaster that had been applied by way of restoration and covered with dye. On an X-ray, this plaster layer was clearly visible, covering large parts of the surface, and this lowered the value considerably, for repairs are not supposed to be too extensive. The evaluation in Tervuren came to the conclusion that the stool was authentic, but had been heavily restored. Now at that time, I was an advisor to Sotheby's, and when I was there judging other pieces, not this one, I was told the whole story. It would not be put up for auction, it was said, because it was too incomplete. I took the piece and weighed it. Plaster is heavier than wood, so the piece, in view of the extensive restaurations, should have been relatively heavy—heavier than had it consisted of pure wood. In my judgment, however, that was not the case. So I became interested, and was able to buy the stool for a fraction of the price I would have paid had it been intact. I had the restoration reversed, during which process, every step of which was photographed in detail, it appeared that only a few small areas had been restored and that the restorer had smeared a thin layer of plaster over a large area so as to make the whole seem as even as possible, after which he had applied the paint. That explained the misleading impression that the x-ray had made. I was on cloud nine! That piece is currently worth about a million dollars.

2.4 Tijs Goldschmidt, Art Collector

I'm talking with Tijs Goldschmidt, in his apartment which looks out over a beautiful stretch of Amsterdam canal. We are surrounded by Asmat and Sukuma carvings and *gope* ancestral cult boards from the Gulf of Papua, but also by contemporary art from Dutch artists such as Reinier Lucassen, Jan Roeland, Arjanne van der Spek, and others. Goldschmidt grew up in Amsterdam. He is a biologist and writer who regularly publishes on evolution, animal behaviour, and art and literature. He has written a doctoral thesis on the ecosystem of Lake Victoria in East Africa, as well as scientific articles and a book for the general public, *Darwin's hofvijver*, published in English as *Darwin's Dreampond*, which was well received in the Netherlands, the United States, Germany, and Japan.[101] Goldschmidt says he doesn't feel like a collector.

You don't want to be seen as a collector?
I don't really care how I'm seen. What I care about is that I don't feel like a collector, even if others call me one. I'm surrounded by objects fraught with meaning: drawings, paintings, carvings, photographs. I want to be near them. I think a collector is more systematic, someone who strives for completeness, who still wants this or that in his collection because he sees a gap. I've never gone about it in that way. But perhaps my view of the collector is too narrow. In any case, I'm an art-lover and it doesn't really matter where that art comes from. But I do have a predilection for contemporary western art, and for non-western art which, I believe, is related to it. If I'm on holiday somewhere where there's no art around, it doesn't take long before I start feeling miserable. During a long period when I was ill and couldn't work, what kept me going were the art objects in my room.

How did it start, your fascination with ethnographics?
"Ethnographics"? Again, it's art that interests me. I associate ethnographic objects with clubs and axes of remote peoples, with stories of cannibals. I'm not interested in people because they're remote or

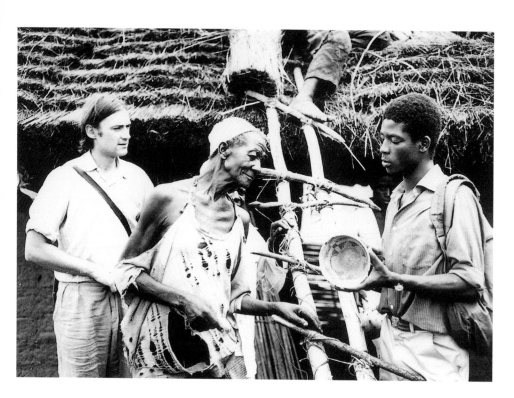

40. Tijs Goldschmidt (left) with his Tanzanian research assistant Kevin Makonda (right) in a village near Usagara, Tanzania, 1985. The Sukuma man in the middle is explaining the meaning of the abstract patterns on the woven basket Makonda is holding. One of the patterns symbolizes the renewing of the roof—an activity that happens to be taking place in the background. The baskets are made exclusively by women.

cannibalistic, but because they make beautiful carvings. But let me tell you how it all started. In high school, I was already fascinated by the marvellous, metres-high ancestral poles of the Asmat of Irian Jaya which were in the Amsterdam Tropenmuseum, and also by modern and contemporary art. In books, I came across "nail fetish" figures from the Congo which had a magnetic effect on me; I thought they were magnificent. As a student, in the early seventies, I was looking for a place to live in Amsterdam. There were scarcely any affordable places available, but at one point I found a ground-floor apartment which had previously housed an antique shop. The owner said I could live there on the condition that I ran a shop. I agreed and registered at the Chamber of Commerce as Goldschmidt & Sons, open only on Saturdays from two

to four. It was mostly a joke, but I did have to put something in the shop or the owner would start nagging me. The problem was what, in God's name? Then some friends put me in contact with an elderly lady who lived in Zaltbommel in the central Dutch province of Gelderland, in a stately house beautifully situated on the river. She had lived in Indonesia for many years, when it was still a Dutch colony, and had returned to the Netherlands in 1931 with her family and a few score of indigenous objects she had collected with love and affection; you could see that in the selection she made. They had been lying around in her attic for years, and she wanted to dispose of them, so she asked if I would act as intermediary in their sale, and I did. She set the prices herself.

What kind of things were they?
They included ancestral carvings from the Indonesian island of Nias, a *korwar* ancestral figure from the Geelvink Bay area on the northwest coast of New Guinea, several Dayak masks from Borneo, and woodcarvings from Bali and Java. I was particularly impressed by one Nias carving made in a flattened branch which forked as it extended upwards. At the fork, a head had been carved; halfway down the branch was a phallus. It was an *adu hörö*, the personification of an ancestor standing at a strategic position near a house or at the entrance to a village in order to protect the inhabitants. A good carving, although not nearly as beautiful as they can be when the carver leaves some of the carving simply as a branch.[241] If you follow the carving with your eye you feel alternately: branch, carving, branch, carving, branch, carving. It's acrobatics on the tightrope between a piece of wood and expression.

How did your interest and taste develop after that?
I visited museums, read a lot, looked at pictures in books endlessly, and learned a lot from other collectors. Whenever I could afford it, I bought pieces from Indonesia, New Guinea, and Africa. Much later I came into contact with Dutch artists who were also collectors, like Lucassen, Vandekop, Freymuth, and Villevoye—and I learned a lot from them. My interest in both contemporary and non-western art has developed at about the same pace since. It started through my contact with the artist Reinier Lucassen; a wonderful initiation. He has an utterly distinct way of looking at objects that falls outside the standard canons of beautiful and ugly, patina or no patina, good or bad, authentic or false. That man knows how to look, has a unique eye.

Your fieldwork as a biologist in East Africa probably played a role in your development as an art lover, or not?
Oh, yes. I lived in Tanzania for five years during the 1980s. I worked with Tanzanians among whom there were many who saw themselves first as Sukuma or Nyamwezi and only then as Tanzanian. Unfortunately, tribal sentiments run deep. The Sukuma and Nyamwezi make highly expressive, crude carvings, but I didn't get to see them. I did see dance and singing performances though, in Usagara, a village south of Mwanza (Fig. 40), on Sundays, on a wide open plain surrounded by high rocks, the bodies of the dancers painted frighteningly white, like ghosts, the dead.

You didn't manage to collect any Sukuma carvings during that period?
I never saw any then, let alone collected them. There was beautiful basketwork, though, baskets with patterns woven into them with coloured grass, so-called *masonzo*. They used to be made by the women, in large numbers, but they have become less important since the advent of aluminium and plastic. There was a language encoded in the patterns. Through the symbols on a basket, the women were able to vent their feelings about things that couldn't be talked about. Although there was still fine traditional basketwork in those days, I never saw any carvings. Not even the Sukuma museum near Mwanza had a single Sukuma or Nyamwezi carving, and I don't remember seeing any in the National Museum at Dar es Salaam either, at least not on display. For decades, the mission and the Socialist government, led by Nyerere, pursued policies that actively discouraged traditional practices. Awful things seem to have happened and sometimes still do: witchhunts, clitoridectomies, and other medically unacceptable practices of traditional healers. A Western biologist couldn't lay his eyes on carvings, unlike the big dealers who could put money on the table. Belgian and French dealers bought up Tanzanian carvings while I was studying the colour patterns of small mouthbrooding fish in Lake Victoria. I would have given anything to have been able to be the first to choose two carvings. It wasn't until 1990 that I saw my first Sukuma and Nyamwezi carvings and that wasn't in Tanzania but, strangely enough, in the Netherlands. Rudi Fuchs had brought a beautiful exhibition, "The Standing Person," from the Ludwig Museum in Cologne to the Gemeentemuseum (Municipal Museum) in The Hague, where he was director, and there they stood. I was particularly impressed by two life-sized Sukuma carvings, a pair. Later, three carvings were sent to me through a colleague. They had been brought to his house as a delayed reaction to the question I had posed to several Nyamwezi: "Do you have any carvings?" I still clearly remember the reaction to that question, "What are you going to do with them?" My reply was "I"m going to put them in my house." This made those people

laugh heartily: that I wanted to put *their* carvings in *my* house. One of
them said to another, "I guess they don't make any carvings themselves."

Where, in general, did your new acquisitions come from?
From galleries in Amsterdam. Until recently, it wasn't a bad place to buy
them. At least not if you had an unusual taste, like me. Patina doesn't
matter to me the way it does to so many dealers and ethnographers. A
poor carving with an old patina or with old Western labels—and thus
with a "pedigree "—is often valued more highly than a good carving that
hasn't been used. Whether a carving has been used or not can be of
interest to an anthropologist or ethnographer, but it doesn't matter to
me. A carving doesn't become more expressive through use. The painter
and art historian Roger Fry already resisted the glorification of patina at
the beginning of this century, and Lucassen voiced opposition to it also
on several occasions, but these protests don't seem to have helped. In the
early nineties, there was virtually no interest in Sukuma or Nyamwezi
carvings and these carvings had no status at all as collector's items in the
Netherlands. That's ideal, of course, if you love carvings which fall outside
the value hierarchy dealers try to impose on their clients. I'm not saying
these dealers aren't or won't eventually be proved right financially, but I
don't think that's the most interesting aspect of art. Until 1990, these
carvings had scarcely or never appeared in books; some dealers even
claimed they didn't exist at all. They were probably right in saying that
"old" as well as new carvings were being made for the market in
workshops. If such carvings are intentionally aged through mistreatment
or giving or the application of an artificial patina then I'm not interested,
but I have no problem at all with a good new carving. This differs from
the ethnographic approach. Why should a carving that an African makes
to sell not be a good one? In any case, I took great pleasure in these
carvings which were not supposed to exist; had it been assumed they did
exist they would undoubtedly have been unobtainable for me.

*So you collect, purchase, following your own private intuitions and without
a preconceived aim, without a system?*
During the rare periods when I could afford it, I bought intuitively,
sometimes too impulsively; I have made mistakes on occasion. The
surprising part of it is that you really only realize how you looked at those
mistakes in retrospect. A good collector doesn't know how his collection
will develop any more than a writer knows which direction his book will
take. A collection developed on the basis of passion may not be as
troublesome as a growing child, but it certainly does rise up in revolt and
occasionally imposes its will, its own system, so to speak, on you.
Carvings exist in relation to each other, they can make or break each

41. Part of the interior of Goldschmidt's living room, with juxtapositioning of tribal and contemporary art. *Wow ipits*, the text in the painting by Reinier Lucassen, one of Goldschmidt's mentors, is the Asmat term for a woodcarver. The shield which is partly visible to the right of the painting is a recent Asmat one; underneath the painting stands a rare, very old shield from the Asaro River area, Papua New Guinea, and to the left hangs a *gope* ancestor board from the Gulf of Papua.

42. Barkcloth aprons made by Mbuti Pygmy women from the Ituri Forest in Congo, spread on the floor of Goldschmidt's living room. Against the wall are three Asmat ancestor figures.

other. You can damage a collection by buying things that don't fit into it, or by getting rid of essential links. If you're not careful, a collection can be ruined in this way.

In looking at the non-western art in this room (Figs. 41 and 42), I notice a distinct preference for Oceania.
Yes. I wasn't aware of it at the time—such things become clear only later on. From Africa, I bought only a few carvings by the Nyamwezi and Sukuma, and in buying them, more than just sculptural quality play a role. I wanted to have them near me because I thought I recognized in them the mentality of the people among whom I had lived so happily. Four almost man-sized carvings stand behind me in my studio. I feel their support in my back as I work.

What has the selection of carvings in Amsterdam been like since you started collecting here?
In addition to a more or less steady stream of the usual objects, every so often you will see a lot of objects show up in Amsterdam from one specific area. First there's nothing, then suddenly there's a lot, then there's nothing again. The reasons are often tragic: civil war or famine. The owners of the carvings have been killed, forced to sell them, or forced to flee and leave them behind. In such a war situation, there's nearly always a shopkeeper around with a garbage bag, ready to load up abandoned objects. There's something repulsive about it, but I don't really know if it's bad. Things do get saved this way. Lucassen and I talked about this recently. Nowadays, it's politically correct to be against taking carvings out of Africa. I, too, am against this, if the cultural heritage is being destroyed on a large scale, as in the Niger delta, or if objects are being stolen from African museums, but I think it's ridiculous to say anything in general about it. Very often local governments care little about such carvings, and do nothing to preserve them, while the population has long lost any interest in them. Is it so bad then if some of them are taken to the West for a while? There, they will end up in museums or with collectors who care about them. Today, a century later, the Japanese are buying back their prints, and the same thing could happen one day to African art. On the other hand, it's painful to see a book like *African Art in American Collections*.[242] All those beautiful things are in America and there's almost nothing left in Africa. What we need now is a volume on American art in African collections! A lot of Ibo carvings came to the West around 1970. The reason: the civil war in Biafra. When there was fighting in Mozambique in the eighties and many of the inhabitants fled to neighbouring countries, a lot of traditional Makonde masks turned up here in Amsterdam. I'm not sure whether that had to do with the war in

Mozambique, because carvings from neighbouring Tanzania also showed up here through Western dealers and, increasingly, African dealers. For years in Tanzania, I never saw one Sukuma or Nyamwezi carving, even though I spent every day with people of the Sukuma tribe; but I had scarcely found my way back to the Netherlands, or these carvings landed on my doorstep. It's strange!

To return to the affinity you have with artists: that must have to do with your basic aesthetic appreciation of objects.
As I said, my interest is not ethnographic.[243] I'm not trying to form as complete a picture as possible of the material culture of a tribal group and certainly not to present that culture in its ethnographic context. The only thing I'm interested in is the quality of a carving. In the best case, form and content engage in a symbiosis, and it's impossible to say where the dividing line is. In that case, the carving begins to glow. Incidentally, the same applies to a poem. What were you asking about again? You can't say anything meaningful about art. Whether an object is "early" or "late," "used" or "not used" in an indigenous ritual context, is, I think, immaterial. It only matters whether the carving moves me. There are beautiful *gope* cult boards with highly stylized renderings of the dead from the Gulf of Papua which were carved for the market in the 1970s. Anyway, why should Western artists be allowed to make things to sell but non-Western artists not be allowed to do the same? In my opinion, that's only the newest form of Western paternalism. If you ask me, it comes from being afraid to look with your own eyes. The "ethnographers" among the collectors are willing to study a carving very seriously when they find themselves standing face to face with it, as long as, for the love of God, they don't have to look at it.

So a tribal object, as far as you're concerned, doesn't have to be old?
No. The Asmat from Irian Jaya have been making beautiful ancestor figures and man-sized shields in recent years. You have to look carefully, because there's also a lot being made that doesn't have much quality. The good things are those made by *wow ipitsj*, the traditional woodcarvers. They're still around and new carvers are joining their ranks every day. In addition, many less-talented people are also trying to make wood carvings to sell; what they make isn't always as successful.

You mentioned the Asmat. You have beautiful Asmat carvings (fig.42) and shields here. You spent a few months there two years ago, didn't you?
Yes, but all but three of these carvings were bought in the Netherlands and date from the 1950s. I was in the Asmat region with a friend of mine, an artist who travels there regularly, and it made a deep impression on

me. I had already wanted to go to there before, but it has only just become possible again: the Asmat region was closed off to tourists for many years. Besides, I wasn't free to go earlier, for I had to finish a few articles first and the book about my stay in Africa. To my own amazement, I found, in old notes, that I'd already been fascinated by the Asmat in the early 1970s. The visit there made a big impression on me. The Asmat are people who know only their own carvings and ideas. Their minds don't immediately start comparing the way ours do. In the Netherlands, a mind that doesn't compare but looks is almost certainly that of a poet or an artist. You see the way I immediately start making comparisons with the Netherlands? Among the Asmat, the user of an everyday object literally makes it his own by carving references into it to his dead ancestors. I am aware that as a Westerner I look at those ritual objects with a totally different eye than an Asmat. I will never be an Asmat, but I did want to feel more of the way they experience things than a carving that has been torn out of its context can facilitate. I would dearly love to have an Asmat mind for a few days. In the Netherlands, you see only the carvings, not the people. The Asmat no longer exist, it is generally complained in Amsterdam, Brussels, and Paris. That fascinated me. Every day at home, I was surrounded by Sukuma and Nyamwezi carvings which were supposed not to exist any more. So, I finally wanted to see the culture which dealers, museum staffers, and documentary makers said no longer existed. Nowadays, the Asmat are supposed to be Catholic, Coca-Cola drinkers, and second-rate citizens, but it isn't like that yet and perhaps never will be. I have seen a Coca-Cola-drinking Catholic make a very good carving. Apparently, that's not an impossibility. There's also still a lot of rainforest left, but it's true that it's being destroyed very quickly and with the full approval of the Indonesian government. What bothers me is that people in the West are saying that the Asmat no longer exist, while what I found there was a highly dynamic culture. The Asmat are the ones who will decide when they no longer exist.

2.5 Coos van Daalen: Collector and Auction Expert

I have scarcely walked through the door of the old house packed with
exotica and Coos van Daalen is already pushing a shield into my hands
that is supposed to be from the Dayak in Borneo but is quite different
from the normal type. It is obviously very old, but painted with European
paint, with coarse patterns that have nothing of the usual refined and
symmetrical Dayak curls. He wants to know if I have ever seen anything
like this before, and if I can place it. But before I have time to really look
at it the conversation has already shifted to a *korwar* ancestor figure
from New Guinea that is going to be auctioned in Amsterdam. Is it
authentic? It appears to be caked in sacrificial blood, which is a good
sign, says van Daalen, but it is of a rather singular style. This sets the
tone for our conversation. We spend the whole afternoon and part of the
evening moving through the over-full and chaotic interior of the house,
going from one object to another, at the same time making great leaps
across the globe, through cultural history and through van Daalen's life.

On the door of the lounge, there is a yellow newspaper clipping with
the German phrase "Auch das Chaotische hat sehr viel Kreatives und
Liebenswertes an sich" (Even in chaos, there is much that is creative and
much to be appreciated). At the time of this visit, the chaos is even
greater than usual in this cabinet of curiosities due to renovation work
that is being done, but the clipping, sent years ago by a German
collector-friend of the van Daalen's, proves that a certain degree of
disorder is an integral part of this household. On the kitchen table, there
is an open copy of a handbook for Dutch customs officials pertaining to
the recognition of various types of ivory, tusk, and bone—much too
complicated for ordinary officials, in van Daalen's opinion. Mrs. van
Daalen lies bed-ridden in the front room. She is of German origin, and
was trained as an ethnologist specializing in Africa. They have two
daughters, one of whom has studied Japanese and works and lives in
Japan, while the other has a shop selling antique books which is lavishly
adorned with family ethnographics.

Van Daalen (1922) studied Japanese language and culture in Utrecht
and his birthplace of Leiden for several years, but did not complete his

studies due to the war. Collecting ran in the family, and he has, in fact, continued the collecting activities of his parents, both of whom were teachers born in the Netherlands East Indies. Most of the parents' collection was lost during the war. After the war, he worked in a furniture factory, where he became familiar with types of wood and methods of woodworking. Subsequently, he also began to restore antique furniture, and eventually became an auction expert specializing in ethnographics and oriental antiquities, working for the Lempertz auction house in Cologne as well as for other German and Dutch auction houses. He has compiled countless auction catalogues, many of them together with his wife, in which he has committed to print some of his knowledge and insights. Known far and wide as an uncontested authority on both ethnographics and orientalia, Coos van Daalen has helped with many museum exhibitions, often lending pieces from his own collection as well. When he gave the following interview, he was still on the road every week to the degree that he was capable, for he was recovering from a mild stroke and still somewhat shaky on his legs.[244]

How did it all start for you?
My parents collected extensively: Chinese porcelain, textiles from the East Indies, Japanese *tsuba* and *netsuke*, ethnographics, and so forth. As students in Leiden, they often went to the Rijksmuseum voor Volkenkunde, which in those days was still on the Rapenburg, in the old von Siebold house. That's where it all began for me too, for I accompanied them there even before birth. Later, in the thirties, we lived in Rotterdam, and thanks to their steady income as teachers they were regularly able to buy exotic articles in the antique shops they browsed around in. At the shop of a certain antique dealer in Utrecht we received a *netsuke*—a carved Japanese belt knot— as a present for every piece of Chinese porcelain we bought. I remember well how my mother once virtually exploded when my father came home with a whole bag full of kris hafts that he had received for free from an antiquarian in The Hague; the antiquarian had torn off the hafts to function as handles for walking sticks, and my mother found that barbarous. As a boy, I used my pocket money to buy my first *tsuba* —Japanese sword rings—at van Veen, a well-known Rotterdam company that, in addition to tea and silk, also imported heavier things which served as ballast in its ships. An awful lot of nice things arrived in Rotterdam, one of the world's largest harbours, from overseas.

Do you have a favourite line of approach?
I have several lines of approach, but the most important one is the materials from which the objects are made. That's the first thing I pay

attention to when I get my hands on something. I look at the materials—with suspicion. You must always start with mistrust. Due to my work as a furniture maker, I have developed a feeling for the characteristics of different types of wood and the techniques used to work them, but also for the metals from which, as a furniture maker, I used to make my own woodworking tools. I have a very complete reference collection of materials here—mineral, vegetable and animal, from all over the world—together with a great variety of objects made from those materials.

For instance?
I have some examples here in these boxes: teeth of different species of elephant with the typical lamella, not to be confused with ivory from the tusks; hippopotamus' teeth—if you come across an object in Eskimo style made from that you know immediately there's something fishy; bone and horn, of several species; the weirdest types of woods, with and without bark, and of each type a rough, a polished, a waxed, and a brushed example; countless types of coral, shell and mother-of-pearl; narwhal tusks; ray, shark, and fish skins, which, incidentally, are materials that are also very popular in western art and arts and crafts; skin and leather of mammals, at all different stages of tanning and processing; reptile skins; coconut—you could hold a complete exhibition on that alone, which I believe has been done; many sorts of gourds; other fruits, and, of course, also their seeds; the quills of porcupines; all types of feathers; beetles; tree ferns; all manner of fungi—you'd be amazed by the things that have been made of that material; and the list goes on. What are the characteristics of these materials? What determined why certain materials were chosen? It can be anything, for instance, the natural form. Here, I have a so-called annunciation—a statuette of the Blessed Virgin hearing that she shall give birth to Jesus—made of a hippopotamus tooth, the natural curve of which has been used by the artist to render her praying position.

Your activities as a restorer must have contributed greatly to your expertise concerning materials.
As a restorer, you're in a position to gain a great deal of hands-on experience; you deal with a wide range of different materials in a very intimate fashion. How do they wear out, how do patinas build up, how deep do they normally go? What sort of restrictions, problems and possibilities are posed by various materials, and how did various cultures and various individuals cope with them? When you make comparisons between different cultures you often see that given a certain material and certain tools in different times and places, people independently arrive at the same solution. Some things you discover by accident, for example that a certain Japanese *netsuke* in my collection is made of a beautiful but

43. Mr. Van Daalen looking at one of his subcollections: a cupboard full of krisses and kris hafts from the Indonesian Archipelago.

strange cloud-like material from the inside of an elephant's tusk which has been deformed by disease—look, here is that *netsuke*, and here is an example of the type of pathological raw material it is made of. Incidentally, I can't show you everything right now, because a lot of my raw material is currently at the *netsuke* exhibition in the Rijksmuseum voor Volkenkunde in Leiden. What I do have to show you is this complete skull of a hornbill from Borneo, and these Dayak earrings made from this particular part of the upper bill.

Is the way in which you have compiled your collection based on your passion for raw materials?
To a certain degree, yes; it has to do with my interest in materials and in the technical aspects of the fashions in which they are worked and processed. I've always collected the smallest everyday types of objects, things with which people live, with which they clothe themselves, which they keep in their houses, but which may also be part of their religious

activities. Little things which they keep in their pockets, like small knifes with worked hafts, or amulets to ward off dangerous spirits. I do have a few masks and larger carvings, but an awful lot more in terms of woven cloth, buckles, headdresses, aprons, betel nut cutters, fans, and smelling bottles. My interest in weaving patterns and the application of beads is an extension of my interest in materials. In these areas, I also have reference collections. In particular, glass beads with their specific characteristics concerning material and style give you a lot to go on when tracing the origin of the object they are part of, and in dating it. Often beads were not made in the area in question but were obtained through trade. My Japanese *netsuke* and *tsuba* are my favourite everyday articles. As far as my *tsuba* are concerned, well, they're pretty special—possibly the most complete collection in the Netherlands.

What about your krisses and kris handles from the Netherlands East Indies? You enjoy a reputation in that field as well.
Kris hafts are one of my favourite types of object (Fig. 43), but in this field there are certainly even better collections in the Netherlands, really beautiful ones. Often, only the hafts are collected. Some collectors have the barbarous habit of removing and disposing of the blade. In one case, I know for certain that this was because the collector's wife didn't want to have any weapons in the house, but that was an exception. I use the word "barbarous" not only with regard to the feelings of the many genuine afficionados concerning such practices, but also with regard to the feelings of people from Indonesia, who cherish, deeply respect and even fear krisses as sacred family heirlooms.[245]

You said you preferred little objects, but I see quite a few larger objects around us here: some Moluccan ceremonial parry shields,[246] a Sepik mask, spears from the Geelvink Bay, paddles from the Asmat Papuans, an African Kuba mask decorated with beads, Javanese and Balinese wayang topeng *masks (Fig. 44), machetelike* mandau *from the Dayak of Borneo, and even ... isn't that the door of a Hindu temple?*
Yes, it's from Lombok, done in Balinese style, nineteenth century. Professionally, as an auctions expert and a restorer and also as a collector, my field of interest has always been very broad. Coincidence plays a certain role—it also depends on what comes your way. Of course, because of my work a considerable amount has come my way, from the estates of the recently deceased, for example, or from defunct collections of missionary societies. The Sepik mask hanging there is from the Steyler Missionare, and I bought those Asmat paddles from the Missionaries of the Sacred Heart in Tilburg.

44. The Van Daalen family's washroom, adorned with a collection of *wayang topeng* masks from Java (up right, below left) and Bali (the two far right of centre).

I gather that basically your collection is not one, but an aggregate of various subcollections?
You can see it that way, for I do indeed have a number of collections: the kris hafts, the *tsuba*, the beads and beadwork, Indonesian bottle stoppers, New Guinea bone daggers, Indonesian textiles, and so on and so forth. Each one has a central theme, such as the materials used, the techniques adopted, but also phenomena of acculturalization: the adoption of materials, motives and style characteristics originating from other cultural areas. For example, European soldiers are depicted on this bamboo quiver from the Toraja in Sulawesi; on the haft of this Dayak knife from Borneo, a so-called *mandau*, you can see the carved head of a figure from the Javanese *wayang* theatre, done in horn; and here I have an old-fashioned plane, which is a typically European tool, but made by the Dayak and decorated entirely in Dayak style. That I find fantastic. By the way, I think that people often jump too quickly to the conclusion that similarities in style between different areas are the result of influence or acculturalisation. In fact, many similarities are a result of the fact that clever people hit on the same solutions, even less obvious ones, independently of each other.

So your collecting activities have been guided by roughly three points of view: materials, techniques, and acculturalisation?
Yes, but that's not it completely. Another angle from which I work is articles with indigenous repairs, such as this West African gourd here, and yet another, a fifth angle of approach, if I am counting correctly, is formed by gradual geographic shifts in style. These three ceremonial parry shields are an example of such shifts. One is from Sulawesi, the second from the northern Moluccas (see Figure 2 for three comparable shields), and the third from the northwest coast of New Guinea. What I regret is that in ethnological museums today you can't take your own object from display case to display case anymore until you find one that resembles it. Previously you could easily find twelve or fifteen pairs of *ibedji* twin figures from the Yoruba in Nigeria in a single museum, whereas nowadays you will only find one pair, illuminated with a spotlight and surrounded by masses of text, diagrams, maps, and photographs.

So you attach a great deal of importance to the series?
Yes, but not the series of beautiful things, but the series of relevant types, collected systematically. In the fifties, Dutch ethnological museums sent C.M.A. Groenevelt[247] to New Guinea as an official collector. But what did the good man do? He only sent the most spectacular pieces home, as a result of which Dutch museums have hundreds of decorated Asmat paddles, like these three here, but scarcely any undecorated ones, which

COLLECTOR AND AUCTION EXPERT

199

were in fact much more the norm. The most beautiful things from New Guinea were transferred to Dutch museum depots in large quantities, but when they wanted to do something on the preparation of sago in an exhibition there wasn't one complete sago set to be found anywhere in the Netherlands, while that's the most everyday piece of equipment in every village in New Guinea. I find that unacceptable. Basically, my collection is one for reference and comparison, in which you can find as many materials, techniques, styles, and style shifts as possible; it is not primarily a collection of beautiful things.

2.6 Anthropologist and Curator: Dirk Smidt

Dirk Smidt (1942) is a curator through and through, and one with considerable experience in the field, whose activities to the present can be divided into two phases: from 1970 to 1980, when he was affiliated with the National Museum and Art Gallery in Port Moresby, Papua New Guinea, and from 1981 to the present, period in which he has been curator of the Oceania department of the Rijksmuseum voor Volkenkunde in Leiden. One of Smidt's strong points is his meticulously detailed contextual analyses of Oceanic objects. In Port Moresby, thousands of ethnographics from the hundreds of cultures of Papua New Guinea passed through his hands, and, equally importantly, he had the chance to carry out fieldwork in different parts of the country. As a result, he developed an expertise regarding the tribal art of this part of Melanesia which is the envy of many.

How did you end up in Port Moresby?
Through one of my instructors, Adrian Gerbrands, who was a professor of cultural anthropology at Leiden University from 1966 until 1983 and thereafter worked at the Rijksmuseum voor Volkenkunde, also in Leiden. When he travelled to New Britain in 1970 to carry out fieldwork among the Kilenge he heard from the trustees of the museum in Port Moresby that they were looking for a temporary substitute for the head of the museum, who had taken a six months leave, and he recommended me. The six months became a year, which then became two years, and in this way I became a more or less permanent employee of the museum. I worked in different functions, including those of director, assistant director, and subsequently researcher. In the latter position, I had fewer administrative duties, and was able to devote more of my time to fieldwork. It was an exciting period, which included Papua New Guinea's independence in 1975. As Australia offered generous financial support for "cultural development," it was possible to expand the collections greatly, and we made a serious attempt to protect the cultural heritage through a National Cultural Property Act.

Were you influenced by Gerbrands' specific line of approach?
Certainly. As a student, I had worked with Asmat material at the Leiden museum which he had collected in 1960/61, in the village of Amanamkai. He had concentrated his fieldwork and collecting on the individuality of the *wow ipits*, the woodcarver. One result of that research was his well-known film *Matjemosh*,[248] named after one of the Asmat woodcarvers he had studied; another was his book on Asmat woodcarvers in general.[249] I was deeply impressed by both, and while working there helped prepare an exhibition on this subject in Antwerp. His stress on the individuality of the artist has also come to characterize my own fieldwork. I turned my attention to the social and religious context, to symbolic meanings, and to technical aspects of woodcarving, which you can't separate from the social and verbal interaction between woodcarvers, between teacher and pupil, and with those present.

What was the focus of your fieldwork in New Guinea?
In 1976/77 and 1978/79, I spent two periods of a good six months each in the Ramu river basin in the north, studying the Kominimung. In addition, in the seventies, I spent a number of shorter periods, varying from several weeks to several months, in the field, in the Sepik area and among the Kilenge in West New Britain. I also made a short collecting trip to the various groups on the Gulf of Papua in the south, which was relatively close to where I was based in Port Moresby. Virtually nothing was known, apart from a few shields, about the rather idiosyncratic art of the Kominimung, a small group of around 330 people on the Goam, a tributary of the Ramu. The masks and figures that I saw when I went there for the first time were completely new to me, although I had by then already seen a great deal, I didn't even recognize them from pictures in publications.[250]

Apart from fieldwork, what were your other tasks in Port Moresby?
In the period I was working for the museum, the collection grew from some 7000 to some 23,000 objects, all of which passed through my hands. They had to be identified, documented, catalogued, stored, and if necessary restored. Some of them were used in our exhibitions. I also saw a great deal that never ended up in the museum, for another of my tasks was providing export permits to scientists, collectors, dealers, and others, and, if necessary, having objects classified as "of national importance" confiscated by customs, under the National Cultural Property Act. There were a number of major dealers in the country, especially in the Sepik-Ramu region which could claim tremendously rich art traditions.

How did these dealers go about their business?
They operated through networks of locals who tracked down objects for

them, they searched themselves, and sometimes pieces were also offered to them at home. Sometimes they negotiated for years with the owners of irreplaceable treasures, for instance, figures of clan founders, until the locals finally came around. Often the younger members of the tribe would finally sell only after the older people had passed away. One instance concerned a ceremonial hook from the village of Nyaurengai, in the Iatmul area, portraying a life-size standing male figure. I had just photographed and documented it in the village, and with permission of the owners had had it declared national cultural property when, just before the declaration was to appear in the government gazette, we heard that the figure was at the home of a dealer. When we approached him about it he maintained that it had just been stolen from him, which was nonsense, of course. We then publicised the case, so that the figure became unsellable, and eventually the dealer sent it to the museum, where it is now part of the permanent collection.

Isn't it hard to imagine that the original owners sold such a sacred and cherished figure just like that?
Well, in fact they didn't sell it just like that. It appeared later that it was a bit more complex. Before they sold it, for a quite a lot of money, at least according to local standards, they had a copy made. Scrapings from the cheeks, the neck, and the chest of the old figure were put on the new one in a ritual manner, to enable the spirit of the figure to house itself in the freshly carved copy, thus rendering the old statue a mere shell and making it possible for it to be sold.[251]

The objects confiscated in those years must be a substantial collection, if the exhibition catalogue The Seized Collections of the Papua New Guinea Museum *is anything to go by.*[252]
There were some very special pieces, or rather, they were virtually all pretty special pieces in their original settings. In that catalogue, which appeared in 1975 on the occasion of an exhibition on the art we had confiscated in 1973, I described 104 objects we had seized. These experiences have steadily made me very aware of the problems of maintaining and protecting the cultural heritage. What we were trying to do, to put it bluntly, was to see that the country wasn't stripped of its treasures.

How did you get along with the tribal art dealers that operated in the country?
Every now and then there were conflicts, but basically there was a sort of arrangement: if certain things were given to the museum, for which the dealers were remunerated in some cases, then other items would be

ANTHROPOLOGIST AND CURATOR

203

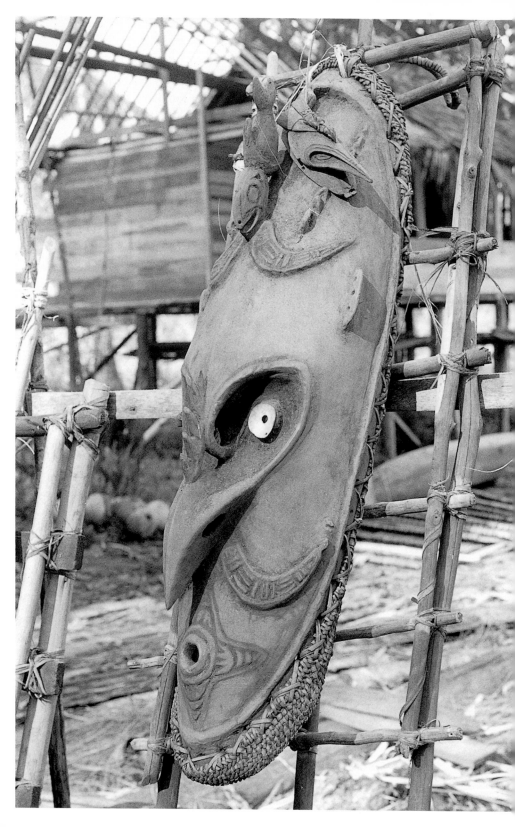

permitted to be exported. Of course, we were in a very strong position for negotiating, with the National Cultural Property Act on our side. Sometimes confiscations from dealers led to emotional scenes, including screaming rows, but the major dealers were noticeably self-controlled, with an attitude of "it's all in the game." In general, relations between museum staffers and dealers are ambivalent. You get in each other's way and you have a different agenda and a different professional ethic, but at the same time you have the same interest in quality and you respect the expertise of the other. Sometimes you might even have a beer with each other. Personally, I have always preferred some contact above no contact at all. Dealers often have specific knowledge and contacts that are difficult to come by for a curator; because of all your duties in such jobs you just don't have the time for it. On the other hand, a dealer collects in the field without many scruples, while anthropologists are always weighing the pros and cons of taking something with them. Dealers say that villagers sell objects to them of their own free will, but I know from experience how forceful such a request to sell can be. I am convinced that villagers often sell things that deep in their hearts they don't what to sell, and regret it afterwards.

There is a word of thanks in the back of the The seized collections
catalogue expressing gratitude to a number of people for providing
information concerning the origin of some of the objects described.
Ha! I am not giving away a secret if I say that that does, in fact, refer to some major dealers—well-known names. In 1973, a number of dealers attempted to export a large collection of objects from various regions. Some of the pieces confiscated were completely new to me, I had never seen anything like them, either in collections or in publications. Information provided by the dealers mentioned in the catalogue led me to the places where they had originated, in the Middle Ramu area, where I subsequently carried out some research.[253]

45. The Murik Lake mask (see text) as it was photographed by Smidt in 1971 in the village of Mendam, Lower Sepik, Papua New Guinea, one year before a dealer in tribal art tried to smuggle it out of the country. The wooden mask is now preserved in the National Museum and Art Gallery, Port Moresby, Papua New Guinea.

How did the 1973 confiscation of tribal art take place?
Rumors and reports had reached us at the museum that dealers were busy secretly buying up objects on a large scale in various districts. We set up a large-scale investigation together with police, customs, and Post and Telegraphs authorities, complete with search warrants and inspections of warehouses at a number of airfields and harbours. That led to some results, but what we found on the tenth of July in a warehouse at the Madang airfield exceeded our worst expectations as far as both quantity and quality were concerned. There were seventeen large crates packed full of the most beautiful and rare tribal art from the Gulf of Papua, the Sepik and Ramu river basins, and the mountains: shields, *gope* ancestor boards, an *agiba* 'skull keeper', ancestor figures, spirit masks, drums, neckrests, chairs, and so on. One of the masks, a large one, was from Murik Lake, the area from which the Prime Minister at that time, Michael Somare, came. It was so sacred that he had not yet been allowed to see it, for he had not yet undergone the requisite initiation by the clan elders. We had been searching through tons and tons of cargo for three days in Madang, and were about to call off the raids, when we found these seventeen crates literally at the last minute, a few hours before the cargo plane was due to leave. All of the objects were confiscated by customs and two years later officially presented to the museum. One year earlier, I myself had photographed (Fig. 45) and documented the Murik Lake mask in Mendan, the village from which it came, and in the same year it had been published in the *Government Gazette* as "Proclaimed National Cultural Property."[254]

The mask represents a spirit?
It represents, or rather is, a mythical ancestor spirit called Gweim. Interestingly, this old mask was not made in Mendan, where it was later preserved and subsequently bought by a dealer, but in Gapun, to the southeast, near the mouth of the Sepik. According to what I heard from the people of Mendan, this particular spirit was reputed in Gapun to be a killer of people and a causer of miscarriages and illness, which was why the people of Gapun had wanted to get rid of him. The grandfather of the person who was the keeper of the mask in 1971 had come across Gweim when he was in Gapun, and been impressed by his power. Therefore, he acquired this powerful mask and brought it back to Mendan with him, where Gweim began to play a new, more positive role in the beliefs of the community. This is a good example of the traditionally richly patterned movements of objects in that particular region not only to places outside, but also within the region, from village to village.

As to movements to places outside: how is the ritual art of the Murik Lake area represented in western museums?
Quite adequately, in fact. The Field Museum of Natural History in Chicago has an outstanding collection from this area, brought together during the Joseph N. Field South Pacific Expedition to Melanesia, between 1909 and 1913.[255] In addition, as you might expect in view of colonial history, German museums have beautiful material, part of which was accumulated by German missionaries—among others Father Joseph Schmidt, SVD.

Let's get back to the practices of dealers: for every piece that was brought to safety there were probably several others which were successfully smuggled out of the country?
Sadly, yes. Shortly after the 1973 seizure, for instance, we were too late when several French collectors cum dealers escaped in a private plane with a whole cargo load of artefacts from the Gulf of Papua. Still, I do derive a certain comfort from the fact that in those years we were able to realize the implementation of strict laws to prevent this type of trafficking. In another case, a book appeared in which a number of ancestor boards and a unique statue from the Orokolo Bay area (Fig. 46) were illustrated which were still preserved there, and had long been kept hidden from outsiders. Because we were afraid that this publication would lead to initiatives on the part of dealers, we decided to anticipate their movements, in cooperation with a member of the board of the museum who was from that area, the later Minister of Foreign Affairs, Sir Albert Maori Kiki. After lengthy discussions and negotiations with the people of the village, we acquired those items for the museum.

Didn't you have mixed feelings about taking sacred things away from where they belonged?
I did, indeed, but in that case it was the only option left. In the museum, which was not far from the area in question, the objects would be safe and would still be accessible to the villagers. In particular, the owner of the figure only agreed after long hesitation, for he wanted to bury the figure in due course. Its spirit had appeared to him and made it known that its power was coming to an end in these modern times and that it wanted to be buried in western clothing. At that time, I still saw things very much from a western perspective, primarily weighing the national and international interest of an object. Nowadays, I would probably let the views of the local people play a more important role, and would hesitate more before asking them to part with an object. I know from my own experience how much pressure such a request can put on people.[256]

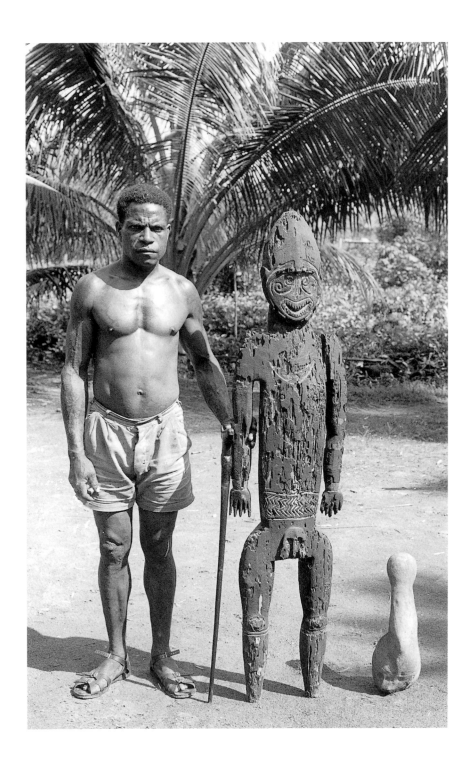

One of the differences between the anthropologist-curator and the dealer is, of course, that the former sees an object primarily in its cultural and ritual context, while the latter tends to pay more attention to aesthetics, patina, and age. But I've often caught you, in my eyes an exemplary anthropologist-curator indeed, showing enthusiasm for beautiful old pieces, for instance, during a course on Oceanic art you gave in the Leiden museum.

I approach an object first of all as a piece of culture, and accordingly also advocate the preservation and study of recent products, made for sale, that have little value to up-market dealers. But I am also interested aesthetically; that is how I initially got involved with tribal art in the first place. An anthropological, contextualizing approach doesn't mean that you can't look at it aesthetically at the same time, and I will certainly allow aesthetic considerations to play a part in the new permanent exhibitions that we are now setting up in Leiden. But as far as I am concerned, the unconditional rejection of market-orientated carvings by many collectors and most dealers takes things too far. There are remarkable pieces among them!

Can you give an example?
I'll give several. Just go and have a look at the interiors of Roman-Catholic churches in the Asmat region, or at the way in which native dances and rituals influence the Christian liturgy in the whole Pacific area! Another example is the Wahgi Valley (Papua New Guinea) shields which could be seen at the 1993 exhibition *Paradise* at the Museum of Mankind in London. On some of them, "six 2 six" or "6 two 6" was painted, which was a statement by their carriers that they were prepared to fight from six in the morning till six in the evening.[257] On other shields, you see the trademark of the national brand of beer, "SP," which stands for South Pacific. Western oilpaint and all, I think such things are wonderful! Culture is a bubbling, living thing and not a fossil, as many patina-minded collectors would have it. Last but not least, there are the aesthetic standards of the native makers themselves. If you want to find out what those standards are, you're back to the ethnographic approach. Basically, good documentation of an item is more important than its aesthetic value, and how the people themselves see it is more important than how a collector or dealer somewhere else sees it. A piece plus documentation is a museum piece, as we in the museum world say.

46. The Orokolo Bay ancestor figure (see text), photographed by Dirk Smidt in 1971, shortly before he collected it for the museum in Port Moresby. To the left, a family member of the owner of the statue; the stone figure to the right right depicts the aucestor's wife.

ANTHROPOLOGIST AND CURATOR

209

In your opinion, is there indeed a sharp line which can be drawn between woodcarvings for local use and market-orientated ones?
Certainly, but not always. In 1993, during a collecting trip to an Asmat village, I had some shields carved to order for the museum; these were clearly associated with certain deceased villagers. Before they were handed over to me a ritual was carried out: an arrow was fired "to release the spirits from the shields," spirits which were thus sent to the realm of the spirits where they could not annoy the villagers anymore. Here you see how the two extremes of "authenticity" and "non-authenticity" virtually coincide. Another example is a *mbisj* ancestor pole of perhaps five metres tall which is now in the private possession of someone here in Holland who worked as a doctor among the Asmat. At the top of the pole is a remarkable figure, portrayed wearing glasses: the Dutch colonial official Hein van der Schoot, who was presumably regarded as a reincarnated ancestor, or at least represented that way. "Authentic" or not?

Western influence on native art production in many cases seems to go all the way back to the time of the earliest contacts. This once again would prove "authenticity" to be a problematic concept.
I agree. In the Sepik area, just after the first German collecting expeditions, there were suddenly large—too large—numbers of so-called debating chairs on offer from ceremonial houses. Seekers of authenticity sometimes have double standards: they consider recent Asmat carvings to be inauthentic, but nobody asks how authentic a *malanggan* sculpture from New Ireland is if it boasts a beautiful old label in German and was collected around 1890, given that, as is described by German sources, things were being produced for sale on a fairly large scale at that time. In some cases, it is difficult to tell which things were and weren't made for proper use. Pieces for export were often more richly decorated than was traditionally the case. Age is, of course, a relative concept: what is collected now will also be old in a hundred years time. With regard to the future, I would recommend that quality be given attention when collecting, and that includes letting local aesthetic standards play a role.

In 1980, you returned to the Netherlands to take up the position that you have held since that time: curator for Oceania at the Leiden Rijksmuseum voor Volkenkunde (Fig. 47). What have the high points in your activities been since then?
What I enjoyed most was a 1987 collecting trip to the Abelam in the Sepik area on behalf of the museum, together with Noel McGuigan, an Irish anthropologist who had worked for years as a teacher in that area.
There, I bought the more or less complete interior of a *haus tambaran*, a ceremonial or spirit house. McGuigan had drawn my attention to the fact

that the owners wished to sell it after completion of the initiation rites for which it had been made. We are going to set it up permanently in the museum.

Shortly after you returned home I heard you give a talk on that adventure. The impression that I got was that it was an authentic piece of centuries-old tradition, directly from the primeval forests of New Guinea. Shortly afterwards, however, I spoke to the Dutch anthropologist Ton Otto, who, on his way back from fieldwork on the Admirality Islands, was in the same village a week after your departure, where he regretted that he had missed you. He told me that many of the villagers had been drunk, that they had already spent the money they had received for the interior of the house, and had begun on a new house in order to sell it to the next museum that came along. That doesn't quite fit with the way you described it in the talk. Ah! So you say I have been romanticizing it! I see. I am going to have to defend myself a little. There is indeed some market-orientated production, but as far as iconography and style are concerned those woodcarvings are largely very traditional, just like the initiation rituals they were made for, and as such they are certainly worth it ethnographically. Less traditional, but as remarkable, was a woodcarving in the house on which the national emblem of Papua New Guinea was carved, together with a cow's head. The cow's head referred to a cow at the mission post with which the makers of this carving were to be paid in exchange for their work. The maker appeared to have gotten the idea for this uncharacteristic carving while working in a completely different part of the country, New Britain. Both the initiation and the sale are two pieces of original, living culture that are not mutually exclusive. So once again, you can see that culture is something very creative and dynamic.

Point taken. To get back to your activities in Leiden: your collecting trip to the Abelam was in a sense an extension of your work in Port Moresby, but in Leiden you've also revived an old interest—an interest in the Asmat. In 1993 you edited Asmat Art: Woodcarvings from Southwest New Guinea.[258] In 1990, we held an exhibition here in Leiden on Asmat shields and figures which was subsequently moved, in a slightly different form, to the Museum Justinus van Nassau in Breda, which has since closed. The book you mention was connected to those activities. In 1995 I put together an exhibition, again in Leiden, on continuity and change in Asmat woodcarving since 1960, focussing on woodcarvings by Matjemosh of Amanamkai which had been collected by Gerbrands in 1961, by Jac Hoogerbrugge in 1970, and by myself in 1993.

47. Anthropologist-curator Smidt in one of the depots of the Rijksmuseum voor Volkenkunde in Leiden in 1997, handling an Abelam mask from the Sepik area.

As a curator for Oceania, do you collect actively, also with respect to other areas within your region?
Yes, but on a very modest scale; in that respect, there's no greater contrast with my work in Port Moresby. There, well over a thousand objects came in yearly, while here it may be ten or at the most a few dozen. We were recently able to buy a magnificent *korwar* ancestor figure from the Geelvink Bay, Irian Jaya, which is certainly one of the finest known, and was brought to the Netherlands before the Second World War.[259] Someone showed up at the museum with it and asked us to have a look. It's amazing what can still be found in private homes dating from the colonial era. But there's little acquisition. The yearly budget for my region is very small—approximately 5000 dollars. You can hardly buy anything for that amount of money. When we buy, we try to do it

systematically, filling gaps in our collections. There's a lack of money, space, and staff. On the other hand, of course, we have a great deal of beautiful early material from Oceania in the Rijksmuseum voor Volkenkunde.

For ten years, you worked in a non-western ethnographic museum, and now you have worked for eighteen years or so in a western institute. Is there a big difference?
That's an interesting question, and one which has preoccupied me for quite some time. There is a tremendous difference! A western museum holds up a mirror in order to let you see that the way things are here is not the only possibility. It helps you discover, appreciate, and admire other cultures and puts your own cultural identity in perspective. In non-western museums, such as in Port Moresby, it is precisely the other way around: there one's own culture is discovered, appreciated and encouraged—it is not put into perspective as just one among many others, but is presented as something to be proud of. In western museums, sacred articles are, so to speak, desacralized by showing them to the uninitiated; they are used as material for study or approached aesthetically. In non-western museums, on the contrary, sacred artifacts are respected; they are seen as having a soul and appreciated for their inner spiritual power. This is, of course, in part because in non-western museums the people from whom such articles originate themselves participate in their presentation in museums. Another difference is that in western museums international unity is stressed, while in non-western institutions it is more about stimulating national unity in a multitribal society.[260]

Are there differences concerning the way in which collections are compiled?
Here, too, there's a considerable difference. In the colonial period, collecting in the West was done on a large scale, while it is now usually done on a small scale. In non-western museums, you see that collecting is now done on a large scale, in order to make up for the arrears. I already mentioned that in the ten years that I was in Port Moresby the collection grew by well over a thousand items every year. In this case, as is often the case, the non-western museum grew out of a small colonial museum that could only collect on a small scale because of its modest means.

48. Art historian and director of exhibitions Frank Herreman in New York, 1998, with two *minkisi* from the Lower Congo area.

2.7 Art Historian and Curator: Frank Herreman

One of the two curators given a chance to air their views in this book is Frank Herreman, who trained as an art historian and specialises in African art. From 1974 till 1995, he was a curator at the Etnografisch Museum Antwerpen in Belgium, holding the position of assistant director from 1989 to 1995. In 1996, he accepted the position of Director of Exhibitions at the Museum for African Art in New York.

I became aware of Mr. Herreman's activities pertaining to African art in 1990, when I visited the *Sculpture from Africa and Oceania* exhibition at the National Museum Kröller-Müller in Apeldoorn, the Netherlands. He had been consulted as an African art expert and contributed extensively to the exhibition catalogue, which was much appreciated for its professional, thorough descriptions and contextualizations of objects.[261] In 1993, I saw *The Face of the Spirits: Masks from the Zaire Basin*, an exhibition he himself curated in Antwerp and which subsequently travelled to the Smithsonian Institution, Washington, D.C.. That show established Herreman's reputation as an expert on African art and its ethnological backgrounds. The concomitant volume of the same title was well received by the professional world.[262]

Just as many of the most beautiful Central African objects in American collections came via Belgium, so too are a number of experts in this field working in the American museum and academic realms of Belgian origin. Through its historical ties with Central Africa, Belgium has the most complete collections and archives and a fine scholarly tradition—one Mr Herreman was trained in—pertaining to that area. He was not the first Belgian scholar from that particular academic tradition to make the move to the United States in order to share his thorough expertise with colleagues there; Daniel Biebuyck and Jan Vansina, among others, preceded him.

We talked in his apartment in a pleasant nineteenth-century part of Brooklyn, surrounded by modern art and a few African objects, and over lunch in the cafeteria of the Brooklyn Museum of Art, two blocks away.

In a remarkable essay entitled "New York post- et préfiguratif,"[263] the
anthropologist Claude Lévi-Strauss portrays New York, where he stayed
during the Second World War, as an amazing cultural wonderland, a
complex, chaotic and surprising Eldorado, not only for the anthropologist
and the afficionado of modern art, but also and in particular for the
collector of ethnographics. Can you relate to that?
Certainly. New York is a bubbling city, also with respect to tribal art and
its relationship to modernism in western art; the history of tribal objects
here is one which is added to on a daily basis. Lévi-Strauss, himself an
avid collector, offers a fascinating snapshot of the World War II period,
when, together with his surrealist friends, he tramped around searching
for ethnographics. Since then, the constellation of museums, exhibitions,
galleries, dealers, and collectors, and also, more recently, auctions, has
developed considerably here. Countless objects come and go, and there's
a lot of expertise. You could say that New York is one of the places where
it's all happening and where at any given moment there is a lot to be
seen. It is *the* center for American Indian art, and it competes seriously
with Paris and Brussels in tribal art from other continents.

How did tribal art come to be appreciated in New York?
That the art scene had much to do with it is obvious when you look at the
exhibitions that have been organized since the beginning of this century.[264]
Just around the corner is the Brooklyn Museum of Art, a typical
American museum set up in an encyclopaedic manner, where the first
real exhibition of tribal art expressly presented as such in the United
States, *Primitive Negro Art*, took place in 1923. A number of these
objects are still exhibited. Incidentally, "Museum Expedition 1922" is
written on their labels, which I find quite amusing because it hints at an
adventurous undertaking deep in the primeval forests of Africa, while in
fact it was a journey made by a curator, Stewart Culin, to Europe, from
one fancy hotel to another instead of through the rainforest. In Brussels,
he bought a number of articles that were on display at that first
exhibition and even today form the core of the museum's African
collection. *Ex Africa semper aliquid novi*, but then and still: through
Belgium! But to get back to your question: that 1923 exhibition was the
first of a whole series,[265] and galleries of primitive art had appeared in
New York even earlier, usually in combination with the work of
modernists, for example, in the gallery of the photographer, Alfred
Stieglitz.[266] Charles Ratton, the Parisian dealer in *art nègre*, did business
here too, in the thirties. He had good contacts with some galleries
through which he was able to sell tribal material that he bought in
Europe, partly from German museums. At the same time, he bought
Indian and Eskimo material here, mostly from Gustav Heye, the wealthy

collector with his own private museum, to sell in Paris.[267] Ratton was also involved in the exhibition *African Negro Art*, in 1935 in the Museum of Modern Art, for which he arranged the loans from Europe.

If the appreciation of tribal art here in New York began somewhere at the beginning of the twentieth century, then what about the American Museum of Natural History, here in New York, with its rich nineteenth-century ethnographic collections?
Well, you said it yourself: *ethnographic* collections rather than tribal *art*. In the context of the three large natural history museums in the United States, in New York, Chicago, and Washington, D.C., there has scarcely been any mention of tribal *art*, but rather of artifacts and ritual articles of "natural peoples," and that is still the case today. It comes out quite clearly in the three cities I just mentioned, where in the natural history museums they talk about ethnographics, while in the art museums right next door, they talk about tribal *art*: in New York at the Metropolitan, in Chicago at the Art Institute, and in Washington at the National Museum of African Art. It all boils down to the well-known controversy: art or artifact, an aesthetic approach or an ethnographic one.

What's the current situation in the ethnographics trade in New York?
It's a booming business! A noticeable difference with Paris and Brussels, the two other centers of the trade, is that there you are inundated with African art, while here in New York, that is only one of the areas, in addition to Oceanic and American Indian art. There are a great many dealers here, but only a few with open galleries. They prefer to work from behind closed doors, from their apartments. I have the impression that the dealer-client relationship is much stronger here than is usually the case in Europe. The art dealer is a sort of mentor, with a certain specialty, who maintains trust relationships with regular customers over many years. He gives them a ring whenever he finds something that fits into their collection. As far as African material goes, there are, of course, close connections with Paris and Brussels, from which a steady stream of objects flows. Dealing is a very international business; many dealers are very mobile, continually on the road.

What's your job here in New York?
I work for the Museum for African Art. We are a museum without collections, and only put on temporary exhibitions that generally go on the road after having been displayed here. That's why, strictly speaking, I'm not a curator here, as I was in Antwerp, but "director of exhibitions." The first two I helped with, as in-house curator, were *Memory: Luba Art and the Making of History*, put together by Mary Nooter-Roberts and *Art*

ART HISTORIAN AND CURATOR

217

of the Baga: A Drama of Cultural Reinvention, put together by the Baga specialist Frederick Lamp from the Baltimore Museum of Art.[268] Contentwise, I found the Baga exhibition the most interesting one. It was about new articulations of traditional Baga art and identity in the framework of opposition to political and religious repression from outside—a dramatic struggle. Subsequently, we produced two exhibitions that have been opened simultaneously: *To Cure and Protect: Health and Sickness in African Art*, and *Art that Heals: The Art of Healing in Ethiopia*. The first was entirely my own work, including its physical design. Some of my colleagues complain that they, to put it bluntly, tend to get demoted to being the lieutenant of the specialized exhibition designer, but luckily that wasn't the case this time.

How do you go about organizing such an exhibition?
The most important thing is the selection of good material. For *To Cure and Protect*, which was a relatively small exhibition with a hundred or so items, I visited dozens of collections and considered many hundreds of pieces. That's very exciting work. For the exhibition on Congo masks we put together in Antwerp in 1993, I held no less than two to three thousand masks actually in my own hands. Their quality differed enormously. You try and pick out the best ones. That show was a great success, also here in the United States.

Hundreds of styles in Africa, and thousands of pieces you have to choose from: can you cope with that, I mean: can anyone? Can one person have all the necessary experience and expertise?
Well, yes and no. Yes, to the extent that I eventually manage, and no, because nobody can know all the types and regions equally well. A thing which I realized time and time again when preparing those two exhibitions was how incredibly little is known about most of the masks and figures that we brought together. In *To Cure and Protect* alone, there was enough material for a number of doctoral dissertations. What I really enjoyed is that one of my close co-workers on *The Face of the Spirits*, Constantijn Petridis, actually produced a fine Ph.D. thesis at Ghent University in Belgium on the Lulua of Congo as a direct consequence of his work on that exhibition. One of the points he makes, with which I fully agree, is that it is not really useful to talk about "ethnic groups" because that suggests distinct borders. "Lulua" is a particularly good example: it's just a label which was stamped on a group by European colonial officials. What you usually see, however, is more or less a mosaic style of patterns and gradual transitions.

When preparing an exhibition, do you exclude articles that were not made for private use but for a local or western market?
No, certainly not! I don't think that we have the right to decide what is art and what isn't—who is an artist and who isn't. I try to leave that open. Art is something very special: the more you work with it the more you discover that it is something that just happens, in unexpected ways, in unexpected places, at unexpected moments. All of a sudden it is there, from its own background and from its own necessity. An example is the so-called naive or outsider's art that is arousing great interest at the moment. Here in New York there's an annual art fair where absolutely everybody who wants to show something can do so. A number of things that happen there are extremely exciting, while other things are banal, or produced primarily to make money. As in the case of outsiders' art, you shouldn't approach tribal art with preconceived criteria, but with as open a mind as possible.

Does that also go for non-traditional or less traditional African art?
Absolutely! The reinvention of tradition among the Baga is one example; another one is the intriguing work of the Congolese artist Tshibumba Kanda Matulu. Tshibumba painted in the mining towns of southeastern Congo in the seventies, in different styles simultaneously, in accordance with the taste of different types of clients.[269] I find the most fascinating a number of paintings he did for a clientele consisting largely of young Congolese intellectuals, about the life of the politician Patrice Lumumba; these paintings were based on press photos that appeared during his life and after his death. There you see something that is very characteristic of African tradition, more specifically of Central Africa, executed in a completely new form, in this case how a prominent person, someone crucial for the independence of Congo, is given the status of a cult hero. Representations of that person become icons.

Most dealers and collectors of tribal art, however, prefer "good," that is, fine traditional pieces, preferably early and patinated, above all else.
Preferably with a *patine téléphonique*, just like the old bakelite telephones! I can understand that. I myself like fine old pieces, but, on the other hand, find it a little bit monomaniacal, for you can't just rule out that very special things may appear at a more recent date, or in contact situations, can you? Take, for example, the native crucifixes that were made in the sixteenth and seventeenth centuries in the Lower Congo area under the influence of the missionaries: gorgeous! On the other hand, I must admit that I have grave doubts about an awful lot of modern African art. But isn't that quite normal? Look at the great Dutch painters from the seventeenth century that everybody knows: how many were

there who are now no longer remembered by anybody? The same goes for the present-day modern art scene here in New York with its hundreds of galleries.

How, as a curator, do you relate to dealers in tribal art? Curators and dealers are interested in the same things and have similar expertise, but they frequently get in each other's way.
As a museum person, I have always tried to maintain good contacts with both dealers and collectors, but you do have to be on your guard against too close a relationship—for instance, when you are paid for your expertise. Dealers often know a great deal and do their own research in their own way, which is, of course, a prerequisite of the job: if they don't know what they are doing, it can cost them a lot of money. A number of dealers I know in Belgium—for instance, Marc Felix or Pierre Dartevelle—have a thirst for knowledge, a burning desire for the truth about things, and that for them is the most important thing. Felix' documentation centre with its huge data bank on the arts of the Congo Basin bears testimony to that. It's no coincidence that he contributed to the catalogue I drew up, *The Face of the Spirits*, on the zoomorphic masks of East Congo, a subject he knows very well, and that he worked on the catalogue that accompanied the large Berlin exhibition on Tanzania in 1994.[270] Here in the United States, curators are often on good terms with dealers. Museums buy from dealers, dealers may act as sponsors, and the dealer's best clients are on the boards and among the friends of the museums.

What's your viewpoint concerning the questions of cultural property which a number of your colleagues are having so much trouble sorting out?
When a while ago an exhibition on archaeological finds from Niger opened in the Parisian Musée des Arts d'Afrique et d'Océanie, the same type of objects appeared in the hands and showcases of many dealers, while the whole point of the exhibition was that the cultural heritage of West African peoples should be protected. That upset me. I understand perfectly what those of my colleagues who take a sharp stance on this mean, but I am somewhat less extreme. I think there is something wrong with the system. If you dig up two thousand Nok terracottas, should you pile them all up in the depots of your museum while you only put sixty or so on display? I don't think so.

So how do you think things ought to be organized?
I think that we should strive for a system which preserves the most important items as "national heritage," while the rest is open to traders and collectors, having first been checked and documented. Good

documentation is also a form of conservation. I know of many large museums with hundreds of thousands of artifacts in their depots, including series of hundreds of the same type, but with only a few percent of the total, sometimes less than one percent, on display. I don't believe in that. In the Etnografisch Museum Antwerpen, where I was curator, some fifteen hundred Congolese knifes are preserved in the reserves, while a strict selection of, say, four hundred of those knifes would offer an excellent and relatively complete typological set, which, for museum purposes, would be perfectly sufficient. The rest only costs money and space, so why not document it and then recirculate it? That's how I see it, but the Antwerp museum falls under municipal regulations which forbid deaccessioning.

What do you think of the sale, in the forties, fifties, and sixties, of thousands of fine objects by the Heye Foundation? George Gustav Heye didn't fancy certain things, for instance, elaborately decorated Yup'ik Eskimo masks from Alaska, which he found too carnival-like.
That was an example of extremely careless deaccessioning. Most of the masks formed parts of a whole, made for one ritual, and were well documented, something which usually isn't the case with Yup'ik material collected early on. There were masks that belonged together in pairs or in threes, but Heye probably saw those simply as redundant double pieces.[271] Of course, it is essential that deaccessioning is done carefully and in a scientifically responsible fashion, and that such disasters are avoided.

Ironically, however, the pieces Heye sold were thus prevented from mouldering away in a museum depot, and many came to play a role in surrealism when artists such as Max Ernst, René Breton, and Roberto Matta got their hands on them!
That's correct, and indeed ironic, but there's a considerable difference between what happened in the case of the Heye Foundation and what I suggest for ethnographic museums, for there are tens of thousands of Congolese throwing knifes in various museums and private collections, while Eskimo masks are rare, as was known even in the period when they were dumped on the market by Heye. A restricted number of known examples is in itself a reason not to make such a decision, as is the fact that objects often form sets. I am not against certain articles circulating, but in this case, it would probably have been better if the masks had stayed together. "Deaccessioning" can't be allowed to take place simply on the spur of the moment, or as a result of the taste of whoever is holding the reins at a certain point. On the other hand, nobody can see into the future—there's always an uncertainty factor.

Do you yourself collect?
I don't. Museum people shouldn't collect privately, in order to prevent conflicts of interest. Nonetheless, apart from some contemporary art, I do possess a few African pieces. In my case, you can rule out a conflict of interest because I work for a museum with no collection. To be precise, the Museum for African Art possesses exactly one object: a Baule mask from Ivory Coast. The few things I possess are important to me. I sit looking at them at unexpected moments during the day. They give me a great deal of pleasure, and they certainly help me subconsciously in judging other works of art. As far as that's concerned, I can understand the collectors who really want to possess, to be close to their treasures every day.

Is there much difference between collectors in Belgium and those in the United States?
At a certain level, a collector is a collector; it has to do with a passion for possession. Next, it has to be said that in the United States, not least of all here in New York, there are a goodly number of really wealthy collectors who operate on a certain scale, although it can't be said that they all have as much taste and expertise as they have means. Some of them act as trustees or philanthropes of museums, donating pieces, or an entire collection, or money. That's one way in which many tribal objects end up in museums. For wealthy Americans, in general, it is not infrequently the case that, at a certain moment in life, for reasons of prestige or family tradition, they will donate part of their possessions or money to an institution for the good of the community, such as a hospital, library, university or museum. Philanthropy is part of being a respectable, well-to-do citizen here, while in Belgium it is the exception, not the rule. What they get in return is honour and recognition—unless, of course, it takes place anonymously. Many museums in the United States are not state-run but have to look after themselves. The Museum for African Art, for instance, does a lot in the way of fund-raising. Sponsorship by business corporations constitutes another source of income for museums.

"At a certain moment in life," you said—so it's usually about somewhat older people?
Something that I have noticed here in New York is that not just philanthropists, but also most collectors of African art are a bit older, in their fifties or sixties. Now that I think about it, I realize that it's moving in that direction in Belgium, too. I have the impression that it's because this sort of material requires a certain maturity. You don't immediately get access to African art; it takes time. Additionally, there is, of course, a financial aspect: these days good African art costs a lot, and the price

keeps increasing. Usually people can only afford it after they have worked a long time. Then, of course, there's the generation aspect: people who are now in their sixties had a better opportunity to obtain good pieces for reasonable prices earlier on. Since then good pieces have become much scarcer, and in part because of that, prices have increased enormously.

Could you name a few New York collectors?
I could, of course, name many; two well-known collectors are the psychiatrist and anthropologist, Werner Muensterberger, and the wealthy anthropologist and Inuit specialist, Edmund Carpenter. Muensterberger, who is Dutch and lived in England for a long time, wrote a psychoanalysis of the collector a few years ago.[272] While it received a mixed reaction, also from collectors, I personally found a number of things in it which confirmed my own opinions. The French artist Arman, another fervent collector who lives here in New York, told me not long ago, and he seemed quite amused, that he found it an exceptional book on himself.[273] Muensterberger is a psychiatrist with a Jewish background. Remarkably, quite a few New York collectors of tribal art are psychiatrists or psychoanalysts by profession, and have a Jewish background, like Muensterberger.

You expressed your appreciation for the expertise of certain dealers. How do the collectors you know rate in that respect?
Through their intimate dealings with pieces, they often develop considerable expertise in their field. The Belgian artist Willy Mestach, for example, is an expert in the art of the Songe of Congo.[274] Many collectors I know in Belgium and here in the United States are really driven to find out more about the objects they possess. I particularly admire the highly specialised ones, those individuals who only have ten or fifteen objects, all from the same region or pertaining to a very specific theme, but every one of them so beautiful that it takes your breath away. Contentwise, such collections can be much more powerful than large ones that lose part of their intensity through sheer size.

In Belgium, was there a clear connection between art and ethnographics, as there was in New York and Paris?
As I see it, the influence of African art upon the work of Belgian artists has been only marginal, in any case, much less extensive than, for instance, among the cubists and surrealists in Paris. There were several good Belgian artists with decent collections, like René Guiette, but no trace of it can be found in their art. There is, however, a certain connection with Flemish expressionism. Gust De Smet, for instance, appears to have been influenced by BaKongo grave figures from Congo which, probably even

ART HISTORIAN AND CURATOR

223

before sale to colonials, frequently had an anecdotal character, representing music makers, males and females in western clothing, or a man with a bottle. Frits Van den Berghe was attracted to the magical aspects of African ritual objects through his interest in the surreal.

What's your position in the discussion "art or culture"? How do you see ethnographic objects?
I trained as an art historian and I like to look at things with an aesthetic eye, but at the same time, I've worked for a long time in an ethnographic museum and I find the ethnographic background of the pieces just as important as their aesthetic qualities. One doesn't need to exclude the other, as I hope I've been able to make clear in the exhibitions and exhibition catalogues on which I have worked. In practice, however, you frequently see that one approach is stressed to the detriment of the other. I can't get along with collectors, specialists, or exhibiters who only talk about aesthetics or only talk about the meaning. Surely the two complement each other? In particular, I think that focusing purely on aesthetic appreciation is taking things too far. You also have to look at the content, at what it means, how it functions in the culture. Although I can profoundly enjoy the fine exhibitions in the Musée Dapper in Paris, for example, I find the texts accompanying the pieces too restricted. The important questions are what was it used for, by whom, and why? I advocate the use of captions and explanations on panels, albeit as concise as possible. In addition, I like to see a well-illustrated catalogue that further explores the religious, social, political, and economic functions and meanings of the objects ethnographically. That the Louvre until recently only paid attention to expressions of art of peoples who have writing is something that I find almost racist. The recent initiative to create space in the Louvre for tribal art—*arts premiers*, as they like to call it in France— is something that I can only applaud.

Notes

1 Appadurai 1986, p. 5.

2 In *Primitive Art in Civilized Places,* Sally Price (1989; cf. Kasfir's 1992 essay in *African Arts* and the commentaries it provoked in the following issues of that journal) does not focus on the actual travels of the objects as we do here, but rather analyzes and criticizes the various stereotypical, "primitivistic" western interpretations of those objects, stressing the United States and France. A case study on such interpretations is the exhibition catalogue prepared by Mary Bouquet and Jorge Branco on the labelling of a collection of Melanesian objects that ended up in Portugal via Germany (Bouquet & Branco 1988).

3 Phillips 1995.

4 The substantial, two volume catalogue is Rubin 1984; for a highly critical review, see Clifford 1988, pp. 215-251. A more concise treatment of primitivism in modern art is Rhodes 1994; another, very thorough approach is Bilang 1989. D. Dutton published a cutting essay denouncing postmodernist exaggerations of tribal art (Dutton 1995).

5 See Van Duuren 1990, based on archival research in that museum, to which Van Duuren is attached.

6 Two Moluccan parry shields from a Dutch museum collection are described and illustrated by Greub 1988, pp. 230-233; see also the illustrations in Tavarelli 1995, pp. 33 and 90.

7 The following is based primarily on Platenkamp 1988, pp. 198 ff.

8 A starting point is provided by Platenkamp's (1988) thorough, structuralist-orientated analysis of the meaning of parry shields in the context of Tobelo cosmology; on the analogous parry shields of the Nuaulu from Seram, one of the other Moluccan Islands, see Ellen 1990; on shields in island Southeast Asia and Melanesia in general, see Tavarelli 1995.

9 A useful survey of the literature to that point and of the problems encountered when trying to interpret *churinga* is given by Pannell 1994. An early and classical text on *churinga*, in this case, those of the Aranda, can be found in Chapter 5 of Spencer & Gillen 1969 [1899].

10 There is—scandalously enough—as yet no thorough standard work on krisses, but a fine introductory text has been written by David van Duuren (1998). Van Duuren is finishing a more substantial treatment of the subject, which will hopefully fill this gap.

11 The French curiosity cabinets and expeditions of the eighteenth century are dealt with by Annick Notter (1997), who reconstructs the routes of some 1200 objects from Oceania, collected at an early stage, to a number of museums in northern France. Christian Feest (1984) provides a survey of collecting activities focused on North-American Indians since the sixteenth century.

12 For a typical history of a German ethnological museum— Hamburg—against the background of German colonialism, see Zwernemann 1980.

13 Coombes (1994) analyzes how Africa was represented in all sorts of exhibitions in the United Kingdom around the turn of the century; Ebin and Swallow (1984) describe the history of the Cambridge University Museum of Archaeology and Anthropology.

14 Three surveys of ethnographic collections in western museums at the end of the last century, all three based on so-called "inspection journeys" by the authors, offer a good snapshot of the beginning of the period studied in this book: Schmeltz 1896, Bahnson 1888, and Brigham 1898. Concerning the routes taken by African objects to specific museums, one can, for instance, read Erna Beumers (1988) on the Museum voor Volkenkunde Rotterdam, or B. Arnold (1982) on the Staatliches Museum für Völkerkunde Dresden. The exhibition catalogue l'Art africain dans les collections publiques de Poitou-Charentes (Anonymous 1985) provides insight into the ways in which African ethnographics ended up in a number of small provincial museums in France during the colonial era. A survey of the movements from the whole of Oceania to Europe and the United States, with particular attention given to the role of surrealist and other avant-gardist artists, is given by Peltier (1984; cf. Peltier 1992).

15 Cf. Corbey 1993b.

16 In the following, I shall refer to the Democratic Republic of Congo, formerly Zaire, as Congo or Congo-Kinshasha, not to be confused with the adjacent Congo-Brazzaville, formerly called French Equatorial Africa.

17 Douglas Cole's Captured Heritage: The Scramble for Northwest Coast Artifacts (Cole 1985), a substantial and invaluable study such as one would wish to have for every tribal region, describes the collecting activities among the Kwakwaka'wakw (Kwakiutl), Haida, Tlingit, and neighbouring groups, by, or on behalf of, the three large American natural history museums and two Canadian museums between 1870 and 1930. These institutions had some competition from German initiatives, among those that of A. Jacobsen, the Norwegian captain who from 1881 to 1883 collected 7000 objects along the Northwest Coast for the Berlin Museum für Völkerkunde (Jacobsen 1977); Jacobsen also collected among the Yup'ik of Alaska. Aldona Jonaitis' richly illustrated From the Land of the Totem Poles: The Northwest Coast Indian Art Collection at the American Museum of Natural History (Jonaitis 1988) provides a good deal of background information on how that collection was formed. Clifford (1991) discusses and compares several museums along the Northwest Coast, thus offering a valuable supplement to Cole's and Jonaitis' research.

18 For an analysis of this phenomenon of Völkerschau, see Corbey 1993a.

19 Cf. Van Vugt 1991. Susan Legêne (1998) describes how four well-to-do Dutch citizens brought exotic objects back home from their activities overseas in the first half of the nineteenth century; most of these objects ended up in museums.

20 The following is mainly based on Van Duuren 1990. On the Batak, see also the following interview with Jac Hoogerbrugge.

21 I am still following Van Duuren, op. cit. Collecting activities along the north coast of Dutch New Guinea are described in some detail in Greub 1992, and cf., again, the interview with Hoogerbrugge; information on a Japanese collecting trip through that area in 1932 can be found in Anonymous 1937a.

22 Schmidt 1996 gives a detailed biography of Wirz focussing on his collecting activities.

23 From Bergner 1996, p. 229, who is citing a letter from Visser which is kept in the archives of the Museum für Völkerkunde in Leipzig.

24 Bergner 1996, p. 228.

25 See Geary 1994, in particular Chapter 3.

26 Geary 1994, 31.

27 Ibid., note 17 on p. 55. For a picture and a description of the stool, see Newton & Waterfield 1995, p. 136-137.

28 On colonial science as exploration (cognitive survey) and exploitation (political surveillance), see Corbey 1997.

29 Anonymous 1909-1936.

30 Strictly speaking the Asmat area itself was not visited in 1953; the Leiden anthropologist, Simon Kooijman bought a large number of objects in Merauke, an administrative post to the southeast.

31 On Boas' role in the formation of museum collections, see Cole 1985 and Jonaitis 1988.

32 Olbrechts 1935.

33 Olbrechts 1940.

34 Cf. Veirman 1996, p. 129.

35 Olbrechts 1931; cf. Holsbeke 1996.

36 Neyt 1992.

37 Thilenius 1918.

38 Fischer 1981, pp. 117-118.

39 Cf. Cole (1985) on a similar pattern of competition with regard to the American Indian cultures of the Northwest Coast.

40 Anonymous 1991, p. 49; Welsch 1998.

41 On the Fuller collection, see below, p. 51

42 Wirz 1951, p. 131.

43 Wirz 1928, 1951; cf. Schmidt 1996, p. 268 ff.

44 Mack 1990. The 1909-1915 expedition of the American Museum of Natural History to northeastern Congo and other collecting activities in that area are dealt with in great detail in Schildkrout & Keim 1990, and in Schildkrout & Keim's *The Scramble for Art in Central Africa* (1998). One of the essays included, by Johannes Fabian (Fabian 1998), is on Torday and Frobenius as collectors. For a detailed reconstruction of a German collecting expedition to Angola by the ethnologist Alfred Schachtzabel for the Museum für Völkerkunde in Berlin from 1912 till 1914, see Heintze 1995.

45 Another captivating, largely unwritten chapter in the history of expeditions, museums and other dealings with tribal objects, which is not touched upon here, is provided by Japan; of note 21.

46 Leiris 1981, p. 156; cf. Clifford 1988: 165-174.

47 Price & Price 1992; they are very much aware of this contrast and quote this same passage from Leiris. Their novel, *Enigma Variations* (Price & Price 1995), partially based on real events and the actual state of affairs, is about the same region.

48 Friedrich Fülleborn, "Berichte über den Verlauf der Südsee-Expedition der Hamburgischen Wissenschaftlichen Stiftung. An das Kuratorium, 1908-1909," kept in the archives of the Museum für Völkerkunde Hamburg. Quoted by Fischer 1981, p. 118.

49 Anonymous 1983b.

50 See Van Brakel, Van Duuren & Van Hout 1996. Like the Raedt collection auction catalogue, the inventory of the Tillman collection in this publication allows one to see how it was put together. In 1997, a substantial private collection on loan to the Volkenkundig Museum Gerardus van der Leeuw

NOTES

in Groningen made a similar move; it was taken back by the collector's heirs and sold through a Dutch gallery. A glossy catalogue was made for the occasion, and there was some quibbling as to the correctness of the consultant dealer-expert's assessments of authenticity and value.

51 Gianinazzi & Giordano 1989, a bilingual edition, Italian-English. Apart from Brignoni's collection, the riches that came to Germany from its colonies in Melanesia and in Africa is apparent from the collection of the Düsseldorf artist Klaus Clausmeier, which since 1966 has been preserved in the Rautenstrauch-Joest Museum für Völkerkunde of the city of Cologne; cf. Stöhr 1987, pp. 295-378.

52 Leurquin 1988, pp. 318-319. I would like to acknowledge my indebtedness for what follows to this short but very useful text on tribal art collections in Belgium, which is partly based on a number of talks with the Tervuren curator Albert Maesen, as well as to Patricia Van Schuylenbergh's thorough "Découverte et vie des arts plastiques du Bassin du Congo dans la Belgique des années 1920-1930" (Van Schuylenbergh 1995). See also Salmon 1992, and Wastiau 2000.

53 Leurquin 1988, ibid. For more on the Wellcome collection, compiled by Henry S. Wellcome (1853-1936), founder of the immensely successful pharmaceutical firm of the same name and of the Wellcome Trust, a charitable organization, see Anonymous 1965. Together with fifteen thousand objects, the collection bought from Pareyn was donated to the Museum of Cultural History of the University of California at Los Angeles in 1965-1967, where it remains today.

54 Anonymous 1928.

55 A copy of the auction catalogue (Anonymous, 1928) and several undated newspaper clippings— probably from around December 18th, 1928—are preserved in the Pareyn Dossier in the archives of the Koninklijk Museum voor Midden Afrika, Tervuren, Belgium.

56 Leurquin 1988, p. 319.

57 Anonymous 1937b, pp. 7-9.

58 The following is based on Leurquin 1988, pp. 327-328, and on the personal communications of several dealers and collectors who knew Jef Vander Straete personally.

59 Joseph Cornet's standard work *Art of Africa: Treasures from the Congo* (Cornet 1971) is illustrated with stunningly beautiful objects from the Vander Straete collection.

60 The following is based on personal communication with Bas van Lier, Carel van Lier's grandson, and Van Lier's daughter Franca Brunet de Rochebrune-van Lier, Spring 1998, which I gratefully acknowledge here; on documents from the family archive; and on Van Lier 1997. Bas van Lier is writing a biography of his grandfather.

61 The Rijksdienst voor Kunsthistorische Beelddocumentatie in The Hague possesses 429 letters to Van Lier (cf. Van Lier 1997), mostly from artists, but also thirteen from Han Coray, dating from the earlier 1930s, in which Coray asked for advice on how to sell his collection of African art. On the Coray collection and for a short biography of Coray, see Szalay 1995.

62 The following is based on personal communications with Lemaire's son F.L. Lemaire and daughter T.F. Lemaire, in June 1997, who also kindly provided access to the gallery's archives.

63 In the introduction to an exhibition catalogue he published in 1946, Lemaire gives his views on "primitive art," p. 1-5. Contextual information, he claims, obscures our spontaneous experience of it.

64 Not a relative, but a client, and later on for some time a successor of Carel van Lier; see below, p. ..

65 The Rotterdam museum immediately staged an exhibition of the newly acquired collection and published a short cataloque (Anonymous 1951).

66 Tischner 1965. His analysis is largely based on an article by Alfred Bühler, director of the Museum

für Völkerkunde (now called the Museum der Kulturen) in Basel, who gathered information on thes figures in 1959, both from villagers along the Korewori itself and from missionaries (Bühler 1961). It appeared that even then there was not much left of such figures, nor of the myths and rituals associated with them.

67 Claerhout 1965.

68 De Lorm 1941.

69 Beumers 1988, p. 17-21.

70 It was, of course, not only Indonesian or African material wich was desired by Dutch museums. Collections focussing the Plains Indians of North America, for example, were put together in the 1880s by the physician and anthropologist Dr. Herman ten Kate, a well-to-do Dutch traveller from the province of Zeeland, and are now in the ethnographic museums in Leiden and Rotterdam.

71 Schmeltz & Krause 1881.

72 The following is based on Zwernemann (1986) and on the personal communications of Coos van Daalen and several tribal art dealers.

73 Schaedler 1992.

74 Paudrat 1984, pp. 152 ff.

75 A long biographical article by Raoul Lehuard on Ratton (Lehuard 1986; cf. some comments and additionns by Barbier 1987, and cf. Paudrat 1984) provides a good picture of the goings-on in the Parisian circles of dealers, collectors and modernist artists. For an interview with Ratton, see *Primitive Art Newsletter*, February 1983, pp. 1, 2 and 4 (Hersey 1978-1983).

76 In the nineties, the Louvre was agian to be provided with this possibility; see below.

77 See MacClancy 1988 and Phelps 1976, pp. 9-15.

78 Reprinted in Oldman 1976. An interesting source on tribal objects-in-transit are the bound catalogues of the British dealer, W.D. Webster, which appeared between 1895 and 1901 (Webster 1895-1901). In 1943, Oldman brought out an inventory of his Polynesian ethnographics, and in 1946, one on his Maori objects (Oldman 1943, 1946). In the years 1937 to 1939, shortly before his sudden death, Beasley (1937-1939) published a survey of the holdings of his private museum. On the tribal art trade in Great Britain since the 1950s, see MacClancy, op. cit; cf. Benthall 1987 on the relations between ethnographic museums and the auction world in that country.

79 On the occasion of the donation of the Fuller collection, a thick monograph appeared: Force & Force 1971. A substantial volume on Hooper's collection was published by Hooper's grandson Steven Phelps (1976); for the catalogues of the Hooper collection auctions, see Anonymous 1976, Anonymous 1979, and Anonymous 1980. Both the books on the Fuller collection and the Hooper collection have become sought-after collectibles themselves, as have Oldman's sales catalogues.

80 See the interview with Frank Herreman, p. 215 ff.

81 On the Heye Foundation, see the following interview with Herreman, pp. 221-222.

82 Leurquin 1988, p. 327. For an analysis of missionary exhibitions and missionary museums in England around the turn of the century, see Coombes 1994, Chapter 8. Barbara Lawson wrote a case study on a collection of 125 articles from the New Hebrides, collected by a missionary and currently kept in the Redpath Museum in Montreal (Lawson 1994).

83 I am obliged to Father Nico Akerboom, MSC, who since the 1950s has been handling ethnographics from New Guinea and Indonesia on behalf of his congregation, for the information he provided during a number of conversations. On Brignoni's activities and collection, see Gianinazzi & Giordano 1989.

84 Cf. Dirkse 1983a and Corbey 1989, Chapter 5.

85 Neurdenburg 1883.

86 See, for example, Bink 1897, pp. 143-211.

87 Lamann 1953-68; see also MacGaffey 1991, who in addition to background information offers a selection from the answers to Lamann's questionnaires.

88 *Minkisi* of the type with nails driven into them loomed large in my own first fascination with tribal art.

89 Lehuard 1980, p. 5.

90 Van Hasselt 1933. With thanks to Jac Hoogerbrugge.

91 Williams 1838, Chapters 12 and 18; cf. Harding 1994.

92 Williams 1838, 152-153. With thanks to julian Harding, Cambridge, UK, for his helpful comments.

93 Anonymous 1902. Rudersdorf's initials are not given. With thanks to David van Duuren, who brought this case to my attention Cf. Feldman 1994.

94 Munde 1902; no initials given.

95 The letter was published in Steinhart 1989, pp. 27-28. With thanks to Sister Willie Schröder (Utrecht, the Netherlands) and Mr. and Mrs. Leo Steinhart (St. Michielsgestel, the Netherlands) for a number of clarifying comments.

96 Lamp 1996, p. 224. I would like to acknowledge my indebtedness to Lamp's book for what follows on the Baga.

97 Ibid, p. 226.

98 Convers 1991; Convers 1997.

99 Cf. Perrois 1979, pp. 285-287.

100 Perrois 1979, ibid.

101 See Ndiaye 1996.

102 Bilang 1989, pp. 79 ff.

103 Bilang 1989, pp. 103 ff.

104 J.-L. Paudrat 1984 gives a survey of the interest in *art nègre* among avant-garde artists in Paris.

105 Van Baaren 1968; on the Volkenkundig Museum Gerardus van der Leeuw and its backgrounds, see Arnoldus-Schröder 1998.

106 Bilang 1989, pp. 219-213.

107 Quoted by Kerkhoven 1995, p. 50.

108 With thanks to Willy Mestach for a number of inspiring exchanges in the cafe Trein de Vie, Brussels, one of the favourite hangouts of a number of Grote Zavel tribal art dealers. Cf. Mestach 1985 and Leurquin 1988, p. 326; for an interview with Mestach, see Willis 1995/96.

109 Rubin 1984 and Maurer & Mestach 1991, respectively.

110 Vermeijden 1996.

111 Price 1989.

112 On Arman, see Anonymous 1996a; on Georg Baselitz, Kerchache 1994, containing an interview with Baselitz. Tribal objects owned by some sixty western artists along with their visions on these were compiled in *Arts primitifs dans les ateliers d'artistes* (Anonymous 1967).

113 I have indeed been able to identify and, in many cases, talk to representatives of all these categories.

114 "The airplanes carrying weapons to the Biafrans," the dealer Hélène Leloup (1994, p. 92) writes on the Biafra civil war, "came back with loads of masks and statues. The artistic production of a

country with several million inhabitants arrived, and it was necessary to sell quickly; therefore prices were very reasonable."

115 An invaluable source is Guy van Rijn's *Who's Who in African Art* (Van Rijn 2000), which alphabetically lists and shortly describes no less than twelve thousand twentieth-century dealers, collectors, scholars, curators, explorers, missionaries, and others who somehow have, or have had, something to do with African art. Van Rijn, son of the well-known Amsterdam tribal and Asiatic art gallerist, Lode van Rijn (who died in 1997), is a tribal art consultant in Brussels. Another, virtually unparalleled (but cf. Marc Felix on his data base, below, pp. 177-178) research tool is his data base with photographs, data and prices met concerning almost a hundred-thousand African art objects.

116 Anonymous 1994, p. 24.

117 Krüger 1999/2000, based on personal communication with Duponcheel.

118 Crystal 1994, p. 33.

119 Cornet 1975; Wastiau 2000.

120 Geers 1998.

121 De Grunne 1993—partly based on personal communications with Langlois.

122 Imperato 1983, p. 52. Hélène Leloup (1994) provides a revealing sketch of connections between Mali and the West with regard to the trade in Dogon art since the 1950s. Her survey of the movements of Dogon objects also offers a perspective on the effects of islamicization, and on her own life as a successful high-level tribal art dealer. In one of the interviews included in this volume, Mamadou Keita, a Malinese dealer based in Amsterdam, tells about his father's and his own role in the movements of objects from Western Africa to Europe.

123 Van Beek 1988.

124 After her divorce, Hélène married Philippe Leloup and continued her business in partnership with him; cf. H. Leloup 1994, pp. 89-91.

125 Cf. Steiner 1994: 4 and *passim*.

126 Peter de Boer (personal communication, January 1998) of Kalpa de Boer Gallery in Amsterdam observed on the basis of his frequent contacts with small-time African traders that, for most of them, ethnographics is only one of things they deal in. Cf. collector John Rohner on his collection of *Art Treasures from African Runners*, with an introduction on his personal experiences with African traders in the United States as well as pictures of 817 objects he bought from them (Rohner 2000).

127 With respect to the African side, see Christopher Steiner's (1994) excellent monograph on commodification and other aspects of the trade in ethnographics in Ivory Coast, including fakes. The book is based on intensive fieldwork done in the 1980s.

128 Steiner 1994, p. 14, 15; in particular, see Chapter 6.

129 "Authenticity," a problematic concept, is discussed in several of the following interviews. See also Price 1989, Kasfir 1992 and Steiner 1994.

130 I was able to reliably establish several cases of embellishment; one example was a *korwar* ancestor figure from New Guinea which, while in the hands of a Dutch dealer in 1997, suddenly acquired inlaid eyes, and a Luba neckrest from Congo that mysteriously obtained an intricate abstract decoration it previously lacked.

131 The catalogues that went with the two exhibitions are Anonymous 1988 and Van Koten & Van den Heuvel 1990.

132 Beaulieux 2000.

133 Two periodicals focusing primarily on collectors and dealers and offering a wealth of information concerning what went on, and still goes on, in these circles are *Arts d'Afrique Noire* (since 1971) and the *The World of Tribal Arts / Le Monde de l'Art Tribal,* available in both English and in French since 1994. A more acadamically orientated American equivalent of the former, aimed more at the museum world, is *African Arts* (since 1967). A well-written, very informative *Primitive Art Newsletter* was published monthly from 1978 till 1983 by the New York-based dealers Irwin and Hester Hersey in association with Alan Alperton (Hersey, Hersey & Alperton 1978-1983). Since its establishment in 1983, the Dutch Vereniging van Vrienden van Etnografica (VVE—Society of Friends of Ethnographics) has published a quarterly newsletter, the *Nieuwsbrief van de Vereniging van Vrienden van Etnografica* (Newsletter of the Society of Friends of Ethnographics).

134 Personal communications by Steven Alpert and Thomas Murray, June 1997. The relatively small market for Indonesian tribal art grew somewhat due to a number of major exhibitions in the 1980s.

135 A collection of essays with the telling title *Fragile Traditions: Indonesian Art in Jeopardy,* edited by Paul M. Taylor (1994), gives a good picture of collecting and dealing activities in Indonesia over the last few decades up to the present. It deals, among other things, with the trade in Lamaholot textiles, Toradja *tau-tau* ancestor figures, objects from the Lesser Sunda Islands, from the Dayak of Borneo, and from the island Nias, where production for sale started at a very early stage. Attention is also given to the falsification activities which over the last two decades have increased considerably in Indonesia.

136 Robbins & Nooter 1989.

137 Catalogues of private collections constitute another source concerning the travels of tribal objects and their role in philanthropy and conspicuous consumption. Examples of such catalogues are those on the Dwight and Blossom Strong collection of art from Equatorial Africa (Siroto & Berrin 1995), and the magnificent collection of tribal art accumulated by Raymond and Laura Wielgus (Pelrine 1996).

138 Cf. Marc Felix's comments on p. 175

139 Anonymous 1996d.

140 Cf. what Dirk Smidt has to say about this, pp. 202 ff..

141 *Kulap* figures were (are?) made as a dwelling place for the spirits of the deceased, to stop their spirits from wandering about and harassing them.

142 Groenhuizen 1984.

143 See Ray 1967 and Fienup-Riordan 1996.

144 Jacobsen 1977; Fienup-Riordan 1996: 217-303.

145 Nelson 1983; cf. Fitzhugh & Kaplan 1982: 13-36. Nelson, who soon became known among the Yup'ik as "The buyer of good-for-nothing things" (Nelson 1983: 297), brought together the largest, best documented, and most complete Inuit/Eskimo collection available, comprising just under ten thousand items. Pinart's collection of Eskimo masks is now preserved in the Château-Musée of Boulogne-sur-Mer in France and is described in detail by Rousselot et al. (1991). Between 1868 and 1896, employees of the Alaskan Commercial Company brought together about two thousand Eskimo and Aleut artifacts which are now housed in the Phoebe Apperson Hearst Museum of Anthropology in Berkeley, California; Graburn, Lee and Rousselot (1996) made a catalogue raisonné of this collection, with photographs of all the objects.

146 Höpfner 1995.

147 Fienup-Riordan, op. cit.

148 With thanks to Guy van Rijn, Brussels, who pointed out this pattern to me, and cf. Steiner 1994: 124-128. I came across at least one Dutch and two Belgian dealers who exchanged beads for ethnographics with the Dayak. Other commodities taken into the bush as mediums of exchange by western tribal art dealers included t-shirts, brassieres, bikes and all sorts of trinkets.

149 Personal communication with David van Duuren, Tropenmuseum, Amsterdam.

150 Anonymous 1966, Anonymous 1978, and Anonymous 1992, respectively. Raymonde Wilhelmen (1985) covered tribal art auctions in Paris for newspapers for twenty years, from 1965 to 1985, and reworked her pieces to form a book containing valuable information on the—in many cases, colonial—backgrounds of the collections sold.

151 See Anonymous 1996d, Anonymous 1996c; and Anonymous 1996b, respectively.

152 Quoted in the *International Herald Tribune* of July 12-13, 1997 (Riding 1997). On how the Barbier-Mueller collection came into being, see Barbier 1995.

153 For a discussion of the function of pedigrees, compared with that of signatures on western paintings, see Price 1989, Chapter 7.

154 Reche 1913, Plate XL nr. 6 and p. 167.

155 Gianinazzi & Giordano 1989.

156 Sold as lot 563 by M.C. Daffos and J.-L. Estourel, Auction Experts, on June 3rd, 1997, in St. Germain-en-Laye: the estimated value of the lot was $ 20,000-30,000.

157 Northern 1986, p. 20. Cf. what was said on the similar trajectories of two figures from King Njoya on pp. 25-26.

158 Anonymous 1990c, item 127 (no page numbers).

159 Barbier 1995, p. 14.

160 The following is based on a number of personal communications from collectors and dealers who did business with Van Lier, and on an interview which Jacques Vogelzang of the Vereniging Vrienden van Etnografica had with him in 1993, two years before his death (Vogelzang 1997).

161 Anonymous 1997b. I am obliged to Nol Wentholt for his sustained feedback on Dutch dealings with tribal art, including this auction, and would also like to thank Peter van Drumpt for a number of talks.

162 Information on price development with respect to the better Polynesian art at auction, 1965-1980, is provided by Charles Mack (1982; partly based on research by Christian Duponcheel), Mack also gives pedigrees of many of the approximately 600 objects which are described and illustrated, so that their movements are to some extent traceable.

163 Barrow 1971, p. 8.

164 A short but thorough, theoretically up-to-date introduction to Asmat society and culture in the context of adjoining south-coast New Guinea cultures can be found in Knauft 1993.

165 Vgl. Lamme & Smidt 1993.

166 Gerbrands 1967a.

167 Gerbrands 1967b.

168 Cf. what Jac Hoogerbrugge has to say about this below, p. 151.

169 Ursula Konrad does not practise a profession; Gunter Konrad is a medical specialist.

170 Konrad, Konrad & Schneebaum 1981. In addition to the one in Heidelberg, other permanent exhibitions on Asmat culture are the Asmat Museum of Culture and Progress (Museum Kebudayaan dan Kemajuan Asmat) in Agats, Irian Jaya, Indonesia; the Asmat Museum of the Crosier Missions

in Hastings, Nebraska; and the Rockefeller Wing of the Metropolitan Museum of Art, New York.

171 Helfrig, Jebens, Nelke & Winkelmann 1995. Cf. Konrad & Konrad 1995.

172 A number of discussions with Jac Hoogerbrugge and the late Father Gerard Zegwaard, MSC, the first missionary among the Asmat, were essential for developing my commentaries on the Berlin exhibition. For a more extensive exhibition review, see Corbey 1996.

173 As perhaps does the underplaying of warfare and headhunting, far more pivotal in traditional Asmat culture than the exhibition would have us believe (cf. Zegwaard 1959).

174 Cf. the four pictures on page 439 of Konrad & Konrad 1995.

175 The following is based on a personal communication with Roy. Villevoye, Amsterdam, who witnessed part of the ritual described here. The figure was carved by a villager by the name of Owak; the village was Sawa-Erma.

176 The following is partly based on a number of conversations I had with Father Zegwaard. When he arrived in a certain Asmat village in the late 1940s as the first westerner the people had ever seen, so he told me, they believed he was a particular ancestral spirit who according to local myth had white skin. Only after the villagers had smelled his faeces did they conclude that he was not a spirit but a living being. I would also like to acknowledge many most useful exchanges on Asmat art with Jac Hoogerbrugge, Wil Roebroeks, Tijs Goldschmidt, Nico Akerboom, MSC, and Roy Villevoye.

177 On "authenticity," see also the interview with Dirk Smidt in this book.

178 Eskenasy, Peyroulet & Solvit 1990.

179 This is not the gallery which participated in the 1990 *churinga* sale.

180 Cf. Morphy 1991.

181 I would like to express my gratitude to the anthropologist Eric Venbrux of Nijmegen University for a number of clarifying comments on Tiwi spears and Purkupali figures, and to archaeologist-anthropologist Tim Murray of LaTrobe University for a number of discussions, in the course of recent years, on cultural property issues and other aspects of Aborigine history.

182 How objects and skeletal remains of Australian Aborigines ended up in England, for instance, in the Pitt-Rivers Museum in Oxford, is sketched in *Australia in Oxford* (Morphy & Edwards 1988) and in the first part of a monograph by Tom Griffiths (1996). The backgrounds of Aborigine ethnographics in another European museum, the Museum für Völkerkunde in Dresden, are presented by Günther Guhr (1982).

183 For a case study of one contemporary Tiwi artist, see West 1987.

184 Goodale & Koss 1971.

185 For the following, cf. Pannell 1994, an excellent essay on the moral and legal rights of Aborigines to their *churinga*, pictures, ceremonies and land, against the background of their mythical view of humans and nature.

186 Lang 1991.

187 The *Journal of Cultural Property* is a good place to start getting acquainted with the relevant debates; see also Leyten 1995.

188 Leyten 1995.

189 Welling 1995.

190 Van Witteloostuijn 1995.

191 Kerchache, Paudrat & Stéphan 1988.

192 The same point comes to mind when tribal art dealers publish their collections; see, for example,

the French dealer-collector Alain Schoffel's *Arts primitifs de l'Asie du Sud-Est* (Schoffel 1981).

193 Kerchache, Paudrat & Stéphan 1988, p. 496.

194 Anonymous 1990b. On the devastation of tribal people provoked by the loss of sacra, cf. note 238, and the interview with Felix, p. 181.

195 Personal communication with the dealer in question, who speaks fluent Bahasa, July 1997. Unlike this dealer, I personally am not quite sure whether the figure was indeed an original cult object in its original cult context; Jac Hoogerbrugge, who saw the figure, had the same doubts (personal communication, 1997).

196 In Smidt 1975, p. 2; Smidt tells more about the seizure of these objects in the following interview.

197 Barbier 1995, p. 16, in his "The story of a collection, 1907-1994."

198 Ben-Amos & Rubin 1983.

199 Anonymous 1980a.

200 Kerchache et al. 1990.

201 Kerchache ed. 1967.

202 Kerchache, Paudrat & Stéphan 1988.

203 For an interview with Kerchache, see Anonymous 1997a.

204 'Guerre tribal', 1997.

205 Most of that contextual information can be found on the cd-rom: Kerchache & Godelier 2000. I am obliged to Maurice Godelier and Philippe Peltier for their feedback on the developments around tribal art in Parisian museums.

206 Kerchache 2000.

207 Clifford discusses several museums along the Northwest Coast (Clifford 1991, which at the same time constitutes a valuable supplement to Cole 1985).

208 Vogel 1988.

209 One of the best introductions to the current debate on the tasks and identities of museums still is the volume edited by Karp and Lavine (1991). McLeod (1993), the curator for ethnography at the Museum of Mankind (the British Museum), offers a look behind the scenes with an account of various aspects of the acquisition of ethnographics for the Museum of Mankind's collections between 1973 and 1990; he sketches how the Board of Trustees would meet about ten times a year to make the final decisions on the proposals of the curators.

210 Appadurai 1986, 21; in the introduction to the volume. This also provides an line of approach to the phenomenon of pedigree.

211 Cf. Thomas' (1991) *Entangled Objects: Exchange, Material Culture and Colonialism in the Pacific*, which follows from debates in anthropology on gifts, exchange and reciprocity, and also highlights the role of missionaries (ibid., 151-162). Cf. Schindlbeck 1993, and Küchler 1997, who explores one particular aspect of native agency: the transfer of ritual objects to westerners as an alternative means of ritual destruction, which normally takes place by, for instance, letting them rot away.

212 A topic largely outside the scope of this book are the ethnographic museums in the newly emerged states, and the colonial museums from which they frequently issued—such as the Museum met de Olifant, of the Bataviaasch Genootschap voor Kunsten en Wetenschappen (Batavia Society of Arts and Sciences) in Batavia, present-day Jakarta, which is now the National Museum of Indonesia. On the development of museums in independent Indonesia, see Taylor 1994a. In one of the following interviews, however, Dirk Smidt tells a great deal about his experiences in a museum in Papua

New Guinea that made the transition to independence when he was working there: the National Museum and Art Gallery in Port Moresby.

213 Goffman 1980: 15-16

214 At present, the Tropenmuseum in Amsterdam has more than a thousand items in its collection which were collected by C.M.A. Groenevelt in New Guinea, and the Museum voor Volkenkunde Rotterdam has almost an equal number. He collected for about ten years, throughout New Guinea, including the Trobriand Islands in the east, until the transfer to Indonesia in 1962. Groenevelt also bought from missionaries and colonial officials.

215 Hoogerbrugge 1967; Kooijman & Hoogerbrugge 1992; Hoogerbrugge 1992; Hoogerbrugge 1995.

216 After his death, Kamma's private collection was bought by Loed and Mia van Bussel, dealers in tribal art in Amsterdam.

217 Hoogerbrugge, op.cit. 1995; cf. Peltier 1992.

218 On ornamented bark cloth in Indonesia, cf. Kooijman 1963.

219 Peltier 1992.

220 Hoogerbrugge, op.cit. 1967.

221 Cf. Part one, pp. 111 ff..

222 See Hoogerbrugge 1993.

223 The Asmat Art Project was rounded off with two publications packed with well-documented photos, and an exhibition on the project at the Volkenkundig Museum Justinus van Nassau in Breda, the Netherlands: Hoogerbrugge & Kooijman 1976, Hoogerbrugge 1977.

224 Cf. Dirk Smidt's statements on one particular case of the carving of shields for sale on p. ..

225 Wirz 1928a, 1928b; De Clercq & Schmeltz 1893; Anonymous 1959.

226 For more information on the trade in tribal objects from Mali since the Second World War, see Leloup 1994.

227 Both Sally Price (1989) and Christopher Steiner (1994) made a number of observations on the tribal art market that support Keita's views. African traders are typically called "runners," a term with a sligtly negative connotation, while western traders are called "dealers." The aesthetic intentions of African carvers tend to be denied; they are supposed to create "spontaneously." Similarly, aesthetic competence is ascribed to western dealers and collectors, not to African dealers. African individuals who are connected with specific objects tend not to be identified by name, unlike western individuals.

228 Felix, Kecskési et al. 1994.

229 Cf. what is said on the CoBrA movement in Part One, p. 73.

230 On Philippe Guimiot, see also Part One, p. 76.

231 Moss (1994) sketches a broader picture of the activities of dealers in the Lesser Sunda Islands. During the 1970s and 1980s what was left of the traditional ancestral sculpture, relatively speaking quite a bit, was systematically tracked down by dealers and sold to western collectors and museums.

232 Bernatzik 1939; see pp. 198 ff.

233 Cf. Dournes 1968.

234 Felix 1995.

235 See Part One, p. 99 and the references given there.

236 Felix 1987; a thoroughly revised second edition of this volume is in preparation.

237 See for example Biebuyck 1985, 1986.

238 In her essay with the tell-tale title "Without Cloth we Cannot Marry," Ruth Barnes (1994: 22) describes the consequences of the export of important heirloom cloth from the villages of the Lamaholot in the lesser Sunda Islands. While more common traditional cloth can be replaced by acceptable new material, she writes, the loss of clan treasures brings a sense of devastation to the people, for "their value is of a mystic nature. The cloth, like all other clan treasures, manifest the lineage's well-being in every sense, and for such an object to leave the clan house, or to be sold, is disastrous. The loss is believed to bring illness and misfortune to the entire group."

239 On Maniema masks, see Felix 1989; on Tanzania, Felix 1990; on the Ituri Forest, Felix 1992; on the arts of the Lower Congo area, Felix 1995; on the stylistic zones of Congo masks, Felix 1997; on Zambia, Felix 1998.

240 Pirat 1996.

241 For a history of western dealings with the traditional art of Nias, including the adaption of indigenous forms to western taste, see the essay by J. Feldman in Taylor 1994.

242 Robbins & Nooter 1989.

243 Sally Price stresses the incompatibility of the collector's passion and the scholar's erudition; for many of the tribal art collectors and dealers she talked to, she writes, "avoidance of scholarly analysis was seen not only as acceptable, but as necessary to satisfactory aesthetic enjoyment." (1989: 106). That certainly was the view of the Amsterdam tribal art dealer M.L.J. Lemaire-see note 63.

244 I am grateful for the use of Steenbergen (1993) in preparing this interview.

245 Cf. Part One of this book, pp. 19-21.

246 For a discussion of the Moluccan parry shield, see Part One, pp. 17-19.

247 Compare what Hoogerbrugge says about Groenevelt on p. 145-146.

248 The full title of the film is *Matjemosh: A Woodcarver from the Village of Amanamkai, Asmat, South New Guinea;* 16 mm., colour, sound, 27 minutes; produced by Cine-film in collaboration with the Rijksmuseum voor Volkenkunde Leiden, 1963.

249 Gerbrands 1967a.

250 For a general survey of Kominimung woodcarving, see Smidt 1990.

251 For an analogous replacement of an old statue in another part of New Guinea, see p. 121-122.

252 Smidt 1975.

253 I have been able to verify this with one of the dealers concerned.

254 *Government Gazette* No. 43, December 23rd, 1971.

255 Cf. Part One, p. 31, Welsch 1998, and Anonymous 1991.

256 Cf. an observation by Ruth Barnes (194: 25), who did fieldwork in another region, the Lesser Sunda Islands, on the effects of an outsider's request for an object: "A purchase legitimate in law is not necessarily morally beyond reproach. The buyer may exert considerable pressure, whether by offering what may seem in the local context vast sums of money or by calling upon a relationship of obligations."The latter, she adds, is how local middlemen may proceed and is the most difficult to refuse.

257 See O'Hanlon 1993, figures 13, 11 (left) and 14.

258 Smidt 1993.

259 See Figure 37 on p. 72 of Smidt 1996. For other *korwar* figures, see Figure 133 in this book.

260 For an analysis of a fledgling, rapidly growing museum system in another region, Indonesia, which deals with what in the new nation-state has come to be seen as its "national heritage," see Taylor

1994a. Cf. what was said on postcolonial museums in the Democratic Republic of Congo op p. 77-79.

261 Van Kooten & Van den Heuvel 1990.

262 Herremans & Petridis 1994.

263 Lévi-Strauss 1983; cf. Clifford 1988, pp. 236-251.

264 The impact of American Indian art on the New York avant-garde artists in the first half of the present century has been explored by Rushing (1995).

265 A number of trend-setting exhibitions followed that of 19233: *African Negro Art* in 1935, *Indian Art of the United States* in 1941, and *Arts of the South Seas* in 1946; all three were organized by and in the Museum of Modern Art, wich once again shows how modern and tribal art were appreciated by the same group of people. In 1957, the Museum of primitive Art was set up by Nelson Rockefeller; since 1982, its collections have been kept in the Rockefeller Wing of the Metropolitan Museum of Art. Another crucial, more recent moment in the history of the appreciation of tribal art in New York was the exhibition *"Primitivism" in Twentieth-Century Art* at the Museum of Modern Art in 1984 (Rubin 1984), not least because of the controversies it provoked.

266 This modernist reception of tribal articles took many of its cues from Europe, more specifically from Paris. The avant-garde artists consciously or unconsciously integrated African elements into their artistic production, and the first collectors of their products frequently combined their purchases with figures and masks from Africa.

267 Gustav Heye ran his own museum, the Museum of the American Indian of the Heye Foundation, which opened in 1922; see below.

268 See Nooter-Roberts & Roberts 1996 and Lamp 1996, respectively, and cf. what is said on the Baga in Part One, p. 67-68.

269 See Fabian 1996.

270 Felix, Kecskési et al. 1994.

271 Heye sold the Yup'ik masks for between fifty and a hundred dollars a piece, while nowadays at auctions hundreds of thousands of dollars a piece are sometimes paid for similar masks. The Heye Foundation was at that time still a private museum, the largest ever, with hundreds of thousands of American Indian objects.

272 Muensterberger 1994.

273 On Arman, see Part One, p. 74.

274 See Part One, p. 73.

References

Anonymous. 1902. "Missionsvandalismus auf Nias." *Globus* LXXXII (1902): 179.

Anonymous. 1909-1936. *Nova Guinea: Résultats de l'expédition scientifique néerlandaise à la Nouvelle-Guinée* I-XVIII. Leiden: E.J. Brill.

Anonymous. 1928. *l'Art Nègre du Congo: Catalogue de la remarquable collection de feu Monsieur Henry Pareyn d'Anvers*. Antwerp: F. & V. Claes, Experts.

Anonymous. 1937a. *Illustrated Catalogue of the Ethnographical Objects from Melanesia Collected by Nanyo Kohatsu Kaisha I*. Tokyo: The Japan Society of Oceanian Ethnography [Minami-no-Kai].

Anonymous. 1937b. *Tentoonstelling van Kongo-Kunst, Stadsfeestzaal, 24 december 1937—16 januari 1938, Catalogus*. Antwerp.

Anonymous. 1951. *Kunst uit Melanesië*. Exhibition catalogue. Rotterdam: Museum voor Land- en Volkenkunde.

Anonymous. 1957. *Arts d'Afrique et d'Océanie*. Cannes: Palais Miramar.

Anonymous. 1959. *The Art of Lake Sentani*. Exhibition catalogue. New York: The Museum of Primitive Art.

Anonymous. 1965. *Masterpieces from the Sir Henry Wellcome Collection at UCLA*. Exhibition catalogue. Los Angeles: Museum and Laboratories of Ethnic Arts and Technology.

Anonymous. 1966. *The Helena Rubinstein Collection. African and Oceanic Art. Parts One and Two*. Catalogue of an auction at Parke-Bernet Galleries, New York, on April 21th and April 29th. New York: Parke-Bernet Galleries.

Anonymous. 1967. *Arts primitifs dans les ateliers d'artistes*. Paris: Musée de l'homme.

Anonymous. 1974. *Papua New Guinea Public Museum and Art Gallery: Guide to the Collection*. Port Moresby: The Trustees of the Papua New Guinea Public Museum and Art Gallery.

Anonymous. 1976. *American Indian Art from the James Hooper Collection*. Catalogue of an auction at Christie's London on November 9th. London: Christie's.

Anonymous. 1978. *Catalogue of the George Ortiz Collection of African and Oceanic Works of Art*. Catalogue of an auction at Sotheby Parke Bernet & Co. on June 29th. New York: Sotheby Parke Bernet & Co.

Anonymous. 1979. *Melanesian and Polynesian Art from the James Hooper Collection*. Catalogue of an auction at Christie's London on June 19th. London: Christie's.

Anonymous. 1980a. *Catalogue of Works of Art from Benin: The Property of a European*

Private Collector. Catalogue of an auction at Sotheby's London on June 16th. London: Sotheby's.

Anonymous. 1980b. *Oceanic Art from the James Hooper Collection.* Catalogue of an auction at Christie's London on June 17th. London: Christie's.

Anonymous. 1980c. *The Meulendijk Collection of Tribal Art.* Catalogue of an auction at Christie's London on Octobre 21st. London: Christie's.

Anonymous. 1983a. *De heiden moest eraan geloven: Geschiedenis van zending, missie en ontwikkelingssamenwerking.* Exhibition catalogue. Utrecht: Rijksmuseum het Catharijneconvent Utrecht.

Anonymous. 1983b. *Oriental Export Porcelain, Works of Art and an Important Collection of Tribal Art from the Indonesian Archipelago from the Late H.J.A. Raedt van Oldenbarnevelt, Formed circa 1900 and Loaned to the Tropeninstituut, Amsterdam, in 1915.* Catalogue of an auction at Christie's Amsterdam on June 22th and June 23rd. Amsterdam: Christie's Amsterdam.

Anonymous. 1985. *L'art africain dans les collections publiques de Poitou-Charentes.* Exhibition catalogue. Angoulême.

Anonymous. 1988. *Utotombo: Kunst uit Zwart-Afrika in Belgisch privé-bezit.* Brussel: Vereniging voor Tentoonstellingen van het Paleis voor Schone Kunsten.

Anonymus. 1990a. *Au commencement était le rêve.* Exhibition catalogue. Paris: Galerie Le Gall Peyroulet.

Anonymous. 1990b. "L'art africain: Une marchandise dissimulée." *Gradhiva: Journal et Archives d'Histoire d'Anthropologie* 8: 100-1018 (signed: G.D.).

Anonymous. 1990c. *The Harry A. Franklin Family Collection of African Art.* Catalogue of an auction at Sotheby's New York on April 21st. New York: Sotheby's.

Anonymous. 1991. *A Companion to the Regenstein Halls of the Pacific.* 1991. Chicago: Field Museum of Natural History.

Anonymous. 1992. *Important Tribal Art and Antiquities from the Collection of William A. McCarthy-Cooper.* Catalogue of an auction at Christie's New York on May 19th. New York: Christie's.

Anonymous 1994. *The Doris and Eric Beyersdorf Collection of Africam Art.* Catalogue of an auction at Christie's London on June 29th. London: Christie's.

Anonymous. 1996a. *Arman et l'art africain.* Marseille: Musées de Marseille and Réunion des Musées nationaux.

Anonymous. 1996b. *Arts primitifs: Collection Pierre Guerre.* Catalogue of an auction at Drouot-Montaigne on June 20th. Parijs: Etude Loudmer.

Anonymous. 1996c. *Collection A. et J.P. Jernander.* 1996. Catalogue of an auction at Drouot-Richelieu on 26 June 26th. Paris: Etude De Quai Lombrail.

Anonymous. 1996d. *Collection Van Bussel.* 1996. Catalogue of an auction at Drouot-Richelieu on June 24th and June 25th. Paris: Etude Jutheau de Witt.

Anonymous. 1997a. "Arts premiers: Quel musée?" Interview with Jacques Kerchache. *Connaissance des Arts*, May, pp. 56-60.

Anonymous. 1997b. *African, Oceanic and Indonesian Art from the Van Lier Collection.* Catalogue of an auction at Christie's Amsterdam on April 15th. Amsterdam: Christie's.

Appadurai, A., ed. 1986. *The Social Life of Things: Commodities in Cultural Perspective.* Cambridge: Cambridge University Press.

Arnold, Bernd. 1982. "Afrika". In G. Guhr & P. Neumann, eds., *Ethnographisches Mosaik: Aus den Sammlungen des Staatlichen Museums für Völkerkunde Dresden,* 65-70. Berlin: Deutsche Verlag der Wissenschaften.

Arnoldus-Schröder, V. 1998. *The Collection Van Baaren.* Groningen: Volkenkundig Museum Gerardus van der Leeuw, University of Groningen.

Bahnson, K. 1888. "Ueber ethnographische Museen." *Mittheilungen der Anthropologischen Gesellschaft in Wien* XVIII: 109 ff.

Barbier, J.P. 1987. "Toujours à propos de Charles Ratton." *Arts d'Afrique Noire* 60: 50-52.

Barbier, J.P. 1995. "The Story of a Collection, 1907-1994." In Douglas Newton & Hermione Waterfield, *Tribal Sculpture: Masterpieces from Africa, South East Asia and the Pacific in the Barbier-Mueller Museum,* 8-17. London: Thames and Hudson.

Barnes, Ruth. 1994. "<Without Cloth we Cannot Marry>: The Textiles of Lamaholot in Transition." In P.M. Taylor, ed., *Fragile Traditions: Indonesian Art in Jeopardy,* pp. 13-27. Honolulu: University of Hawaii Press.

Barrow, Terence. 1971. *Art and Life in Polynesia.* London: Pall Mall Press.

Baumann, Hermann. 1935. *Lunda: Bei Bauern und Jägern in Inner-Angola. Ergebnisse der Angola-Expedition des Museums für Völkerkunde, Berlin.* Berlin: Würfel Verlag.

Beasley, H.G. 1937-1939. *Ethnologia Cranmorensis.* vols. 1-4. Chislehurst: H.G.B.

Beaulieux, Dick (ed.). 2000. *Belgium Collects African Art.* Brussels: Art and Application Editions (in press).

Ben-Amos, Paula & Arnold Rubin. 1983. *The Art of Power, the Power of Art: Studies in Benin Iconography.* Los Angeles: Museum of Cultural History—UCLA.

Benthall, Jeremy. 1987. "Ethnographic Museums and the Art Trade." *Anthropology Today* 3 (1987), October: 9-13.

Beumers, Erna. 1988. "The African Collection." In Suzanne Greub,ed., *Expressions of Belief: Masterpieces of African, Oceanic and Indonesian art from the Museum voor Volkenkunde Rotterdam,* 17-21. New York: Rizzoli.

Bergner, Felicitas. 1996. "Ethnographisches Sammeln in Afrika während der deutschen Kolonialzeit." *Paideuma* 42: 225-235.

Bernatzik, Hugo, ed. 1939. *Die grosse Völkerkunde.* Vol. II. Leipzig: Bibliographisches Institut.

Biebuyck, D.P. 1985. *The Arts of Zaire: Southwestern Zaire.* Berkeley: University of California Press.

Biebuyck, D.P. 1986. *The Arts of Zaire: Eastern Zaire. The Ritual and Artistic Context of Voluntary Associations.* Berkeley: University of California Press.

Bilang, K. 1989. *Bild und Gegenbild: Das Ursprüngliche in der Kunst des 20. Jahrhunderts.* Stuttgart, Berlin, Cologne: W. Kohlhammer.

Bink, G.L. 1897. "Drie maanden aan de Humboldtsbaai." *Tijdschrift voor Indische Taal-, Land- en Volkenkunde* 39: 143-211.

Bouquet, Mary R. & Jorge F. Branco. 1988. *Artefactos melanésios—Reflexoes pós-modernistas / Melanesian Artefacts—Postmodernist Reflections.* Lisboa: Museu de Etnologia.

Brigham, W.M.T. 1898. "Report of a Journey around the World Undertaken to Examine Various Ethnological Collections." *Occasional Papers of the Berenice Pauahi Bishop Museum* I, No. 1: 1-72.

Bühler, A. 1961. "Kultkrokodille vom Korewori." *Zeitschrift für Ethnologie* 86: 183-207.

Claerhout, A. 1965. "De verzameling Christoffel." *Bulletin van de Vrienden van het Etnografisch Museum Antwerpen*. 3(4): 2-4.

Clifford, James. 1988. *The Predicament of Culture: Twentieth-century Ethnography, Literature and Art*. Cambridge, Mass. & London: Harvard University Press.

Clifford, James. 1991. "Four Northwest Coast Museums: Travel Reflections." In I. Karp & S.D. Levine, eds., *Exhibiting cultures: The Poetics and Politics of Museums*, pp. 212-254. Washington, D.C.: Smithsonian Institution Press.

Cole, D. 1985. *Captured Heritage: The Scramble for Northwest Coast Artifacts*. Seattle and London: University of Washington Press.

Convers, Michel. 1991. "L'aventure de *massa* en pays Senufo." *Primitifs* 6, Sept./Oct., pp. 24-29.

Convers, Michel. 1997. "In the Wake of the Massa Movement among the Senufo." *The World of Tribal Arts* III(4): 52-66.

Coombes, Annie E. 1994. *Reinventing Africa: Museums, Material Culture and Popular Imagination in Late Victorian and Edwardian England*. New Haven and London: Yale University Press.

Corbey, R. 1989. *Wildheid en beschaving. De Europese verbeelding van Afrika*. Baarn: Ambo.

Corbey, R. 1993a. "Ethnographic Showcases, 1870-1930." *Cultural Anthropology: Journal of the Society for Cultural Anthropology* 8: 338-369.

Corbey, R. 1993b. "Etnografische verzamelingen: retoriek en politiek, koloniaal en postkoloniaal." In A.J.J. van Breemen et al., *Denken over cultuur: Gebruik en misbruik van een concept*, pp. 445-470. Heerlen: Open Universiteit.

Corbey, R. 1996. "Asmat in Berlin." Review of the Exhibition <Asmat: Mythos und Kunst im Leben mit den Ahnen>. *Anthropology Today* 12: 21-23.

Corbey, R. 1997. "Inventaire et surveillance: L'appropriation de la nature à travers l'histoire naturelle." In C. Blanckaert et al., eds., *Le Muséum au premier siècle de son existence*, pp. 541-557. Paris: Archives du Muséum national d'Histoire naturelle.

Cornet, Joseph. 1971. *Art of Africa: Treasures from the Congo*. London: Phaidon Press.

Cornet, Joseph, ed. 1975. *Art from Zaïre: 100 Masterworks from the National Collection / L'art du Zaïre: 100 chefs-d'oeuvre de la Collection Nationale*. New York: The African-American Institute.

Crystal, Eric. 1994. "Rape of the Ancestors: Discovery, Display, and Destruction of the Ancestral Statuary of Tana Toraja." In P.M. Taylor, ed., *Fragile Traditions: Indonesian Art in Jeopardy*, pp. 29-41. Honolulu: University of Hawaii Press.

De Clercq, F.S.A. & J.D.E. Schmeltz. 1893. *Ethnographische beschrijving van de West- en Noordkust van Nederlandsch Nieuw-Guinea*. Leiden: P.W.M. Trap.

De Grunne, B. 1993. "La sculpture classique Tellem: Essay d'analyse stylistique." *Arts d'Afrique Noire* 88: 19-30.

De Lorm, A.J. 1941. *Indië in België: Voorwerpen uit Nederlandsch Oost-Indië in Belgische*

openbare verzamelingen. Leiden: E.J. Brill.

Dennett, R.E. 1887. *Seven Years among the Fjort, Being an English Trader's Experiences in the Congo District.* London: Sampson Low, Marston, Searle & Rivington.

Dirkse, P. 1983. "Tentoonstellingen van zending en missie." In Anonymous, *De heiden moest eraan geloven: Geschiedenis van zending, missie en ontwikkelingssamenwerking,* exhibition catalogue, Utrecht: Rijksmuseum het Catharijneconvent Utrecht, pp. 38-49.

Dournes, J. 1968. "La figuration humaine dans l'art funéraire Jöraï." *Objets et Mondes: la Revue du Musée de l'Homme* VIII(2): 87-118.

Dumont, Louis. 1996. "Non au Musée des Arts Premiers." *Le Monde,* 25 October, p. 18.

Dutton, D. 1995. "Mythologies of Tribal Art." *African Arts* XXVIII(3): 33-43, 91.

Ebin, V. & D. Swallow. 1984. *'The Proper Study of Mankind ..': Great Anthropological Collections in Cambridge.* Cambridge: Cambridge University Museum of Archaeology and Anthropology.

Edwards, Elizabeth & Howard Morphy, eds. 1988. *Australia in Oxford.* Oxford: Pitt Rivers Museum.

Ellen, R. 1990. "Nuaulu Sacred shields." *Etnofoor* III(1): 5-25.

Eskenasy, A., G. Peyroulet & M. Solvit. 1990. *Au commencement était le rêve.* Sale exhibition catalogue. Paris: Galerie Le Gall Peyroulet.

Essner, Felicitas. 1996. "Ethnographisches Sammeln in Afrika während der deutschen Kolonialzeit." *Paideuma* 42: 224-235.

Ezra, K. 1992. *Royal Art of Benin: The Perls Collection.* New York: The Metropolitan Museum of Art.

Fabian, Johannes. 1996. *Remembering the Present. Painting and Popular History in Zaire.* Berkeley, Los Angeles and London: University of California Press.

Fabian, Johannes. 1998. "Curios and Curiosities: Notes on Reading Torday and Frobenius," in: Enid Schildkrout & Curtis A. Keim, *The Scramble for Art in Central Africa,* pp. 79-108. Cambridge: Cambridge University Press.

Falgayrettes-Leveau, Christiane & Lucien Stéphan. 1993. *Formes et couleurs: Sculpture de l'Afrique noire.* Paris: Editions Dapper.

Feest, Christian F. 1984. "From North America." In William Rubin, ed., *'Primitivism' in 20th Century Art: Affinity of the Tribal and the Modern,* Vol. I, pp. 85-98. New York: The Museum of Modern Art.

Felix, M.L. 1987. *100 Peoples of Zaire and their Sculptures: The Handbook.* Brussels: Tribal Arts Press.

Felix, M.L. 1989. *Maniema: An Essay on the Distribution of the Symbols and Myths as Depicted in the Masks of Greater Maniema.* München: Fred Jahn.

Felix, M.L. 1990. *Mwana hiti: Life and Art of the Matrilineal Bantu of Tanzania.* München: Fred Jahn.

Felix, M.L. 1992. *Ituri: The Distribution of Polychrome Masks in Northeast Zaire.* München: Fred Jahn.

Felix, M.L. 1995. *Art & Kongo: Les peuples kongophones et leur sculpture I.* Brussels: Zaïre Basin Art History Research Center.

REFERENCES

243

Felix, M.L. 1995. "Les bonnes idées font leur chemin. Similitudes dans la typologie artistique de l'Afrique de l'Est, de l'Indonésie et de Madagascar." *The World of Tribal Arts* 2: 47-53.

Felix, M.L. 1997. *Masker: Magt og magi / Masks: Might and Magic*. Odense (Denmark): Kunsthallen Brandts Klaedefabrik.

Felix, M.L. 1998. *Makishi Lya Zambia: Mask Characters of the Upper Zambezi Peoples*. Brussels: Congo Basin Art History Reserach Center.

Felix, M.L., M. Kecskési et al. 1994. *Tanzania: Meisterwerke afrikanischer Skulptur*. Berlin: Haus der Kulturen der Welt, and Munich: Fred and Jens Jahn.

Fienup-Riordan, Ann. 1996. *Agayuliyararput—Our Way of Making Prayer: The Living Tradition of Yup'ik Masks*. Seattle and London: University of Washington Press.

Fischer, Hans. 1981. *Die Hamburger Südsee-Expedition. Über Ethnographie und Kolonialismus*. Frankfurt am Main: Syndikat.

Fitzhugh, William H. & S.A. Kaplan. 1982. *Inua: Spirit World of the Bering Sea Eskimo*. Washington, D.C.: Smithsoniam Insitution Press.

Force, R.W. & M. Force. 1971. *The Fuller Collection of Pacific Artifacts*. London: Lund Humphries.

Gathercole, Peter, Adrienne Kaeppler and Douglas Newton. 1979. *The Art of the Pacific Islands*. Washington, D.C.: National Gallery of Art.

Geary, Christaud. 1994. *The Voyage of King Njoya's Gift: A Beaded Sculpture from the Bamum Kingdom, Cameroon, in the National Museum of African Art*. Washington, D.C.: National Museum of African Art and Smithsonian Institution.

Geers, Hilde. 1998. "De uitverkoop van Afrika." *Humo*, 24 November: 24-28.

Gerbrands, Adrian. 1967a. *Wow-Ipits. Eight Asmat Woodcarvers of New Guinea*. The Hague and Paris: Mouton & Co.

Gerbrands, Adrian, ed. 1967b. *The Asmat of New Guinea. The Journal of Michael Clark Rockefeller*. New York: The Museum of Primitive Art.

Gianinazzi, C. & C. Giordano, eds. 1989. *Culture Extraeuropee: Collezione Serge e Graziella Brignoni*. Lugano.

Goffman, E. 1980 (1959). *The Presentation of Self in Everyday Life*. Harmondsworth: Penguin Books.

Goldschmidt, Tijs. 1997. *Darwin's Dreampond*. Cambridge, Massachusetts: MIT Press.

Goodale, J.C. & J.D, Koss. 1971. "The Cultural Context of Creativity Among the Tiwi." In C.W. Otten, ed., *Anthropology and Art*, pp. 182-200. New York: Natural History Press.

Graburn, N.H.H., M. Lee & J.-L. Rousselot. 1996. *Catalogue Raisonné of the Alaska Commercial Company Collection, Phoebe Apperson Hearst Museum of Anthropology*. Berkeley, Los Angeles & London: University of California Press.

Greub, S., ed. 1988. *Expressions of Belief: Masterpieces of African, Oceanic and Indonesian Art from the Museum voor Volkenkunde Rotterdam*. New York: Rizzoli.

Greub, S., ed. 1992. *Art of Northwest New Guinea: From Geelvink Bay, Humboldt Bay and Lake Sentani*. New York: Rizzoli.

Griffiths, Tom. 1996. *Hunters and Collectors: The Antiquarian Imagination in Australia*. Cambridge: Cambridge University Press.

Groenhuizen, L.F.H. 1984. Letter to the Editor, in *Nieuwsbrief van de Vereniging Vrienden van Etnografica* 50, March, pp. 3-4.

"Guerre tribal pour les < arts premiers >". 1997. *Le Canard Enchaîné* (Paris), 20.8.1997.

Guhr, G. 1982. "Australien." In G. Guhr & P. Neumann, eds., 1982, *Ethnographisches Mosaik: Aus den Sammlungen des Staatlichen Museums für Völkerkunde Dresden*, pp. 252-263. Berlin: Deutsche Verlag der Wissenschaften.

Guhr, G. & P. Neumann, eds. 1982. *Ethnographisches Mosaik: Aus den Sammlungen des Staatlichen Museums für Völkerkunde Dresden*. Berlin: Deutsche Verlag der Wissenschaften.

Harding, Julian. 1994. "A Polynesian God and the missionaries." *The World of Tribal Arts* I(4): 27-32.

Harter, Pierre. 1986. *Arts anciens du Cameroun*. Arnouville: Arts d'Afrique Noire.

Heintze, Beatrix. 1995. *Alfred Schachtzabels Reise nach Angola 1913-1914 und seine Sammlungen für das Museum für Völkerkunde in Berlin: Rekonstruktion einer ethnographischen Quelle*. Köln: Rüdiger Köppe Verlag.

Helfrig, K., H. Jebens, W. Nelke & C. Winkelmann. 1995. *Asmat: Mythos und Kunst im Leben mit den Ahnen*. Berlin: Museum für Völkerkunde - Staatliche Museen Preussischer Kulturbesitz zu Berlin.

Herreman, Frank & Constantijn Petridis, ed. 1994. *Face of the Spirits: Masks from the Zaire Basin*, Antwerp: Martial & Snook.

Hersey, Irwin, Esther Hersey & Allen Alperton. 1978-1983. *Primitive Art Newsletter*. New York: Irwin Hersey Associates.

Holsbeke, M. 1996. "Frans M. Olbrechts en zijn onderzoek in Noord-Amerika." In Holsbeke, M. ed., *Het object als bemiddelaar*. Antwerp: Etnografisch Museum van de Stad Antwerpen, p. 92.

Holsbeke, M., ed. 1996. *Het object als bemiddelaar*. Antwerp: Etnografisch Museum van de Stad Antwerpen.

Hoogerbrugge, J. 1967. "Sentani-meer, Mythe en ornament." *Kultuurpatronen. Bulletin Etnografisch Museum Delft* 9: 5-91.

Hoogerbrugge, J., ed. 1977. *Ukiran-ukiran kayu Irian Jaya / The Art of Woodcarving in Irian Jaya*, Jayapura, Jakarta: Regional Government of Irian Jaya, in cooperation with United Nations Development Programme.

Hoogerbrugge, Jac. 1992. "*Maro* Paintings of Lake Sentani and Humboldt Bay." In Suzanne Greub, ed., *Art of Northwest New Guinea: From Geelvink Bay, Humboldt Bay and Lake Sentani*, pp. 127-140. New York: Rizzoli.

Hoogerbrugge, Jac. 1993. "Art today: Woodcarving in Transition." In Dirk Smidt, ed., *Asmat Art: Woodcarvings from Southwest New Guinea*, pp. 149-153. Singapore, Leiden, and Amsterdam: Periplus Editions and the Rijksmuseum voor Volkenkunde in association with C. Zwartenkot.

Hoogerbrugge, Jac. 1995. "Notes on the Art of Barkcloth Painting in the Jayapura Area, Irian Jaya, Indonesia." In D. Smidt, P. ter Keurs & A. Trouwborst, eds. *Pacific Material Culture: Essays in Honour of Dr. Simon Kooijman on the Occasion of his 80th Birthday*, pp. 167-179. Leiden: Rijksmuseum voor Volkenkunde.

Hoogerbrugge. J. & S. Kooijman. 1976. *70 Jaar Asmat houtsnijkunst / 70 Years of Asmat Woodcarving*. Breda: Volkenkundig Museum Justinus van Nassau.

Höpfner, G. 1995. "Die Rückführung der Leningrad-Sammlungs des Museums für Völkerkunde." *Jahrbuch Preussischer Kulturbesitz* 29: 157-171.

Imperato, P.J. 1983. *Buffons, Queens and Wooden Horsemen*. New York: Kilima House.

Jacobsen, J.A. 1977. *Alaskan Voyage 1881-1883: An Expedition to the Northwest Coast of America*. From the German text of Adrian Woldt, originally published in 1884. Translated by Erna Gunther. Chicago and London: The University of Chicago Press.

Jonaitis, Aldona. 1988. *From the Land of the Totem Poles: The Northwest Coast Indian Art Collection at the American Museum of Natural History*. New York: Americam Museum of Natural History.

Karp, I. & S.D. Levine. 1991. *Exhibiting Cultures: The Poetics and Politics of Museums*. Washington, D.C.: Smithsonian Institution Press.

Kasfir, Sidney Littlefield. 1992. "African Art and Authenticity: A Text with a Shadow." *African Arts* XXV(2): 41-53, 96.

Kerchache, Jacques. 1967. *Le m'boueti des Mahongoue. Gabon*. Text by Claude Roy. Paris: Galerie Jacques Kerchache with Editions François Maspero.

Kerchache, Jacques et al. 1990. "Pour que les chefs-d'oeuvre du monde entier naissent libres et égaux," *Libération*, March 15.

Kerchache, Jacques. 1994. *L'art africain dans la collection de Baselitz*. Catalogue of the 4ème Salon International des Musées et des Expositions, Paris. Paris.

Kerchache, Jacques (ed.). 2000. *Sculptures: Afrique, Asie, Océanie, Amériques*. Paris: Seuil.

Kerchache, J., J.-L. Paudrat & L. Stéphan. 1988. *L'art africain*. Paris: Mazenod.

Kerchache, Jacques & Maurice Godelier. 2000. *Sculptures: Afrique, Asie, Océanie, Amériques*. Cd-rom. Paris: Carré Multimedia.

Kerkhoven, R. 1995. *Het Afrikaanse gezicht van Corneille*. Ph.D. thesis. Nijmegen: Katholieke Universiteit Nijmegen.

Knauft, Bruce M. 1993. *South Coast New Guinea Cultures. History, Comparison, Dialectic*. Cambridge: Cambridge University Press.

Konrad, Gunter & Ursula Konrad, eds. 1995. *Asmat: Mythen und rituale Inspiration der Kunst*. Venezia (Italia): Erizzo Editrice.

Konrad, Gunter, Ursula Konrad & Tobias Schneebaum. 1981. *Asmat. Leben mit den Ahnen. Steinzeitliche Holzschnitzer unserer Zeit*. Glashütten/Ts. (Germany): F. Brückner.

Kooijman, Simon. 1963. *Ornamented Bark-Cloth in Indonesia*. Mededelingen van het Rijksmuseum voor Volkenkunde 16. Leiden: Rijksmuseum voor Volkenkunde.

Kooijman, Simon & Jac Hoogerbrugge. 1992. "Art of Wakde-Yamna Area, Humboldt Bay and Lake Sentani." In Suzanne Greub, ed., *Art of Northwest New Guinea: From Geelvink Bay, Humboldt Bay and Lake Sentani*, pp. 57-125. New York: Rizzoli.

Krüger, Klaus-Jochen. 1999/2000. "The Arts of Bahr-el-Ghazal: Funerary Sculpture of the Bongo and Belanda," *The World of Tribal Arts*, Winter/Spring: 82-101.

Küchler, Susanne. 1997. "Sacrificial Economy and its Objects: Rethinking Colonial Collecting in Oceania." *Journal of Material Culture* 2(1): 39-60.

Kuhn, I. 1956. *Ascent to the Tribes: Pioneering in Northern Thailand*. London: China

Inland Mission and Lutterworth Press.

Lagardère, Geneviève. 1996. *Borneo: The Dayak in the François Coppens Collection.* Solutré: Musée Départemental de Préhistoire de Solutré.

Laman, Karl Edward. 1953-68. *The Kongo.* 4 vols. Uppsala: Almqvist & Wiksells.

Lamme, Adriaan & Dirk Smidt. 1993. "Collection: Military, Explorers and Anthropologists." In Dirk Smidt, ed., *Asmat art: Woodcarvings from Southwest New Guinea*, pp. 137-148. Singapore, Leiden, and Amsterdam: Periplus Editions and the Rijksmuseum voor Volkenkunde in association with C. Zwartenkot.

Lamp, Frederick. 1996. *Art of the Baga: A Drama of Cultural Reinvention.* New York: The Museum for African Art & Prestel Verlag.

Lang, S. 1991. "Handover of remains <undignified>." *Sunday Territorian* (Australia), October 6th, 1991.

Lawson, Barbara. 1994. *Collected Curios: Missionary Tales from the South Seas.* Montreal: McGill University Libraries.

Legêne, Susan. 1998. *De bagage van Blomhoff en Van Breughel. Japan, Java, Tripoli en Suriname in de negentiende-eeuwse cultuur van het imperialisme.* Amsterdam: Koninklijk Instituut voor de Tropen.

Lehuard, R. 1980. "De la circulation de l'art nègre." *Arts d'Afrique Noire* 35: 4-15.

Lehuard, R. 1986. "Charles Ratton et l'aventure de l'art nègre." *Arts d'Afrique Noire* 60: 11-33.

Leiris, M. 1981 [1934]. *L'Afrique fantome.* Paris: Gallimard.

Leloup, Hélène. 1994. "Arrivée de la sculpture Dogon en Occident." In Hélène Leloup with William Rubin, Richard Serra and Georg Baselitz, *Statuaire Dogon*, pp. 63-92. Strasbourg: Daniele Amez.

Lemaire, M.L.J. 1946. *Neger-kunst, Zuidzee-kunst: Catalogus ener tentoonstelling te houden van 12 januari tot 9 februari 1946—Leidschestraat 28, Amsterdam.* Exhibtion catalogue. Amsterdam: M.L.J. Lemaire.

Leurquin, Anne. 1988. "De verspreiding van het Afrikaanse object, of de geschiedenis van een zwerftocht." In Anonymous, *Utotombo: Kunst uit Zwart-Afrika in Belgisch privé-bezit*, pp. 315-330. Brussel: Vereniging voor Tentoonstellingen van het Paleis voor Schone Kunsten.

Lévi-Strauss, Claude. 1983. "New York pré- et postfiguratif." In idem, *Le regard éloigné*, pp. 345-356. Paris: Plon.

Leyten, H., ed. 1995. *Illicit Trade in Cultural Property: Museums against Pillage.* Amsterdam & Bamako: Koninklijk Institut voor de Tropen & Musée National du Mali.

MacClancy, Jeremy. 1988. "A Natural Curiosity: The British Market in Primitive Art." *Res* 15: 163-176.

MacGaffey, W. 1991. *Art and Healing of the BaKongo Commented by Themselves: Minkisi from the Lamann Collection.* Stockholm: Folkens Museum—Etnografiska.

Mack, Charles. 1982. *Polynesian Art at Auction, 1965-1980.* Northboro: Mack-Nasser.

Mack, John. n.d. (c 1990). *Emil Torday and the Art of the Congo, 1900-1909.* London: The Trustees of the British Museum.

Maurer, E.M. & J.W. Mestach. 1991. *The Intelligence of Forms: An Artist Collects*

African Art. Minneapolis: The Minneapolis Institute of Art.

McLeod, M. 1993. *Collecting for the British Museum*. Quaderni Poro 8. Milaan.

Mestach, J.W. 1985. *Etudes Songye. Forme et symbolique. Essai d'analyse*. Munich: Fred Jahn.

Spencer, A.B. & R. Parkinson. 1900. *Album von Papúa-Typen II*. Dresden: Stengel & Co.

Moore, D.R. 1984. *The Torres Strait collections of A.C. Haddon: A Descriptive Catalogue*. London.

Morphy, Howard. 1991. *Ancestral Connections. Art and an Aboriginal System of Knowledge*. Chicago: The University of Chicago Press.

Morphy, Howard & Elisabeth Edwards. 1988. *Australia in Oxford*. Oxford: Pitt Rivers Museum.

Moss, Laurence. 1994. "Art Collecting, Tourism and a Tribal Region." In P.M. Taylor, ed., *Fragile Traditions: Indonesian Art in Jeopardy*, pp. 91-121. Honolulu: University of Hawaii Press.

Muensterberger, Werner. 1994. *Collecting, an Unruly Passion: Psychological Perspectives*. Princeton: Princeton University Press.

Mundle (no initials). 1902. Letter to the editor, in *Globus* LXXXII: 280.

Ndiaye, Francine. 1996. "Daniel-Henry Kahnweiler et l'art nègre." *Arts d'Afrique Noire* 98: 39-44.

Nelson, Edward William. 1983 [1899]. *The Eskimo About Bering Strait*. Washington, D.C.: Smithsonian Institution.

Neurdenburg, J.C. 1883. *Catalogus der voorwerpen ter Internationale Tentoonstelling te Amsterdam ingezonden vanwege het Nederlandsche Zendelingsgenootschap*. Rotterdam.

Newton, Douglas & Hermione Waterfield 1995. *Tribal Sculpture: Masterpieces from Africa, South East Asia and the Pacific in the Barbier-Mueller Museum*. London: Thames and Hudson.

Neyt, F. 1992. "Hommage à Albert Maesen." *Arts d'Afrique Noire* 82: 9-10.

Nooter-Roberts, Mary & Allen F. Roberts, eds. 1996. *Memory: Luba Art and the Making of History*. New York: The Museum for African Art, and Munich: Prestel.

Northern, Tamara. 1986. *Expressions of Cameroon Art: The Franklin Collection*. Los Angeles: The Los Angeles County Museum of Natural History.

Notter, Annick, ed. 1997. *La découverte du Paradis Océanie: Curieux, navigateurs et savants*. Paris: Somogy Editions d'Art.

O'Hanlon, Michael. 1993. *Paradise: Portraying the New Guinea Highlands*. London: British Museum Press.

Ohnemus, Sylvia. *Zur Kultur der Admiralitätsinsulaner in Melanesien: Die Sammlung Alfred Bühler im Museum für Völkerkunde Basel*. Basel: Museum für Völkerkunde und Schweizerisches Museum für Volkskunde.

Olbrechts, F. 1931. "Over Irokeesche maskers." *Bulletin des Musées Royaux d'Art et d'Histoire* 3(1): 27-30.

Olbrechts, F. 1935. *Het roode land der zwarte Kariatieden*. Brussel.

Olbrechts, F. 1940. *Maskers en dansers in Ivoorkust*. Antwerp: Davidsfonds.

Oldman, W.O. 1943. *The Oldman collection of Polynesian Artifacts*. Memoirs of the Polynesian Society 15. New Plymouth.

Oldman, W.O. 1946 [1938]. *Skilled Handwork of the Maori, being the Oldmann Collection of Maori Artefacts*. 2nd ed. Wellington: Polynesian Society.

Oldman, W.O. 1976. *Illustrated Catalogue of Ethnographical Specimens*. London: W.O. Oldmann. Reprint of the original monthly brochures, issued from 1903 untill 1914 and numbered from 1 to 130.

Pannell, Sandra. 1994. "Mabo and Museums: The Indigenous (Re)Appropriation of Indigenous Things." *Oceania* 65: 18-39.

Parkinson, Richard H.R. 1907. *Dreissig Jahre in der Südsee. Land und Leute, Sitten und Gebräuche im Bismarck-Archipel und auf den deutschen Salomoninseln*. Stuttgart: Strecker und Schröder.

Paudrat, Jean-Louis. 1984. "From Africa." In William Rubin, ed., '*Primitivism' in 20th Century Art: Affinity of the Tribal and the Modern*, Vol. I, pp. 125-175. New York: The Museum of Modern Art.

Pelrine, Diane M. 1996. *Affinities of Form: Arts of Africa, Oceania and the Americas from the Raymond and Laura Wielgus Collection*. Munich and New York: Prestel.

Peltier, Philippe. 1984. "From Oceania." In William Rubin, ed., '*Primitivism' in 20th Century Art: Affinity of the Tribal and the Modern*, Vol. I, pp. 99-124. New York: The Museum of Modern Art.

Peltier, Philippe. 1992. "Jacques Viot, the Maro of Tobati, and Modern Painting: Paris-New Guinea: 1925-1935." In Suzanne Greub, ed., *Art of Northwest New Guinea: From Geelvink Bay, Humboldt Bay and Lake Sentani*, pp. 155-176. New York: Rizzoli.

Perrois, Louis. 1979. *Arts du Gabon: Les arts plastiques du Bassin de l'Ogooué*. Arnouville: Arts d'Afrique Noire.

Phelps, Steven. 1976. *Art and Artefacts of the Pacific, Africa and the Americas: The James Hooper Collection*. London: Hutchinson.

Phillips, Tom, ed. 1995. *Africa: The Art of a Continent*. Munich and New York: Prestel.

Pirat, C.-H. 1996. "The Buli Master: Isolated Master or Atelier? Toward a Catalogue Raisonné." *The World of Tribal Arts* III(2): 54-77.

Platenkamp, J. 1988. *Tobelo: Ideas and Values of a Moluccan Society*. Ph D diss. Leiden: Leiden University.

Price, R. & S. Price. 1992. *Equatoria*. New York and London: Routledge.

Price, R. & S. Price. 1995. *Enigma Variations: A Novel*. Cambridge, Mass. & London: Harvard University Press.

Price, S. 1989. *Primitive Art in Civilized Places*. Chicago: University of Chicago Press.

Ray, D. 1967. *Eskimo Masks: Art and Ceremony*. Seattle and London: University of Washington Press.

Reche, Otto. 1913. *Der Kaiserin-Augusta-Fluss. Ergebnisse der Südsee-Expedition 1908-1910 , II Ethnographie: A. Melanesien, Band I*. Hamburg: L. Friederichsen & Co.

Rhodes, Colin. 1994. *Primitivism and Modern Art*. London: Thames and Hudson.

Riding, Alan. 1997. "Geneva Collector Keeps his Works Travelling the World." *International Herald Tribune*, July 12-13.

Robbins, W. & N. Nooter. 1989. *African art in American Collections*. Washington DC: Smithsonian Institution Press.

Rohner, John. 2000. *Art Treasures from African Runners*. Niwot: University Press of Colorado.

Rousselot, J.-L., B. Abel, J. Pierre & C. Bihl. 1991. *Masques Eskimo d'Alaska*. Strassbourg: Éditions Amez.

Rubin, William, ed. 1984. *'Primitivism' in 20th Century Art: Affinity of the Tribal and the Modern*. 2 vols. New York: The Museum of Modern Art.

Rushing, W. Jackson. 1995. *Native American art and the New York Avant-Garde: A History of Cultural Primitivism*. Austin: University of Texas Press.

Salmon, Pierre. 1992. "Réflexion à propos du goût des arts zaïrois en Belgique durant la période coloniale (1885-1960)." In M. Quaghebeur & E. Van Balberge, eds., *Papier blanc, encre noire: Cent ans de culture francophone en Afrique centrale (Zaïre, Rwanda et Burundi)*, pp. 179-201. Bruxelles: Éditions Labor.

Schaedler, Karl-Ferdinand. 1992. "Das Sammeln afrikanischer Kunst in Deutschland." In id. *Götter, Geister, Ahnen: Afrikanische Skulpturen in deutsche Privatsammlungen*. München: Villa Stück / Kinkhart & Biermann.

Schildkrout, Enid & Curtis A. Keim. 1990. *African Reflections: Art from Northeastern Zaire*. Seattle and London: University of Washington Press; New York: American Museum of Natural History.

Schildkrout, Enid & Curtis A. Keim, eds. 1998. *The Scramble for Art in Central Africa*. Cambridge: Cambridge University Press.

Schindlbeck, M. 1993. "The Art of Collecting: Interactions between Collectors and the People they Visit." *Zeitschrift für Ethnologie* 118: 57-67.

Schmeltz, J.D.E. 1896. *Ethnographische musea in Midden-Europa: Verslag ener studiereis. 19 mei—31 juli 1895*. Leiden: Brill.

Schmeltz, J.D.E. & R. Krause. 1881. *Die ethnographisch-anthropologische Abteilung des Museum Goddefroy in Hamburg:* Hamburg: Friederichsen.

Schmidt, Andrea. 1996. *Leben und Werk des Ethnologen und Sammlers Paul Wirz (1892-1955)*. Unpublished Ph. D. thesis. Freiburg im Breisgau: Albert-Ludwigs Universität.

Schoffel, Alain. 1981. *Arts primitifs de l'Asie du Sud-Est (Assam, Sumatra, Bornéo, Philippines). Collection Alain Schoffel*. Meudon: Alain et Françoise Chaffin.

Siroto, Leon, with Kathleen Berrin as editor. 1995. *East of the Atlantic, West of the Congo: Art from Equatorial Africa—The Dwight and Blossom Strong Collection*. San Francisco: The Fine Arts Museum of San Francisco. Distributed by The University of Washington Press, Seattle.

Smidt, Dirk, ed. 1975. *The Seized Collections of the Papua New Guinea Museum*. Port Moresby: Creative Arts Centre and University of Papua New Guinea.

Smidt, Dirk. 1990. "Kominimung Sacred Woodcarvings (Papua New Guinea): Symbolic Meaning and Social Context." In P. ter Keurs & D. Smidt eds., *The Language of Things: Studies in Ethnocommunication*, Mededelingen van het Rijksmuseum voor Volkenkunde 25. Leiden: Rijksmuseum voor Volkenkunde.

Smidt, Dirk, ed. 1993. *Asmat Art: Woodcarvings from Southwest New Guinea*. Singapore,

Leiden, Amsterdam: Periplus Editions and the Rijksmuseum voor Volkenkunde in association with C. Zwartenkot.

Smidt, Dirk. 1996. "Korwars: Sprekende beelden als bemiddelaars tussen levenden en doden." In M. Holsbeke, ed., *Het object als bemiddelaar*, pp. 69-77. Antwerp: Etnografisch Museum van de Stad Antwerpen.

Spencer, B. & F.J. Gillen. 1969. *The Native Tribes of Central Australia* (1899). Oosterhout (NL): Anthropological Publications.

Steenbergen, Renée. 1993. "Alles van nijlpaardtand: Gesprek met een bezeten verzamelaar van etnografica." *NRC Handelsblad*. December 24.

Steiner, Christopher B. 1994. *African Art in Transit*. Cambridge: Cambridge University Press.

Steinhart, A. 1989. *1889-1989: 100 Jaar Kerk op de Batu-eilanden*. Woerden: Stichting Lutherse Uitgeverij en Boekhandel in opdracht van de Zendingsraad van de Evangelisch-Lutherse Kerk.

Stöhr, Waldemar. 1987. *Kunst und Kultur der Südsee: Sammlung Clausmeyer, Melanesien*. Køln: Rautenstrauch-Joest Museum für Völkerkunde.

Szalay, M. 1995. *Afrikanische Kunst aus der Sammlung Han Coray, 1916-1928*. Zürich: Völkerkundemuseum der Universtät Zürich, and München: Prestel Verlag.

Tavarelli, A., ed. 1995. *Protection, Power and Display: Shields of island Southeast Asia and Melanesia*. Boston: Boston College Museum of Art.

Taylor, Paul Michael, ed. 1994. *Fragile Traditions: Indonesian Art in Jeopardy*. Honolulu: University of Hawaii Press.

Taylor, Paul Michael. 1994a. "The Nusantara Concept of Culture: Local Traditions and National Identity as Expressed in Indonesia's Museums,", in idem, ed., *Fragile Traditions: Indonesian Art in Jeopardy*, pp. 71-90. Honolulu: University of Hawaii Press.

Thilenius, G., ed. 1918. *Ergebnisse der Südsee-Expedition 1908-1910*. Hamburg: Hamburgische Wissenschaftliche Stiftung.

Thomas, N. 1991. *Entangled objects: Exchange, material culture and colonialism in the Pacific*. Cambridge, Mass. and London: Harvard University Press.

Tischner, Herbert. 1965. *Das Kultkrokodil vom Korewori*. Hamburg: Hamburgisches Museum für Völkerkunde und Vorgeschichte.

Van Baaren, Th.P. 1968. *Korwars and Korwar Style: Art and Ancestor Worship in North-West New Guinea*. Paris and The Hague: Mouton & Co.

Van Beek, Walter A.E. 1988. "Functions of sculpture in Dogon religion." *African Arts* XXI(4): 64.

Van Brakel, J., D. van Duuren & I. van Hout. 1996. *A Passion for Indonesian art: The Georg Tillmann (1892-1941) Collection at the Tropenmuseum Amsterdam*. Amsterdam: Royal Tropical Institute.

Van Dalen, A.A. 1928. *Van strijd en overwinning op Alor*. Amsterdam: Spruyt.

Van Duuren, David. 1990. *125 Jaar verzamelen*. Exhibition catalogue. Amsterdam: Tropenmuseum.

Van Duuren, David. 1998. *The Kris: An Earthly Approach to a Cosmic Symbol*. Wijk en Aalburg: Pictures Publications.

Van Hasselt, F.J.T. 1933. "Momentopnamen van Jappen." *Kennemer-Bode: Zendingsorgaan van het Indramajoe-, Jappen- en Nimboran (N.Guinea)-Comité* 12(2): 1-4. Haarlem: Centraal Zendingscomité.

Van Kooten, Toos & Gerard van den Heuvel, eds. 1990. *Sculptuur uit Afrika en Oceanië / Sculpture from Africa and Oceania.* Otterlo: Rijksmuseum Kröller-Müller.

Van Lier, Bas. 1997. "The Carel van Lier Archive." *RKD Bulletin* 1997-3: 5-10. The Hague: Rijksdienst voor Kunsthistorische Documentatie.

Van Rijn, Guy. 2000. *Who's Who in African Art.* Antwerp: Van Rijn Documentation Center.

Van Royen, H. 1996. *Pater Petrus Vertenten MSC, 1884-1946: Een veelzijdig missionaris.* Borgerhout: Missionarissen van het Heilig Hart.

Van Schuylenbergh, Patricia. 1995. "Découverte et vie des arts plastiques du Bassin du Congo dans la Belgique des années 1920-1930." *Enquêtes et Documents d'Histoire Africaine* 12: 1-64.

Van Vugt, Ewald. 1991. "<België schenkt de beschaving aan de Congo>: Resten van koloniale propaganda in volkenkundige musea." *Vitrine* 4(3): 40-43.

Van Witteloostuijn, H. 1995. "Een handelaar geeft zijn mening." *Nieuwsbrief van de Vereniging Vrienden van Etnografica* 50: 33-34.

Veirman, A. 1996. "De Belgische expedities naar West-Afrika in de jaren 1930." In

Vermeijden, Marianne et al. 1996. "Wrijforakels en voodoo-goden." *NRC Handelsblad* 30 August, pp. 6, 7.

Vertenten, Piet. 1935. *Vijftien jaar bij de koppensnellers van Nederlandsch Zuid Nieuw-Guinea.* Nederland/België: Davidsfonds.

Vogel, Susan, ed. 1988. *ART/artifact.* New York: Center for African Art and Prestel Verlag.

Vogelzang, Jacques. 1997. Leendert van Lier: Kunsthandelaar-verzamelaar-schilder. *Nieuwsbrief van de Vereniging Vrienden van Etnografica* 59, Summer, pp. 49-51.

Wastiau, Boris. 2000. *Congo - Tervuren: Aller - retour.* Tervuren: Musée Royal d'Afrique Central.

Webster, W.D. 1895-1901. *Illustrated Catalogue of Ethnographical Specimens, European and Eastern Arms and Armour, Prehistoric and Other Curiosities.* Bicester: W.D. Webster.

Welling, W. 1995. "Nieuwe missie in Afrika? Musea en kunsthandel over illegale etnografica."*Vitrine* 8(5): 16-20.

Welsch, Robert. 1998. *An American Anthropologist in Melanesia: A.B. Lewis and the Joseph N. Field South Pacific Expedition 1909-1913.* Two volumes. Honolulu: University of Hawai'i Press.

West, Margaret K.C. 1987. *Declan: A Tiwi Artist.* Melbourne: Australian City Properties Limited.

Wilhelmen, Raymonde. 1985. *Le Guidargus de l'art primitif, 1965-1985: 20 ans d'art primitif en ventes publiques.* Paris: Les Editions de l'Amateur.

Williams, J. 1838. *A Narrative of Missionary Enterprises in the South Sea Islands.* London: Snow.

Willis, Ryann. 1995/96. "Jean Willy Mestach." Interview. *The World of Tribal Arts* II(4): 76-79.

Wirz, Paul. 1928a. *Bei liebenswürdigen Wilden in Neuguinea.* Stuttgart: Strecker und Schröder.

Wirz, Paul. 1928b. "Beiträge zur Ethnologie der Sentanier (Holländisch Neuguinea)." *Nova Guinea* XVI(3). Leiden.

Wirz, Paul. 1951. "Meine Sepikfahrt. Eine Sammelreise für das Bernische Historische Museum." *Jahrbuch des Bernischen Historischen Museums* XXXI: 122-140.

Zegwaard, Gerard A. 1959. "Headhunting Practices of the Asmat of Netherlands New Guinea." *American Anthropologist* 61: 1020-1041.

Zwernemann, Jürgen. 1980. *Hundert Jahre Hamburgisches Museum für Völkerkunde.* Hamburg: Museum für Völkerkunde.

Zwernemann, Jürgen. 1986. "Julius Konietzko: Ein 'Sammelreisender' und Händler." *Mitteilungen aus dem Museum für Völkerkunde Hamburg* 16: 111-127.

Picture credits

Cover picture: Svenska Missionsförbundet, Stockholm; 1 Dennett 1887; 2 Photo Peter Hermus, Rotterdam; 3 Baumann 1935, Plate 29; 4 Archives of the Koninklijk Museum voor Midden-Afrika, Tervuren, Belgium; 5 Meyer & Parkinson 1900, Fig. 13; 6 Center for Tribal Art, Brussels; 7 Bernaerts Auction House, Antwerp; 8 Bas van Lier, Amsterdam; 9 Frits Lemaire, Lemaire Gallery, Amsterdam; 10 Frits Lemaire, Lemaire Gallery, Amsterdam; 11 Archives of the Museum voor Volkenkunde Rotterdam; 12 Nijmeegs Volkenkundig Museum, Nijmegen, the Netherlands; 13 Archives of the Museum voor Volkenkunde Rotterdam; 14 Centre for Tribal Art, Brussels; 15 Van Dalen 1928 and Museum voor Volkenkunde Rotterdam; 16 Wirz 1928a; 17 Nijmeegs Volkenkundig Museum and Fer Hoekstra; 18 Centre for Tribal Art, Brussels; 19 Peter de Boer of Kalpa Art Gallery, Amsterdam; 20 Ph. Konzett, Vienna; 21 Richard Parkinson; 22 Wil Roebroeks, Leiden; 23 Museum für Völkerkunde, Berlin; 24 Museum für Völkerkunde, Berlin; 26 Father Gerard Zegwaard MSC, Rotterdam; 27 Museum für Völkerkunde, Berlin; 28 Dirk Smidt, Leiden, 1993; 29 Wil Roebroeks; 30 B. Spencer, *Wanderings in Wild Australia*, Vol. II, Figure 476, and R. Corbey; 31 Service de Presse, Présidence de la République Française, 2000; 32 Wil Roebroeks; 33 Wirz 1928; 34 Father C. van Kessel, MSC; 35 (upper picture) Photo Ferry Herrebrugh, Amstelveen; 36 Anonymous; 37 Marc Felix, Brussels; 38 Frans Jacobs Fotografie, Brussels; 39 Marc Felix, Brussels; 40 Tijs Goldschmidt, Amsterdam; 41 Tijs Goldschmidt, Amsterdam; 42 Tijs Goldschmidt, Amsterdam; 43 R. Corbey; 44 R. Corbey; 45 Dirk Smidt, Leiden; 46 Dirk Smidt; 47 Wil Roebroeks; 48 De Standaard / Peter Vandermeersch, Brussels.